Essential CG Lighting Techniques with 3ds Max

Darren Brooker

Autodesk®
Media and Entertainment
Techniques

ELSEVIER

AMSTERDAM • BOSTON • HEIDELBERG • LONDON • NEW YORK • OXFORD
PARIS • SAN DIEGO • SAN FRANCISCO • SINGAPORE • SYDNEY • TOKYO
Focal Press is an imprint of Elsevier

Focal
Press

Focal Press is an imprint of Elsevier
Linacre House, Jordan Hill, Oxford OX2 8DP, UK
30 Corporate Drive, Suite 400, Burlington, MA 01803, USA

First edition 2003
Second edition 2006
Reprinted 2007

Notice
No responsibility is assumed by the publisher for any injury and/or damage to persons
or property as a matter of products liability, negligence or otherwise, or from any use
or operation of any methods, products, instructions or ideas contained in the material
herein. Because of rapid advances in the medical sciences, in particular, independent
verification of diagnoses and drug dosages should be made

British Library Cataloguing in Publication Data
A catalogue record for this book is available from the British Library

Library of Congress Cataloging-in-Publication Data
A catalog record for this book is available from the Library of Congress

ISBN: 978-0-2405-2022-3

For information on all Focal Press publications
visit our website at www.focalpress.com

Printed and bound in *China*

07 08 09 10 10 9 8 7 6 5 4 3 2

Working together to grow
libraries in developing countries

www.elsevier.com | www.bookaid.org | www.sabre.org

ELSEVIER BOOK AID
International Sabre Foundation

Essential CG Lighting Techniques with 3ds Max

Dedication

To all the friends and family who continue to support me through the many years of my abnormally circuitous career and to Georgina for keeping me in check.

Contents at a glance

Table of contents

Part 2: Techniques

Appendices

About the author

Darren Brooker is an award-winning CG artist, writer and illustrator with over a decade specializing in texturing, rendering and lighting in architecture and post production. He works for Autodesk's Media & Entertainment division in London, where he specializes in 3ds Max.

He has previously worked for leading UK production studios Cosgrove Hall Digital, Pepper's Ghost and Red Vision. It was at this company that he was part of a team that won a BAFTA for Best Visual Effects. He was also runner-up in the European Junior 3D Animator's Award and has been shortlisted for the British Book Design and Publishing awards.

His writing credits include *The Guardian, CGI, 3D World, Computer Arts, Broadcast Engineering News* and *Creation*.

Acknowledgments

First of all comes the team at Focal Press who've made this title possible. From Marie's initial approach at SIGGRAPH 2000 to the final proofreading stage, the professional manner in which the production has been overseen has been much appreciated. This applies equally to the amount of control in terms of layout and design that Focal were willing to give me, which has resulted in a very close match to my initial vision for a definitive lighting text.

Particular thanks goes to the folks at Autodesk Media & Entertainment in the UK for their continued help and support over the last decade. The support team deserve a special mention for their understanding in the way that this book crept into my day-to-day duties at Autodesk.

The majority of renderings featured in this book were carried out at my home on a mixture of Dell and IBM hardware, but a lot of this work involves previous collaboration with London Guildhall University, where the guidance of Mike King and Nigel Maudsley was an enormous amount of help. The design and layout of this book also took place in my home in London, with occasional work at the homes of various friends, who deserve thanks for their patience, not to mention their food and accommodation.

Thanks go to all the studios that kindly gave me permission to talk to them about their projects and use their images for print, and also to the individual artists who have been very supportive in this project. You know who you are.

'Light and illumination are inseparable components of form, space and light. These are the things that create ambience and feel of a place, as well as the expression of a structure that houses the functions within it and around it. Light renders texture, illuminates surface, and provides sparkle and life.'

Le Corbusier

Lighting's vital role is understood across a whole spectrum of disciplines, from animation to architecture, film to photography. The modernist architect Le Corbusier, quoted above, perhaps sums up the considerable role it plays most poetically. Though speaking about architecture, his words express succinctly just why lighting is so important in the world of 3D. Equally, he speaks for those working across the full spectrum of visual arts.

Though getting increasingly mature with each passing software release, when looked at in context of its complementary disciplines, 3D remains a comparatively young industry. As such, those who work in it can learn a lot from the established lessons of these complementary disciplines. As an industry arguably still in its adolescence, it still lacks the knowledge base of tried-and-tested techniques and conventions that have established themselves around older art forms.

Image courtesy of:
Luciano Neves
www.infinitecg.com

Indeed, the conventions that exist in the world of cinema were certainly not established overnight, and those working in the early days of film gradually developed the language of cinematography as we understand it today. As the world of 3D continues to mature, conventions similar to those that now exist in cinematography will slowly become established and adhered to. This is indeed happening already, as those who have worked on a big CG production will testify. For example, its model of operation has already become stratified by specialism, with many productions divided between modeling, animation, lighting, rendering and compositing teams.

This mode of operation demands of 3D artists a skillset that is focused on one specific area, yet an understanding of the full production pipeline is also necessary in order to understand the needs of fellow workers in other teams.

In answer to this demand for specialized skills within 3D, this book aims to provide a single volume that looks at both the technical and practical aspects of lighting in CG. It aims to assist you in becoming skilled at using the lighting tools available within 3ds Max, whilst placing this in context of the world of lighting in the complementary visual arts and always looking at this in context of the real world of professional computer graphics production. This book does not only aim to teach the reader the skills demanded of a 3D lighting specialist, it considers the fundamentals, both aesthetic and theoretical, of the real world of lighting, placing this technical knowledge in a wider context.

To become skilled at 3D lighting, one must first have a basic understanding of how light works. The emotive power of different hues and color schemes must be comprehended, as must the manner in which the construction of a system of lights unifies a scene, bringing everything together as a cohesive whole that reinforces the atmosphere of the script. Composition and staging need to be appreciated, as well as the psychological effect that these considerations will convey to your audience. Only once a thorough understanding of all of these factors has been gained can anyone really call themselves a lighting artist. Fortunately, the established rules of cinematography, painting, photography, stage design and architecture can provide many valuable lessons in helping us to understand the wider context in which 3D lighting exists.

With a firm grasp of the principles of lighting, you will understand how to set off the hard work of the other teams in your studio (or occasionally even to hide the bad work), bringing about a cohesive image that reinforces the emotions of the storyline. Until a 3D scene has been lit, it remains nothing more than a bunch of polygons, and with the lighting carried out professionally, every team involved benefits.

This book aims to use as a cornerstone the lighting conventions that have already become established within computer graphics, and it will examine those that are just starting to be used in a professional production environment. It will do this whilst drawing on the complementary arts to look at the valuable lessons to be learned from these more time-honored disciplines.

Of its four main sections, the first will examine theories to give you a firm foundation on which to build before moving on to sections covering techniques, then tips and tricks - from painting, photography, film and television, stage design and architecture. The final section will reinforce this content with practical knowledge and advice from the real world of 3D production to enable you to take this knowledge further.

Whilst all the science will be explained in plain English along the way, this book's main concern is not with the theory of lighting; its aim is to teach the reader how to apply these lessons in CG, with every ounce of theory backed up by tutorials, and every tutorial placed in context of the holistic world of the visual arts.

Who this book is for

Professional users:
This book is designed to help the experienced 3ds Max user supplement their existing knowledge with new techniques that will provide further creative possibilities and help negotiate the continuing trials and tribulations of the production world.

Intermediate users:
This book is perfect for the user who already has some working knowledge of 3ds Max and wants to produce more professional results by learning about the techniques of lighting.

Beginners:
This book aims to cover extensively the skills of 3D lighting in a modular approach that guides the reader step by step, using tutorials aimed at teaching the general processes involved rather than the technicalities of dealing with complex 3D scenes.

The tone of the book is intended to be clear and concise without being packed full of jargon. Each industry term is defined in plain English, and backed up with clear and colorful images, diagrams and, of course, renderings. Tutorials are provided, using both 3ds Max and Combustion, and demo versions of these Autodesk applications are included on the book's DVD. The tutorials are written in such a way that their content is transferable to other 3D solutions.

How to use this book

This book is written in a modular fashion, with the information organized into relevant sections to provide a more effective teaching aid. The first section deals with the important theoretical aspects of lighting in a clear and informative manner. Whilst not going into the theory to an unnecessarily deep level, it does attempt to outline the basic principles of light that will serve as a guide to the lighting tasks that lie ahead, before moving into the theory of lighting in 3D. The newcomer in particular will find that this section provides an invaluable yet understandable reference to appreciating the physical properties and nature of light and how this relates to computer graphics.

The second section deals with the specific techniques applicable to 3D lighting and forms over half of the book's content. Armed with an understanding from the last section of how lighting operates within the 3D environment the reader will move on to examine different aspects of 3D lighting, where every ounce of theory is backed up by hands-on tutorials. This takes both the aesthetic and theoretical fundamentals of different lighting tasks and breaks each down into a method that fits in with professional 3D pipelines in terms of efficiency and output.

The third section provides guidelines for using the techniques introduced so far in an efficient fashion, as well as tips and tricks for breaking all the rules that have been introduced so far through faking and manipulating, which are all very valuable skills in the world of CG! Knowing which tricks save rendering time and which give the most controllable results allows you, the artist, to work in the most appropriate and flexible way possible.

The fourth section looks at further aesthetic considerations, and how as a lighting artist you have more than just illumination to worry about. An appreciation of composition, drama and the more technical aspects of the job reinforces the concepts introduced thus far and provides several junctions to explore from. From here you should be ready to explore and create all on your own!

Tutorials

Rather than being laid out in a methodical step-by-step fashion, the tutorials are designed to be readable and understandable, with decisions put in context of why they were made. However, an attempt has been made to ensure that each numerical value required has been provided so that the reader is not left guessing. Whilst these numbers will yield results that are faithful to the accompanying illustrations, these should not necessarily be taken as definitive, and experimentation and deviation from these values should be encouraged.

Software requirements

Whilst the concepts discussed throughout the book are applicable to all the major commercial 3D applications, the tutorials are designed to be used with the demo version of 3ds Max (and in the later chapters with Combustion) that can be found on the accompanying DVD; their subject matter can also be easily adapted to any software application. Should you use Maya, Softimage XSi, LightWave or another commercial solution, the techniques and concepts contained in these tutorials will be just as applicable, as lighting skills can be learnt and applied in any of these environments. The more experienced user will be able to transfer the tutorials straight from the page into their particular 3D software, but the less experienced user might first want to run through the tutorials with the demo version of 3ds Max. For the newcomer, the tutorials together with the demo version of 3ds Max provide the perfect starting point to dive headlong into 3D lighting techniques.

However, it should be stressed that software is not the main focus of this book - terrible results can easily be produced using the best software, and vice versa - its focus is rather an appreciation of the many factors that go together to produce well-lit output.

part 1: theory

Image courtesy of:
Weiye Yin
http://franccg.51.net

2

'And God said, "Let there be light," and there was light.'

Genesis 1:3

Real world lighting explained

We are so accustomed to light that not many of us often really stop to consider it, even though it is exceptionally fundamental to human existence. Light dictates our activities, influences our frame of mind and affects the way we perceive all manner of things. It may be true that a lot of CG lighting artists often work so many hours that they are less accustomed to seeing natural daylight than a lot of people, but an understanding of its nature and behavior is fundamental to being able to work with it effectively.

Whilst this chapter aims to explain the important theoretical aspects of lighting, it will not go into this theory to an unnecessarily deep level. This section is not supposed to be treated as if it were a physics textbook. Instead, the following three short chapters aim to outline the basic principles of light that will serve as a guide to fully understanding the lighting tasks that lie ahead in the following sections. Whilst one must understand

Image courtesy of:
Ivan de Andres Gonzalez
www.oxhido.com

light to be able to exploit it fully, this is by no means a chapter that cannot be skimmed through by the more experienced lighting artist. Nevertheless, it provides an easily understandable reference to understanding the physical properties and nature of light, which will be particularly useful to those new to 3D and lighting.

The visible spectrum

We are surrounded by a whole different variety of waves in our everyday lives, from x-rays to radio waves. The main difference between these types of waves is their wavelength. They all form part of the electromagnetic spectrum, which goes from the short wavelength of x-rays at one end to radio waves at the other, which have a very long wavelength. Between these two extremes lies a very narrow band that is visible to us, and this is light.

Visible light's wavelength is nearer to the x-ray end, because its wavelength is small - from around 400 nanometers at its smallest value to less than 800 at its largest. (One nanometer is a billionth of a meter.) Taking this subsection, which is called the visible spectrum, we have ultraviolet radiation at the end with the shortest wavelength, known for its harmful effects on skin. Moving up through the visible spectrum, you'd move from violet through blue, green, yellow, orange and red before encountering infrared radiation at the opposite end, which we experience as heat.

Figure 2.01
The distribution of light within the visible spectrum

Figure 2.02
The pigment- (left) and light- (right) based color wheels

Color mixing

This spectrum of visible colors is represented on your monitor using light of three colors: red, green and blue (RGB). These three colors are the primary colors of light, rather than the red, yellow and blue of pigment-based color mixing that you may remember from art class. The reason for this is that paint is mixed using a subtractive approach, whereas light uses an additive. The additive mixing of the three RGB primaries makes white light. This can be demonstrated in 3D by pointing three overlapping lights of red, green and blue at an object and rendering. The result: white light. In this way, additive mixing takes the monitor's black screen and adds the three primary colors of light to make white.

Subtractive mixing works the opposite way round; starting with a white canvas and mixing the three primary colors to make black. Printers use subtractive color mixing, but rather than use the red, yellow and blue primaries, the complementary colors of cyan, magenta and yellow are used as primaries. Professional machines use a four-color palette with black also thrown in, which is generally referred to as CMYK. The primary reason for the addition of this fourth ink is that for most printed literature a pure black is required for uniform text.

The differences in these color mixing systems mean that it is important to calibrate your monitor to match the printer you are working with if your rendered image is for print publishing. This process involves altering the monitor to match the printed version as closely as possible. Monitor calibration is important, however, for all 3D users, whatever the delivery medium. As detailed in Appendix A, if you are working with too light a display, your

Figure 2.03

In the printing process, cyan, magenta, yellow and black plates combine to make a color image

image might look fine on screen, but you'll actually be using less lighting than you should to compensate and using only a fraction of the tonal range available. Your output viewed on other monitors will be too dark. This applies in reverse if you are working on too dark a display. If you have not calibrated your monitor recently, make sure you follow the procedure detailed in Appendix A before attempting any of the practical techniques in the following section.

Our perception of light

Our graphics card settings may lead us to believe that what we are viewing is 'True Color'. In reality when sat in front of a PC or TV, what we are in fact seeing is a very restricted interpretation of the whole visible spectrum. The fact that just three colors of light make up a single pixel on-screen means that only red, green and blue colors can actually be displayed and a mixture of these three colors is used to represent colors of other wavelengths.

The reason why we can perceive the full spectrum within such a restricted interpretation of it is due to the way that the human eye operates. Our eyes are only responsive to three parts of the visible spectrum. They sample from these three areas using photosensitive receptor cells called cones - there are three types of these cones located in our retinas, which each respond to light of different wavelengths. These three values correspond roughly with red, green and blue, but are not limited to these colors; their sensitivity to areas of the spectrum overlaps, so the RGB palette does actually convey a realistic and convincing reproduction of the full visible spectrum to the human eye.

Figure 2.04

The cones in our eyes detect light in three areas of the spectrum that RGB color roughly corresponds to

Indeed, just as the RGB primaries are related to the way the human eye operates, other primaries would have to be used in generating color ranges for other species. Birds, for example, are among the many creatures with four different color receptors and

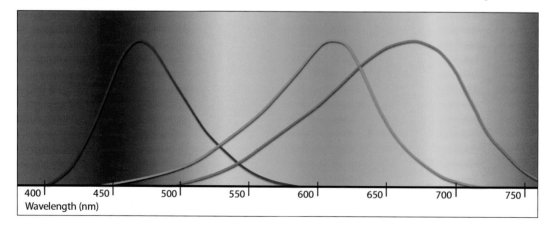

so a system aimed at generating color for these species would have to use four primaries, whilst most mammals would only require two primaries.

Color temperature

The system of measuring color temperatures works like the Centigrade scale. Subtract 273 from a Centigrade temperature and you get the measurement in Kelvins. The reason for this is that the Kelvin scale begins at absolute zero, rather than at the freezing point of water. Hence absolute zero is –273 degrees Centigrade. This scale was conceived in the late nineteenth century by the physicist Lord William Thompson Kelvin, who discovered that heated carbon would emit different colors depending on its temperature. Increasing the temperature of this substance results in a red glow, then, as the temperature increases, a yellow glow is produced that moves to a light blue and finally a violet color upon further increase.

Based on this research, the color temperature scale was established, and this is most commonly found in the physical world of lighting design. A 2k tungsten lamp that has a color temperature of 3,275 °K emits light at the yellow end of the spectrum, though this contains enough wavelengths of all the other colors to be considered white light. One thing that must be stressed is that color temperature is based on the visible color and not, as is a common misunderstanding, the physical temperature of the filament. Indeed, the melting point of tungsten is 3,800 °K, so to represent high color temperatures of around 5,600 °K that mimic daylight, special optical coatings must be used that fake a

Table 2.01
Common color temperatures

Source	°K
Candle flame	1,900
Sunlight: sunset or sunrise	2,000
100-watt household bulb	2,865
Tungsten lamp (500W - 1k)	3,200
Fluorescent lights	3,200-7,500
Tungsten lamp (2k - 10k)	3,275-3,400
Sunlight: early morning/late afternoon	4,300
Sunlight: noon	5,000
Daylight	5,600
Overcast sky	6,000-7,000
Summer sunlight plus blue sky	6,500
Skylight	12,000-20,000

Table 2.01
Real-world color temperatures, with the lower temperatures going from red, through white light to blue.

daylight spectrum by reducing the colors complementary to blue. If you are using photometric lighting, which we will discuss in more detail in the next chapter, you can set the color of your lights by adjusting the color temperature controls, as these lights are based on real-world physical lights.

Color balance

Whilst color temperature might seem a little meaningless in isolation, it is its combination with the concept of color balance that provides a solution to rendering images as if they had actually been filmed. Professional cinematographers use different films that have been color balanced at a specific color temperature. This dictates which color of light will appear white when filmed, and thus how other light sources will be tinted.

There are two types of color-balanced film that are common: tungsten-balanced film for indoor use and daylight-balanced film for outdoor. These two types of stock are balanced at 3,200 °K and 5,500 °K respectively. What this means, if you look at table 2.01, is that for tungsten-balanced film light of 3,200 °K (i.e. tungsten lamps) would appear white. And yes, you guessed it, for daylight-balanced film, daylight appears white, as the color balance of the film is around the same as for daylight.

The camera in a 3D environment generally does not have these kinds of capabilities, so to produce a rendering that mimics the recognizable colors of film you need to adjust the colors of your lights using your own judgment. Whilst there's no direct correlation between color temperatures and color values of lights in 3D, using a table of color temperatures will assist you in selecting the tints to give your lights relative to your chosen color balance.

The first decision to make would be your color balance. From here you should look at each individual light source and identify what type of light this actually represents. Then you should tint its RGB value according to its relative position to the chosen color balance, as per the following guidelines.

Figure 2.05
Once a color balance has been chosen, the RGB values of lights should be adjusted relative to this

Color balance

If the light source is of a lower color temperature than your chosen color balance, then it should be tinted first yellow then red, as the degree of difference between the two temperatures increases. This is shown in the left-hand side of figure 2.05. If the light source is of the same color temperature as the color balance, it would appear white.

If the light source is of a higher color temperature than the color balance, then it should be tinted blue, with the amount of tint again depending on the degree of difference between the two temperatures. This is shown towards the right-hand side of figure 2.05. As you can see from both the left- and right-hand sides of this diagram, the more the color balance and the color temperature of the light differ, the stronger and more saturated the tint should be. However, you should be careful about not making the colors too bright, as it only takes a small amount of color to begin to tint a surface and too saturated a color will begin to blow out the lighter values of your rendering.

There is no set formula for tinting lights in this way to produce a final look that mimics a recognizable film stock, and your own aesthetic judgment is the best tool. However, one thing that should be understood is that the choice of indoor or outdoor film is not based on the location of a scene, but on its dominant light source, so outdoor daylight-balanced film might be used for an indoor shot

Figure 2.06
With tungsten-balanced film, indoor lighting appears white

Images courtesy of:
Alexey Glinsky
http://3dstudio.nm.ru/

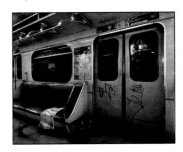

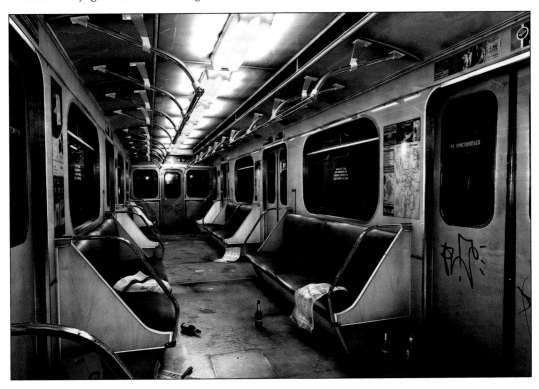

if the main light source is a window. This also applies conversely: indoor film is generally used for outdoor night scenes, as the dominant light in this situation would be artificial lights.

For an outdoor rendering, if you wanted to mimic daylight-balanced film, you'd start with a color balance of 5,500 °K. Your light representing the direct sun, depending on the time of day, would, according to table 2.01, have a color temperature of somewhere between 4,300 °K and 5,000 °K. Being slightly less than your chosen 5,500 °K, you'd give this light a yellow tint, with the saturation increasing the lower the value. The light from the sky would be given a saturated blue tint, as its color temperature is much higher than your 5,500 °K color balance. However, the saturation of these tints is something ultimately left to your own assessment. Furthermore, in reality outdoor illumination is made up of many more colors, due to the way in which the sun's light reflects off objects in the environment, bringing into the scene light tinted with the colors of these reflectors. Take a look at your scene and the principal colors of the largest surrounding objects. For example, if your scene were set against a backdrop of a large brick wall, the red color of the light bouncing from the bricks would have to be imparted to your lighting scheme.

For lighting scenarios where the dominant light source was artificial, the same principles would apply, though you'd be looking at a color balance of 3,200 °K to mimic tungsten-balanced film. Now the lights that would have a lower temperature and thus have to be given a yellow tint would be things like domestic lights. Direct sunlight, however, would now be of a higher color temperature and thus would be given a blue tint, unless it was sunrise or sunset. The colors of the light bouncing off the walls, floor and ceiling of the environment would now have to be taken into consideration using extra lighting.

One final thing of note is fluorescent lighting, which has a high color temperature range - from 3,200 °K to 7,500 °K. Whilst this is straightforward with a 3,200 °K color balance representing tungsten-balanced film - all fluorescent sources invariably should be tinted blue - with 5,500 °K as a chosen color balance, should a fluorescent light be tinted blue, yellow or red? The answer depends on what atmosphere you're trying to create. However, for all situations, no matter what the color balance selected, fluorescent light invariably looks more obviously so when it has been given a green tint, as this color makes it look more artificial.

There is certainly no such thing in photography as correct results and the hue, saturation and brightness of any light will appear differently for each individual, producing different colors in the print. This is due to a number of factors: the color balance of the film (which is invariably daylight-balanced); the tint of the flash bulb used; and the filters used by the processing laboratory.

Indeed, just as sometimes happens in the world of photography, you might want to throw this whole system out of the window and instead concentrate on a more stylized look. In this case the tinting of lights is still best done by eye, but as with all things, it's ideal to understand how to best use the rules of color balance before you can break them.

The behavior of light

Light obeys a whole heap of rules, some relevant for understanding CG, some not so relevant. One rule that certainly is very pertinent to the world of 3D is the inverse square law. This explains how light fades over distance and this law is applicable to all types of radiation. It is a law that is most easily explained by considering heat. If you walked slowly towards a fire, you would feel yourself getting gradually hotter. However, the rate at which you would get hotter would not increase uniformly as you approached; you would feel a slow increase early on, but as you got closer and closer to the fire, you'd feel a very rapid increase in heat. This is the inverse square law in action.

The way in which light fades from its source also obeys this law. The light's luminosity (the light's energy emission per second) does not change; what alters is the light's brightness as perceived by the viewer. As light travels further away from its source, it covers more area and this is what makes it lose its intensity, fading according to the reciprocal of the square of the distance. For example, at two meters away from the source it has lost a quarter of its intensity compared with its intensity at one meter from the source. This is simply because the area it has to cover is four times bigger, so the light is spread over four times

Figure 2.07
The inverse square law in action

Figure 2.08
Glass is rendered with an IOR of 1.5

Image courtesy of:
Antoine Magnien
antoine@m54.fr

Table 2.02
Typical Index of Refraction (IOR) settings

Material	IOR
Air	1.0003
Alcohol	1.329
Water	1.330
Ice	1.333
Glass	1.500
Emerald	1.570
Ruby	1.770
Sapphire	1.770
Crystal	2.000
Diamond	2.419

the area. At three meters, it's lost a ninth of its intensity compared with its intensity at one meter, because it is spread over nine times the area. This law is important in 3D because this is how real lights behave, and though 3D solutions have an option to turn this behavior on, most in fact have this off as a default unless you are working with photometric lights and radiosity, but we'll go into this in more detail when we examine the anatomy of a light later in this section.

Light also obeys the simple law of reflection, which you might remember from physics class. This explains how light is reflected from a surface. The law states that the angle of reflection equals the angle of incidence, which is measured relative to the surface's normal at the point of incidence. The simulation of this law in CG takes place using a rendering process called raytracing, which simulates accurate reflections and refractions. This second term, refraction, describes how light bends and obeys Snell's law, which concerns transparent and semi-transparent objects. Basically this determines the extent of refraction when light passes between different materials. This bending causes the distortion that you can see by looking at a lens. There is no need to explain Snell's law itself, it is simpler to explain what determines how much the light will bend: the index of refraction.

This number is calculated by taking the speed of light in a vacuum and dividing it by the speed of light in a material. Since light never travels faster than in a vacuum, this value never goes below 1.0 for basic applications. At this value there will be no bending of light and as this value increases up to 2.0 and beyond, the amount of distortion will increase. Table 2.02 lists the index of refraction for several materials, with figure 2.08 demonstrating how these values appear once rendered in 3ds Max.

Understanding the qualities of light

The eye is one of the most incredible and intricate of our organs; yet seeing is so undemanding that it's very rarely that we tend to give this ability a second thought. We are so used to looking in fact, that we can easily spot when something, especially in CG, does not look quite right. To ensure that your lighting efforts in 3D appear convincing, there are several characteristics that make a light source look real, and these qualities of light must be thoroughly understood and simulated in 3D.

You might have at some point come across the term 'quality of light', which is a subjective term that means different things to different people. If you gave several Directors of Photography (DoP) the task of lighting a movie scene, you'd undoubtedly get very individual and different results, as diverse as the DoPs' imaginations. First, considering the space that the DoP has to light, each would refer to the script and consider the events, emotions and personalities of the story before arriving at a solution, or possibly even several possible approaches towards a solution.

If you then examined each individual's lighting schemes, you'd no doubt get a wide range of variations that might go from the gritty and realistic to the sumptuous and glamorous. Depending on the nature of the scene, the results might equally be slick and clean or futuristic and stylized. The lighting does not have to follow the script literally: a miserable situation placed within a sunny scene might seem more compelling, particularly if this irony is reflected elsewhere in the script. Matching the lighting to a story can be done in a seemingly infinite number of ways, and each DoP's set-up would be quite individual.

Figure 2.09
Hard light is overused in CG due to it being closer to most 3D applications' default settings

If you then attempted to sit in front of these different versions and categorize the qualities of the lighting in each instance, you'd end up with a long list indeed. If you examined the work of Darius Khondji, for instance, you'd undoubtedly dwell on the way the soft light wraps around its subjects and the way this contrasts with other more hard light sources. Khondji has become renowned for his expressionistic look and his use of soft lighting techniques in such films as *Delicatessen, City of Lost Children, Stealing Beauty, The Beach*, and *Se7en*, which featured a bleak color-noir style. Khondji's soft-lit style has become fashionable in cinematography due largely to the advances in lighting equipment.

However, were you to view the lighting efforts of not just Khondji, but the other DoPs you'd given the same task to, you'd find yourself describing not just the soft and hard aspects of lights. Your descriptions would also concern the intensities and colors used, the shapes and patterns that the lights form, and the way in which these shadows move. You could go on to describe the motivation behind the light, whether it's natural or artificial and whether it relates to a visible source in the scene. However, if you attempted to categorize these many different descriptions under as few headings as possible, you'd probably come up with something based around the following: animation, color, intensity, motivation, shadows, softness and throw.

Figure 2.10
Soft light is a little more difficult to achieve, but looks much better

You might come up with more or less categories, depending on how much you think that shadows and throw were part of the same thing, or whether you think animation is a quality of light. Anyway, looking at these rough categories, if you tried to put them into some kind of logical order, you might put intensity first, followed by color, softness, animation, shadows and finally motivation. This would depend on what your role was; if you asked Darius Khondji, he'd probably put softness nearer the top of the list. However, these have been ordered thus from the point of view of a CG professional.

Intensity

The primary reason why intensity is top of our list is because of its role as one of the most obvious and perceptible qualities of light. The light with the strongest intensity in a scene is known as the dominant light and will cast the most noticeable shadows. Indeed, in cinematography's established three-point lighting system, it is this dominant light that is considered the key light. This system of lighting is heavily applied to CG and is described in considerable depth in the following techniques section, so don't worry too much if you don't know about three-point lighting yet.

There is, however, a considerable difference between cinematography and CG where light intensity is concerned. In the world of film, whether you're dealing with a cave scene lit by the light of a single flaming torch, or a beach scene lit by the brightest sunlight, the camera's exposure settings are adjusted to allow it to record properly in these dim or bright conditions. In CG, there are no exposure settings as such, so the intensity of a light source directly affects the final output's brightness and it is this that is altered, rather than the camera's exposure.

The upshot of this is that just as a cameraperson would have to change the exposure settings on the camera depending on the location, a lighting artist has to adjust the intensity of the lights depending on their context within the shot. For example, if the flaming torch were carried out of the cave to the sunlit beach, its intensity would have to be adjusted to a considerably smaller value to make the scene appear realistic and correctly exposed.

The intensity of a light is controlled by its color and its multiplier or brightness value, along with its attenuation. All light in the real world falls off, as previously mentioned, at an inverse square rate, that is its intensity diminishes in proportion to the reciprocal of the square of the distance from the light source.

In CG, attenuation can be dealt with in several ways, with inverse square decay one of the options. This is often too restrictive for CG work, so a start value allows you to specify where the decay actually starts, which allows for more realistic results. It's worth

Figure 2.11
Color plays a big part in lighting

Image courtesy of:
Patrick Beaulieu
www.squeezestudio.com

noting that light obeying the inverse square rule never actually reaches a zero value, so it's worth setting the far attenuation value to a distance where the illumination appears to have ended to avoid unnecessary calculations. This value, along with an accompanying one that dictates the near attenuation point, can be used along with linear attenuation to give a very predictable falloff from the near to the far value. Alternatively, attenuation can be turned off entirely, making the distance to the light irrelevant, as the illumination from such a light would be constant.

Color

As a visual clue to the type of light source or the time, season and weather being represented outside of a scene, color is incredibly important. The similarities and differences of lighting colors within a scene will help determine its mood, with more neutral colors giving a more somber tone, for example. Colors also have emotional properties and different people have different reactions to a color depending on the associations that they make with the color. However there are color families that denote and evoke a

similar response in nearly all people. The use of cool colors versus warm colors for example has been used by artists for centuries to denote obvious feelings to a broad audience.Color is extremely useful in reinforcing the type of light source that is being represented, and though this will vary due to the color balance that you may have selected, yellow to orange light is typical of domestic lighting. Place a blue light outside a window and the viewer will associate the light coming inside the room from this source with the light coming from the sky.

Whilst cameras and film are color balanced for different environments and their light types, the color of light sources in CG needs to be altered depending on not only what type of light you are representing, but also what mood you are attempting to portray. Blue light can help to paint a moody and unhappy scene or a calm serene one, whilst red is often used to signify danger or passion. Consider also the symbolisms that different colors have become associated with - green recalls such things as peace, fertility and environmental awareness on the positive side, but greed and envy on the negative side. Its use in lighting can also reinforce a sense of nausea in a scene, as it imparts a very artificial, almost chemical feel to the light. For all these reasons, color is a sizable consideration in lighting design.

Softness

Though soft light is widespread in the real world, and is used widely in the world of cinematography, in CG it appears nowhere near as often as it should. Though it is not difficult to reproduce the full range of light from hard to soft in all 3D applications, the fact that most default settings produce fairly hard results means that we see more crisp-edged shadows than we should in CG productions. We come across hard light in real life comparatively rarely and few of the light sources that we come into contact with exhibit the sharp focus that we so often see in CG. The sun can cast this kind of light, but a lot of us are used to seeing its light diffused through a layer of clouds or pollution. Bare light bulbs, car headlights and flashlights can also produce the crisp shadows of hard lights, but most lights give soft-edged shadows.

Throw

The manner in which a light's illumination is shaped or patterned is described by the term 'throw'. This breaking up of the light can be due to the lampshade of a domestic lamp, blinds or net curtains on windows or clouds in the sky. The approaches to recreating this aspect of light in 3D can vary from modeling the actual object causing the throw effect, which might be likely in the case of a light fitting, to the use of texture maps which cause the light to act like a projector, which would be more applicable for light filtering through leaves or foliage.

Figure 2.12
Throw patterns break up a light
into interesting patterns

These types of texture maps mirror the use of a cookie or gobo
(also known as a cucoloris or go-between) in cinematography.
These objects are placed in front of studio lights to break the light
into interesting patterns of light and shadow. In CG the use of
texture maps acting like cookies generally involves a grayscale
texture map, where the amount of light allowed through depends
on the grayscale value: at one extreme, pure black blocks all light
and at the other 100% white lets all light through.

Physically placing objects in front of lights works in the same
manner as using cookies, and this practice is often used with
things like venetian blinds. However, if the window itself were
not actually visible in the rendering, it might be more efficient to
use a texture map acting as a cookie.

Animation

This might not be a quality that you immediately associate with
light, especially if you were thinking about photographs or
paintings, but animation is a quality of light that is common to
winking car indicators, flickering neon signs and fading sunlight.

Think of several different instances where a light is changing
somehow and you can see that when it comes to lights, animation
covers color, intensity, shadows and other attributes.
Furthermore, the light can actually physically move, in the case of
a car indicator, for example, and the objects that a light
illuminates can also move, causing moving shadows to appear.

Animating a light's parameters to simulate the flickering of a neon sign, as we'll do in chapter 9, can introduce a gritty sense of location. Merely turning the intensity of a light up and down really quickly and abruptly makes a light appear to flicker; this is one of the more common ways of animating a light's parameters and one that we'll use when we come to designing the neon lighting later. Animating the color of a light can help to produce a flickering fire effect, especially when coupled with an animated intensity value. This is also true for televisions, which cast a similarly varying light on a scene.

Though animation might not be considered one of the primary qualities of light, what it can bring to a scene in terms of atmosphere cannot be ignored. For instance, a light bulb swinging from the ceiling will create the feeling of movement - from the gentle swaying of an outdoor light in the wind to the sickness-inducing swaying that might be experienced if this light were in a room on board a ship. Moving objects in front of a light to produce dynamic shadows can add a great deal to a scene, in the way that a tree swaying in the wind would cast interesting shadows through a window.

Shadows

Figure 2.13
Logical lights are visible in a scene

Image courtesy of:
Platige Image - "Fallen Art"
www.fallen-art.com
www.platige.com

Shadows play a massive role in describing a light, and this is an area that we will go into in much greater depth in a couple of chapters' time. Shadows add to a scene's realism, consistency, relationships and composition. Rather than thinking of shadows as something that things get lost in (though this can be very useful for hiding imperfections), shadows actually show us

things that otherwise would be impossible to see. Arguably, designing shadows is as significant a task as designing the illumination in a scene, so important is their role. You will find that when you get down to setting up your lighting schemes in 3D, a huge amount of time will be spent on shadows. You'll face choices as to which algorithms to use to generate both hard and soft shadows, and how to do this in the most efficient manner possible. In fact this is such a big subject that the whole of chapter 4 is dedicated to this issue.

Motivation

Lights can be categorized by how they operate in the scene in terms of their motivation. Lights will sometimes be referred to as logical, if the light forms part of the logically established sources that are visible or implied within the scene. Logical lights can represent an actual source such as a table lamp, or they can represent the illumination from outside a window. These lights are also called practicals in the theater and film industry.

The placement of lights can also be motivated by purely aesthetic reasons. If a light has been placed simply because the effect it produces is pleasing, then this can be described as a pictorial light. Pictorial lights are often needed, as placing only logical lights can result in a very uninspiring look and it's generally the pictorial lights that introduce the drama and create the emotional link with the audience. Most people looking at a CG production, however, won't even consciously consider your lighting at anything approaching this level, but this is one of the keys to good lighting; if it plays the emotional role that it is designed to without drawing attention to itself, then it has certainly succeeded.

By looking at light in terms of these different qualities, we can begin to learn how to break it down into its component parts and start to be able to record its essence. This is the first step towards seeing light, which is the key to being able to light a scene to underscore and show off the hard work of everyone involved.

3

'We are storytellers, and we tell our stories with light and sound. Take away the light and all you've got is a radio show. We paint with light. It gives depth and presence to a scene and creates mood. In order to paint with light you first need to see it in all of its nuance and spectrum.'

Scott Billups: *Digital Moviemaking*

Lights in CG

The difference between lighting a scene and just illuminating it is vast. All you have to do to illuminate a scene is create a single omni light and it's illuminated. Lighting is a different matter entirely, relying on the careful reasoned positioning of the various individual sources that make up a lighting scheme.

Each of your lights should be placed where it is for a specific reason, with the lighting scheme built up steadily and purposefully. As such, you should be able to explain the role of each light in the overall set-up, which should be balanced, with each of these sources playing a harmonious part in the cumulative solution, rather than battling against each other. The lighting scheme should emphasize the 3D nature of the medium of CG, showing off the 3D forms to best effect when rendered. You will never be able to do this by using omni lights every time, and as such, a good understanding of the different light types available and their characteristics is very important.

Image courtesy of:
Pascal Blanche
lobo971@yahoo.com

Two types of lights are provided within 3ds Max. If you go to the Create tab and click on the Lights button, the drop-down below displays two options: standard and photometric. Standard is the default option and this is the type of lights that most people will use most of the time. Standard lights are very versatile and can be made to simulate any type of light from the sun to a desk light, and it's this versatility that makes standard lights so attractive. The color of light, its decay and intensity; all of these things and more can be controlled to act as the lighting artist requires. Standard lights are also comparatively quick to render, something that is always a consideration when working in production.

Photometric lights, on the other hand, are not very flexible. This you might think is not a good thing, but this is their very advantage. Unlike standard lights, photometric lights are based on the real world of physical lighting and are built around the parameters of light energy. As such, photometric lights use real-world parameters such as distribution, intensity and color temperature. This makes them very attractive for users who are looking for very physically accurate renderings (so accurate that lighting analysis is also possible).

Though these lights can be used with the standard scanline renderer, they benefit from a special advanced lighting mode, with which they will produce physically accurate lighting. 3ds Max has two advanced lighting modes, which we'll cover in detail later, but for the moment you should know that they are called Radiosity and Light Tracer. Radiosity is the mode which the photometric lights operate best within and though it is processor intensive and relatively slow to render, it is simple to set up and the results can be very realistic, which is their very appeal.

Standard lights

As we've already mentioned, flexibility is what makes standard lights so attractive. Though radiosity techniques are capable of beautiful and highly realistic results, the professional lighting artist will often work using the standard lights alone, for several reasons. The main rationale behind using standard lights is that they can be easily controlled and adapted to produce any style of lighting and their controls allow the lighting artist to tightly streamline their performance, especially at render time.

Omni lights

Though referred to as omni lights by 3ds Max users, other 3D applications call these lights point lights or even radial lights (indeed, within 3ds Max's photometric lights, you'll find point lights). All of these names help to explain how omnis behave because these lights, whatever their name might be, provide a

Figure 3.01
Omnis and spots combined to make a simple lighting fixture

point source of illumination that shoots out radially from a single infinitely small point. Due to the omnidirectional manner in which these lights distribute their illumination through three dimensions, they are the easiest light to set up, but in the real world you'd struggle to find a light that acts in this manner, beyond a star, or possibly a candle flame or firefly. Most lights in reality don't emit light evenly in all directions, especially the electrical lights that they are often used to represent, which you can see by looking at any light bulb around you.

There are of course several options for adapting omni lights to work in this manner. You can place the omni within a geometrically modeled light fitting, as in figure 3.01, and turn on the light's shadow-casting function, though as you'll discover in the next chapter, the generation of shadows is the most computationally intensive part of rendering a light, so this might not always be the best option. Alternatively, you could use a bitmap as a projector, which acts as a throw pattern, restricting the emission of light. Omni lights are often used to provide fill lighting, and restricting the objects that are illuminated by these lights to a subset of the entire scene is a common practice to provide controllable levels of local lighting.

Spots

No confusion with names here, a spot is a spot in any 3D package, and is the basic building block of a lot of lighting situations. This is due to the fact that a spot light is eminently controllable in terms of its direction. Spots cast a focused beam of light like a flashlight beam, and behave as in figure 3.02. Like omni lights, spots emit light from a single infinitely small point,

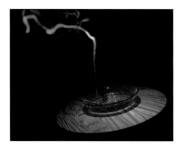

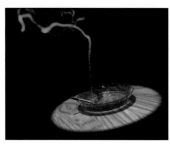

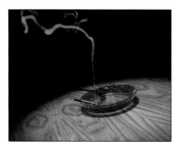

Figure 3.02
Target objects allow spotlights to be aimed most conveniently

Figure 3.03
A spotlight's cone can be adjusted to give soft or hard falloff of light

but unlike omni lights, a spot's illumination is confined to a cone. As such, spot lights need to be aimed and this can be done in several ways. One method is to position the light freely and rotate it until it's aimed correctly, which might not be the simplest method, but is perhaps closest to how a real-world light is aimed. A method that often proves itself to be more useful involves giving the light a target object, so it remains facing this no matter how the light is oriented. Alternatively, the light itself can be attached to a 3D object, so that the light moves and radiates from the model, like a car headlight.

As well as being able to manipulate a spot light's orientation, you can also control its cone, which is defined by two angular values: one defines the hotspot and the other controls the falloff. The light's intensity falls off gradually from 100% at the hotspot angle to 0% at the falloff angle that defines the very edge of this cone.

Varying the amount between these two values controls the softness of the light at the edge of the cone. With a small difference between these two values, the light will appear in a sharply defined circle, and as these values get further apart, the light's edge will get softer and softer. When given a really soft edge, a spot will lose its defined edge and the location of the light itself will become ambiguous, which is a very useful tool, effective for subtly lightening a specific region.

Spot lights will play a major role in the design of many lighting schemes due to their controllable nature. The fact that they can be easily targeted, given a falloff that can range from the crisp and hard to the soft and subtle, makes them an obvious choice for a huge amount of lighting tasks.

Direct lights

If you modeled several simple objects and placed an omni relatively close to them, you would see that the shadows cast by these objects would depend on their relative position to the light source. Move the light steadily further away and you would see the shadows becoming increasingly parallel. Move this source an infinite distance away and the light source would cast parallel rays. Whilst even the sun is not far away enough to cast totally parallel light, to all intents and purposes it does, as this is how it appears to the naked eye.

This is the role of a direct light: to cast parallel light rays in a single direction. It is unsurprising then that these lights are used primarily to simulate sunlight. These types of lights are eminently simple to control: since the parallel light does not vary, its position does not matter, only its rotation does, which is controlled like a spot light by rotating the light itself or by moving the object to which it is targeted.

However, this type of light should not just be confined to sunlight. Direct lights are also often used for fill lighting, which is a secondary light that complements a scheme's main (or key) light. We'll go into this in more detail in the following techniques section. The general light known as ambient light - which is explained in a few paragraph's time - is most noticeable in exterior scenes, when the sky's broad lighting produces an even distribution of reflected light to surfaces not in direct sunlight. Direct lights are a good solution to modeling this kind of light, far better than 3ds Max's ambient light controls, due to the way that directional light can provide even illumination to large areas.

Figure 3.04
The direct light is the building block of a lot of lighting scenarios

HDR maps

High Dynamic Range images, rather than using single integer values between 0 and 255 to represent R, G and B values feature non-clamped colors, which gives the renderer a far higher range of luminance values to work with. This means that a whole range of whites, from fully-illuminated paint to the superwhite of the sun itself can be accurately represented.

The HDR images in this book were provided by Sachform. www.sachform.com

Figure 3.05
Area lights provide a light with physical size and hence realism

Skylights

The Skylight light type acts as a dome above the scene and models daylight, the light scattered through the atmosphere. This light can be used with the standard scanline renderer, where it is capable of casting soft shadows. It also is commonly used with one of 3ds Max's two Advanced Lighting modes: the Light Tracer.

However, it is worth pointing out that when used in this mode, the Skylight does not support shadows. We'll go into this in more detail in the next section on techniques, but it is enough to say at this stage that the Light Tracer produces the color bleeding associated with global illumination, but unlike radiosity, it does not calcuate a physically accurate lighting model.

This can be a well-suited solution for outdoor scenes, where the daylight component can be quickly set up without the computational demands of radiosity. The skylight has few controls besides the color of the sky and the intensity, but notably a map can be assigned to the skylight's color and particularly good results can be achieved using HDR maps, which we'll go into in more detail in the radiosity chapter in the next section.

Area lights

As we have already discovered, in the real world there is no such thing as a point light, whose illumination comes from an infinitely small light source. Real life light sources invariably have a physical size. Area lights provide a light type with size (or even volume), from across which light is emitted, providing a far more realistic solution for depicting everyday light fittings.

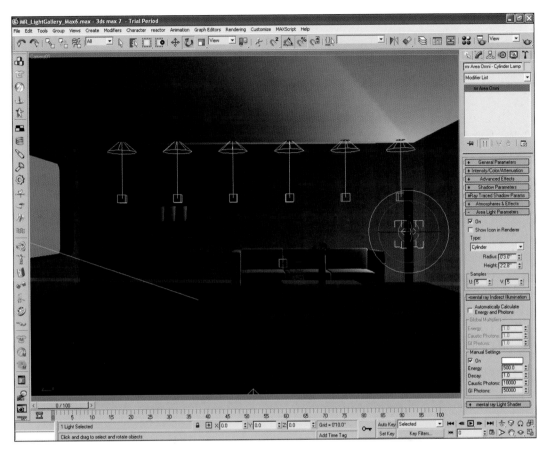

The larger your area light, the softer the shadows will become and the more pervasive the illumination - the light will begin to surround objects that it is bigger than due to the source's size and the way it reaches over them. Conversely, if the same light was made increasingly smaller, its shadows would become gradually less soft until they eventually become hard-edged and crisp. At this point the area light would have been scaled down to a small enough size to start acting as a point light.

Area lights make for very believable lights and as such they are capable of incredibly realistic results, but their downside is that they can be quite computationally intensive and take a lot of time to render. As such, they will often only be used for final quality output, or for producing single still images. In longer productions, their use can be too costly in terms of render times - but their look can be achieved using more efficient methods, which we'll get to in a couple of chapters' time when we take a look at arrays. Indeed, area lights cannot be used when using the default scanline renderer in 3ds Max as the only area light type is implemented for rendering with mental ray. When rendering with the scanline, arrays must be used in the place of area lights.

Figure 3.06
Cylindrical area lights have obvious applications for some light fixtures

Within 3ds Max's standard lights, there are two options for area lights: the mr Area Omni light and the mr Area Spot light. The first of these two uses either a sphere or a cylinder as the emitter that emits light in all directions, just like an omni light. The second of these lights uses either a rectangle or a disc along with a target object that is used to control the direction of the light. The mr Area Spot Light has Hotspot and Falloff values that are used to control the light's cone, just like a regular spot light. There'll be more about these lights, and their operation alongside mental ray in chapter 13, which deals specifically with this renderer.

Ambient light

The final type of light is not a physical light that can be placed in a scene, but the light which we referred to in the direct light section as ambient light. This general light is set to illuminate the entire scene. In the real world ambient light is the general illumination we experience from light reflecting off the various elements in our environment. Learning to use this lighting type in 3ds Max is simple; you learn not to use it! Why? Due to the unrealistic way it deals with ambient light.

In real life, ambient light is light that has bounced off the various objects in our surroundings. It is this type of light that makes it possible for us to see into shadowy corners that aren't directly lit by light sources. However, in 3ds Max (and other 3D solutions) this light is applied with uniform intensity and is uniformly diffuse. The upshot of this is that the ambient light is applied using the same value across an entire scene, not taking into account the changes of intensity and color that real-world ambient light demonstrates.

Figure 3.07 (above)
With ambient light, the image is robbed of contrast

Figure 3.08 (right)
Ambient light provides unrealistic results and should be set to black

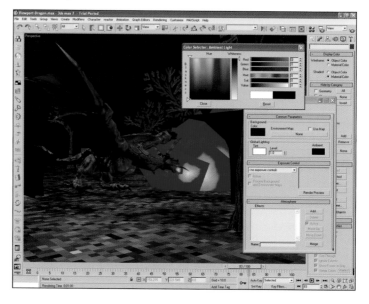

Ambient light in 3ds Max is controllable only in terms of its amount and color. This is unrealistic because the fact that this light has bounced off the various surfaces of an environment means it has absorbed different tints as it has bounced off different colored objects. Furthermore, real-life ambient light varies in intensity around its environment whereas CG ambient light uses a set intensity across the whole scene.

The best practice in lighting is to turn off your ambient lighting by setting its value to black, which luckily is the default setting. Ambient lighting deprives a scene of the depth of shading and color that provide it with valuable variation, especially in the all-important shadow areas, which are important regions as we'll discover in the next chapter, providing a surprising amount of visual information. Turning on even a small amount of ambient light robs you of the full range of tones available, as pure black will now appear slightly grayed.

Adding fill lights is the best way to provide a subtle level of secondary lighting that works like real-life ambient light. This is more controllable and produces far richer and more realistic results. We'll learn all about using secondary fill lighting to give your scene this kind of general lighting in the next section.

Photometric lights

Photometry is the measurement of the properties of light. When you use photometric lights, 3ds Max provides physically-based simulation of the propagation of light through its environment. The results are not only highly realistic, but also physically accurate. However, renderings produced using these lights will only look highly realistic if your scene is set up using realistic units, as you can imagine, a single light bulb placed within a 1 foot cube would look very different from the same light fitting within a 100 foot cube. Think of the light bulb that illuminates your bedroom suddenly placed as a stadium's light source.

The photometric lights in 3ds Max use different types of light distribution: isotropic, spotlight, web and diffuse. These distribution methods determine how light is distributed from a light source. The first method – isotropic – is the simplest and applies only to one light type, the point light. You might be forgiven for thinking that a point light is just an omni by another name, and with this distribution method, you'd be correct: an isotropic light distributes lights equally in all directions. However, the point light also features spotlight and web distribution types.

With the spotlight distribution turned on, the point light stops acting like an omni and starts acting like (you guessed it) a spot light. This differs from a standard spot, because instead of hotspot

and falloff values, the spotlight distribution uses the physically correct beam angle and field angle. These parameters differ from hotspot and falloff in that the beam angle defines where the light's intensity has fallen to 50% and the field angle defines where the intensity has fallen to zero.

The web distribution type uses a photometric web to distribute the light. This is a 3D representation of the light intensity distribution of a light source. These definitions can be stored and delivered in several formats: the IES (Illuminating Engineering Society) standard file formats, as well as other formats. Photometric data is often depicted using goniometric diagrams, which visually represent how the luminous intensity of the source varies. The photometric web extends these goniometric diagrams to three dimensions.

The point light uses this distribution type, as do the remaining photometric light types: linear and area. These two lights act like you might expect - the linear light is akin to a fluorescent tube, with light emitted from a line and the area light emits light from a rectangle. These two light types also feature the diffuse distribution, which deals with light emitted from a surface. Light that leaves the surface at a right angle is at the light's greatest intensity. At increasingly oblique angles, the intensity of the emitted light diminishes.

The final two photometric light types combine to model outdoor light, providing the light that comes from the sun itself as well as the light scattered through the atmosphere. The sky component is modeled as a rectangle and needs to be oriented to point down the z-axis, whilst the sun acts like a direct light, providing direct parallel light. These two components can be set to operate automatically based on geographic location, time and date if used in conjunction with a daylight or sunlight system, which allows the user to input these details which 3ds Max uses to calculate the sun's movement. We'll look at these methods in more detail in the techniques section.

The anatomy of a CG light

All of the aforementioned light types have some common parameters, as well as some that are specific to their individual type. For example, spotlights have a specific group of parameters that control the hotspot and falloff (which defines the cone of illumination), as well as the target distance, if this is being used. Of the common parameters, the simplest of these is the on/off toggle, which is invaluable in isolating individual light sources to test their effect. Indeed, lighting a scene is all about testing and revising the lighting set-up, and the initial placement of lights takes a fraction of the overall time.

Color is also common to all light types, and is an important consideration as we have discovered. Color is most commonly specified using RGB values, though the HSV model (Hue, Saturation, Value) is also used. Many people use the RGB model exclusively, as they find it preferable for color selection, but the HSV model is very useful in terms of increasing the brightness of a color. With the HSV model, the Hue field chooses the color from the color model, the Saturation field the purity of the color (the higher the saturation, the less gray the color). The Value field sets the brightness of a color, and it is this that can be used to control the intensity of a light, in combination with its Multiplier value.

Figure 3.09
Fill lights are the best way to provide subtle secondary lighting that works like real ambient light

Images courtesy of:
Jason Kane
www.KaneCG.com

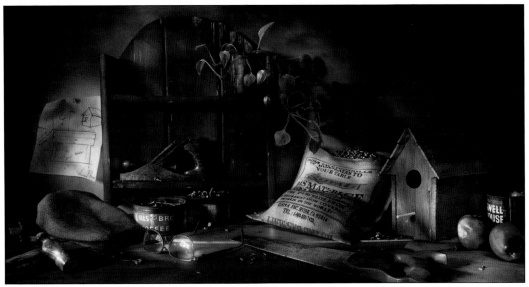

Figure 3.10
A standard light's controls

This value amplifies the power of the light (by a positive or negative amount), so setting the Multiplier value to 2.0 would double the intensity of the light. Using this value to increase the intensity of a light can cause colors to appear burned out, as well as generating colors not usable for video. For example, if you set a spotlight to be red but then increase its Multiplier to 10, the light is white in the hotspot and red only in the falloff area, where the Multiplier isn't applied. For this reason, Multiplier settings over about 2 should not be used without using 3ds Max's Exposure Controls to compensate for the limited dynamic range of display devices, which is particularly useful when working with radiosity and is something we'll explore in the next section.

The color of photometric lights, however, is controlled internally: when you pick the lamp specification that matches your light fitting, the color of the light is adjusted to match this setting. However, the color temperature, as detailed in the last chapter, can be altered, and a filter color value can also be used to act as if a color filter has been placed over the light source.

Back with standard lights, negative settings can also be used for the Multiplier and values less than zero can be very useful indeed, though likewise they should not really go beneath –1.0. Negative settings result in light that darkens objects instead of illuminating them. Most commonly, negative lights are used to subtly darken areas like the corners of rooms, though they can be used to fake shadows themselves with the benefit of less computation time.

Also useful in gaining close control over a scene's lighting is the ability to exclude or include objects from a light's influence. This feature, which obviously does not occur in nature, allows you to add a light that specifically illuminates a single object but not its surroundings, or a light that casts shadows from one object but not from another. The color of a photometric light is again controlled by its lamp specification (though this can be overriden) whilst its intensity is controlled manually - using the physically-based units of lumens, candelas or lux.

Attenuation settings allow you to control how light diminishes over distance. In real life, as we've already touched on, light decays in proportion to the square of the distance from the light source and this is how all photometric lights behave. Using this type of decay with standard lights provides a subtle realism to the light, but can prove too restrictive and can produce dim results in areas distant from the light whilst at the same time applying an overly bright area around the source.

The use of inverse square attenuation also does not reduce the light calculation time as one might first think, as the light actually never fades to zero. To this end, most solutions actually provide the ability to input two values - Near Attenuation and Far

Attenuation - that control where the attenuation begins and where it ends. With the Far value used to specify an end to the light's illumination, render times are often improved by a decent margin, as light only travels within this attenuation range, so the renderer is saved the calculation of anything that lies outside this area.

These two values can also be used to control exactly how a light attenuates, for precisely controllable results, and the option to still use inverse square falloff is often provided, as is the option for linear falloff. This algorithm calculates a light's decay in a very straightforward manner, falling off in a straight line from full intensity to zero intensity between the Near and Far values. Linear decay produces results that are not quite as realistic as inverse square, but the upside is that the falloff is much more predictable.

Whilst lights with no attenuation can demand unnecessary calculations, they can often produce the most realistic results, especially in terms of bright light entering a relatively small space. The few meters that sunlight, for instance, travels within a CG scene is proportionally nothing compared with the gargantuan distance that the light has traveled from the sun, so any attenuation that might occur in this small space would be too minute to be spotted by the naked eye.

Shadows are also managed from within a light's controls, and the reason that this has been left until the end of this chapter is because they merit a whole chapter to themselves...

Figure 3.11
A photometric light's controls

4

'Envy will merit as its shade pursue,
But like a shadow proves the substance true.'

Alexander Pope

The importance of shadows

Shadows might be considered something that things get hidden or lost in, but this element of lighting is actually so vital in terms of composition and defining spatial relationships, that the importance of shadows in a lighting scheme simply cannot be overstated. The human eye takes a cue from shadows not only in judging where a light source is located, but also what an object is made of, how far away it is and how it relates spatially to its surroundings. Shadows vary enormously in their many qualities of shape and form with the environment's illumination. It is the ability to reproduce these characteristics that is one of the keystones of obtaining realistic renderings.

As well as being one of the biggest aesthetic considerations for a lighting artist, in the world of CG, shadows are also one of the most important technical aspects to get to grips with. From the initial choice of algorithm, shadow casting can be a computationally intensive business, so knowing the rules of how to best

Image courtesy of:
Weiye Yin
http://franccg.51.net

represent your lighting scheme's shadows is vital, as is then learning how to break these rules and trick your way to creating convincing shadows in a fraction of the time.

Though the ability to hide things in shadows can prove very useful, the visual role of shadows is more considerable than you might first guess. They serve many purposes visually in terms of composition, detail and tonal range.

Perhaps the most obvious function that a shadow serves is to serve as a visual clue to depth and position. Without shadows, as you can see in figure 4.01, it's difficult to judge where the different elements are located relative to their surrounding environment. The relative size of the various cubes gives you a clue about their depth in the image, but without knowing that the cubes are all of the same size, this cannot be taken as given.

With the shadows present, however, it's easier to judge the positions of the cubes. The size of the different objects becomes apparent and we can see which are actually suspended in space and which are resting on the ground plane.

You can also see from this same image that the shadows help impart a better tonal range to the rendering. This is of particular importance when you are dealing with environments consisting largely of similar colors. Without the shadows, the elements that make up such a scene would be more difficult to tell apart. The contrast that the shadows bring gives important visual clues that help to shape the space and define the elements within it.

Figure 4.01
Without shadows it's difficult to judge relative positions of objects

The way in which lighting can help show off the modeling work in a scene is of paramount importance. CG productions deal in a three-dimensional form, and though this is invariably presented as a series of flat rendered images, lighting has a pivotal role to play in reinforcing a production's 3D nature. For instance, lighting can be purposefully placed to produce a shadow that reveals the outline lying perpendicular to the camera, which as such would not normally be apparent. Likewise, using a throw pattern such as one that would be produced by a horizontal or vertical blind can be an unusual way of emphasizing a subject's three-dimensional form, which might otherwise have been less apparent.

Furthermore, it's not just what's framed in the image that shadows tell us about, they also give us clues as to what lies outside the rendered image. The sense of what's going on outside the frame is important in film, and a long creeping shadow can tell us of an approaching figure that tells us a little of the story without revealing the identity of the character. Shadows inform us as to what lies in the space around the viewer, and what is out of shot can go a long way in terms of atmosphere and mood.

As you'll examine in further detail in chapter 17, it's important to consider the overall composition and balance of your output and shadows can be very useful as a compositional device. They can be used to give detail to large areas that might be otherwise too bare, to frame key elements and to draw your audience into a certain area of the image. Shadows can be an incredibly useful tool in terms of quickly establishing the all-important focal points of a rendering, by obscuring the areas surrounding a focal point; you are effectively framing part of the image.

Figure 4.02
Shadows give us visual clues as to what lies outside of the frame

Motorola 'Grand Classics' by Smith & Foulkes at Nexus Productions
www.nexusproductions.com

Additionally, shadows reassure us that objects are sharing the same space. This might not seem like a big consideration, but in the world of CG you'll often have scenes that don't relate to normality and anything you can do to suspend your audiences' disbelief is helpful. We all know that dinosaurs are extinct, but we are willing to accept their presence when immersed in a movie. However, if one came stomping towards the camera without a shadow tying it into its environment the whole illusion would immediately be shattered.

Shadows help to bring such disparate elements together into a visually cohesive whole. If you want an audience to accept a scene which is somewhat implausible, the shadow can be a great tool in creating convincing interaction that assures the viewer that yes, what they are seeing is actually happening. Without the subtle interplay of shadows, even the most photorealistic of scenes becomes less credible, and the human eye is so used to seeing shadows that even for the most casual observer it does not take much to stretch the illusion too far.

The technical side of shadows

Lighting algorithms can be roughly divided into two categories: direct illumination and global illumination. The first method can be thought of as a scene composed of objects and lights. The lights cast light directly onto the objects, unless there is a further object in the way, in which case shadows are rendered. This way of working with direct illumination within 3ds Max would involve using standard lights and the scanline renderer. This is the principal lighting method used in 3ds Max since its first release

Figure 4.03

Rendering with shadow maps can produce undesirable results

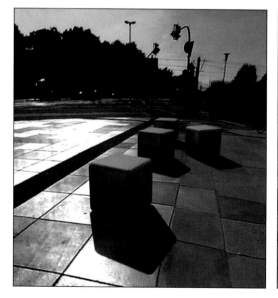
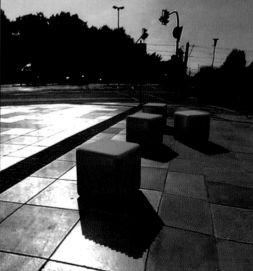

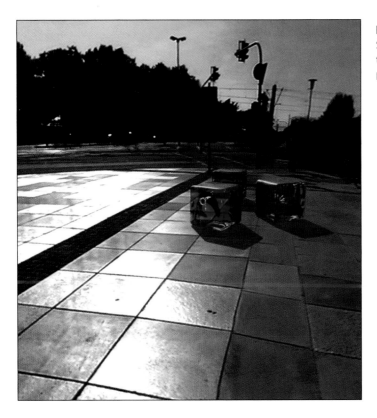

Figure 4.04
Showing the color cast by
transparent objects is often only
possible using raytraced shadows

and is something that has been possible since day one. Direct
illumination only calculates the light that is received at an object
direct from the light source. The light that bounces up off the floor
and other surfaces of a scene and back into the environment is
not calculated using this model.

Global illumination, on the other hand, attempts to model not just
this direct lighting component, but also the indirect light that is
introduced when light hits a surface and bounces back into the
scene. If you used direct illumination to render a scene with a
single default shadow casting light source, the shadows would be
pure black, as would any surface that was not receiving direct
light. In real life, objects that are not directly lit are quite visible.
Introducing 3ds Max's ambient light will solve this to a certain
extent, but as we discovered in the last chapter it will address this
by adding a uniform amount of light across a scene. This does not
take into account the changes of intensity and color that real-
world ambient light demonstrates; that's where global
illumination comes in.

It is this ambient light component that global illumination
techniques address, and these techniques do so by calculating the
many bounces of light around a room from the scene's different
direct light sources. Those familiar with both direct and global

Figure 4.05
Shadow maps are more
controllable in terms of their
softness

illumination will know that placing one light will never give you good results with the former method, yet with the latter, quite beautiful results can be attained with just a single light.

In contrast, working with direct illumination involves the placement of many lights to simulate this bounced ambient light within a scene. Shadows also need to be simulated and in terms of tools there are two basic types of shadow that you have at your disposal: shadow maps and raytraced shadows. Though you might think that two algorithms is not a lot to work with for shadow generation, the amount of variation that can be produced between these two methods is wide, in terms of softness, form, quality, color, and most importantly, render times. The difference between one set-up and another might not be vast in terms of the visual results, but the all-important factor of rendering speed might be vastly different.

Broadly speaking, shadow maps work well with soft shadows, whilst raytraced shadows are good for sharp-edged and accurate shadows, but the key point here is that for a direct illumination method, a shadow algorithm needs to be selected. However, in the world of global illumination, the simulation of the light's emission into a scene and bouncing off its surfaces actually defines the shadows without the user having to choose any one algorithm.

Whilst this technique sounds great, the calculation of the light bouncing around the scene's environment is calculated using raytracing-based algorithms and as such it is very processor

intensive. We'll go into exactly how radiosity works in chapter 7, but for the moment we'll just look at the two shadow algorithms for direct illumination: shadow maps and raytraced shadows.

Shadow-mapped shadows use a bitmap that the renderer generates during a pre-rendering pass of the scene. This bitmap, called a shadow map (or depth map in some applications) is then projected from the direction of the light. 'Depth mapping' is perhaps the more accurate term, as the calculation involves numbers that represent the distances from the light to the scene's shadow casting objects. With this information pre-calculated, the rendering process does not cast light beyond distances specified in this map, making it appear that shadows have been cast.

Raytraced shadows are generated by tracing the path of rays sampled from a light source. This process is called raytracing, and by following the rays in this manner the software is able to calculate to a great degree of accuracy which objects are within the light's zone of illumination and are therefore casting shadows. It was stated earlier that raytraced shadows are best suited to sharp-edged and accurate shadows. Though this is true, 3ds Max also features an 'Advanced Raytraced' shadow algorithm, which can calculate soft raytraced shadows.

However, concentrating on these two base algorithms for the moment, it's clear that the differences between these two processes are considerable, and the choice of shadow type can have a great effect on both rendering speed and output quality. This is particularly true if you are getting into the render-intensive realm of soft raytraced shadows. Shadow mapping is less accurate, but as a result generally requires less calculation time

Figure 4.06
Using shadow mapped lights side by side can be more efficient

Figure 4.07
Soft raytraced shadows fall off more realistically than shadow maps

Image courtesy of:
© Tobias Dahlén
www.rithuset.se

Illustration for an intranet-solution for Thalamus.
Agency: Mogul Sweden

than raytraced shadows. Finally, showing the color cast by transparent or translucent objects is only possible using raytracing to generate the shadows.

Generally, raytraced shadows require little by way of adjustment and they do not generally have swathes of controls, so in terms of fine-tuning, they require less effort. Shadow maps, on the other hand, have far more features and functions, so generally take a fair amount of tweaking from their default settings. The reason that this adjustment is necessary is because shadow-map shadows are only bitmaps, and you need to keep in mind their resolution in relation to your distance from the shadow, and the detail required by the shadow.

If their resolution is too low (especially if the camera is very close) the shadow can end up looking blocky and crude. If shadows appear too coarse and jagged when rendered, the map size needs increasing or blurring. However, the greater their size, the more memory required and the longer the shadow takes to generate. If hard edges are required, there can come a point where using raytracing can become a better option, depending on the complexity of the scene. The more complex the shadow casting objects, the longer the render time for raytraced shadows.

If you have enough RAM to hold the entire scene including the shadow maps, then shadows don't affect performance, but if the renderer has to use a virtual memory swap file, rendering time can slow considerably.

The upside of shadow-mapped shadows is that they are much more controllable in terms of their softness, and thus it's easier to control the all-important tradeoff between quality of output and render time. One further point of note is that as an omni is the equivalent of six shadow-casting spotlights, the memory requirements of shadow-mapped omni lights jump up as a result, as obviously do the render times if you begin to work outside the amount of RAM on your machine.

Sometimes, only raytraced shadows will do. If you were attempting to render a scene with transparent objects, this method's ability to handle transparency and tinting of light, due to these objects being colored, can make it the simplest choice, if not the method with the shortest render time. In attempting to produce convincing results with this kind of scene using shadow mapping, you'd have to place additional lights that did not include the transparent surfaces in their shadow casting in an attempt to cheat the correct look. Nevertheless, a convincing cheat that works in half the time of the raytraced solution might be exactly what is needed in a realistic production environment.

The key to controlling render times with shadow mapping depends on several things, the first of which is the shadow's resolution, which dictates the level of detail within the shadow cast. Raising this value makes for increased accuracy, but with the usual penalty on memory requirements. Too low a resolution can result in blocky aliasing around the shadow's edges and the larger the light's coverage, the greater the distance this map has to be spread over, so again, the resolution might need to be increased.

By keeping any shadow-mapped lights restricted to as tight an area as possible you are making certain that these shadow maps are used efficiently. After tightening the light's hotspot and falloff values, reduce the shadow map size as much as is possible. When shadows are required across a significant space, it can be much more economical to use an array of lights with smaller shadow maps rather than just one light with a huge shadow map.

As you can see from table 4.01, eight lights with a shadow map resolution of 512 side by side would demand 8Mb of memory to render. This compares favorably with a single light of resolution 4,096 (the same as eight lots of 512), which would demand 64Mb, eight times the amount. Alternatively, one light with its shadows turned off could be used to illuminate the entire area, and then shadow casting spotlights could be placed selectively in the various locations where they were needed, thus keeping things as

Table 4.01
Shadow map memory requirements

Shadow map resolution2 x 4 = memory requirement

Resolution	Memory
512	1Mb
1,024	4Mb
2,048	16Mb
4,096	64Mb

tight and efficient as possible. Furthermore, 3ds Max allows lights to overshoot, which limits shadow casting to within the cone, but allows the illumination to overshoot this area, which can be useful for large-scale illumination when coupled with efficient shadows. Finally, as we've already mentioned, shadow casting omni lights should be avoided wherever possible, as the memory requirements can be up to six times that of a spotlight.

To avoid the crisp shadows that are seen all too often in CG, you'll need to acquaint yourself with the shadow's controls. Physically small lights do cast hard-edged shadows, as do distant light sources, but in real life the majority of lights cast shadows with some degree of softness. The larger the light fitting, the softer the shadows which are cast, and whilst shadow mapping can certainly produce soft edges, this is only possible when using the Advanced Raytraced shadow type in 3ds Max, which can take a prohibitively long time to render. (It's also possible using mental ray area lights, but we'll get to that when we come onto mental ray in chapter 13.)

A shadow-mapped shadow is made soft by applying a blur to the shadow map itself. Increasing the amount of blurring increases the render time, but it is worth bearing in mind that smaller resolutions of shadow maps can be used when blurred in this way, thus extra time spent computing the blur is often saved from the shadow map calculation. Blurring raytraced shadows within 3ds Max, as we've already discovered, involves the use of the Advanced Raytraced shadow type, but the algorithm behind this method can see render times increase unrealistically. As you can see in figure 4.07, the raytraced and advanced raytraced shadow types can produce quite different results. What is worth noting is that both shadow types are capable of hard-edged shadows, but only the advanced raytraced shadow type is capable of soft raytraced shadows.

This type of shadow is about as good as it gets in terms of quality, but as you might expect this comes at the expense of render time. If you are willing to accept this price, this algorithm can produce beautifully realistic results, with shadows growing softer as the

distance from the shadow casting object increases. Calculating soft raytraced shadows in this way can be akin to using raytraced shadows with area lights, which produces similarly soft and subtle shadows. The fact that these methods can take a prohibitively long time means that their use might be best limited to one-off still renderings. For longer sequences, finding a more workable solution like an array of shadow mapped lights will often be preferable, as this would take a fraction of the render time, and that's why learning how to cheat shadows is what everyday production techniques often come down to.

Faking it

Whilst using the accurate raytraced soft shadow methods will generally give you the best results in the most straightforward manner, the fact that shadow calculation is the most time-consuming part of a light's rendering means that we often need to fake our way to a quicker solution. There are several tricks and techniques employed in CG to save on render times.

Lights with negative brightness are sometimes used to add fake shadows into a scene. By adding such a light with its multiplier or intensity given a negative value, you can selectively darken a region. As we've touched on before, this technique is most commonly employed to selectively and subtly darken a scene in areas like the corners of rooms, but it can also be a useful way of cheating quick rendering soft shadows.

With a scene illuminated only by lights that cast no shadows, target a spotlight at the base of the object, where the fake shadow is to appear. This light should also not be set to cast shadows, but the object that is to cast the shadow should be excluded from the light's illumination. Finally, adjust the brightness or multiplier to a negative number, which will darken the area at the object's base rather than lighten it. Adjusting the hotspot and falloff will control how soft-edged this shadow appears. By constantly evaluating different methods of lighting your scenes and minimizing the need for shadows you will certainly keep render times down. Simply underlighting the areas where you want the shadows to fall might sound strange, but can be effective and saves your software a whole lot of bother.

This practice is commonplace when it comes to designing simple light fittings. Rather than simply use an omni light to represent the bulb and the lightshade to cast shadows on the ceiling and floor, two spotlights can instead be used inside the shade - one oriented upwards and one downwards - whose cones fit the circular holes in the shade making it appear that the lightshade is actually casting shadows. A third light should also be introduced in the form of an omni which will illuminate the semi-transparent

shade and mimic the light passing through it. By using three lights, none of which is set to cast shadows, in place of a single source that uses shadows, you not only speed up the render, but allow the lamp's illumination to be more closely manipulated.

Shadows-only lights can be used to create shadows without adding any light to a scene, something that obviously is not possible in real life. However, if shadows are the most costly part of rendering light, why would you want to introduce shadows-only lights? The value of these lights is found in terms of cheating lighting angles to hide a modeling imperfection perhaps, or reveal something that would otherwise fall in shadow, or even as a stylistic or compositional device. The use of shadows-only lights also gives you more individual control over the shadow's color, saturation and so on, without having to alter the scene's lighting. Furthermore, as touched on previously, these lights, when used selectively to cast shadows in restricted areas, can provide a very controllable and efficient solution in large illuminated areas of a scene that can first be lit with a light set not to cast shadows.

If you do look in 3ds Max's help files for shadows-only lights, you won't find anything. That's because there is no such thing in 3ds Max (indeed, there is no such thing in most 3D applications) as a shadows-only light. However, this type of light is easy to construct; you first need to create the light that casts the shadows that you desire, and then make a clone of it. Shadow casting should be turned off for this new clone and the multiplier should be set to the same amount as the first, but with a negative value. The result of these two lights is a shadows-only light, with the illumination of the first light counteracted by the negative multiplier of the second.

Figure 4.08
By reducing the need for shadows, you can keep render times down

When to fake

Though there are only two widely used algorithms for shadow generation, as this chapter should have demonstrated, there are a huge number of ways of manipulating your lights to produce results that don't take an age to render. Knowing when to use a faked solution and when not to fake is something that comes with experience, and your own reasoning will become your best tool.

Yes, computers are getting faster all the time so you might be able to get away with using increasingly intensive algorithms, but a lot of the decisions will be based on a studio's production schedules, and whether they allow for the extra time it takes to set up a convincing lighting design using the methods outlined here.

Indeed, more often than not you'll be asked to produce results that render as efficiently as possible in little time, due to other production demands. In this situation, it is not viable to set up a quick, accurate solution that is slow to render, nor is it ideal to spend a long time experimenting on a faked solution that renders quickly. In these situations, the only way to make a quick compromise is to know as many ways of completing a lighting task as possible, whether faked or not. Knowing all the options will enable you to best find a happy medium between quality of output, speed of render, set-up time and the degree of control that each method furnishes the user with.

Figure 4.09
Faked solutions that render quickly can be a production demand

To use shadows or not?

The fact that casting a shadow is the most computationally expensive part of rendering a light is not the only reason you should consider restricting shadows within your lighting scheme to select sources. Visual considerations can sometimes also dictate that only one or two of your lights need to cast shadows. In considering this, you should ask yourself several questions, some of which might only become apparent as you begin to render and refine your output.

The primary consideration concerns your scene's light sources and what they represent. Does the scene need shadows to fall from any particular source in terms of the necessary realism? With a single shadow casting light in place, the next question you should ask of this source is: is it enough on its own? Single shadow scenes can work well, and a common set-up is to have the key light casting a shadow and any fill light set not to. For scenes requiring no great complexity of lighting, this is generally a good method if what you desire is a clean, straightforward solution.

Figure 4.10
Shadows play a key part in tying a CG element into a scene

However, if you decide that there are other places within the scene that shadows should be being cast from, you should turn these on and work with these shadows in place. Now you are in a good

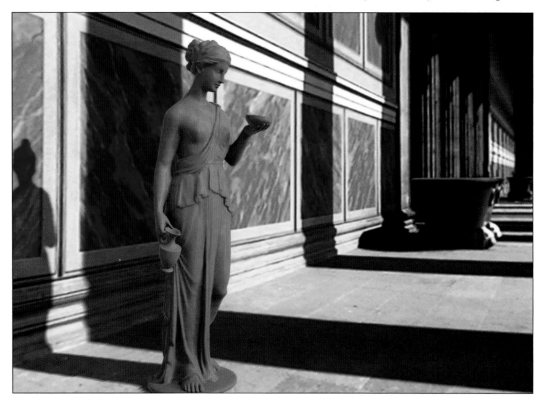

position to judge whether extra shadows are needed. Even with several light sources casting shadows as you might expect them to, things might not look visually cohesive, and you might want to consider adding shadows from one or more fill lights to tie things together. This is especially likely if you just have one shadow-casting source, as the ambient light that bounces around the surfaces of a scene would generally cast additional subtle shadows. Turning on shadow casting for your lights representing this bounced light can help to build up a subtle level of secondary shadowing that really adds to the realism.

Having fill lights that cast shadows is particularly necessary if your key light becomes obstructed at any point within an animation, as it will cast large shadows as a result, and these can look somewhat flat and uniform. Secondary shadowing adds a depth and variation to the image that can impart a sense of life. However, too many shadows can begin to compete, especially when the surrounding environment is very simple, and a subtle approach is more often than not necessary to avoid disorderly results.

Too many light sources casting shadows, especially if these shadows are all coming from different directions, can produce results that are visually distracting. Indeed, look at the world around you, and you can see that most shadows are soft edged and subtle, so a couple of underplayed shadows can often look more convincing.

Furthermore, you should not rule out using no shadows what-soever, depending on the visual style you are aiming for. A great deal of 2D productions, for example, manage quite happily without shadows, and especially if it's a slightly more abstract or

Figure 4.11
Having no shadows at all is most times an unrealistic proposition

cartoon look that you are going for, then the lack of shadows will improve your render times no end and can impart a stylized edge that when done right can be extremely appealing. With the lighting set up to match the environment, the variations in unlit dark areas that appear on the subject can appear convincing enough, and the need for actual shadows is not always necessary.

Shadow saturation

Figure 4.12
Shadow saturation is one thing that needs to be watched closely

The saturation of shadows is a major factor in achieving realistic and believable results, and whilst shadows that are too light can look just as unrealistic, it's generally darkness that causes the problems. Even when a lone bright light source is illuminating a scene, the light bouncing off the surfaces of the environment lightens the shadow it casts. Adjusting the saturation of your shadows is possible in several ways.

The first and most obvious method is by using the Shadow Color control, which imitates light penetrating the shadow area. Unfortunately, this light penetrates only the cast shadow, and not the unlit portion of the object casting the shadow, which can result in an unrealistic amount of contrast between these two adjacent areas, as shown in figure 4.11.

This is not the only problem either; the strange phenomenon of shadows leaking through objects can occur when the shadow color has been altered. This rather freaky occurrence makes using shadow color a somewhat flawed solution.

The equally unappealing second option is to use global ambience to brighten the whole scene slightly, but as discussed in the previous chapter, this control should not be used if it can at all be avoided. Allowing even a small amount of ambient light into your scene deprives you of the full range of tones available, as pure black will now appear slightly grayed. Furthermore, the ambient light that is added will not bring out any details on the object's unlit side, as ambient light simply adds an unvarying amount of illumination across the scene.

The only real way to lighten your shadows is to add fill lights to recreate the light bouncing off the surfaces surrounding your object. This lightens the cast shadow and the unlit portion of the object consistently, and the unlit portion is illuminated in a way that brings out any detail across this area. Fill lights representing the light bouncing off the surrounding surfaces that are colored to match their material, impart not only a sense of realism, but add to the all-important visual richness and depth of a rendering.

part 2: techniques

Image courtesy of:
Marek Denko
http://denko.maxarea.com/

5

'Remember the phrase "Lights, camera, action"? Lights come first for good reason. Without them the camera and action are useless.'

Chuck B. Gloman & Tom LeTourneau: *Placing Shadows*

Learning to light

Lighting plays a pivotal role in reinforcing the mood of a scene and creating an emotional connection with your audience, and this is as true for cinematography and photography as it is for CG. As long as your lighting successfully achieves this emotional link, the way in which the set-up was constructed is largely unimportant. However, the fact that there are so many different methods in CG of arriving at a solution makes the whole process much more flexible. Though the end result might be the same, the different approaches to arriving at a particular lighting set-up can vary by an astounding amount.

In attempting to learn lighting in the following chapters, it is important that rather than focus on how you are lighting a scene you should concentrate on the reasons why you are lighting it, not just the buttons you are pressing. This will help you to appreciate the various different principles and when to apply them, rather than approaching lighting as a step-by-step task.

Image courtesy of:
Patrick Beaulieu
www.squeezestudio.com

Basic three-point lighting

The convention of three-point lighting is one that is firmly established in cinematography, and has become one of the main foundations for CG lighting too. One of the principal reasons for this is that the technique helps to emphasize three-dimensional forms within a scene using light. Experimentation with this simple method can bring all kinds of variations to almost any CG lighting scheme, and learning how to get the most out of the basic three-point set-up will equip you for many situations. It might sound like common sense to state that making sure everything is illuminated and visible to the camera does not constitute good lighting. Ensuring that the three-dimensional form of your subject is fully appreciated takes considered lighting from various angles, and this is exactly where three-point lighting comes in.

The last thing you want is for your animation to look as flat as the screen that it will be viewed on, and three-point lighting's approach is based on treating light almost as a modeling tool. Learn it well and your renders will benefit from added depth and definition. Flat looking output is most likely to occur when a single light source is placed behind the camera. This is analogous to a professional photographer using nothing but a camera mounted flash. The three light sources that you might have guessed make up three-point lighting serve different purposes, yet work together to emphasize shape and form in your final output.

The difference that this approach makes can be seen in figure 5.01, where the left-hand statue has been lit with one light behind the camera, whilst the one on the right benefits from a three-point set-up. The difference in form of the statue is quite startling.

Figure 5.01
Three-point lighting can really help to emphasize 3D forms

Unsurprisingly, there are three lights involved in three-point lighting, and each has a specific function. Providing the main illumination in a scene, the key light is the dominant light, or the one that casts the most obvious shadows. This can represent practical lights for night time indoor shots, sunlight for outdoor work or sunlight entering through a window for daylit indoor shots. This defines a scene's dominant lighting, giving the biggest clue to the location of the presumed light source.

The job of fill lights is to model the indirect lighting that is produced by direct light bouncing off an environment's surfaces. The primary fill is usually placed on the opposite side of the subject from the key, where it opens up the lighting on the side of the subject in shadow and reduces the density of the shadows.

Helping to separate the subject from the background, the backlights give a scene depth. They do this by illuminating the back of a subject, and in doing so they create a subtle glowing edge to the subject, which helps to create definition.

When placing these lights, the overall effect desired is one of variation, with no large areas of shading. Studying your renderings closely is the only way to do this, though there is a useful method for gauging just how much variation you're getting with your lighting. This involves turning off any sub-division surfaces or similar smoothing algorithms or producing a low-res proxy version of your subject so you can more easily judge the lighting in individual areas. Viewing your subject defined by bigger polygons rather than smooth surfaces allows you to quickly determine how the light varies across your subject's surface. Regions of the model where the shading does not alter from plane to adjacent plane will appear flatter and less three-dimensional than those areas with greater variation.

With your model displayed in this manner, it is a lot easier to quickly gauge how the lighting varies across your subject, and your aim should be to use the aforementioned three lights to make the gradients as varied as possible.

Key light

Figure 5.02 shows just the key light added to our street scene, and with just this light our subject is illuminated from one side, with the other side falling off into an unrealistic level of darkness. The key light is the most influential of the three lights involved, as its intensity is greater than any other light. This means that it will create the most defined and noticeable illumination and shadows, whose angle, density, softness and so on will provide clues to the type and location of this source, as well as serving as pointers to the time of day, if this light is representing the sun.

For this reason, choosing the angle of your key light relative to your camera is of paramount importance. Cameras should always be placed first when working with three-point lighting, with the key light following closely behind. Changes of camera angle from shot to shot within a scene can require subtle changes of lighting set-up. The key is usually placed above the subject to some degree, so that the shadows point downwards, as this is how we're used to seeing things illuminated. However, placing the light too high can result in shadows that obscure and this can be less than flattering.

How far you move the light to one side of the subject depends on the light source you are trying to mimic, though to move the light too far to the side can again result in distracting shadows. If you were working on an exterior shot, then the time and season would dictate the key light's position. With a warm light placed low to form soft and long shadows, the result would be a scene that looked as if it were set during early morning or late afternoon.

The key light is not always located in front of the subject, because as its role is to represent the dominant light source in the scene it can be to the rear of the subject if the scene was, for example, lit primarily from a window to its rear. This scenario places the key light where it could present a dramatic silhouette of the subject to the camera, and is known as an upstage key light in stage lighting. In this case your key light remains a key light, despite its position at the back of the subject, as what defines the key light is the fact that it is the dominant light, with the most distinct shadow.

The prominence of these shadows will be reduced as the amount of fill light used increases. The ratio of the intensities of the key light to fill light goes a long way to establishing the atmosphere of

Figure 5.02
With just the key light established, the shadowed areas are very dark

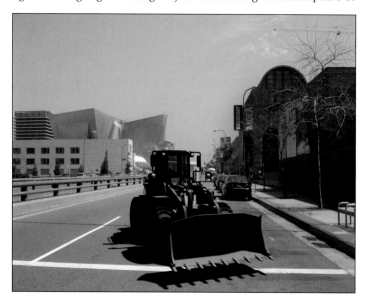

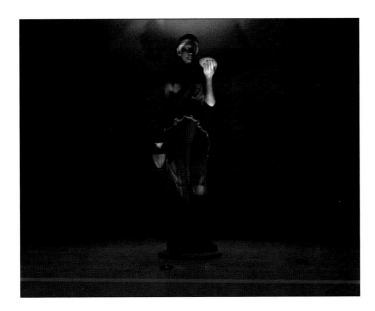

Figure 5.03
Low level key lighting can produce
lend a scene a menacing edge

a scene, with low key-to-fill ratios invoking a lighter, happier
mood than high ratios, which produce a darker atmosphere. The
importance of this light in terms of mood is perhaps demonstrated
most clearly by the low level positioning of the key light, which
produces a very unnatural lighting, which can make a character
look menacing. Whether the key light in this situation comes from
a campfire or a light held under the chin by the character itself,
the result is noticeably eerie, which can be a good device.

The best guide when placing a key light is the shadow it casts.
For regular lighting set-ups, the angle formed by the light, subject
and camera should be roughly between 10° and 50° to the side of
the camera, as well as above the camera. Finally, when you're
working on test renderings from a sequence, bear in mind that a
single rendered image is just a snapshot representing only one
fraction of a second. Your lighting set-up will need to work with
your character's movement, so bear this in mind. Rendering your
scene at all your character's key poses is important, especially if
the subject turns from the camera and appears in profile, when
the turn of around 90° can really test your lighting set-up.

The most flattering set-up is the portraiture set-up, which is
commonly used by portrait photographers. Here the key light is
placed so as to cast a small shadow of the nose below or below
and to one side toward the corner of the mouth. Photography of a
subject in profile, however, requires that the key light be moved
between 10° and 50° from being perpendicular to the camera.
These angles should certainly be kept in mind when placing your
key light, but only as rough guides. What is far more important is
the angle at which your shadows will fall and what this suggests
about the presumed light source.

Fill light

Placed on the opposite side of the subject from the key, the primary fill light starts to open up the unlit areas. In cinematography, the fill light is generally placed around eye level, so as not to cast its own shadows onto the subject's face. However, because in CG we can turn a light's shadows off so easily, vertical position is not as important. Nevertheless, the primary fill should rarely be placed any lower than the eye level, as then you have upward illumination of the face, which can be unsettling.

In both cinematography and CG the primary fill light's role involves several things. The first is to open up the shadows of the key light. The second is to provide subtle illumination of the subject where it lies in the shadow of the key light. However, in CG the fill light also has to act as the indirect illumination that occurs naturally in real life, which is something that film makers don't need to worry as much about. Here, the key light provides much of its own fill either through the natural reflections off surrounding surfaces, or through manipulation using boards to bounce the light back at the subject. The fill lights in CG have to represent this bounced light, unless radiosity rendering is being used of course, but we'll move on to this subject next chapter.

The fill lights in CG then also have to simulate this reflected light, and as such should take on the color of the reflecting surface. However, the position of the fill lights does not have to be so precise as to represent this perfectly, and their position can vary quite a lot. Roughly opposite is about as precise as it needs to get for your primary fill, though don't position things too symmetrically, as this can soon begin to look too staged.

Figure 5.04
The fill lighting opens up the shadowed side of the subject

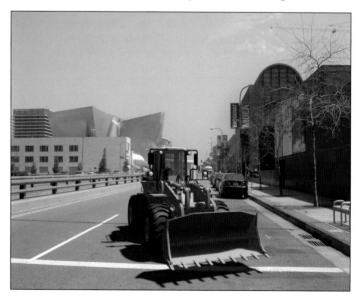

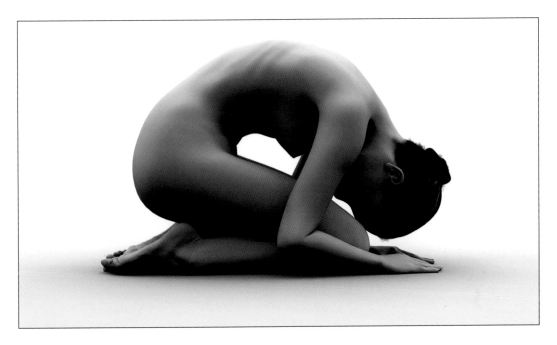

If rough positioning guidelines were to be suggested, like the ones for the key, between 10° and 60° to the side of the camera, and up to 15° above the camera would be about right. It is worth attempting to ensure that the fill and key lights actually overlap in terms of their illumination, as this ensures that you have no patches where there will be minimal variation in shading.

Obviously, as your fill lights are representing light that has bounced off the larger elements of a scene's environment, as well as secondary illumination sources, then one fill light will likely not be enough. It is not unusual to have dozens of fills in a scene, with some representing bounced light and others secondary light sources. You might still want more to help soften the key light's shadows further. There's no real problem with using as many fill lights as you need.

Backlight

The ability of the backlight to separate the subject from the foreground makes it more important in 3D than in today's cinematography, where it is used much less than when black-and-white film was the only option. Working without color increases the need to separate elements from backgrounds of similar tones. There is occasionally a need for this technique in CG, when the sense of depth is an important consideration, though it is not always actually needed, as color can provide sufficient visual separation. This will certainly become a consideration though if you find yourself working in black-and-white, as in figure 5.05.

Figure 5.05
Working in black-and-white brings challenges with similar tones

Image courtesy of:
Marek Denko
http://denko.maxarea.com/

Figure 5.06
Backlighting can be difficult in CG
and is often best built into materials

Image courtesy of:
Patrick Beaulieu
www.squeezestudio.com

In photography and cinematography, a backlight is generally placed directly behind and above a subject, striking an angle of around 45°. At a higher angle, it might begin to toplight the subject, causing distracting highlights on a character's forehead and nose, whilst at a lower angle, there's a danger of lens flare. However, in the world of CG, backlighting tends to be fixed somewhere between 50° and 10° above or below the camera.

The main problem that occurs with backlighting in CG is that it is actually quite difficult to simulate properly. This is because no matter how organic a subject might look, the model's cleanly defined surfaces don't have the layers of hair, dust and fibers that we have all around us in real life. This is what backlighting catches and illuminates, causing this layer to subtly glow, due to the light being diffused slightly. Because this layer does not exist in CG, putting a backlight directly behind the subject is often relatively ineffective, as the subject will not appear to receive any illumination due to the lack of this diffuse layer. If your subject is a character with hair, then backlighting can be very effective. Backlighting without hair, as is generally the case, requires that the backlight be moved up over the subject so that it just catches the edges of its surface. Different shading models also work better than others at catching backlighting, so experiment with these settings.

Quite often you'll find that one backlight won't be enough, and an array of these lights might well be needed to get the backlighting that you desire. One final thing that can help is to use a slight falloff map in the self-illumination channel of your subject, which can create a slight glow on the faces whose normals point outwards from the camera view, the outer edge of a surface.

Key-to-fill ratios

The relationship between key light and fill light is important in terms of your lighting scheme's contrast, which has a significant effect on the mood of the rendering. Basically, this is determined by the ratio of the intensity of your key to your fill light. A high key-to-fill ratio has comparatively little fill light, so it is darker and more moody, with lots of contrast. A low key-to-fill ratio has a lot of fill light, which results in lighter results, with less contrast and a lighter and happier mood.

The intensities are measured at the subject, not from the light itself, which is considerably easier with real lights and a light meter, but not all that difficult in CG. Taking the intensity of the lights and working out the loss of intensity due to falloff, you will arrive at figures for the key and fill intensities. If there is more than one fill light, you simply need to total each one's intensity.

The most tricky part to calculate will be inverse square falloff, if you are using this form of attenuation. Linear attenuation is easier to work out, but neither are particularly tricky. One further noteworthy point is that any fill light that overlaps the key should be added to both key and fill lights. Too high a ratio can result in the rendering being too dark in the shadowed areas, due to the relative lack of fill, and likewise too low a ratio can produce uniformly flat results, when the fills begin to counteract the key.

Finally, it is worth pointing out that the terms low-key and high-key, which are used in the physical world of lighting, confusingly enough mean the opposite of what you might expect. So, low-key is a high key-to-fill ratio, and high-key is a low key-to-fill ratio.

Figure 5.07
Cloudy and snow are conditions
likely to produce low ratios

Low key-to-fill

Ratios of between 2:1 and 4:1 are classified as having a low key-to-fill ratio, which produces brightly lit renderings with little contrast in the scene's lighting. The brightness of the resultant output and the way that any shadows are opened up by the pervasive fills invokes a happy, positive mood. Figure 5.08 uses a low ratio, with the key light bouncing off the light and highly reflective snowy landscape and opening up the shadows. Exterior scenes are on the whole much more likely to feature a low ratio if it's an overcast day. Direct sunlight does not generally produce low ratios, unless there's snow to reflect the sunlight and give the high level of fill required or the walls of the scene are quite light. Cloudy conditions scatter the sunlight and this reduces the key light of the sun whilst brightening the sky. Stylistically the happy, bright look that can be achieved with low ratios is frequently used in CG productions targeted at a younger audience.

Generally speaking, interior scenes are more likely to produce low ratios than scenes set outdoors. Here, the potential for light, reflective surfaces and walls is higher. This type of interior, with

Figure 5.08

Low key-to-fill ratios can impart a light and cheerful mood

© 2002 Sesame Workshop/Pepper's Ghost Productions

its light colored surfaces, would bounce sufficient light back into the scene to produce a low key-to-fill ratio. At the low end, you should avoid going near 1:1, as it is at this level that a key light will start to become overwhelmed by the competing fill, and your results will be in danger of becoming flat and uniform.

High key-to-fill

When your ratio approaches 10:1 and beyond, your output has a high key-to-fill ratio, which will result in dark shadows that contrast strongly with the brightly lit areas. Due to the lack of reflected light, this type of lighting would most likely occur at night in the real world, where there would be no fill light coming from the sky, which explains the dramatic atmosphere this can create. Figure 5.09 uses a ratio of 10:1. Due to the single practical light source, there's relatively little bounced light represented using fill lights.

The key to using this kind of ratio successfully lies in carefully regulating your light to illuminate the important visual details well, therefore using the full range of tones available to you by having well lit sections alongside the darker areas. Just because a scene is set in dark conditions, this does not mean that the dark areas should be underlit, so that there is no fear of the audience not being able to make out the important details and action. High key-to-fill ratios are only generally used for night scenes, where the key light represents the moon or artificial light. Stylistically, this kind of look was established by the film noir directors of the 1940s and is still used frequently in horror movies to build suspense.

Figure 5.09
High key-to-fill ratios can impart a very dramatic atmosphere

Image courtesy of:
Arild Wiro
wiro@secondreality.ch

Contrast

The difference in the tonal range of TV and video means that if your final output method is going to be film, the ratios suggested here may need to be adjusted. Film can support a 1,000:1 contrast ratio, whilst TV can only sustain around 150:1, a fraction of this. For TV work, you should work with much more fill light than when working towards film (or even print), and for TV the key-to-fill ratio should never exceed around 9:1. In film, however, you would only achieve the same effect with a ratio of around 18:1.

Tutorial - three-point lighting

In this tutorial you will learn the basics of three-point lighting by examining a simple interior scene and setting up the lighting to produce a flattering set-up. You will set up the key light to represent the dominant source, the fill lights to mimic bounced light, and open up the shadows and add backlights to emphasize depth. Open the C5-01.max file from the tutorials folder of the DVD. You will see a kitchen table set for breakfast. The table, as you can see from the Top viewport, is square, and the scene currently has no lights set up. Your first task will be to place the key light. This is going to represent daylight coming from a window to the left of the table, as seen through the camera.

For this you need to create a Target Directional light, anywhere in the scene, targeted on the eggcup in the centre of the scene. Click the Move button, then right-click it to bring up the Type-in dialog. This light should be located at X:-110, Y:150, Z:90. Now, in the Front and Top viewports, move this light's target so it's somewhere around the eggcup. Rename this light *directKey* and

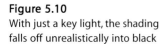

Figure 5.10
With just a key light, the shading falls off unrealistically into black

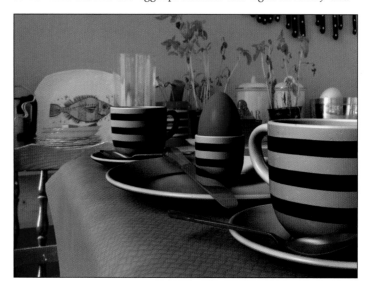

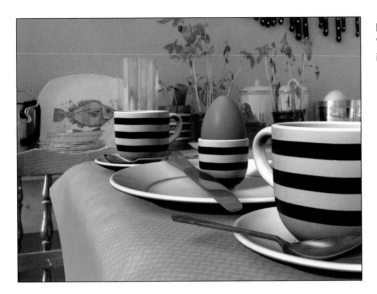

Figure 5.11
Your overall shading is vastly
improved with a few fill lights

give it a Multiplier value of 0.9. Turn on shadow casting by
checking the Cast Shadows checkbox and clicking the color
swatch, give the light a yellow tint - R:237, G:229, B:188 - to
represent morning light as represented on daylight balanced film.
Finally, within the Directional Parameters rollout, change the light
from Circle to Rectangle, set the Aspect to 0.5 and change the
Hotspot and Falloff values to 40 and 50 respectively.

If you right-click any viewport label and select the *directKey* entry
from the Views submenu, you can see through this light, which
you can see is like looking through a window that overlooks the
scene. We won't set the Attenuation on this light as it's sunlight,
so it won't attenuate over the distance from our light to the table.

If you render now, you will notice that the shading across the egg
falls off into black, which is unrealistic, as there would be light
bouncing off the walls and floor that would open up and
illuminate this area. We'll correct this in a moment with our fill
lights. The shadows are too dark, which will also be addressed by
the fill lighting and a change to the shadow settings. The edges of
the shadows look slightly jagged and too well defined, which
we'll correct using the shadow map settings. First, open up the
Shadow Parameter rollout and change the color to R:20, G:12, B:0
and the Density to 0.9. Within the Shadow Map Params rollout,
increase the Size to 1,024 and the Sample Range to 10. Render
again and your shadows should look much more realistic, but still
too dark. We'll now begin the process of opening these out by
adding some fill lights.

With the Shift key held down, use the Move tool to drag this
light in the Top viewport, release and select Copy from the
resultant dialog, changing its name to *directFill01*. Now move this

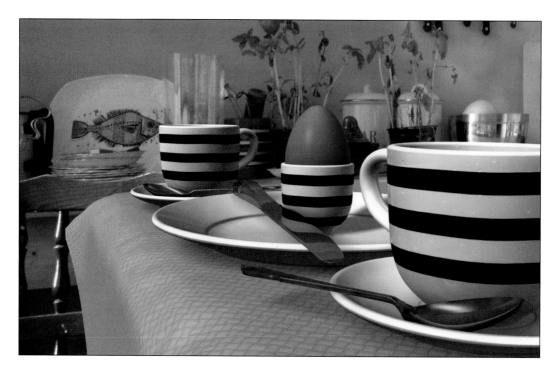

Figure 5.12
With the final fill light and
backlight the lighting opens up
nicely

light to illuminate the shadowed side of the scene's objects (somewhere around X:-140, Y:-10, Z:60), change the Multiplier setting to 0.3 and give this a slightly more saturated orange color. Turn off shadows on this light by unchecking the Shadows checkbox and within the Directional parameters, change this light to Circle and check the Overshoot option. Within the Advanced Effects rollout, uncheck the Specular checkbox, as bounced light does not have much of a specular component. Render now and you should see that the shadows are far more open, though more fills will be necessary to get this looking right.

We need to create some more fills to open up the shadows more and mimic the light that would be bouncing around this environment. Shift-drag a copy of your first fill light and move this to X:-110, Y:-30, Z:60. Change its Multiplier setting to 0.1. Another copy with Multiplier 0.1 should be placed at X:-40, Y:110, Z:60. One more fill placed at X:-120, Y:100, Z:60 should open up the shading adequately.

If you render now, you should see that the overall level of illumination is good and that the rendering is beginning to take shape. However, the underside of the plates and saucers looks a little too dark. This is because all the lights that we have placed so far have been placed above the table, so they are all pointing down and none are pointing up towards these downward-facing surfaces. What we need to do is place a fill light underneath the table that will mimic the light bouncing back up off the table.

Shift-drag a copy of one of your fill lights down underneath the table and in the Top viewport move it centrally to its target near the egg, so it's pointing directly upwards. Give this a Multiplier of 0.3 and a pale blue color that's similar to the tablecloth. If you render now, you will see that the underside of the plates has opened up and these areas are looking a lot more realistic.

Finally you should add a backlight, by creating a copy of one of your fill lights and moving this to X:15, Y:-20, Z:60. This can have the same orange color as your other fills, as it will represent the light bouncing from the far wall, that's visible in the scene.

If you go to the Display tab and click the Unhide by Name button, you can see that there is an extra light in the scene. Unhide this and render again. You should be able to see that this light adds a subtle steam effect to the mug. On www.stinkypops.co.uk you will find a bonus chapter entitled The Natural Elements, which covers effects such as smoke, steam and so on.

You should be able to see that your final render features open shadows with no dark areas and little contrast. This demonstrates, as we've discovered, a low key-to-fill ratio. To calculate this, you need to first work out the key component, which is the key's intensity (its Multiplier value multiplied by the value component of its color). Of course, to this value needs to be added any fills that are overlapping the key:

Key component:
$$= (0.9 \times (237/255)) + (0.1 \times (244/255)) + (0.3 \times (244/255)) + (0.3 \times (217/255))$$
$$= 0.8365 + 0.0957 + 0.2871 + 0.2553$$
$$= 1.4746$$

Similarly, the fill component should be calculated:

Fill component:
$$= (0.3 \times (244/255)) + (3 \times (0.1 \times (244/255))) + (0.3 \times (217/255))$$
$$= (0.2871) + (3 \times 0.0957) + (0.2552)$$
$$= 0.8294$$

The backlight is not calculated as this does not illuminate the front of the subject. So, the key-to-fill ratio is 1.47/0.83, which is approaching 1.8:1 - pretty representative of the environment we're trying to recreate. In your renderings you should try experimenting with the various settings to achieve different key-to-fill ratios, looking at their effect on the lighting, contrast and mood of the resultant image.

6

'When asked to explain how lighting contributes to film making, I often show a completely black slide to emphasize that without light, it doesn't matter how great the composition and acting are - nothing can be seen.'

Sharon Calahan, Director of Photography, Pixar: Advanced RenderMan

Making light work

If, as a lighting artist, you do not stop to consider the emotional aspects of the story at hand, then it does not matter how deep your understanding is of the variety that can be achieved with simple three-point lighting. Knowing all the lighting tricks in the book is all well and good, but without considered application, all your technical wizardry will be for nothing. Your lighting needs to operate on an emotional level to do several things: it should illicit a reaction from your viewer that is coherent with the script; it should guide the viewer visually to the focal points of a scene, whilst reinforcing the atmosphere and providing your audience with clues as to locations and characters. It should do all this whilst emphasizing the three-dimensional nature of your production and helping with the framing and composition of every scene.

Every lighting scenario needs careful consideration, and the following chapters break down the lighting tasks you might face into logical sections: radiosity, indoor lighting, outdoor lighting,

Image courtesy of:
Alessandro Baldasseroni
www.eklettica.com

and special lighting techniques where challenges like underwater lighting are covered. Before we take this step, however, there are several more concepts that need to be introduced.

Other light types

There are several other light types that you may encounter, which are found more in the world of theater and film than in CG, where they are not as relevant. Nevertheless, it is useful to know what purpose these lights serve to be able to communicate with those from a traditional lighting background.

Hair lights

This kind of light does what you might expect - illuminating the subject's hair - providing a nice highlight that also helps to separate the subject from the background. This light is used mostly in photography, as it is only effective if a subject is not moving around a great deal. In CG its use is limited, unless you are using a fur shader, in which case it could be considered, especially as its position can easily be constrained to follow the hair around. However, usually any backlighting that would be set up to work with fur shading would probably serve the purpose of a hair light.

Kicker lights

The kicker is a type of light that is located behind a subject, but unlike a backlight is offset to one side or the other. In film this is used generally for dramatic effect, or can be used to represent a motivational source. The effect of using kickers can be heightened if two are used on either side of the subject, with the sides illuminated, and the front shadow lessened by using fill.

Rim lights

Also referred to as sidelights, these lights have the same purpose as backlights, providing a separation from the background, from one or both sides, though slightly behind the subject. This results in a similar light rim around the subject that provides the separation; though this has a more delicate feel to it. Consequently rim lights are a popular form of lighting in dance-led theater productions, as it emphasizes the dancers in a lighter, more graceful way.

Background lights

Background lights are widely used on film locations to light the set's walls or the studio cyclorama, which has a great effect on the mood of a shot. These lights in particular have to be placed carefully, as they have a habit of giving away the illusion that a

Figure 6.01
The effect of using rim lights gives a very delicate and graceful feel

scene is lit by a primary source like the sun or a window's light.

Area lights

As we've already touched upon, area lights are extremely useful in that their physical size is representative of real-life light fixtures. As a result, the shadows they produce can be soft and pervasive. The rule of thumb for area lights is that the bigger they are the softer the shadows they cast will be, but also the longer the render time. For this reason using area lights is not always realistic. Additionally, the scanline in 3ds Max does not support them and the only way that their use is possible with 3ds Max is alongside mental ray. We'll get to this in chapter 13, where we'll discover that their use is not always practical because of their render times.

The solution, for those working in the scanline or those that can't afford their rendering time, is to use a simple array of lights spread over the surface of the object representing the light fitting, which would be given full self-illumination and possibly even glow. It must be stressed though, that far from being a workaround, the techniques of using a basic grid of lights to represent an area light is an everyday production practice: the spotlight with shadow map is still the mainstay of any production's soft lighting, not the more expensive area lighting techniques you might think are used.

Tutorial - area lights

In this tutorial you will learn how to set up a simple area light, making the physical fixture look realistic and creating an easily controllable array of lights that make for convincing soft shadows. Having set up your dominant light source you will then set up fill

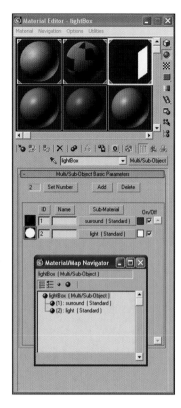

Figure 6.02
Your Multi/Sub-Object material
should have two materials

Figure 6.03
The default settings give us too
hard-edged a light

and backlighting to complement the subject.

Open the C6-01.max file from the tutorials folder of the DVD. You will see a statue in the center of a room underneath a central light fixture. The room, which as you can see from the Top viewport is square, currently has no lights set up, though the first one you'll set up will be based on the box in the center of the ceiling. The room resembles what's known as a Cornell box, which is used to demonstrate bounced lighting.

Select the *lightBox* object and add an Edit Mesh modifier. In Face Sub-Object mode, drag over the whole box to select all 12 faces, and down in the Surface Properties rollout, change their Material ID to 1. Now repeat this, selecting only the two faces that make up the large bottom side and change their ID to 2. In a new slot in the Material Editor, specify a Multi/Sub-Object material with 2 Sub-Materials. Rename this material *lightBox* and apply it to your *lightBox* object. Now, in the first material slot, specify a dark gray material based on the Metal shader and, in the second slot, make the diffuse color pure white with a tiny hint of green and turn the Self-Illumination up to 100%.

Now for the first of our spots that will make up the area light: choose the Free Spot light type and click in the Top viewport to create this light pointing directly downwards. Now move this to X:0, Y:0, Z:8,000, central to the fitting and change the cone's hotspot and falloff values to 40 and 70 respectively. After ensuring that the Cast Shadows checkbox is on, tint the light slightly green to represent fluorescent lighting. Make sure that your shadows are Shadow Mapped and render with the default settings - you should get something like figure 6.03. From this, we can see that despite the falloff being satisfactory, the shadow

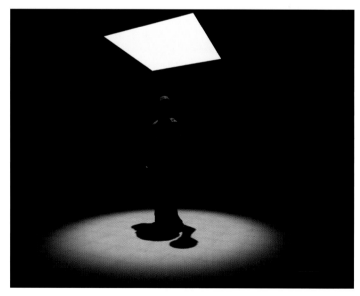

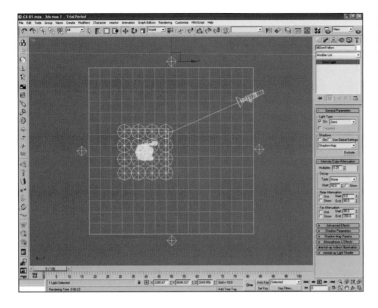

Figure 6.04
Placing the fills colored according
to the walls they are representing

from this light is way too hard-edged for a light of this size and
this proximity. In the Shadow Map Parameters rollout, changing
the shadow map Size to 256 and the Sample Range to 15 should
result in suitably soft shadows.

Rename this light *keySpot01* and move it to the far left corner of
the light fitting - X:–2,000, Y:–2,000, Z:8,000 - if you want to
position it precisely. Next invoke the Array tool and in the dialog
specify an instanced 4 by 4 array spaced 1,250 units along both X
and Y. For those who don't understand the dark arts of the Array
tool, you should first type 1,250 in the top left Incremental X box
to set the spacing in the first dimension. Then you should enter 4
in the 1D Count box to specify how many lights are placed along
this axis. Finally, check the 2D radio button and enter 4 in its
Count field, along with 1,250 in the adjacent Incremental Y box.
Don't forget to specify Instance.

Rendering now will produce an image with almost completely
burned-out whites, so reduce the Multiplier value to 0.12 and
render once more. Finally, the Attenuation should be set to
Inverse Square to give the light real-world decay, and the Start
value should be set to 6,000 or else the effect will be too dim.
With these lights representing the key light, a fill should be
introduced to give the scene some general illumination. For this,
we'll place a non-shadow casting omni directly underneath the
light fitting, renaming it *fillOmniArray*. This should be set to pure
white with a slight green tint, with a Multiplier value of 0.25,
and placed centrally to the fitting.

Our second fill should be placed level with the statue just behind
the right-hand wall as seen from the Top viewport. It should be

given a 30% gray tint to represent the color of the concrete wall. It should again be non-shadow casting, have its Specular component turned off and its Multiplier should be set to 0.25. Rename this *fillNearWall* and create an instance of it placed in the center of the far wall, as in figure 6.04, called *fillFarWall*. We need two more fill lights, both placed centrally on the blue and yellow walls, both the same as the two we've just created, apart from their colors, which should be pure blue and pure yellow; their Multiplier values should be 0.2 and 0.25 respectively. All your fills should have their Specular component turned off.

Finally, a light placed beneath the floor representing the light bouncing back up off the floor is required. This should be a Free Spot, placed at X:2,300, Y:0, Z:-5,500 and pointing directly upwards. Give this a slight pinky-brown tint, a Multiplier value of 0.3 and turn off its specular component.

By tinting these last few lights, particularly the blue and yellow omnis in this way, what you have done is placed lights that represent the light from the central fitting that would bounce off these scene's surfaces, picking up their color on the way. This is how light acts in real life, reflecting off the various surfaces of its environment. This process is called indirect or global illumination. This will be explained in depth in the following chapter, where you'll also learn how to fake this effect properly.

Figure 6.05

Our end result looks like the light has bounced around the scene

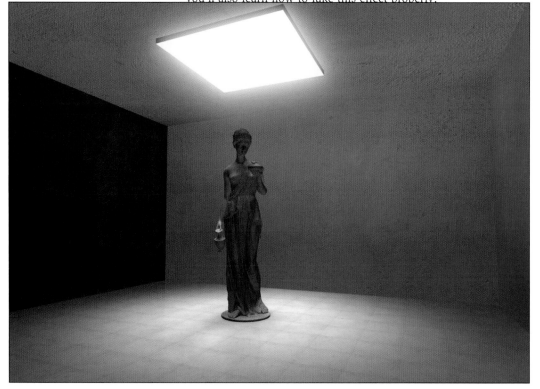

Arrays

You might be forgiven for not knowing anything of lighting arrays, no matter which 3D solution you use. Look through the help files and manuals and you'll find no mention of them. This is also true of the vast majority of books aimed at teaching specific 3D software solutions. This lack of documentation is remarkable, as they can be extremely useful lighting tools.

When a light's illumination needs to wrap around an object, single lights won't suffice and it is in these instances where arrays of lights can be employed. Arrays are simply a group of lights, just like the ones representing the area light in the last tutorial. Arrays can represent area lights, domes of light like the sky's illumination and any instance where the light fixture is large enough to require more than one light. A single light is not representative of a real lighting fixture because the light is coming from an infinitely small point, so the light will not wrap around the object in the same way.

Arrays can basically be thought of as area lights, because that's basically what they are: an array of lights spread over an area. However, just because there are area lights in 3ds Max (when using mental ray anyway) don't jump ahead to the mental ray section. The problem with area lights is that they are usually difficult to control. Generally you don't know how many individual lights are making up the area light, and also the area light color is not generally controllable to the level of the individual light. This is why arrays of lights give you much more control - some can be set up as shadow casting, some not, they

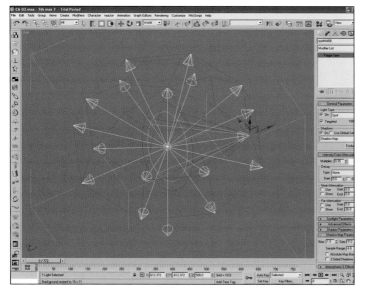

Figure 6.06
A dome array can be used to easily represent an outdoor environment

Figure 6.07
Arrays can be used to give nice soft shadows to a subject

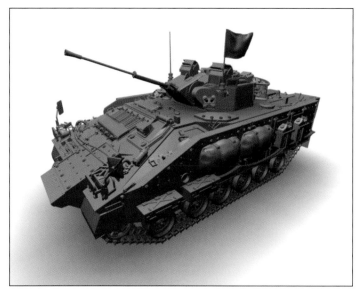

can be given different intensities, and of course colors.

At the simplest level, if you spread lights out over a rectangle, as in the previous exercise, you have an array that acts like a simple rectangular light fitting. However, this is only the start of what is possible, and by using them with three-dimensional forms such as domes, you can build up some interesting lighting effects that can create a realistic environment. This is largely because creating a large array in this fashion gives you the opportunity to alter the light's intensities from different areas of the environment, and more importantly, the light's color. The fact that lights can be given different hues more accurately represents the real-world environment surrounding a scene or an object, with the colors from each light representing the light that would be bouncing off the objects in the environment.

Lighting arrays are best assembled in a similar manner to lighting rigs, with lights attached to the vertices of primitive objects using the Snap tools. Setting up a plane with the relevant number of length and width segments is the best way to arrange a rectangular set-up. Likewise, if you're constructing a dome array, the best way to go about this is to use half of one of the spherical primitive objects. Rather than using a geodesic type of primitive, it's usually best to use a regular spherical object divided like a globe using lines like longitude and latitude. You can then organize your lights more easily in horizontal rows, which makes the identification of each individual light a much simpler task.

There are many effects that can be achieved with arrays organized in tubular form, or as a ring, box, or any other way that you might find useful. Depending on the colors given to the individual lights the illumination will vary and, by specifying some lights as shadow

casting and some not, vast variations in the shadows cast by the array are possible. Obviously, the more lights that are set to cast shadows, the longer the render time will be once your system is unable to hold the shadow maps in RAM, but the softer the shadows will become. Once set up, lighting arrays can be used over and over to represent skies, light fittings and so on. They work fantastically well as fill lights, providing subtle alterations in color and intensity around an object, whose dominant light source is generally a separate entity from the array. This does not mean that extra fill lights are not necessary for the scene though, they might not be, but you should always question whether additional fills would further emphasize the 3D nature of an object or enhance your overall lighting scheme.

Tutorial - light arrays

In this tutorial you will learn how to set up an array of lights around a dome, which will act like the illumination from an open sky. You'll construct the dome as a kind of rig, positioning lights at individual vertices and linking them to the dome. You'll then set up the colors and intensities of the lights to represent the illumination coming from an early morning sky.

Open the C6-02.max file from the tutorials folder of the DVD. You will see a few rocks in the foreground, but apart from that, the scene is empty. In the Create panel, press the Sphere button and using the keyboard entry create a sphere of radius 1,000, with eight segments. Move this to X:0, Y:0, Z:0 and go into the Modify panel, rename this *arrayDome*, and enter 0.5 into the hemisphere setting, which gives you exactly half a sphere, making sure that

Figure 6.08
Using snaps makes placing the lights much more straightforward

the Squash radio button below is selected. From the Edit menu, choose Object Properties, uncheck the Renderable checkbox and press OK. In the Display panel, use the Hide Unselected button to make things a little simpler. Right-clicking the 3D Snap Toggle button on the main top toolbar gives you the various snap options; turn just the Vertex option on before clicking the button again to actually turn the snaps on. You can close the floating dialog to see better, and maximize the Top viewport. If you now choose Target Spot in Create > Lights, you should see a blue marker when you move the cursor over any of the hemisphere's joints.

You should go around the dome and place lights at as many of the vertices as you want to, not worrying too much about where the targets for these lights are placed. For this exercise you should place one right in the middle, plus a ring of lights along the bottom two rows. Now, in the Select Objects dialog, select all of these spotlights (you should have 17) and using the Select and Link tool, use the Select Objects dialog again to link these to the hemisphere object. Now you should select all of the spotlight target objects and in the XYZ coordinate type-ins at the bottom of the screen, move all of them to X:0, Y:0, Z:0. Create a dummy object at the same point and select all of the target objects, and link these to the dummy, which you should rename *dummyDome*. Link this dummy object to the *arrayDome* object and you're done.

Selecting the *arrayDome* object now (check that you're not still in Select and Link mode), you should be able to move the dome around, scale it, squash it, whatever, with the omnis remaining firmly in place at the vertices. You should now rename your 17 spotlights so that they can be identified more easily - something like *spotBot01-08*, *spotMid01-08* and *spotTop* - ensuring that your

Figure 6.09 (above)
Give your lights Multiplier values and colors to match this table

Figure 6.10 (right)
Link all of your 17 lights to the scene's hemisphere object

Figure 6.11
The finished lighting sits
comfortably with the background

numbers correspond on the eight radial branches. In this
instance, you should start with *01* at the 6 o'clock position and
work clockwise to *08*. The lights should be given Multiplier
values as per figure 6.09, and be given color tints to match the
immediate environment of the area, which if you can see from
rendering is sand and foliage. Set the color of *spotBot01-04* to a
light green - R:200, G:255, B:200- and 05-08 to a sandy yellow -
R:255, G:242, B:180. This represents the light bouncing from the
immediate environment, which should be set to match the
surroundings whenever you use the dome array. Make this row of
lights non-shadow casting.

We're using 5,600 °K film and partly overcast sky has a color
temperature of around 8,000-10,000 °K, which is higher than our
color balance, so would appear to have a blue tint. So, color the
next row's lights accordingly to represent this illumination -
R:220, G:249, B:255. This row should have its shadow casting
turned on, with the shadow map Size set to 512 and the Sample
Rangle set to 4.0 within the Shadow Map Params rollout.

The topmost light should be set to a pure white and given a
Multiplier of 0.75, again with shadows turned off. You might want
to Group this whole construction together under a single name, as
it does appear rather large in the Select Objects dialog, then you
can just open and close the group as you want to change colors
and intensities. Another light should be placed underneath the
scene representing the light bouncing up from the sand. This
should be given a sand colored tint and a multiplier value of 0.2.
Now if you unhide our teapot object and render the scene, you
should see that the shadows are nice and soft, the lighting
appears natural and sits comfortably with the background. Most
importantly, the main lighting is coming from directly overhead,
but the array's peripheral lights provide some wraparound and

direct illumination given their subtle coloration.
Skylights

Though we'll go into this in greater depth in chapters 9 and 11, when we'll look at outdoor lighting, now is a good time to introduce skylights. The last tutorial modeled the illumination coming from the sky on an overcast day and that's basically what the Skylight light type does in 3ds Max - it models daylight. It is designed to be used in combination with one of 3ds Max's two Advanced Lighting modes: the Light Tracer. The other mode is Radiosity, which the next chapter is dedicated to. Unlike Radiosity, the Light Tracer does not attempt to set up a physically accurate lighting model and so can be a lot easier to set up.

Using the Skylight is arguably the easiest way to model daylight in 3ds Max. The Skylight is modeled as a dome above the scene; the position of the Skylight, the size of its icon and its distance from objects have no effect. The Skylight object is simply a helper; its light always comes from overhead. The light itself has relatively few controls, but its most notable feature is a Map slot, which allows you to use a map to affect skylight color. Though regular images can be allocated to this slot, it works particularly well with HDR (High Dynamic Range) maps, and once you have discovered working in this way, beautifully realistic illumination is possible with comparatively little effort. We'll go into this in greater detail when we move onto outdoor lighting in chapter 9.

Figure 6.12

A skylight can model daylight with comparitively little effort

For the moment, all you need to know is that an HDR image can store a larger gamut of luminances between dark and bright regions of an image than regular formats. Most image formats are restricted to 8-bits within each of the R, G and B channels, so for each pixel, the R, G and B information is limited to an integer between 0 and 255. A white pixel in an 8-bit RGB image could represent many things from a white wall to the sun itself and its clear that in real life these two items have very different energies. With HDR images a white wall could be represented by a value of 300 and the sunlight by a value of 10,000. It is this range of values that can be used by the renderer to provide a detailed and realistic light source for the scene.

High Dynamic Range imaging

The dynamic range of an image can be thought of as the contrast ratio between the brightest and darkest parts of the image. A photograph with bright light sources and dark shadows would be a prime example of an image with a high dynamic range. However, the term High Dynamic Range image, or HDR image, in the context of computer graphics relates to an image that stores this range of luminance values.

The 8-bit images that we are so used to working with are restricted to 8-bits of information within each of the color channels. This means that the Red, Green and Blue values that make up each pixel of an image are represented by a single integer between 0 and 255. This is typically what a standard display device or digital camera can deal with. The same white pixel value of R:255, G:255, B:255 within an 8-bit image is used to represent a white wall, a portion of the sky and the sun itself. We all know that these three elements would in real life have very different luminances, but 8-bit clips these values all down to the same level of white.

HDR images on the other hand feature pixel values that are stored in a non-clamped format. Though your PC monitor will only be capable of displaying 8-bit color, so it will display these various white elements as the same R:255, G:255, B:255 value; internally things are stored in a floating-point format, capable of up to a million different increments between the darkest and lightest part of an image. A white pixel with a value of 300, for instance, lies a little beyond the range of the regular 0-255 RGB system and could represent a painted white surface. However, a white pixel with a value of 10,000 for example would be used to represent a very bright portion of the image, either from the sky or the sun itself. Because the pixel values in HDR images are directly proportional to the luminance of the actual object, your renderer can tell the difference between these differing luminance values and produce startlingly real images as a result.

Figure 6.13
With pixels stored as floating-point numbers, an HDR image can be darkened, lightened and even motion blurred more effectively than conventional 24-bit images. (HDR version right, 24-bit left)

Images courtesy of:
Paul Debevec
www.debevec.org

Figure 6.14

HDRshop can be used to assemble photographs into HDR images www.hdrshop.com

HDR images can be generated in two ways, the first is to render using a global illumination algorithm and store the information in HDR format. The second is to combine a number of photographs, taken using a range of exposure settings, exposing first for the brightest light source and stepping down gradually to the least bright. Generating the images themselves can require some effort, particularly if you're working with film. Because these images need to capture the full range of luminance information in a scene, the camera operator needs both to overexpose and underexpose in order to capture all the highlights and shadows at a mid-tone exposure level.

The images should be bracketed so that the darkest parts of the scene are clearly visible in the longest exposure and the brightest parts of the image are not burnt out to white in the shortest exposure. The steps between these two exposure settings depends on many things, in particular how well the camera's response curve is calibrated, but by taking these images one f-stop apart you will be guaranteed good results. Using an application like HDRshop (www.hdrshop.com) you can now use this series of images to generate a single HDR image.

These photographs are generally taken of a reflective chrome ball that is placed centrally to a shot, which can be used as a spherical map, providing lighting information for the full scene. As you'll read more about in chapter 11, when we move onto match lighting, this practice of recording the lighting information by photographing gray and chrome spheres is common practice for live action work.

Indeed, HDR technology was slow to filter into production use for feature film work. *X-Men the Movie* saw the first real application of this technology in a single shot (where Senator Kelly melts into a pool of water). Nevertheless, the technology is gradually becoming more established and more widely used.

The arrival of a new high dynamic range file format - OpenEXR - has seen the technology used much more widely over the past year or so. This file format, developed by Industrial Light & Magic, has now become the studio's working file format and saw its first use on *Harry Potter and the Sorcerer's Stone*, *Men in Black II*, *Gangs of New York*, and *Signs*.

The file format is fast becoming a standard within the feature film industry because of its high dynamic range and strong color resolution per f-stop, its compatibility with current graphics hardware and its lossless compression algorithms. Many 3D applications and compositing applications feature support for the .exr format, including 3ds Max and notably Autodesk Toxik, which features a full 32-bit floating-point pipeline to provide a HDR-friendly compositing environment.

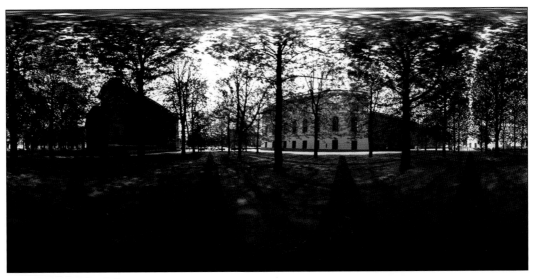

Tutorial - skylight

What we modeled in the last tutorial was a dome shaped array of lights that together provided illumination akin to a sky dome. However, the skylight light type provides a way of quickly getting this type of lighting setup within one light. Open up C06-03.max and you should recognize the scene from the last tutorial. Hit F9 to do a quick render and you'll see that your foreground elements sit in with the background, just as you left it in the last tutorial. Clone your rendered frame for reference.

Bring up the Light Lister (found within the Tools menu) and turn off all your lights. Now select the Skylight light type from the standard lights and click in the center of the array in the Top viewport to create this light. If you render again, you will see that there is no variation in the shading of your foreground objects, as you have no Advanced Lighting solution allocated. Open up the Render Scene dialog and within the Advanced Lighting tab, choose Light Tracer from the drop-down at the top of the dialog. Render again and you will see that the objects are now lit from all angles and the illumination is open with soft shadows and looks like daylight, even if the daylight does not quite match the backplate. The other thing you probably noticed is the render time compared with your last solution. You can make this lighting solution sit in much more comfortably with the background image by changing its color to a more yellow color (R:255, G:253, B:235) and increasing its Multiplier value to 1.4.

Undo these changes however and use the Selection Set drop-down in the main toolbar to select the C06-02 components. Delete these and then hit Unhide All in the Display panel. You should see our statue of Venus appear. With the bottom-right viewport active, hit

Figure 6.15
HDR images can hold a far larger gamut of luminance

Images courtesy of:
Sachform's URBANbase collection
www.sachform.com

Figure 6.16
Setting the White and Black Point
means the full range is used

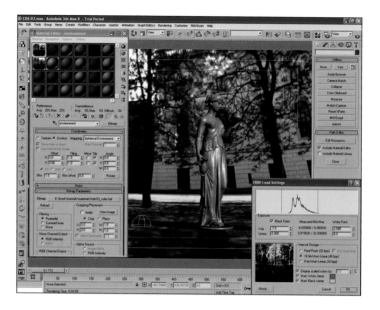

C to look through the new camera that has been set up for this scene. Render again and you will see the way that the folds of the statue's clothes pick up the soft shading of this light type. However, our statue looks a little out of place, so let's set up a more suitable backplate.

Open up the Material Editor and in the top-left slot, hit the long slot marked Bitmap that currently points to our beach background image. Point this instead to hdri-03_color.hdri. When you click Open, a new dialog should pop up with the HDRI Load Settings.

This is where you set the White and Black Points of the image. You should increase the White Point spinner until the pink dots begin to disappear. What these represent are the areas of clamped white color, so you want only the very brightest small areas of the image to display these pink specks. You should reach this point when your White Point Linear spinner reaches about 6.0. Make a note of this number, or enter 6.0 as its value. Similarly, you should turn on your Black Point and move the Log spinner up until the cyan specks just begin to appear. This should happen at about -7.0 for your Log value.

Once you have pressed OK to this dialog, you should see the image appear in the background of the Camera viewport, but you'll see that it looks too dark. To sort this out, you need to go down to the Output rollout and change the RGB Level value to whatever you set as the Linear White Point value, which you made a note of last paragraph. This should lighten the image in your viewport and will ensure that the dynamic range of the image is used to its full extent. One last thing though is that the image is actually distorted. This is because HDR images are

Figure 6.17
The Light Tracer is best suited to outdoor scenarios

created by photographing chrome spheres, which are hence spherically mapped, so 3ds Max needs to be told this in order to work with them correctly. Within the Coordinates rollout, change the Mapping setting to Spherical Environment. If you change the V Offset value to 0.06, you should find that the statue sits centrally to the patterns in the pavement.

Hit Render again and you'll see that your background looks correctly exposed, which means that it's had its black and white points set to a suitable value. However, though the lighting on our statue looks nice and soft, it by no means matches the lighting on our backplate. Select the Skylight and in the Modify panel, click the Map button, choose Material Editor to Browse From and double-click the *environment* material. This map is now allocated to the Skylight, so if you render again, you will find that your statue looks considerably more natural and it sits with the image pretty much perfectly.

The image you have just allocated to the Skylight is 4,000 x 2,000 pixels in resolution, so a better idea is to use a smaller version of this map that is blurred to prevent sampling problems from having to process this level of detail. To do this, drag your *environment* material to an unused slot within the Material Editor

Figure 6.18
Use the Exposure controls to brighten or darken your final rendered image

and rename this new version of it *environmentBlur*. Point this to the hdri-blur-03_color.hdr image, which is a 200 x 100 pixel version of this image. Now allocate this to your Skylight, leaving the full-res version as your environment image. You'll find that there's no difference in the rendered image and your render time should come right down, in this case by about 15%.

There are some material changes that will make this statue sit even better on its background than it does right now. In the *venus* material, turn off the Self-Illumination map. This was faking a small amount of backlighting within the material itself. However, because we have a full spherical map of this environment, we can allocate it as a reflection map. Click the Reflection tab and again choose to Browse From the Material Editor and select the *environmentBlur* material. You could choose the sharper, high resolution version of this map, but your reflections would be very sharp and would take longer to calculate.

If you render now, with your Reflection spinner set to 100, you will see that your reflections accurately match your environment; however the reflections do look like they've come straight out of *Terminator II*. Click the Bitmap button at the top-right of the Material Editor, directly below and to the right of the sample

windows, and choose Falloff (you will have to change the
Browse From setting from Material Editor to New to see the
Falloff option appear), making sure to keep the old map as a sub-
map. You should drag the slot with the HDR map onto the one
labeled None directly below it and choose Swap. Set the Falloff
Type to Fresnel and render again. You should now find that your
reflections look a lot more convincing.

You should finally drag the environmentBlur map from the
Material Editor onto your Skylight object once more, as your
changes to the venus statue's materials will have changed this
map on the Skylight to use a Falloff map.

Finally, if you need to adjust the overall brightness of your render
once you have a workable solution, it's best to use the Exposure
controls found under the Render > Environment menu.

The HDR files used in this
tutorial were kindly provided
courtesy of Sachform.

These images are part of the
company's URBANbase
collection, which features 40
fully spherical HDR maps at a
resolution of 4,000 x 2,000.

www.sachform.com

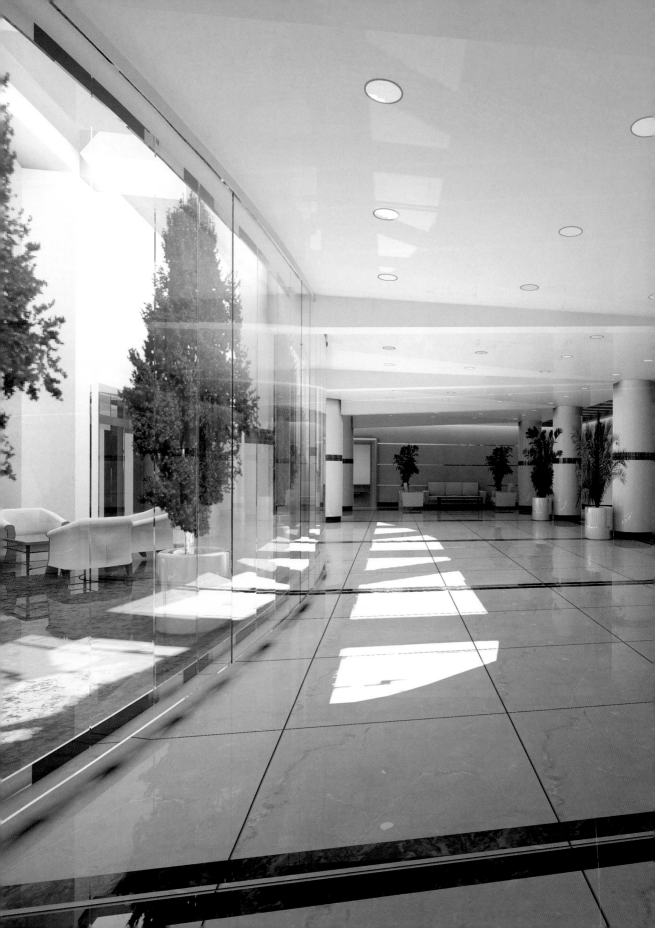

7

'Light is the first of painters. There is no object so foul that intense light will not make it beautiful.'

Ralph Waldo Emerson: *Nature*

Global illumination

There is a certain amount of confusion surrounding the term 'global illumination', but the key to understanding it lies in the first half of the phrase. This refers to the way an object is lit by its surroundings, in effect the global contents of the scene being rendered. This may well seem excessive, but the detail and depth of these images is simply not possible using other methods. Within the umbrella of global illumination lies several algorithms and methods, including raytracing and radiosity, which have been gathering momentum for well over a decade and are now firmly established within most 3D applications.

Until we introduced working with the Skylight and the Light Tracer at the end of last chapter, every technique we've gone into thus far has been based on direct illumination. This algorithm, as we already know, considers only the direct illumination component of a scene's lights. The Light Tracer, as the first of 3ds Max's Advanced Lighting modes, is a great method of acheiving

Image courtesy of:
Chen Qingfeng
www.chen3d.com

the soft light and color bleeding that are associated with full-blown radiosity techniques, without having to run a physically-based simulation. As such, it was our first simple stepping stone from direct illumination into the world of global illumination.

This chapter will see us move fully into working with the global illumination technique of radiosity, which is 3ds Max's second Advanced Lighting mode. What we have attempted to do so far, with standard lights, the three-point lighting technique and the scanline renderer has been to produce realistic lighting that models the light bouncing of light off a scene's surfaces using fill lights. This process could be referred to as 'fakeiosity', as what you are doing with this technique is faking radiosity by modeling the indirect lighting within a scene as a series of fill lights. As well as the direct light component, it is also this indirect light that radiosity considers, and the by-products of this approach are soft shadows, color bleeding and a natural realism that just isn't possible in the scanline renderer without considerable effort.

As this approach produces a physically-based photometric simulation of a scene's lighting, it's perhaps no real surprise to find that it has wider application in architectural visualisation than anywhere else. The need for architects and designers to be able to accurately represent how a particular space will look given specific lighting fixtures is fully catered for by radiosity.

Thus far, all of our lighting values have been specified in arbitrary units. Radiosity however, introduces photometric units like lumens, candelas and so on. For those architects and designers used to specifying real-world fixtures, 3ds Max allows for the use of data from actual lighting manufacturers when placing lights. This data is provided in the industry-standard Luminous Intensity Distribution files via several formats - IES, CIBSE and LTLI. By being able to work with real-world lighting in this way, professionals in these industries are able to set up lighting in their scenes more intuitively, which leaves them free to focus more on design exploration than on the computer graphic techniques required to visualize these designs.

Light distribution

Imagine a 3ds Max scene of a simple room's interior lit by the sun travelling through a single window, as in figure 7.01. The light from this source can be thought of as being emitted in discrete particles, called photons. These photons travel from the source until they hit a surface in the scene. Depending on the surface's material, some of these photons are absorbed and others are scattered back out into the scene. The way in which the photons are reflected from a surface depends primarily on the smoothness of the surface.

Surfaces that are very smooth reflect the photons in one direction, at an angle equal to the angle at which they arrive at the surface, the angle of incidence. These surfaces are known as specular surfaces, and this type of reflection is known as specular reflection. Rough surfaces tend to reflect photons in all directions. These are known as diffuse surfaces, and this type of reflection is known as diffuse reflection. A mirror is an example of a perfectly specular surface, whilst a painted wall (particularly one painted with matte paint) is a good example of a diffuse surface. The final illumination of the scene is determined by the interaction between the surfaces and the billions of photons emitted from the light source. At any given point on a surface, it is possible that photons have arrived directly from the light source (direct illumination) or else indirectly through one or more bounces off other surfaces (indirect illumination).

If you were standing in the room below, a small number of the photons would enter your eye and stimulate the rods and cones of your retina. This would, in effect, form an image that is perceived by your brain. In CG, the equivalent of the rods and cones are the pixels of the screen. A global illumination algorithm aims to recreate, as accurately as possible, what you would see if you were standing in a real environment.

Figure 7.01
Radiosity and raytracing complement each other well

Image courtesy of:
Grigory Koljadin
studio77@bk.ru

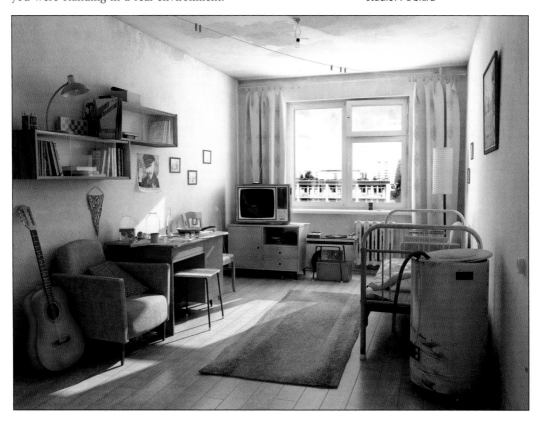

Raytracing

Raytracing was one of the first global illumination algorithms to be developed. This algorithm recognizes that although billions of photons may be emitted, the ones we primarily care about are those that enter the eye and form the resultant image. The algorithm works by tracing rays backward, from each pixel on the screen into the scene. This is quite efficient, because only the information needed to construct the image is computed. To create an image in this way, for each pixel on the screen, the following procedure is performed:

Raytracing pipeline:

Step 1:
A ray is traced back from the eye position, through the pixel on the monitor, until it intersects with a surface. The reflectivity of the surface is known from the material description, but the amount of light reaching that surface is not yet known.

Step 2:
A ray is traced from this point of intersection on the surface to each light source in the scene. If the ray to a light source is not blocked by another object, the light contribution from that source is used to calculate the color of the surface.

Step 3:
If an intersected surface is shiny or transparent, it also needs to determine what is seen in or through the surface being processed. Steps 1 and 2 are repeated in the reflected (and, in the case of transparency, transmitted) direction until another surface is encountered. The color at the subsequent intersection point is calculated and factored into the original point.

Step 4:
If the second surface is also reflective or transparent, the raytracing process repeats, and so on until a maximum number of iterations is reached or until no more surfaces are intersected.

Though raytracing might be considered efficient in that only the information required to construct the image is computed, it is still relatively slow for scenes of anything beyond even moderate complexity. Raytracing is very versatile and can model a large range of lighting effects. It can be used to accurately represent shadows, specular reflections and refraction, and it is because of this that it is employed selectively on objects that rely on these qualities. Though its speed is one disadvantage, a more significant one is that it does not account for one very important characteristic of global illumination - diffuse inter-reflections.

Traditional raytracing (and scanline rendering) only takes into account the light arriving directly from the scene's light sources themselves. However, as shown in our room example, not only does direct light arrive at a surface from the light sources, it also arrives indirectly from other surfaces. If we were to raytrace an image of the room we described earlier, for example, the areas in shadow would appear black because they receive no direct light from the light sources.

Traditionally this would be addressed by adding an arbitrary ambient light value across the scene. However, this has no correlation to the physical phenomena of indirect illumination. For this reason, scanline and raytraced images can often appear very flat, particularly renderings of architectural environments, which typically contain mostly diffuse surfaces.

Radiosity

Thermal engineering research had developed methods for simulating radiative heat transfer between surfaces in the early 1960s. Around twenty years later, computer graphics researchers began looking at these existing techniques as a method of

Figure 7.02
In the real world light bounces around coloring its surroundings

modeling light propagation. This research developed into what is now known within the computer graphics world as radiosity. This is fundamentally different from raytracing in that radiosity calculates the intensity for all surfaces in an environment rather than just the ones traced back from the screen.

This process involves dividing the original surfaces into a mesh of smaller surfaces, referred to as elements. The radiosity algorithm calculates the amount of light distributed from each mesh element to every other mesh element. The final radiosity values are stored for each element of the mesh.

The early versions of this radiosity algorithm had a significant problem in that the distribution of light among mesh elements had to be completely calculated before any useful results could be displayed on the screen. As anyone who's ever worked with radiosity will tell you, this can take a long time, even today, but you can probably imagine how long this would have taken on the hardware of the mid-80s. In 1988, however, a technique called progressive refinement was invented, which displayed immediate visual results that are progressively refined in terms of accuracy and visual quality.

A little over a decade later, a technique called stochastic relaxation radiosity (SRR) was invented, which constructs a series of approximate solutions which then converge towards a final solution. This algorithm forms the basis of the radiosity system within 3ds Max today.

Despite these advances, radiosity does not in fact address all global illumination effects and has its shortcomings just like raytracing does. However, the two do complement each other and work well together. Radiosity excels at rendering diffuse inter-reflections whilst raytracing excels at rendering specular reflections. After your radiosity solution has been calculated, your two-dimensional view of it is rendered, with raytracing adding the effects that it is particularly suited to providing – raytraced shadows, and materials that feature raytraced reflections and refractions. The final render thus combines both of these techniques in an image that appears more realistic than either technique alone could manage.

Radiosity workflow

Hopefully you now have a grasp of global illumination and radiosity and are beginning to understand the workings of radiosity. However, in order to take this knowledge further it is necessary and begin to understand the workflow for working with radiosity in 3ds Max. It makes sense to first take a look at how radiosity is processed by the application.

Radiosity processing stages:

Step 1:
A copy of the scene is loaded into the radiosity engine, a single object at a time.

Step 2:
Each object is subdivided according to individual or global subdivision settings.

Step 3:
A certain amount of rays are emitted, based on the scene's actual lighting distribution.

Step 4:
These rays bounce around randomly in the scene and deposit energy on the objects' faces.

This is a very broad overview of how radiosity works and in order to understand it further, it's important to understand how the solution is refined. This is a three-stage process:

1 - Initial Quality

The first stage of the refinement process that kicks off a radiosity render involves the distribution of diffuse lighting in the scene. During this stage, the radiosity engine bounces rays all around the scene and distributes energy on each of the scene's surfaces. However, rather than tracing the path of what would be an essentially infinite number of photons, statistical methods are used to select a considerably smaller set of photon rays, whose distribution is representative of the actual distribution. Obviously, the greater the number of rays used in this approximation, the greater the accuracy of the solution.

Figure 7.03
Initial quality set to 60% (left) compared with 85% (right)

Between each iteration, the radiosity engine measures the amount of noise that was computed between surfaces. Most of the brightness of the scene is distributed in the early iterations. The contribution to the scene's average brightness decreases logarithmically between iterations. After the first few iterations, the brightness of the scene does not increase much, but subsequent iterations reduce the variance within the scene.

The Initial Quality setting can be set at any value up to 100%, which would provide a 100% accurate energy distribution. It should be stressed that the quality refers to the accuracy of energy distribution, not to the visual quality of the solution. A setting of 80-85% is usually sufficient for good results. However, even at a high Initial Quality percentage, the scene can still show considerable variance. This variance is resolved by the subsequent stages of the solution.

2 - Refine Iterations

Due to the random nature of the sampling during the previous Initial Quality stage, some of the smaller surfaces or mesh elements in the scene might miss being hit by enough rays. These small surfaces remain dark, and result in the appearance of dark spots. To alleviate these artifacts, the Refine Iterations stage 'regathers light' at every surface element.

This second refinement stage increases the quality of the radiosity processing on all objects in the scene. This involves gathering energy from each face in order to reduce the variance between faces mentioned in the previous Initial Quality stage. The Refine Iterations stage does not increase the brightness of the scene, but

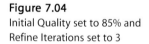

Figure 7.04
Initial Quality set to 85% and
Refine Iterations set to 3

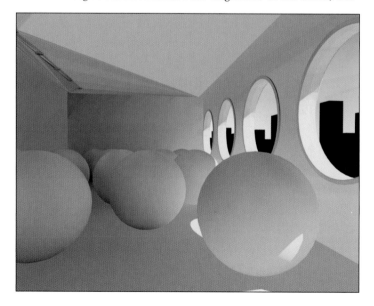

it does improve the visual quality of the solution and significantly reduces variance between surfaces. If an acceptable result hasn't been reached after processing a certain number of Refine Iterations, the number can be increased and processing continued.

3 - Regathering

Even after this second stage, it is still possible for visual artifacts to appear in a scene, largely because of the topology of the original model. These artifacts can sometimes appear as a shadow or light leak. To eliminate these model-based artifacts, a third optional refinement stage, known as Pixel Regathering, occurs at the time of image rendering. This involves a final regather process for each pixel of the image, which can add a considerable amount of time to the rendering of a final image. However, it can also make a considerable difference to detail and eliminating artifacts. When using regathering, the initial model and mesh resolution is much less of a consideration.

Before we jump in and try this process ourselves, there are several golden rules that must be adhered to when working with radiosity and it's worth going briefly over these. First and foremost, your units must be correctly defined. This is because radiosity works with physical lighting, so the lighting simulations obey its physical laws. The most noteworthy of these is the light's falloff, which obeys the inverse square rule. You can imagine that a three-meter high space will look quite different to a three-kilometer high space when lit by the same light fittings. The Units Setup dialog should be used to ensure that this is being dealt with correctly. The System Unit Setup is the most important component of this dialog, as the Display Unit is just a tool that

Figure 7.05
Regathering with 10, 50 and 150 rays per sample (clockwise from below)

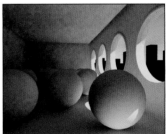

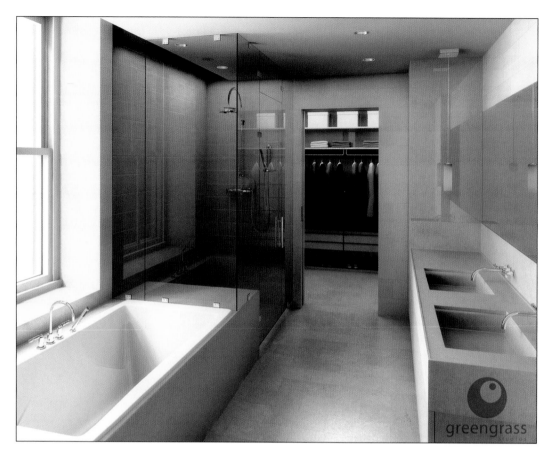

Figure 7.06
Radiosity is prevalent within
architectural visualizatoin

Image courtesy of:
Jesse Sandifer
www.greengrassstudios.com

lets you customize how units are displayed in the UI. Setting up units correctly is particularly important if you are importing geometry from another application.

After you've ensured your geometry is to the correct scale, it's important to ensure that your materials are set up with reflectance values that would be realistic for the physical material they are supposed to be representing. You should ensure that within 3ds Max's preferences, the Display Reflectance & Transmittance option is turned on. This is found on the Radiosity tab of the Preferences.

With this turned on, the Reflectance values of your materials are displayed in the Material Editor and you can easily make sure your materials match their real-life equivalents. You should then add your Photometric lights, ensuring that their light intensities are within a normal range, and use the IES Sun and IES Sky options to represent any natural lighting within the scene. Finally, you should use the Exposure Control to compensate for the limited dynamic range of your monitor and control the look of your final results so that they fit best with the eye's own dynamic range.

Tutorial - radiosity workflow

In this tutorial you will learn how to set up a simple radiosity scene, making use of 3ds Max's photometric lights. You will proceed through the workflow that has just been outlined. We will begin this tutorial by importing geometry, so start up 3ds Max and choose Customize > Units Setup. Go to the System Units Setup and choose 1 Unit = 1 inch. Okay this and choose Metric and Meters as the Default Unit Scale.

You should now choose File > Import. Browse to the chapter07 folder on the DVD and find the C07-01.3ds file. You should make sure that the Convert Units checkbox remains unchecked. With this geometry now in your scene, choose either the Tools > Measure distance, or draw out a box that roughly matches the dimensions of the room. You should find that the room measures approximately 125m x 267m x 82m. This is quite obviously wrong and, as we discussed in the last section, is the first common mistake that people make when starting to work with radiosity.

Reset 3ds Max and instead set the System Units to 1 Unit = 1 Millimeter. Again choose Metric and Meters as the Default Unit Scale and go to File > Import, choosing the C07-01.3ds file and again unchecking the Convert Units checkbox. If you measure the imported geometry, this time you will see that this space is approximately 5m x 10.5m x 3m. If you had accidentally selected Convert Units upon import, the box would have also been of an incorrect size, so it's always worth double-checking at this point that you're working to the correct scale.

The next thing we need to do is to turn on the Reflectance & Transmittance Information, which is found within Customize > Preferences, on the Radiosity tab. Once you've enabled and

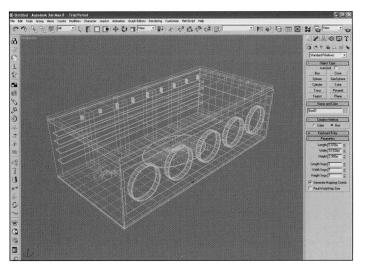

Figure 7.07
Your imported geometry should be roughly 5m x 10.5m x 3m

Figure 7.08

Turn on the Refectance &
Transmittance Information

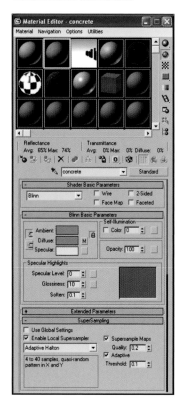

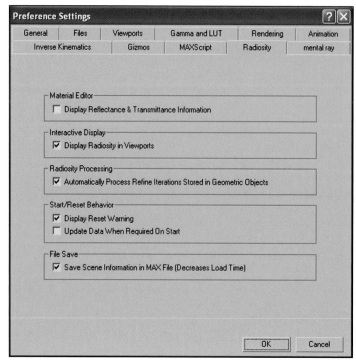

okayed this, bring up the Material Editor and you should see that direcly below the material slots there is an extra set of percentage values, which informs you of the average and maximum values for the Reflectance and Transmittance of any selected material. If this does not appear, close the Material Editor and open it up again.

This geometry has no materials associated with it (3ds files support mapping coordinates but not materials), so there is a separate material library saved with the materials for this exercise. In order to use this, in the Material Editor, click on the Get Material button (which is the leftmost button of the first row of buttons directly below the sample slots) and set the Browse From option to Material Library. Now hit the Open... button within the File section at the bottom left of the dialog and browse to the C07-01.mat file within the matlibs folder of the chapter07 tutorial content on the DVD. You should now bring each material into a separate slot by dragging them from the browser window onto the slots within the Material Editor itself.

Once you have done this, if you click through the various materials and look at their Reflectance values, you will see that none goes up beyond the 80% mark, which represents how real-life materials operate. The *whitePaint* material has the highest value, at 80%, which would be the real-world reflectance value of pristine glossy white paint.

When working with materials, you should not be too concerned when your material previews look too dark, in fact they should always look a little on the dark side. If they look correct in the Material Editor, then the chances are that they will distribute too much of the light energy they receive back into the solution and the render will appear washed out. The color balance of your final render, remember, will be corrected by the exposure control that we will set in a little while.

Likewise, when you have bitmaps allocated to your materials, you will need to dim them by reducing their RGB Level value in the Output rollout to compensate for the fact that these images have already been lit when they were photographed. An alternative way to reduce a bitmapped material's reflectance is to set the diffuse color of the material to black, and then reduce the diffuse map's Amount, within the Maps directory at the parent level. This will give them a proper reflectance range, in line with the values found in table 7.01 below:

Table 7.01 typical reflectance values		
Material	Minimum	Maximum
Ceramic	20%	70%
Fabric	20%	70%
Masonry	20%	50%
Metal	30%	90%
Paint	30%	80%
Paper	30%	70%
Plastic	20%	80%
Stone	20%	70%
Wood	20%	50%

Set your bottom-right viewport to the camera view and you should see that the camera is looking along the room with the windows on the right. Before we can go any further, you need to create some lights, the first of which in this case will be an IES Sunlight (found in the Photometric section of the lights), which should be positioned at X:-40m, Y:-60m, Z:85m with the target placed roughly in the center of the middle window. Change the Intensity of this light to 8,000lx.

You should now select all your geometry, go into the Material Editor and apply the material called *ceiling* to everything. This will give us a nice even tone to everything, to test our lighting setup and get everything looking right before we add materials. Open up your Render Scene dialog by hitting F10 and hit Render without changing anything. What you should get is an image consisting of almost pure blacks and whites.

Figure 7.09
With Radiosity turned on, direct
and indirect light will be rendered

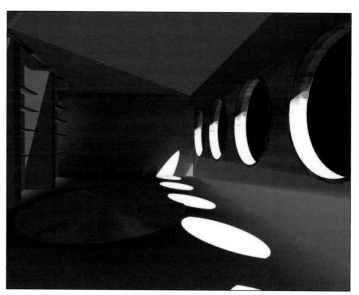

If you now turn on this light's shadows and set these to Shadow Mapped, rendering again will reveal an image that is almost entirely black. That's because the geometry is now creating shadows inside the room. Select the window object, apply the glass material to it and render again. What you will see won't look tremendously different, because the glass is still casting a shadow; to get round this you will need to change the light's shadow type to Advanced Ray Traced. With this shadow type, you need to specify whether transparent shadows are required, which they are in this case. Turn this option on by checking the checkbox for this feature in the Optimizations rollout of the light's controls.

When you've done this, render again and you will see pools of light appear within the room, as now the shadow type supports transparent objects. What you are seeing now is just the direct light only, as you haven't enabled the Radiosity Advanced Lighting plug-in yet. To do this, open up the Render Scene dialog again and go to the Advanced Lighting tab. Select Radiosity from the drop-down list, change the Initial Quality setting to 40% and hit Start within the Radiosity Processing Parameters rollout. With the default settings it should not take more than a minute or two for the solution to calculate. When this has calculated, hit Render again and this time you'll see that your scene is much more evenly illuminated. Though this looks a long way from a passable solution, you should be able to see quite clearly that the indirect illumination component is now being calculated.

In order to improve this solution, there are several things that we need to do. If you remember the first stage of how a radiosity solution is refined, you'll remember that the Initial Quality should be set to around 85%. Change this value accordingly. The next

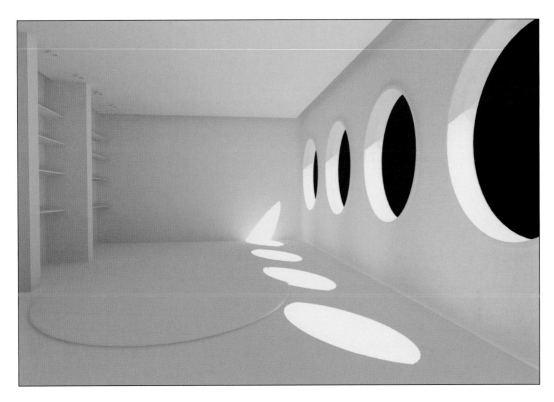

Figure 7.10
Logarithmic Exposure
compensates for the render's high
dynamic range

thing we need to change is the Refine Iterations, which are
currently set to zero. Change this to 2, for all objects and make a
clone of your last rendering using the Clone Rendered Frame
Window button in the top-left of the rendered frame before
calculating your solution again and rendering again.

Though your solution will take longer to calculate this time, you
should see a definite improvement in quality. You should see
several quality issues: the hard-edged faces of the geometry, the
light leaking where the floor meets the walls, and the unrealistic
contrast levels. The last of these three problems can be addressed
using the Exposure Control, which you should configure using the
Setup button in the same rollout.

Set this to Logarithmic, which is the best setting for renders with
high dynamic range: typically exterior shots and those featuring
the IES Sun light type. As ours falls under this category, change
the Brightness to 90 and leave the rest of the settings as they are.
You should see that your preview looks a lot more realistic. To
sort out the light leaking, back in the Render Scene dialog, you
should set the Indirect Lighting filter to 3 and the Direct Lighting
Filter to 2. To begin to address the geometry problems, within the
next rollout, you should turn on Adaptive Subdivision, change the
Maximum and Minimum Mesh Size settings to 0.5m and 0.05m,
and the Initial Meshing Size to 0.15m.

If you calculate this solution and render again, you will see that the solution is getting nearer to final quality. The big problem is the geometry, whose edges are visibly hard. Whilst the subdivision addressed this to a certain extent, it's the final set of refinement controls that will properly sort out this issue. Found within the Rendering Parameters rollout, the Render Direct Illumination option should be turned on and the Regather Indirect Illumination should be set, with Rays per Sample set to 150 and Filter Radius to 10.

If you recalculate the solution and render again, you will see that the lighting solution is now of very good quality. You'll no doubt notice the time that this solution took to render though, which is still the major downside of working with radiosity and why its use is most applicable to still image renderings, typically within architectural visualization. The next stage would be to open up the Material Editor and apply the different materials to the relevant parts of the model. However, it's probably easier to open the C07-01.max file that can be found within the Finished Versions folder on the DVD.

As the materials have changed, you'll have to recalculate the solution, so do this and render again. You should find that your output almost matches that of figure 7.11. There are a few differences between your rendered image and figure 7.11. One thing that does look less than satisfactory is the aliasing on the edges of the pools of light on the floor, which can also be seen in figure 7.10. This is a little jaggy around the edges and it's worth mentioning at this point how this is solved.

The Advanced Raytraced shadow type solves this in a rather unique way. There are in fact two ways to address the aliasing, but both can impact on render times so it's worth testing which one works best in terms of its quality against render hit if you plan on using this shadow type over any period of time. The first, and simplest, method to sort out this problem is to simply uncheck the Supersampled Material checkbox within the light's controls. This is found within the Antialias Suppression group of the Optimizations rollout. However, turning this feature off will certainly increase render times, and this will not necessarily deliver better antialiasing.

The reason for this is that having this option turned off will antialias with a 2-pass algorithm across the scene. However, with this option turned on, the 2-pass algorithm will only be performed on materials with Supersampling turned on and a 1-pass algorithm on those that do not have it enabled. In this case the shadows fall across the three materials of the floor, the rug and the yellow wall, so Supersampling would need to be turned on within these three materials for this 2-pass antialiasing to affect all of the shadows.

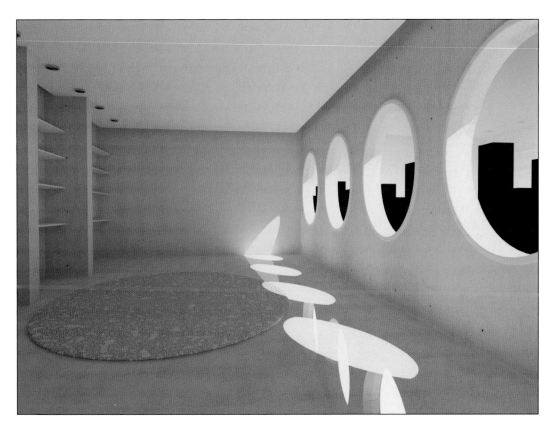

Figure 7.11
Your finished render should feature soft shadows and color bleeding

Similarly, the checkbox below this area within the Optimizations rollout switches between a 1-pass and a 2-pass algorithm when rendering reflections or refractions. This degree of control is one advantage that the Advanced Raytraced shadow type has over the regular Raytraced shadow.

With this complete, you should appreciate how simple it can be to set radiosity up, and having worked through its refinement options one at a time, you also should realize the rendering time that each of these steps entails. You should now try experimenting with this scene by adding some spotlights to the fixtures on the left of the frame, changing the materials and looking at the different Exposure control settings and seeing how they affect the final output.

8

'Architecture is the masterly, correct and magnificent play of masses brought together in light.'

Le Corbusier

Indoor lighting

Le Corbusier, like many architects, was fascinated by the role that light had to play in his buildings and was a master at using natural light to define spaces within and routes through his buildings. He would no doubt be captivated by how such computer-based visualization techniques as radiosity can represent accurately the light within an as yet unbuilt space, at any time of day or night. The interaction of light with form and space can be evaluated and accurate lighting data can be gleaned, which can be an invaluable tool in architectural design and specification of lighting components.

Over the last few chapters, we've covered several methods of portraying light indoors. From the simplicity of radiosity techniques to the comparatively drawn-out method of using colored fill lights to represent the light bouncing off the predominant surfaces of a scene, there are many ways to approach lighting indoor spaces.

Image courtesy of:
Fred Bastide
www.texwelt.net

What we're going to do in this chapter is build on what we've already learned with regards to working with Radiosity, the Light Tracer and HDR maps, as well as three-point lighting. We'll take these three techniques and discuss where they are best applied, and we'll also discuss a further global illumination technique; that of photon mapping.

We'll take a couple of examples and light them using each of these approaches, which will demonstrate which techniques have which advantages over the others. Through this exercise you will learn the value in production of all of these methods and this will teach you about when to apply each method, which is what this book is really about, not which buttons to press.

First though, a recap of these methods. We began this section with a discussion of three-point lighting, which is a very versatile, flexible and manageable approach. The careful placement of lights to represent not only the practical light sources in a scene, but also the bounced fills makes its setup a fairly involved and relatively complex affair, but the fact that this kind of setup can mean dealing with dozens of lights for even a simple scene is also part of its strength; once setup, the look is staightforward to tweak and, most importantly, keep efficient.

Figure 8.01

In the real world, light bounces around coloring its surroundings

The subsequent chapter saw us move on to further techniques, which culminated in using the Light Tracer. Whilst our use of this, the first of 3ds Max's Advanced Lighting modes, was for an outdoor scenario, this technique can equally be used for indoor

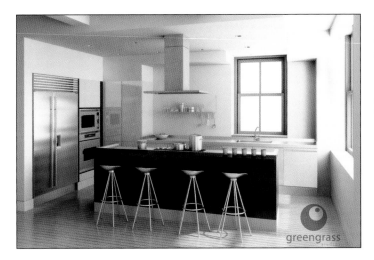

Figure 8.02
Radiosity rendering can produce
some beautifully soft lighting

Image courtesy of:
Jesse Sandifer
www.greengrassstudios.com

shots. It produces the soft shadows and color bleeding that light
bouncing around an environment introduces, but does so in a
way that is straightforward to set up, particularly when working
with HDR maps. However, this method can be render intensive
and finding workable parameters for the renderer that do not
flicker can be a frustrating and time-consuming process.

Following this, we moved onto radiosity, which is 3ds Max's
other Advanced Lighting mode. We discovered that whilst this
technique can produce some quite stunningly realistic imagery,
the subtle diffuse effects that it brings come at a fairly hefty price
at render time. Furthermore, the radiosity solution requires
calculation too. However, this technique is simple to set up and
can produce accurate lighting data, which is invaluable to those
working in and around architecural design.

Radiosity is just one method of rendering indirect light, which can
also be calculated using hybrid global illumination and photon
mapping algorithms. These methods of rendering can produce
startlingly realistic results, which can easily be confused with
photographs. Radiosity uses at its core an algorithm that
calculates diffuse reflection. The scene's surfaces transmit back
the light they receive into the scene, with subtle color bleeding
occurring between surfaces, as in real life.

Our final method is photon mapping, which is another global
illumination alogrithm. This is used by mental ray, which is
available within 3ds Max as an alternative to the scanline
renderer. This technique not only calculates a scene's global
illumination, it can also render caustics, something that is not
possible using any of the methods covered so far. Caustics are the
patterns of light that are generated when light reflects off a
surface like water, or passes through transparent objects like a
glass, as you can see in figure 8.03.

Figure 8.03
Caustics are caused by refracted
and reflected light

Image courtesy of:
Thierry Canon
thierrydare@9online.fr

These effects are possible using photon mapping, because mental ray's photon mapping technique covers specular reflections as well as diffuse inter-reflections. This method has the advantage of working independently from a scene's polygon count, though the photon map that is generated must be calculated for every render. Mental ray allows reuse of the photon map in subsequent renders, which is useful for things like fly-throughs, where the lighting does not change over the course of an animation. Photon mapping works by tracing photons emitted from a light through the scene being reflected or transmitted by objects until it strikes a diffuse surface. The photon is then stored in a photon map.

This will be covered in more detail in chapter 12, when we'll look specifically at this renderer in a lot more detail. The fact that specular reflections are taken into account with this method means that having effects like caustics and raytraced reflections and refractions, as well as global illumination effects, all within one technique is of obvious benefit. However, the downside to all of this is render time, which can be considerable.

So there you have it, four different techniques for rendering indoor scenes. Which one is best for which scenario will all come down to experience and judgment. Each method offers a compromise in terms of the time it takes to set up the solution and the ease of fine-tuning this solution to take on board any direction you might receive as part of a shot's approval process or general creative direction that you might have been given. Similarly, the overall aesthetic that you are trying to achieve might be better suited to one particular method than another. Last, but certainly not least, the all-important time that a shot or image takes to render will be a sizable consideration for any production.

Outdoor light indoors

Armed with the knowledge you've now built up over the last few chapters, you should be pretty comfortable with approaching the way in which outdoor lighting works indoors. We'll cover outdoor light in more detail in the next chapter, but for the moment this can be thought of as a gentle introduction to this kind of light.

When working with standard lights, having established the time of year, day and geographic location, you should begin to think about the color balance of your scene and the bearing this will have on the coloring of your lights. Just because a scene is set indoors, it does not automatically mean that you should automatically choose tungsten-balanced film. If the dominant light source in a scene was entering the set from the outdoors, then daylight-balanced film could and generally should be used. With this in mind, the changes in the color temperature of the sun's light throughout the day should be kept in mind and table 2.01 (see p.13) referred to. Remember: if the color temperature is lower than your chosen balance, the light will appear more yellow; if it is higher it will appear blue tinted. Also, the changes in the color of the sun's light should be examined, and cloud cover and weather conditions would also affect this color.

These kinds of shifts in the sun are closely controlled in cinematography through the use of colored filters called gels, which are placed over artificial lighting, or over openings like windows to ensure that the direct sunlight is of a consistent color. In the virtual world of computer graphics we may not have to battle with these changes in light, but we do on the other hand have to simulate these subtle changes of time.

Figure 8.04
Many different colored filters and gels are available to control color (www.rosco-ca.com)

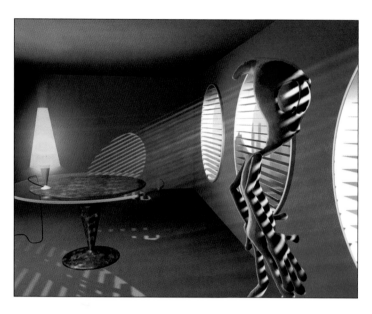

Figure 8.05
Venetian blinds can emphasize the 3D nature of a subject

Cookies and gobos

In the world of cinematography, just as gels can be mounted directly onto the front of a light, so too can gobos (or go-betweens) and cookies. These are simple rectangular panels of metal or wood with patterns cut out of them to break up a light or shape its form into a pattern.

In CG we can either place a physical object in front of a light to break up its shadow, or use a projector map, which acts exactly like a cookie. Whilst placing an object in front of a light will invariably produce more accurate shadows, as a result this can take a lot longer to render, especially if raytraced lights are used. However, if you've set up a visible object to move, like a tree swaying gently in the wind, using the object to create shadows would probably be the easiest option.

Often, generally because of render times, the use of projector maps is preferable over the use of shadow casting objects, especially if the camera cannot see the window through which the light is shining. When working on indoor scenes, a projector map is most likely to be of a tree's foliage or of blinds, and as these bitmaps are rectangular, it does make sense that your projection light be rectangular too.

Breaking up a scene's key light like this can be a very effective way of giving a scene much more visual detail than it actually has. It's worth remembering that light passing through objects such as trees, whose leaves are semi-transparent, will pick up a light green tint as a result, which will again add a further level of subtle detail to the lighting scheme.

Figure 8.06
Breaking up a key light with a
projector map can be effective

Likewise, blinds can add a great deal to a scene visually. Part of
the reason why the horizontal striping of venetian blinds is so
popular in CG is that the shadows that this throws into a room
actually help to identify things as being three-dimensional, as the
straight lines of the shadows curve round organic objects,
emphasizing their forms.

Not only do the shadows cast into a room by things like foliage
provide interior detail, they actually give the viewer valuable clues
about what lies outside of your immediate scene, and this can
help to build atmosphere and link locations. Similarly, there are
many other objects that can be placed outside windows to give
us clues to a location, set a mood and add to a scene's lighting.

Flickering neon signs have been used time and time again in
films, particularly those involving private detectives it seems, to
give the scene grittiness and a recognizable sleazy location. If
your animation requires this kind of mood, then taking a cue from
this kind of movie can provide this atmosphere whilst giving you
the opportunity to introduce some interesting lighting. We'll take
a closer look at designing neon lights in chapter 10.

Similarly, car headlights passing by a window can help build
suspense by momentarily lighting up a dark scene, or can provide
a shock or a clue by revealing something previously hidden in the
shadows. Visual clues are provided as to what is offscreen, and
the roadside location could again impart a certain grittiness.
Again, this kind of animated lighting can provide an interesting
yet simple visual effect that helps to emphasize the three-
dimensional nature of your production, as the lights and shadows
crawl over the scene's objects.

Finally, stained glass can easily be created in CG, which perhaps explains why we see so much of it. This is another simple effect that furnishes a scene's lighting with depth and detail. A semi-transparent surface will impart its colors to raytraced light shining through it, which is how stained glass is most easily achieved.

Volumetric lighting

Stained glass brings us on nicely to our next subject, volumetric lighting, as the two effects are often used together to impart a suitably old and dusty atmosphere to castles, churches and so on. This effect occurs in real life when light interacts with particles in the air, like fog, smoke or dust. Once a light has been specified as being a volume light, the light will act like one, and the skill in creating realistic looking volume light is in being able to craft these particles convincingly.

This principally involves understanding how to use noise to be able to recreate these different types of particles, which is an important skill in almost all atmospheric effects, vital for fog, smoke, clouds and so on, but equally central to underwater scenes, where the water's particulate matter gives it substance.

Volumetric lighting can be a reasonably render-intensive process, so understanding how to squeeze the most out of this type of light is important and like most things is something that will come with experience.

Figure 8.07
Volumetric lighting can be used to impart an old, dusty atmosphere

Image courtesy of:
Musa Sayyed
www.musa3d.com

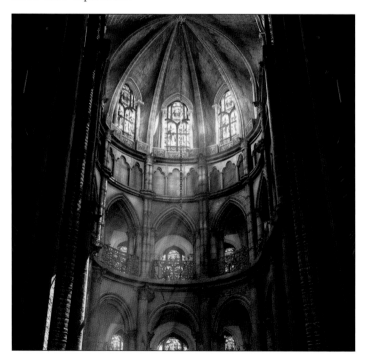

Tutorial - radiosity techniques

We'll start our attempts at indoor lighting with radiosity for a couple of reasons. Firstly, as you have just completed a tutorial on radiosity workflow it's a good opportunity to build on this knowledge while it's fresh. Secondly, and more importantly, using radiosity will give us a benchmark image to try and replicate using three-point lighting.

Open up C08-01.max from the DVD. You should see that the scene is a variation on the one from the last chapter. If you had time to experiment with this last tutorial you may have come up with something similar. If you didn't, then this should go some way to showing how easily done this is. The room is the same size, but some furniture has been added and the windows have changed. As well as these additions, the around camera position has changed, as have some materials.

If you remember from the last section the three refinement stages, you should have little problem getting this scene looking good by just making some quick changes within the Advanced Lighting tab of the Render Scene dialog. Once you have worked with several radiosity scenes, you'll soon get an idea how simple this workflow actually is. It works very effectively as a two stage process. The first stage, which gives you a preview of how the illumination within the room is shaping up consists of setting every thing bar the final regather stage.

Enable the Radiosity Advanced Lighting plug-in and within the first rollout set the Initial Quality to 85%, the Refine Iterations to 2 and the Indirect and Direct Lighting filters to 3 and 2

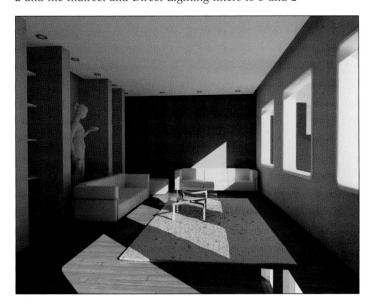

Figure 8.08
The scene from the last chapter has been reworked for a different look

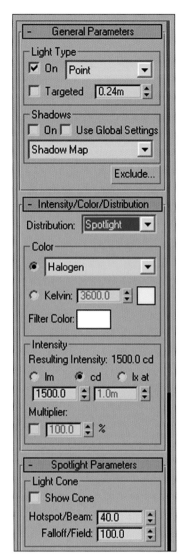

respectively. Also within this first rollout is the Exposure Control, which should be set up as per the last tutorial, with the Logarithmic option selected and the Brightness set to 75. Within the next rollout, enable Adaptive Subdivision and set the Maximum and Minimum Mesh Sizes to 0.5m and 0.05m, the Contrast Threshold and Initial Meshing Size to 75 and 0.15m.

This would give you a preview that is reasonably quick yet also reasonably accurate. The final stage would be to turn on the final gather settings, but that would up our render time dramatically. A quick render will show you that the room is looking well enough lit from the single light source that we have. To make things a bit different from last time around, we are going to move the clock forward to the evening, so first of all change your Environment to the *environmentNight* one that's in the Material Editor. This will give us a much more dusky look outside the window. Next, right-click in a viewport and choose Unhide by Name from the top-right quadrant, and unhide the *blinds* object. Select the light that represents the sun and bring its Intensity down to about 6000lx and change its color to a slightly more saturated orange/yellow that would represent an evening sun.

Finally, we'll add some lights to the light fittings that run around the two edges of the ceiling. Within the Lights panel, go to the Photometric drop-down and select the Free Point light type. In the Top viewport, click to place one of these lights. Now use the Align tool to place this light at the center of any one of the light fittings along all three axes. Within the light's controls, change the Distribution to Spotlight, the color to Halogen and leave the Intensity as it is. Alter the light's Hotspot/Beam and Falloff/Field values to 40 and 100 respectively

Figure 8.09 (above)
Your light's distribution should be changed to Spotlight

Figure 8.10 (right)
Without shadows, your objects will look somewhat detached

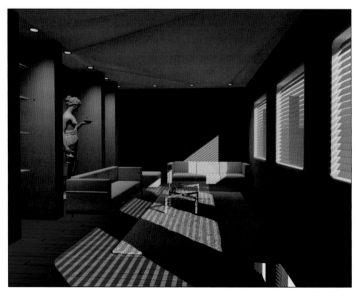

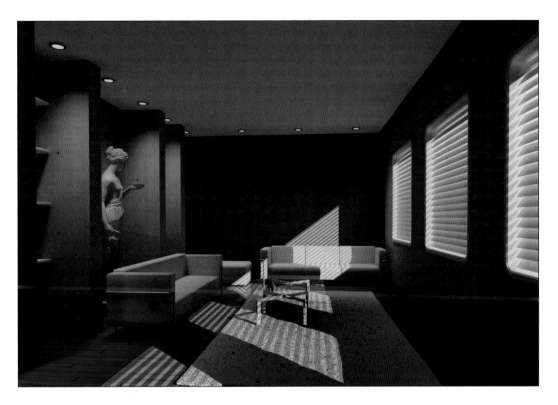

Figure 8.11
Our radiosity scene is easily relit
from day to evening

You should now clone Instances of this light that are centered on every one of the twelve light fittings recessed into the ceiling. If you recalculate your radiosity solution and render now, you should see that your scene is looking like a reasonably convincing evening interior. One thing that is lacking are shadows on these new lights, and the left-hand side of the render, the sofa in particular, seems somewhat detached from the scene, as figure 8.10 demonstrates.

To sort this out, turn on shadows on one of these lights (the fact that they are instances means that shadows will be turned on for every one) and set the shadow map size to 512 and the Sample Range to 8.0. Render again and you should see that everything sits together a lot more comfortably.

This should give you a very good idea of what your final render is going to look like. If you now turn on the Regather Indirect Illumination option and set the Samples to 150 and the Radius to 10, your render should look similar to figure 8.11 above.

You should now have some idea of how straightforward rendering with radiosity is. You should also have a very good idea of how long render times are. However, we now have two images to use as guidelines for our next exercise, where we will attempt to recreate these looks using the three-point lighting techniques that were introduced at the beginning of this section.

Tutorial - simulating global illumination

So now we have a radiosity reference to work towards, let's attempt to take this scene and build up a three-point lighting scheme that produces the same look, but using standard lights. To be able to compare your renders with this reference image, open up the RAM Player, found under the Rendering menu. Now, in Channel A, open the TIF file located within the images folder.

First of all, discard your radiosity solution by opening up the Advanced Lighing tab of the Render Scene dialog and change the drop-down from Radiosity to No Lighting Plug-in. In Rendering > Environment, change the Exposure Control from Logarithmic to Linear, which is far better suited to images of lower dynamic range, like those using standard lights. Now turn off all of your photometric lights from the last exercise.

We'll start with our key lights, of which we have many. There's the sun and the halogen spots, so we'll start with the light respresenting the sun. For this, place a Target Direct light and align it with your photometric IES Sun light. Similarly, align the two targets. Give the light a Multiplier value of 2.5 and the same color as the previous light: R:255, G:225, B:165. Within the Directional Parameters rollout, set your Falloff to 4.0m. Rename this light *directSun*. If you now right-click one of your viewport labels, then pick Views, you should be able to select this light from the list. Having done this you can see that the light's cone is tight to the four windows, as in figure 8.12. This means that the raytraced shadow calculations to come won't be inefficient. Turn the shadows on and set them to Advanced Ray Traced. Turn Transparent Shadows on in the Optimizations rollout, as we did in the last exercise.

Figure 8.12 (above)
Your light's cone should be tight to the four windows

Figure 8.13 (right)
With your key lights placed you have just the direct illumination

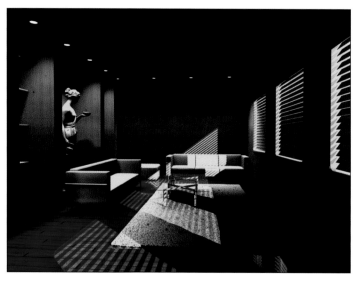

Similarly, for the spotlights that run along the two edges of the ceiling, create a Free Spot anywhere in the Top viewport. Align this with the corner spotlight and give it a Multiplier value of 0.75 and a color of R:255, G:247, B:203. Turn on shadows and set your shadow map Size to 512 and Sample Range to 15. To lighten and open up your shadows a little, set the Object Shadows Color to R:14, G:9, B:0 and the Density to 0.9. Set the Hotspot and Falloff values to 40 and 100 respectively. Finally, you should turn on Inverse Square decay and set the start value to 1.5m. If you render now, you should see something like figure 8.13, with just the direct light from these key lights. If you look at the shadow formed where the shelves meet the pillar, you will see that the shadow has a slight gap to it. To correct this, bring your shadow Bias down from 1.0 to 0.0.

Now for your fill lights, the first of which will represent the light bouncing up off the pools of sunlight on the floor. Place a Target Spotlight in the Top viewport so that it's pointing in the same direction as your *directSun* light. In the Left viewport, alter the position of the light and its target, so the angle it makes with the floor is the same angle that the *directSun* light makes with the floor. Give the light a Multiplier of 0.3 and a color of R:253, G:237, B:216. This light should not have any shadows set and it should also have its specular component unchecked (in the Advanced Parameters rollout) as should every fill light, as this kind of light has a negligble specular component. Within the Spotlight Parameters rollout, set the light's Hotspot and Falloff values to 7 and 70, specify a rectangular cone, then give it an Aspect of 4.0. This stretches the light's cone along the length of the room. You'll need to set a viewport to look through this light and use the Roll Light control in the bottom-right corner of the UI to roll the light to the correct angle with the room. Rename this *directFillSun*.

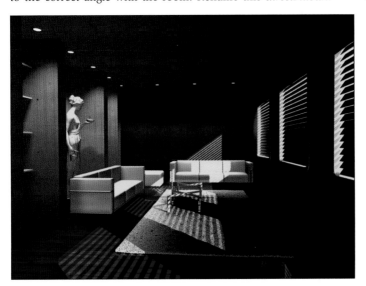

Figure 8.14 (top)
Use the Roll Light tool to roll the light to the appropriate angle

Figure 8.15 (middle)
Use the RAM Player to compare your renderings with the reference

Figure 8.16 (left)
Your first fill light should begin to open up the left side of the image

We'll now add another fill for a general bounce off the floor. This should be another spot, placed centrally to the floor at Z:-8m. Give it a Multiplier value of 0.1, a brown color representative of the floor, R:76, G:47, B:10. Give the light Hotspot and Falloff values of 30 and 60 respectively and change the cone to rectangular, with an Aspect of 3.0. Again, turn off the specular component of the light and rename it *spotFillFloor*.

At this point, you will have to tweak your material settings a little; your ceiling is too dark, so change its Diffuse color to R:230, G:227, B:220. Within your *concrete* material, within the Diffuse channel, change the RGB Level value, within the Output rollout, to 0.9. Your render should now look something like figure 8.17.

Next we'll create a fill light that represents the light bouncing down from the spotlights on the left, towards the windows and floor. For this, create another spotlight, positioned at X:0m, Y:15m, Z:8m and with its target placed at the top of the central window frame. Rename this *spotFillLeft*, give it a color of R:253, G:237, B:216 and a Multiplier of 0.15. This should have a Hotspot value of 30 and a Falloff value of 40, keeping its effect quite local to this area. It should also be made rectangular and given an Aspect of 3.0. Once again, turn off the Specular component.

If you render again, you'll find that the shadowy area from the rug to the windows is too dark, so we'll add another fill light, representing the light bouncing off the ceiling. The light, renamed *spotFillCeiling*, should be placed around X:0m, Y:8m, Z:13m with the target placed where the floor meets the wall underneath the center window. The light should have a Multiplier of 0.2 and have a bright orange color, something like R:249, G:182, B:96.

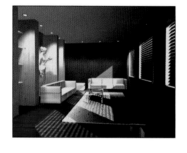

Figure 8.17 (above)
Your second fill also represents the light bouncing up off the floor

Figure 8.18 (right)
Your fills should begin to gradually open up the scene's illumination

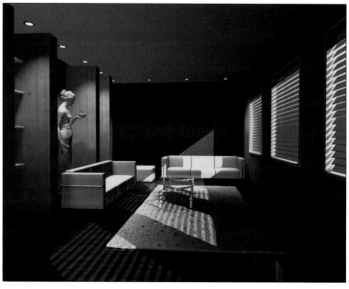

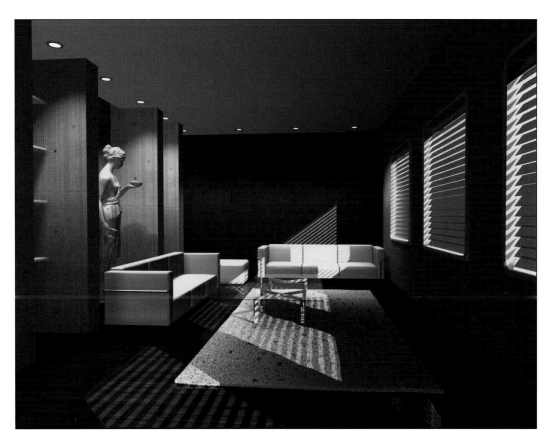

Like the last fill, this should have Hotspot and Falloff values of 30 and 40 respectively and be a rectangular cone with an Aspect of 3.0. It should also have its Specular component unchecked.

Figure 8.19
Your final fills add a subtle amount of blue and yellow color bleeding

Your final fill light that's positioned below floor level is another spot. This should be created somewhere around X:0m, Y:16m, Z:-8m. Rename this light *spotFillFloorLeft* and target it slightly to the right of the ceiling's center, as seen through the camera. This should be given a Multiplier value of 0.1 and a color of R:255, G:236, B:190. Its Hotspot and Falloff values should be again 30 and 40; it should once again be rectangular with an Aspect of 3.0. With this in place your render should be starting to take shape and should look something like figure 8.18.

Now for the fill light that represents the light bouncing back off the far wall in the scene and back towards the camera. This light will be given a saturated blue color, as it is bouncing off a brightly colored wall. It is this light, and the subsequent one that we will place behind the yellow wall that will give our render its radiosity look, and will introduce some color bleeding between the adjacent surfaces, most noticeably along the edges of the ceiling. The first one of these then will again be a spot, positioned centrally to the

wall, but behind it at X:13m, Y:2.5m, Z:1.5m, with its target placed centrally to this far wall. It should be given a Multiplier of 0.25 and a pure blue color of R:0, G:0, B:255. Rename this light *spotFillBlue*. The cone of this light should be set to rectangular with an Aspect of 1.5 and given Hotspot and Falloff values of 30 and 40 respectively. What we do need to give these lights is realistic decay, or else the blue bounced light is going to be applied across the scene and we want the effect to only be local to the wall. Set the decay type to Inverse Square, starting at 7.0m and turn on the Use Far Attenuation, setting the Start and End values to 7m and 15m.

Similarly, for the light representing the bounced light from the yellow wall, place another spot at X:0m, Y:16m, Z:0.5m with its target on a vertical level with the ceiling, directly above the statue. This should have a Multiplier of 0.2, a pure yellow color and should use Inverse Square decay, starting at 10m. Set the Far Attenuation to Start at 11m and End at 15m. The Hotspot and Falloff values should be set to 30 and 40 respectively and the cone should be set to rectangular with an Aspect of 3.0.

Your lighting is getting very close to looking like a radiosity render now, and there are a few material tweaks that we will need to make to address a few problem areas. The rug's RGB Level should be set to 1.0 within the Output section of the Diffuse channel. The whitePaint material should have a Falloff map applied to its Self-Illumination channel, which should be set to Fresnel and given a value of 20 back up at the top level of the material. Similarly, our blinds should be given a Self Illumination value of 10, as these would be glowing more from the direct sunlight that is hitting them from behind.

Figure 8.20

Your gradient ramp should run along the top edge of the wall

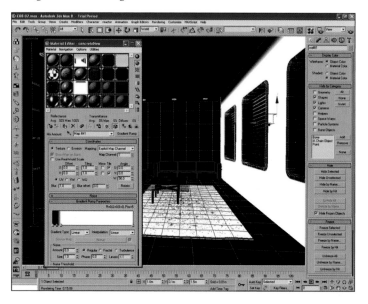

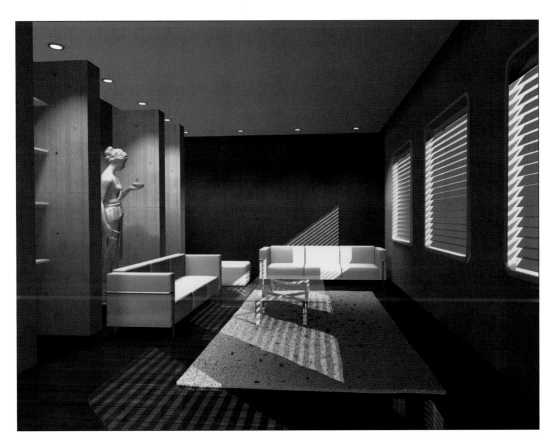

Figure 8.21
Your finished scene should look like a radiosity rendering

Comparing your latest rendered image with your initial radiosity reference image, you can see several differences. The recessed areas around the edges of the ceiling are not as shadowy as they are on the radiosity render and the materials, particularly the sofa's leather material is not as realistic looking as the radiosity version. Most of these details are now addressable via the materials themselves. We'll take a look at the different wall materials and see how easy it is to fake a bit of shadow via the material itself. Open up the Material Editor and drag a copy of the concrete material to another preview slot and rename it *concreteNew*. Apply this new material to the right-hand wall.

Navigate to the Diffuse Color level and click the button labelled Bitmap below and to the right of the preview slots. Choose Mix from the dialog that appears and make sure you keep the old map as a sub-map. Now drag the concrete.tif from the Color#1 slot to the Color#2 slot and choose Copy. Click the Mix Amount slot and choose a Gradient Ramp map. Type 90 in the Angle W field to orient this map horizontally. Add a flag by clicking on the Gradient Ramp and move this to position 10 and give this a white color. If you turn on the Show Map in Viewport button in the Material Editor, you will be able to see where this map is going.

You should see a black stripe running along the top edge of the wall, where you want to darken the material, as in figure 8.20. You might have to temporarily make your material 100% sef illuminated to see this map displayed in the viewport.

Now you should go back up a level in the material and into the topmost slot, the Color#1 slot. Down at the Output rollout, change the RGB Level to 0.45. If you render now, you will see that this material change fakes this shadowing very well. You should repeat this process for the yellow and blue walls, so that this effect runs right round the recessed portion of the room. We'll attempt this with mental ray in a short while, after a quick discussion about outdoor light.

Tutorial - HDR lighting

The HDR files used in this tutorial were kindly provided courtesy of Sachform.

These images are part of the company's URBANbase collection, which features 40 fully spherical HDR maps at a resolution of 4,000 x 2,000.

www.sachform.com

For this tutorial we're going to do two things. First we are going to take a brief look at lighting an indoor space with HDR maps. This is by way of familiarizing ourselves with this technique before we move on to rendering out HDR maps from Max and using these to relight existing scenes. First then, open up C08-02.max from the tutorials folder of the DVD. You will see our by now familiar venus statue and little else, apart from a camera.

First of all, create a Skylight in the Top viewport. If you go to the Render Scene dialog and within the Advanced Lighting tab; change the plug-in to Light Tracer, you should be able to render straight away and get nice soft shaded results. However, with the light selected, hit the Map button and navigate to select the hdri-38_color.hdr map. When you press OK after selecting the map, a dialog will pop up displaying the HDRI Load Settings. Set your White Point so that you just have pink spots where the sunlight's brightest area is. This should happen at about 2.0 (within the linear field), as in Figure 8.22. Make a note of this value before checking the Black Point checkbox and set the Black Point so that you have very few cyan patches, around about -7.1 (within the log field this time). OK this dialog and click Open.

Now open up the Material Editor and drag this map from the light's rollout to a blank slot. Within the Coordinates rollout, you'll need to change from Texture to Environment and select Spherical Environment from the drop-down. Within the Output rollout, you'll need to set the RGB Level field to match whatever value you had in the White Point (linear) field from the HDRI Load Settings dialog, which should have been around 2.0. Rename this material *environment* and open up the Rendering > Environment menu. Now you should drag the map from the Material Editor onto the Environment Map slot. To see this in your viewport, with the Camera viewport active, choose Views > Viewport Background and check the Use Environment Map

Figure 8.22 (left)
Your camera view should match your background image

Figure 8.23 (below)
Your HDRI Settings ensure correct use of the full luminance range

checkbox and the Display Background checkbox. Once you have done this, you should be able to see the image in your camera viewport, but this won't look totally correct and you'll see a small cropped portion of this map.

Set your Output Size within the Common tab of the Render Scene dialog to 640 wide and 1,000 high. Now right-click the cameraRender viewport label and choose Show Safe Frame. You'll see more of the background, but you'll also see that the perspective looks wrong. That's because the scene has been set up around a HDR image that's has had its offsets altered, so in order to match this, change your U and V Offsets for this material (within the Material Editor again) to -0.27 and 0.04 respectively. Your view should now match what you see in figure 8.22 above.

If you were to render now, you'd get a perfect match between your lighting and your background, but you'd be sampling light from a 4,000 x 2,000 pixel image and one with very high variations in luminance over very small areas. What is a much better idea is to produce a far smaller and more blurry version of this image so that sampling problems and render times will be reduced. (This is one of very few situations where something will reduce sampling problems and render times, usually the trade-off works as one against the other).

Within the Material Editor, drag a copy of the *environment* map onto an adjacent slot and rename this *environmentBlur*. You should now, within the Bitmap Parameters rollout, change the map from the hdri-38_color.hdr file to the hdri-38-blur_color.hdr map. By doing this, you won't need to re-enter your coordinate values, White and Black Point settings and RGB Level settings.

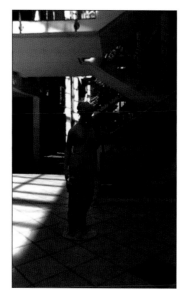
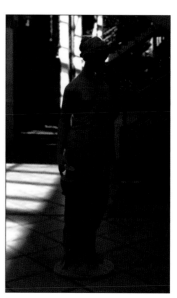

Figure 8.24 (right)
Your reflections should be weaker
on the surfaces facing the camera

Figure 8.25 (below)
Your Mix Curve can be altered to
edit the effect of the falloff

This version of the image is a mere 200 x 100 pixels and will work a lot more efficiently with the skylight. Drag this map from the Material Editor onto the Map slot of the skylight's controls and make sure you check the Map checkbox. Render now and you should find that your subject's lighting matches the background pretty well. It's quite dark though, so change the RGB Level on the *environment* and *environmentBlur* maps to 4.0.

This is the beauty of HDR lighting, you can control the overall lighting method very quickly. There are several more things that we can do to add some more convincing detail to this image. Firstly, as we have a spherical map of the scene, we can apply reflections to our objects that will match our environment and our lighting. Within the Maps rollout of our *venus* material, click the empty slot next to Reflection and choose Falloff. Choose Fresnel as the Falloff Type and drag your *environmentBlur* map onto the bottom of the two slots labeled None, immediately above this drop-down. Choose Instance.

The Fresnel falloff type restricts the reflections of surfaces facing the view, and gives much brighter reflections on angled faces, creating highlights like those on the sides of a glass, which is perfect for this scenario. To boost this effect, you should scroll down to the Mix Curve rollout, use the Add Point button to click and add a point anywhere along the curve. Two buttons to the left is the Move tool, which you should use to move the point down and to the right. If you right-click the point, you can choose Bezier-Smooth and adjust the point's handles to produce a smooth Mix Curve like the one picured to the left. You should reduce the Reflection amount from 100 to 50 within the Maps rollout, at a level above this.

To fake a little extra backlighting from the glazed areas behind the statue, we can place a falloff map in the Self-Illumination slot of the material. Again, you should use Fresnel as a falloff type, with the Mix Curve to curve adjusted this time upwards and to the left, and the amount reduced within the Maps rollout to 25. The statue still looks a little dark, so to adjust this, use the Exposure Controls, setting the Exposure type to Logarithmic. You should find that a Brightness value of about 45 gives you the right level of brightness.

As you can see, this scene requires no shadows, but if you did require them, you would need to set them up separately. One way of quickly visualizing where your shadows would come from is to place a sphere in the scene and apply the HDR map to it. Within the Display panel, pick Unfreeze All and you should see a sphere appear. This has the hdrPreview material applied to it, which uses the hdri-38-blur_color.hdr file, but within the texture map channel rather than as an environment.

You can see quite clearly now within the Top viewport where the sun should be located relative to the HDR maps. To place some shadows, unhide the *planeShadows* object. In the Material Editor, click the slot labeled Standard of an unused material and choose Matte/Shadow. Check Receive Shadows and apply this material to the *planeShadows* object.

Create a Target Direct light with a Multiplier of 1.0, placing the target at the statue, and the light itself outside the sphere, looking through where the sun spot is on the HDR map. Turn on shadow mapped shadows and within the Shadow Parameters rollout, change the Color to R:97, G:97, B:84 and set the Density

Figure 8.26
Applying your HDR map to a sphere helps you position the key light

to 0.1. In the Shadow Map Parameters, set the Size to 128 and the Sample Range to 16. Change a viewport to look through this light and adjust the hotspot and falloff values to bring the cone tight to the statue. You should choose rectangular and adjust the Aspect to 0.4 to make the cone taller than it is wide.

Render now and you'll see a patch of shadow at the base of the statue, which doesn't look quite right. Let's use a bit of artistic license and have the shadow falling right to left. Move the direct light, which you should rename as *directKey*, to X:-8,000, Y:700, Z:13,000 and render. Your shadows look better, but your light has introduced unwanted illumination of the subject.

In order to correct this, we'll use a negative light, which is something that was mentioned in chapter 4. If you can remember back to this section, you will know that this process is quite simple. You should simply clone a Copy of your shadow casting light and give its Multiplier value a negative value, which in this case would be -1.0. Now you should turn off shadow casting for this light and this will cancel out the illumination of the first light without cancelling out the shadows. You should rename this light *directKeyNegative* and render again. This will give you nice shadows that are so sublte as to be barely noticeable, but it's these small details that really do start to tie a CG element into its background and add to the believability of the render.

The main use of the HDR map in an indoor scenario is when these HDR maps have been captured as part of a live-action shoot. In this type of situation you've got a pretty straightforward way of going most of the way to matching your lighting and reflections into your live action plate. However, it's often not

Figure 8.27
HDR provides an easy way of matching lighting and reflections

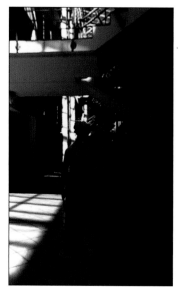
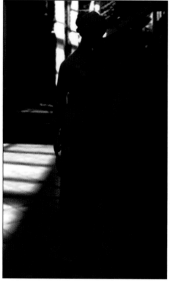

possible to assemble an interior CG shot and use HDR lighting. We'll discuss more about HDR in the next chapter, as its use is much more applicable to outdoor situations. However, what is quite useful within 3ds Max is to use the Panorama Exporter utility to export out a spherical image of your scene, which can be used as a map for quick rendering reflections, or reused as a map for lighting scenes in the future.

To demonstrate this process, you should load the C08-03.max file and under the Utilities panel, open up the Panorama Exporter utility and click the Render button. You'll now get a dialog similar to the Render Scene dialog. You should specify a fairly big map, 4,096 x 2.048 would be good, but we'll go for 2,048 x 1,024 in this instance. You should set your Aperture Width to the same settings as your camera, so 28mm.

You can hit Render at this point to see the process, but you could also use the Viewer button and navigate to the C08-03.hdr file that has already been rendered out if you would rather not wait. As you can see, you can view the full 360 degrees of this image, and if you choose File > Export > Export Sphere, you can save out a spherical map. If you choose HDR as the file type, you should choose the first option - Use Non-Clamped (RealPixel) Color Channel - as this is what 3ds Max's scanline renderer uses, though the second option is available when using mental ray, which supports floating-point output.

If you now apply this image as your Environment map, set to Spherical of course, you'll find that your image will almost match your scene once the U and V offsets have been set to 0.265 and -0.006. Set the U tiling to -1.0 to correct the fact that the

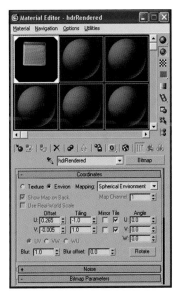

Figure 8.28 (above)
Set your coordinates for the HDR map to match the scene

Figure 8.29 (left)
Your HDR map will match your scene as the environment map

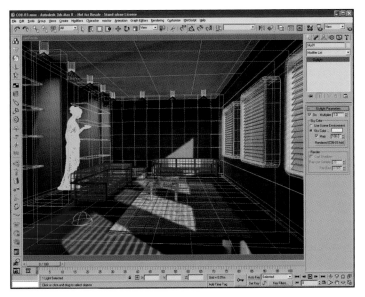

panorama export seems to output a spherical image that is flipped horizontally. Go to the Render Scene dialog and set the Advanced Lighting plug-in to Light Tracer. This will disregard the Radiosity solution and bring your original mesh settings back. If you set the camera viewport to wireframe and turn on Show Safe Frames, which is found by right-clicking the camRender viewport label, you should find that the image matches the geometry exactly.

Now turn off all of your scene's lights, then select all of your geometry bar the venus statue, making it all non-renderable by choosing Edit > Object Properties and clearing the Renderable checkbox. Add a skylight and assign a copy of the HDR map to it, so that you have one copy of the map assigned to the Environment and another assigned to the Skylight. Change the output of this version of the map to 1.5. Finally, change your Exposure Control settings to Linear and alter the Brightness setting to 58 before rendering.

As you can see, this is a reasonably good match - it's never going to be perfect, but if you were to render out a very high-res version of this map, you could then relight your scene by assigning the map as your Environment map and changing the RGB Level of this map. However, there is one extra thing that we need to do to make this method work properly with the methods described so far. We've used the scanline renderer and in order to get floating-point output from 3ds Max, we should really be using mental ray as a renderer. As it is, the HDR map we've just generated doesn't have enough latitude in its luminance range to have its levels changed too drastically. We'll get to the process of rendering with mental ray in chapter 12.

Artificial lighting

When you are working with standard lights and three-point lighting, as the majority of us dofor the majority of the time, learning how to represent the different forms of artificial lighting, whether used indoors or outside, is a very important skill. It is also often a tricky one and one that needs more attention than you might initially think. This is principally because our perception of the varying bulb types is quite different from how they appear when filmed. As we've already touched upon, fluorescent lights can appear slightly green on film, but look white to the naked eye.

The same kind of variations apply to metal halide lights, though this kind of lamp is much more unpredictable from bulb to bulb and can appear from blue-green to blue to white. The only lights that appear the same on film as they do to the naked eye are sodium-based bulbs, which look yellow-orange. As we're lighting for CG, the way in which things appear on film is arguably the most relevant, so this is what should be aimed for. You should

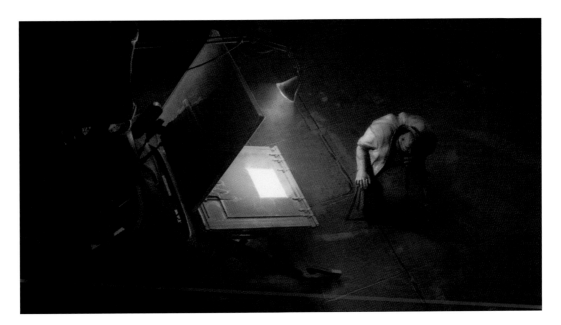

always consider what your desired color balance is and use table 2.01 (see p.13) to decide how the source you're about to model will appear relative to the color balance you've chosen.

The actual placement of lights to work within physical fixtures might not seem that difficult, you just place your light where the bulb would be in the fitting, don't you? Well, the simplest solution is often to do just this, but as with most things in CG, what's easiest is not always what's best. As we've already discovered, generation of shadows is the most computationally intensive part of rendering a light, so this might not be the best option. Placing spotlights with their cones limited to fit to the geometry of your fitting can be the best option, and though you may need several lights to take the place of a single shadow casting source, the resultant render times can mean that this extra effort is well worthwhile.

Figure 8.30
Learning how to represent artificial lighting is an important skill

Image courtesy of:
Platige Image - 'Fallen Art'
www.fallen-art.com
www.platige.com

Tutorial - artificial lighting

In this tutorial you will look at setting up a relatively simple artificial lighting fixture, examining how different methods can yield equally satisfactory results, but as usual with varying render times. You'll look at using physical geometry to cast shadows, then you'll build up a better solution that consists of several lights all serving different purposes. Open the C8-04.max file from the tutorials folder of the DVD. You will see a bedroom scene complete with a bedside lamp on a table at the far end of the room. To begin, select the *lampBedside* object. As you can see, this is a very simple tabletop light fixture.

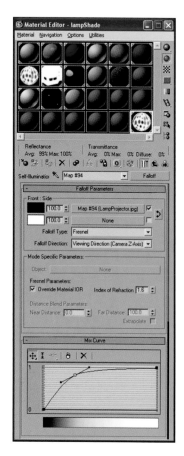

First of all then, place an omni light centrally to the lampshade, about a third of the way up the shade, roughly where a light bulb would be located in this fixture. This represents a standard household bulb, which is generally tungsten. According to table 2.01 (see p.13), this has a color temperature of 2,865 °K. This scene would likely be filmed on tungsten-balanced film, which is color balanced for 3,200 °K. The fact that the tungsten light source has a slightly smaller color temperature means that it would appear as a slightly yellow light on this type of film - refer to figure 2.05 on p.14 if you need to remind yourself of how this works.

Choose a suitably subtle yellow tint for the light's color, turn on shadows and make sure the shadow type is set to Shadow Map. With a Multiplier value of 1.0, render and you should see that though light is cast through the top and bottom of the shade, these results are short of convincing: the overall illumination around the lamp is poor; the spots on the ceiling and floor are too well defined; and the lampshade itself should be brighter.

A far more realistic solution comes from splitting this light's illumination into several components. First, the general illumination that would emanate from this light is best represented by an omni, and seeing as we already have one in place, let's start here. Select the omni light you've just created, rename it *omniLamp* and turn off Cast Shadows. Set the Decay type to Inverse Square and set the Start value somewhere around 225, so you get a subtle pool of light on the ceiling. Now turn on Far Attenuation and set the Start and End values to be 300 and 550 respectively. In the Material Editor, find the *lampShade* material and within the Maps rollout specify a Falloff map within the Self-Illumination slot. Change this to Fresnel and alter your curve to

Figure 8.31 (above)
Set your self illumination falloff type to Fresnel and edit the mix curve

Figure 8.32 (right)
Set your decay to start at a value where it gives you subtle results

bend upwards and to the left, as shown in figure 8.31. Within the topmost of the two blank slots above the Falloff Type drop-down, add a Bitmap and choose the LampProjector.jpg. Change the bottom color swatch to black. This will give you a little less self illumination on the sides of the lampshade.

As the light stands, its Attenuation is completely spherical. Using the Non-uniform Scale tool, scale the light down to 80% along its local Z axis so the light does not reach the ceiling and scale again by 130% along the light's X axis, and 130% along the Y axis, so that the illumination reaches the far walls whilst leaving areas of lesser illumination in the corners. You can see that this has reduced your light's effect on the ceiling however, so change your Decay Start value to 300 and your Far Attenuation Start and End values to 350 and 600 respectively.

Now create a spotlight, pointing directly upwards, and rename this *spotLampTop*. This is representing light from the top of the light bulb, so move it up above the omni an appropriate distance. This should automatically be the same yellow color you've used before, have a Multiplier value of 0.5 and have no shadows. Adjust the falloff cone so that it just fits the hole at the top of the lampshade and set the hotspot light to 10 degrees less. Set the Far Attenuation Start and End values to 100 and 450.

Repeat this process, creating a second spotlight pointing out of the bottom of the shade, positioned roughly where the bottom of the bulb would be. All the light's parameters should already be set correctly apart from the hotspot and falloff which need widening right out. The Multiplier should be reduced to around 0.4. If you render now, this should look about right.

Figure 8.33
Scaling a light cheats its effect into areas it wouldn't normally reach

Figure 8.34 (right)
A simple volume light effect will make the lamp look more realistic

Figure 8.35 (below)
The glow parameters for the top of the two lights from within the lamp

In order to further emphasize this light's illumination, a volume light effect can be added to each of these spotlights. Within Rendering > Environment, add a Volume Light effect and using the Pick Light button specify the top spot associated with the table lamp. Alter the Fog and Attenuation colors to values of R:255, G:255, B:225 and R:174, G:90, B:0 respectively. Alter the Start and End Attenuation values to 70% and 55%, leaving everything else in the Volume section as the default. In the Noise section, turn on Noise and set the Amount to 0.5, the type to Fractal and the Uniformity to 0.3. Repeat this process to add another volume light to your other spot, but this time set both the Far and End Attenuation values to 100%, as your Multiplier value for this spot is lower than the last one.

With this turned on the lamp is complete bar a subtle glow that we'll add using Max's Rendering Effects. To add a glow to a material, you need to alter its Material Effects channel, which is done in the Material Editor, in the row of icons underneath the sample slots. Change the *lampShade* material's value from 0 to 1 and from the Rendering menu, choose Effects; in the resultant dialog, add a Lens Effect. Now, from the Lens Effect Parameters list, specify a Glow, click the arrow pointing right and check the Interactive checkbox. (At this point Max might go away and render out a frame, but once this has been done, the effect will be displayed so that it can be altered interactively.) Now, down in the Glow Element rollout, within the Parameters tab, set the Size to 1.0 and the Intensity to 95. Finally, alter the Radial Color swatches so that the leftmost color, which is the one used at the center of the effect is a desaturated yellow and the rightmost color is a much more saturated version. Your preview should reveal a subtle yellow glow around the light.

We have one last little tweak, which will demonstrates the importance of materials within 3ds Max and show how important it is to know how your materials interact with different light types. We'll make the lampshade produce throw patterns on the wall, which will give us a nice effect. To do this, we'll have to make a new material based on the Raytrace material type, so that we get the transparency effects that we are looking for. Drag a copy of your *lampShade* material to a blank slot. Hit the button that denotes the material type, which is currently labeled Standard, and select Raytrace from the dialog that appears.

The first thing you need to do is to make the material 2-Sided, so check this checkbox. Within the Maps rollout, specify a Bitmap for the Diffuse map and load LampProjector.jpg. One thing we can do, which might surprise you, is turn off Enable Raytracing for this material, which is found in the Raytracer Controls rollout. We don't actually want to raytrace with this material, we are just looking for the transparency, luminosity and fluorescence effects that exist within this material type. Drag an Instance of your diffuse map into the Fluorescence slot.

Figure 8.36
Volume lighting and a glow effect finish off the simple fixture

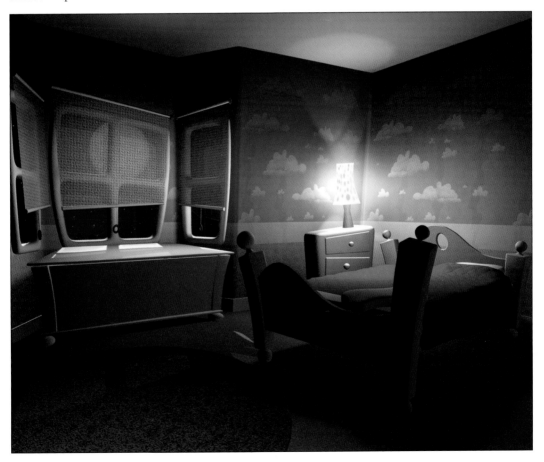

Figure 8.37
Your light's throw patterns reach
too far, so an extra light is needed

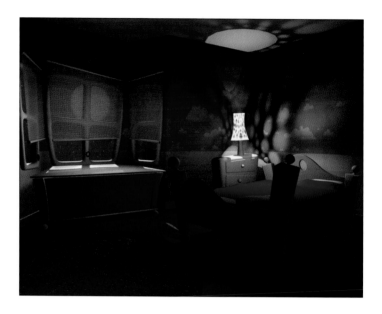

We're not raytracing with this material, so you can uncheck the
Reflect checkbox in the material's Raytrace Basic Parameters
rollout. If you were to render now, you would notice that the
material now has the self illumination that the Fluorescence is
giving to it, but it's still not projecting a pattern. For this to
happen we need to do a couple of things. Firstly, within the
Transparency slot, you need to choose Bitmap again, and then
select the LampProjectorAlpha.jpg image. An Instance of this
map can also be dragged and applied to the Luminosity channel.
Within the Extended Parameters rollout, you should also change
the Fluorescence bias to 1.0. This increases the Fluorescence
effect, as you'll see from your material preview.

The last thing that you need to do is to turn on Raytraced
shadows for the omni in the middle of the lampshade. If you
render now, you'll see that you have the throw patterns, but
they are not quite as you might expect them to be. This is
because the omni's illumination stretches too far along the z-axis,
which results in the patterns being cast way beyond where you
would expect to see them.

To fix this problem we'll need to separate this omni light into two:
one which provides the general illumination; and one which gives
us the throw patterns. Turn off the shadows for this light and
reduce its Multiplier value to 0.75. Now clone a Copy of this light,
rename it *omniLampThrow* and turn your shadows on for this
light. However, in order to prevent the throw patterns being cast
onto the ceiling, we need to alter this light's vertical reach. We'll
do this in two ways, firstly by decreasing its scale value from
80% to 60%, which you should do by right-clicking the Select
and Scale button on the main toolbar and typing in the value over

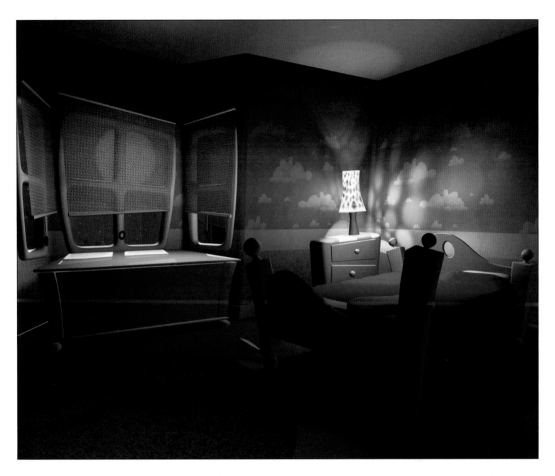

the field which reads 80%. The second way we'll do this is to
reduce the Far Attenuation Start and End values to 300 and 500.
With this done, the throw patterns will be restricted to a realistic
vertical range. Increase this light's Multiplier value to 1.0.

This light should now render just as you want it, but it took us
two omnis and two spots to get to this point. Whilst this might
have taken a comparatively long time to set up, you should
understand how splitting it up into separate components in this
way gives a lot more control over the look of the light and helps
us to streamline its performance at render time as much as
possible. I hope you agree that it was worth the trouble.

Figure 8.38
Your lampshade's throw pattern is
dependant on raytraced shadows

9

'But, soft! What light through yonder window breaks?
It is the east and Juliet is the sun.'

William Shakespeare: *Romeo and Juliet*

The great outdoors

Portraying natural light in an outdoor environment is much more difficult than it is in an indoor scene. Light that enters such a space, through windows and other openings is relatively easy to control, but the fact that sunlight is such a bright source makes this type of light a sizable challenge when a shot is set outside. This is understood by photographers, who have to employ bounce cards, diffusing silk sheets and even extra lighting in order to break down its harsh light and soften its hard shadows. However, the same natural light at a different time of day, or in different conditions, can be poetic in its beauty.

Whilst the light from the sun might seem like one distant bright source, the way it behaves means that its illumination can be split into several components, that layer on top of the single distant bright source. The first lighting component can be referred to as skylight, which is the diffuse light caused by the scattering of the sun's light as it passes through the atmosphere.

Image courtesy of:
Chen Qingfeng
www.chen3d.com

Also, because sunlight reflects off the many objects that make up an exterior environment, bounced illumination casting colored light back into the environment also has a sizable influence on outdoor lighting.

Sunlight

One of the biggest clues to the time of day is the sun and how it changes the lighting around us. Furthermore, just as seasonal depressions can be treated with light, so the illumination that we specify in our animated productions can help create a mood, from light summery happiness to dark claustrophobia. The weather has been used successfully in many feature films to set the emotional tone, and we must think similarly in CG.

The sun's angle

There are two main clues to time in CG, both of which concern the sun's light: the angle and the color temperature, which both change throughout the day. The angle of the sun starts at 0 degrees during sunrise and ends at this same angle at sunset. In-between it rises to its maximum angle at midday that changes depending on the time of year and also the latitude. In London,

Figure 9.01

Clues to time can be seen in the angle and color of sunlight

Figure 9.02
The sun's color changes through the day from yellow in the morning

for instance, the summer solstice on the 21st of June sees the sun rise to an angle of 58.5 degrees at noon, whereas on the same date in December, the highest angle the sun manages is around 12.5, the lowest midday angle of the year.

Fortunately, 3ds Max has a Sunlight System that allows you to simply enter the geographic location of your scene, the time of day and date, from which it can calculate the sun's position. This kind of system can also go one step further, and given a start time and end time, it will place an animated light over the given location. This kind of functionality is of obvious use to people like architects who are interested in shadow studies of proposed structures. However, it can also be a useful feature for verifying that a scene's key light represents the sun at the desired time of day for the location.

Color temperature and time

As you should remember from chapter 2, the color temperature of sunlight changes throughout the day. This begins at around 2,000 °K at sunrise, increasing rapidly to 4,300 °K by early morning. At midday the color temperature reaches its maximum value of over 5,000 °K, though on the clearest of bright summer days, this can go in excess of 15,000 °K. Indeed, overcast skies generally have a higher color temperature than clear ones, around 6,000 °K. These values can vary greatly depending on the weather conditions, and the values presented here and in table 2.01 (see p.13) are just averages to be treated as a guide.

The sun's light changes color throughout the day, from a warm orangey-red at sunrise to a pale yellow around breakfast time, and desaturates to almost pure white by midday. As the day wears on, these colors occur again, in reverse, though cloudy conditions can tint the sun blue, and stormy weather gray.

Figure 9.03
Simulating different times of day in
CG can be a sizable challenge

Images courtesy of:
Bastien Charrier
bast1@free.fr

However, how these colors will appear in your rendering depends on the color balance you have selected - 3,200 °K and 5,500 °K for tungsten-balanced film and daylight-balanced film respectively - and how the color temperature of the sun relates to this color balance. If the color temperature is lower than your chosen balance, the light will appear more yellow, if it is higher, it will appear blue tinted. To normalize these shifts of the sun in cinematography, colored filters called gels are placed over artificial lighting, or over openings like windows to ensure that the direct sunlight is of a consistent color. Of course, these can also be used to make indoor lights appear as if they were emitting daylight.

When you start out trying to light an outdoor scene, use a sunlight system as a starting point to your lighting. You then know that the position of your source is accurate for the time of year, day and geographical location of your scene. One thing that you must remember though is to change the color of the light to reflect the time of day, remembering to take into account which kind of film you're attempting to mimic, though for most daytime outdoor scenes your stock will certainly be daylight-balanced.

There are also various websites that will give you the relevant data for your light source based on the same geographic- and time-based inputs. The one at www.susdesign.com/sunangle/ is very good. Whether or not you use the sunlight system as a starting point, you'll still need to do further lighting work to represent the sky's component and the bounced illumination.

Despite the fact that direct lights can yield quick and accurate results, if your rendering demands an extra level of quality, it's best to break the lighting down into a series of individual lights.

The problem with direct light is that it is too uniform and in isolation results in an image that has too much contrast and can result in a very flat render. The easiest solution is to add an array that represents the diffuse light coming from the sky's dome, or to use 3ds Max's own Skylight light type, if your project suits working with the Light Tracer.

Skylight

The skylight's contribution to outdoor lighting is a very diffuse light, which is at its strongest in the part of the sky opposite to where the sun is located. When skylight is mentioned in CG circles, it is often assumed to include the contribution of the bounced lighting from the environment's objects. It is arguably simpler to think of the skylight as being a separate element that operates like an array of fill lights located round the sky, which can be thought of as a dome, all casting only diffuse light colored to match the sky in their local area.

Light bouncing off the major elements of a scene's environment is also best represented by a circular array of lights, placed around about ground level, again operating only as diffuse emitters. This array of lights can be thought of as having equal intensities, though their colors will vary depending on the color of the objects adjacent to them in the environment.

The simplest way to set up both the skylight and the bounced light is to use a Skylight light type, which we've already covered in chapter 6. This light type, particularly when used in combination with an HDR map, as our tutorial in this section

Figure 9.04
Dome arrays are good for creating the sky's lighting component

demonstrated, creates the dome of diffuse lighting very realistically. Alternatively, if your project is perhaps not suited to working with the Light Tracer, then you could introduce a dome array. We also covered this in chapter 6, when we constructed a simple three-row dome array that was built around a hemisphere made up of 17 lights. This is perfect for representing both skylight and bounced light, with the top two rows (nine lights) operating as the skylight component and the bottom row acting as the scene's bounced light.

Whether you are working with Skylights or dome arrays, your lighting scheme should operate in a subtle manner, with the ratio of sunlight to skylight always dependent on the amount of cloud cover. On a sunny day, the skylight should just provide enough fill to soften out the lighting without detracting from the key light; on an overcast day, the skylight would be the dominant component and would make any shadows far less obvious.

Sunlight and skylight together

As well as the Sunlight System, 3ds Max also features a Daylight System, which provides the sun and sky components all bundled into one system. Once created, this system can be controlled via the Display panel, via the geographic location, date and time.

All of these attributes are linked to the compass orientation that the system places within the scene, and the date and time can of course be animated so that shadow and daylight studies can be carried out very quickly and easily. The Daylight System is also flexible enough to work with photometric lights or standard

Figure 9.05
The sky's component illumination opens up the sun's shadows

Image courtesy of:
Pascal Blanche
lobo971@yahoo.com

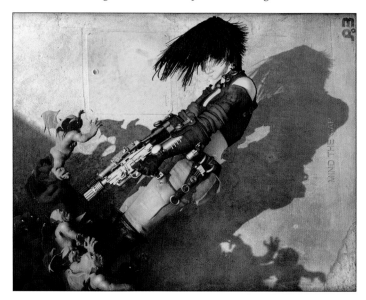

lights and this can be changed via the system's controls within the Modify panel. If you are using standard lights, then the sun will be a target direct light, just as it is when using the Sunlight System, the sky is controlled via a Skylight, which means that to get the best use of this system you need to employ the Light Tracer as a rendering plug-in.

If you use the system's photometric settings, the sun and sky are modeled using IES Sun and IES Sky lights, which work alongside Radiosity. One thing that's worth noting is that if the date and time settings are used to position the light, the multipliers of these lights are set and animated automatically, which can be convenient, but can also be a pain if you are trying to get a certain look alongside your light study.

The multipliers of these lights, when set automatically, are set very high and so it is vital that the Exposure Control is used, with the Logarithmic Exposure set to Exterior Daylight.

Tutorial - sunlight and skylight together

In this tutorial you will learn how to set up a basic daylight scene using the Daylight System to complete a shadow study of a proposed new structure. This will first involve placing a Daylight System - choosing the time and geographical location for the scene - which will provide the skylight. You'll then replace this with a simple dome array and compare this with your previous efforts with Radiosity. Open the C09-01.max file from the tutorials folder of the DVD. You will see a bridge that spans across the landscape in front of the camera.

Figure 9.06
The Daylight System can use either photometric lights or standard

The first thing that we'll do is to set up a Daylight System. To do this, go to the Create panel and press the Systems button; now click the Daylight button. Click and drag in the Top viewport, somewhere to the left of the land mass, to first of all create a compass object. After you've done this, releasing the mouse button and moving the mouse button downwards will move the lights that are created away from the compass along its own local Z-axis. Had you selected a Sunlight System, a single standard light would have been created, representing the Sun. However, the Daylight System features two lights grouped together representing both a Sunlight and a Skylight. Furthermore, we can use this with both the Light Tracer and with Radiosity, which is what we'll start with.

By default, standard lights are created, so go to the Modify panel and change the drop-downs for the Sunlight and Skylight to IES Sun and IES Sky. Now, within the Render Scene dialog, on the Advanced Lighting panel, select Radiosity.

With this newly-created light selected, go to the Motion panel and you should see the controls for setting the location, date and time. Change the location to Paris, France, the date to 12th April 2006 and set the time to 08:00. This gives you an Azimuth value of 100 and an Altitude value of 27. Turn on Auto Key, by hitting the button labelled Auto Key at the bottom right of the UI, and move to the last frame. Now enter 16:00 as the time.

Turn off Auto Key and hit the Play button. You will now see that you have two animated lights that move over the scene, giving us an accurate representation of how the light and shadow affect the scene from 8 o'clock in the morning until 4pm.

Figure 9.07
Setting the sun's parameters

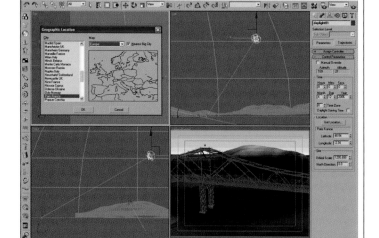

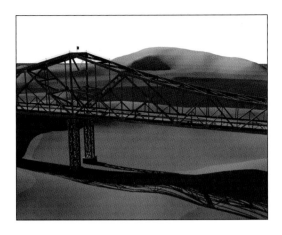
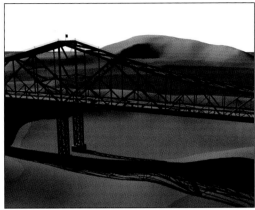

If you were to render now, you would find your scene almost
completely blown out. In order to correct this, you should use
the Exposure Control, found in the Environment section. As with
previous Radiosity renders, change this to Logarithmic, but this
time check the Exterior Daylight checkbox to turn it on. You will
find that your scene is evenly exposed if you change your
Brightness to 70 and leave everything else as it is.

Figure 9.08
Your Radiosity render will look
superior to your Light Tracer render

However easy this set-up has been, there's one rather major
reason why you wouldn't want to go on and render this
sequence. The whole point of the scene is that the lights are
moving, but the downside of this is that the radiosity solution
would need calculating for every single frame of the animation.

A far more useful approach would be to use the standard lights
along with the Light Tracer, so change your IES Sun and Sky
lights for the standard Sunlight and Skylight. Change the
Advanced Lighting plug-in from Radiosity to Light Tracer and hit
Render. With everything left at the default values for both
rendering modes, you should find that your render times are
about four to one in favour of the Light Tracer. True, the
Radiosity solution might look much more convincing, but is it
worth the time penalty at render time?

A better solution might well be to abandon both of these
Advanced Lighting modes and instead go back to basics. Change
the drop-down so that you have no Advanced Lighting plug-in.
Choose File > Merge and select the C09-01lightRig.max file;
select the group from within this scene and merge in. Your
lighting rig will sit right over the scene and should be about the
same size as your skydome object.

If you open up your Light Lister from the Tools menu, you will
see that the brightest lights on each row are numbers 1, 2, 7 and
8. As the numbers of the lights run from number one, clockwise
from six o'clock round the rig, the four lights with the higher

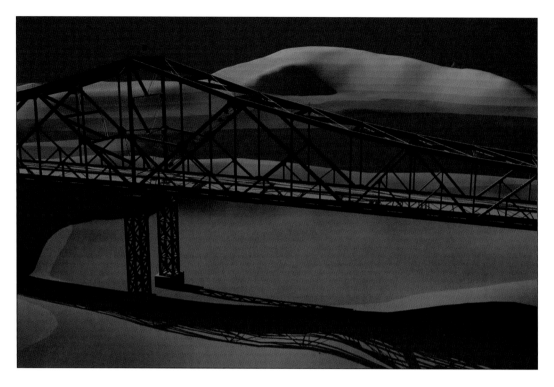

Figure 9.09
Using no Advanced Lighting plug-in makes for a much faster render

Multiplier values need to be in a different position, so that they are in the portion of sky that lies directly opposite the sun. Rotate the *arrayDomeLights* group on the z-axis by -140°.

Select your *daylight* object and within the Modify panel turn off the skylight component of the daylight system by unchecking the Active box in the Skylight section. You should also notice that the Multiplier value is incredibly high; somewhere in the fifties. If you tried to change this value, you would find that it does not allow you to do so. In order to change this value, you need to turn on Manual Override function within the Motion panel. However, if you turn this on, you lose the ability to have an animated light system, so it's important that we learn how to use the Exposure Control to correct this.

You should first open up the Light Lister and quadruple the Multipliers of all the fill lights within this light rig to bring them a little more in line with the high value associated with your sun. Now, within the Exposure Control, keep the Exposure Type as Logarithmic, but change the Brightness and Contrast values to 65 and 50. Now you should find that your render is considerably faster than both the Radiosity solution and the Light Tracer and without any sampling issues. The raytraced shadows over the complex bridge structure are the main reason the render is still quite slow, but by optimizing the solution, you've found a much more efficient method of carrying out your lighting study.

Night time

Whilst a lot of lighting artists might not be all that familiar with the world outside their windows during the day, they have been known to come out from behind their monitors at night. There are actually not that many differences between a daylight and a moonlit scene, because the moon is simply acting like a photographer's bounce card, albeit a very large one, reflecting the sun's light back towards the earth.

Moonlight

As the moon is a neutral gray in color, the light that it reflects toward us is actually exactly the same color as the sun's light, which might seem a little odd at first, as we're used to seeing the moon with a blue tint. However, our perception of the moon's light as blue comes from the way in which the rods in our eyes adapt to low light situations. Since we perceive the moon's light as this color, however, it would be strange to use anything but this color of light when representing it.

When looking at its color shifts more closely, moonlight, like sunlight, does actually change from an orangey-beige color to a pale blue color as it approaches its highest point in the sky. Night time scenes are generally actually much simpler to light than daytime ones, because there is less light bouncing off the objects in your environment.

Its light can cast shadows in the same way that sunlight can, though these are generally far less defined and can be made less obvious by the presence of street lighting, which can become the

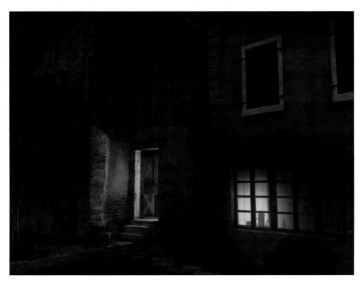

Figure 9.10
Night time scenes are actually a lot easier to light than daytime ones

Images courtesy of:
Bastien Charrier
bast1@free.fr

dominant light source in a scene. It is only when street lighting is introduced to a night time scene that it actually becomes as challenging as setting up a scene lit by daylight.

In cinematography, there are two main methods of simulating moonlight. The first and more common method is to use a white key light along with blue fills; the second older method is to light the scene normally and fit a blue filter to the camera.

As long as the highlights that fall on the shot's objects do not become too blue and remain a whitish color, this produces a very convincing night shot, despite this method - and indeed the first too - being far removed from actual night time lighting.

The best strategy for CG is to make the moonlight a realistic color - between the orangey-beige and pale blue colors already mentioned - and adjust the specular color component of individual materials should the highlights start to look unrealistically blue. Blue fill lights are used to cheat in some illumination where darkness is needed, but in actual fact if darkness were what was present, too little visibility would result. The blue color provides some illumination, but does not break the illusion of darkness because of the way that our eyes adjust to low light situations.

Blue light actually strengthens the illusion in some cases, because of the way that it desaturates human skin tones. As our eyes adjust to the dark, the cones that pick up color information become far less sensitive than the rods that sense brightness. Our vision of a dimly lit situation is very murky: we can make out dark shapes, but not colors.

Figure 9.11
The way our eyes work in low light conditions gives us the perception that the moon's light is blue

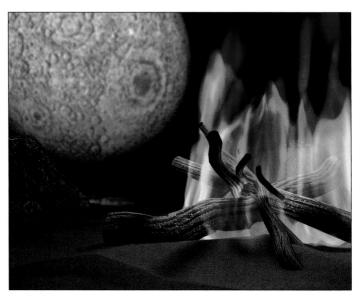

This explains why the blue light looks convincing against skin tones, suggesting a further approach to producing convincing night time scenes that aren't too underexposed to make out - using desaturation. There are several ways to do this. Simply adjusting your colors in the scene's materials to be less saturated, or using the Exposure Controls can make a big difference to the realism of a night scene. Alternatively, altering this kind of attribute is most easily accomplished in a compositing application like combustion. Whatever approach you decide to take, adjusting your colors to be less saturated gives an extra level of believability, as everything can be made out in terms of its shape, but not really its color, which is more of a match for how our own perception of such situations works.

Tutorial - moonlight

In this tutorial you will learn how to set up a moonlit scene using basic three-point lighting techniques. This will involve placing a key light acting as the moon, before adding blue fill light selectively to bring out detail in the shadows.

Open the C09-02.max file from the tutorials folder of the DVD. You will see a beach scene, with an oversized full moon in the background, which is also extremely low in the sky. You already know that the moon's color is an orange-beige when it's low in the sky, so we'll begin by creating this, our key light, which will be a spotlight targeted towards the beach. In the Top viewport, place this light roughly in the center of the *moon* object, using the Align tool to center this light on the moon object in all three axes and its target on the beach object. Rename this light *spotMoonKey* and adjust its Hotspot to fit over the whole beach, which should give you a value of about 35. Turn on Cast Shadows, and give the light a color of around R:250, G:230, B:200 and a Multiplier value of 1.0. Clone a Copy of this light and rename this light *spotMoonWater*.

If you render now, you're getting some foreground illumination and highlights on the water, but no actual illumination of the moon itself, so before we go any further let's sort that out. This we can do by adding a spotlight that just lights up the moon object. Place your spotlight to the right-hand side of the beach object from the point of view of the camera, and target it roughly at the moon. Again using the Align tool, center this new target object on the moon in all three axes. Back in the light itself, use the Include function and select only the moon object, before renaming this light *spotMoonOnly*. Shadows for this light can be turned off; its color should be the same as the last light's, its Multiplier set to 1.0 and the Hotspot should be adjusted to just fit the moon - around 30 should do it. Now if you render, the moon looks licely lit and its reflection on the water is now visible.

However, there's a problem already in that the reflections look unrealistically bright, so Exclude the *water* object from the *spotMoonKey* light. Leave the Multiplier of this light as 1.0, but change the *spotMoonWater* light's Multiplier to 0.5, leaving its shadows turned on. Now the reflections have a more varied appearance with the addition of some brighter highlights.

The shadows from the moon would be nice and soft, so for the two shadow casting lights increase the Sample Rate within the Shadow Map Parameter. This determines how much area within the shadow is sampled and blurred, affecting how soft the edge of the shadow will be. A value of around 10 will give us a suitably gentle shadow, and because increasing this value blurs the shadow map, we can get away with using a smaller shadow map than usual. The default value of 512 will work just fine here, or this value could even be reduced to 256, which is less than would usually be needed in this scene for sharper shadows.

Looking at the rendered image now, the sky, moon and water look fine, but the foreground is somewhat lacking. The lack of illumination looks realistic, but without this any detail in this area is lost. The answer is to cheat some light in using a useful trick to stretch its illumination unevenly to illuminate the rocky area to the right, immediately in front of the camera. First, in the top view, place an omni light roughly in the middle of the rocks and towards the camera, then move it up in the Left viewport, around 55 units.

Turn on the Far Attenuation and set the Start and End values to 75 and 150. As the light stands, its Attenuation is completely spherical. Using the Non-Uniform Scale tool, scale the light down to 50% along its local z-axis so the Near Attenuation does not

Figure 9.12

Scaling a fill light to fit the space

reach the floor and scale again by 200% along the light's x and y-axis, so the illumination stretches along the rocks. You can now move, rotate and scale the light further so that it illuminates the area around these rocks very subtly, just bringing in a small amount of detail.With a pure blue color, the desired amount of illumination should occur with your Multiplier value at around 0.2.

In order to further illuminate this foreground, you should clone one of the lights centered on the moon and turn on Far Attenuation, setting the Start and End values to the near and far ends of the beach, so to about 1,500 and 2,500. You should uncheck the Specular component for this light and the last fill that you placed near the rocks, as fill light does not have a specular component. Set to a pure blue color, this light should have a Multiplier value of 0.75. Rename this light *spotBeachFillFar* and clone another copy of it.

This copy should be placed at the opposite side of the beach, behind the camera and should be moved in the Top viewport until the Far Attenuation Start and End are aligned with the near and far sides of the beach. Bring the saturation of this color down to about half its current value and change the Multiplier value to 0.5. If you render now, you'll notice that the blue light desaturates the foreground sand, which demonstrates why blue fill light looks so convincing against skin tones for night shots.

In order to add some backlighting to your rocks, you should open up the Material Editor and within the *rock* material, add a Falloff map to the Self-Illumination slot. Set this, as you've done before to Fresnel and add a point to the Mix Curve, editing it to curve down and to the right. While you're in the Material Editor, we

Figure 9.13
With six lights placed around the scene, your setup is complete

should sort out the water's antialiasing, which looks a little poor, so enable the Max 2.5 Star Local Supersampler in the Supersampling rollout. This might up the render time by a significant amount, but for some materials anything less than this standard would just not be good enough for final output.

Finally, for the *moon* material, change the Material ID channel to 1, so that we can add a glow effect to the moon. Once you've done this, choose Rendering > Effects and from the resultant dialog, choose Add and specify a Lens Effect. From the Lens Effects Parameters rollout, choose a Glow and click the > button to select this type of effect.

Within the Glow Element rollout, you should change the Radial Color, giving the left swatch the same color as the key light you created, R:250, G:230, B:200 and the right-hand swatch a pure blue color. Change the Size to 10 and the Intensity to 50. Within the Options tab, you should check the Material ID checkbox. With the Image Filters set to All, you should now get a nice glow effect if you turn on the Interactive function in the Effects rollout, or render. This scene is pretty much finished and should demonstrate how much more straightforward a night time lighting scheme is. It has actually been a useful lesson in three-point lighting techniques, after all of our use of the Radiosity and Light Tracer rendering plug-ins over the last few chapters. Your render times should also demonstrate the obvious appeal of these methods and why they are a staple of many CG lighting schemes.

Figure 9.14
With the blue light added, our dark corners are subtly illuminated

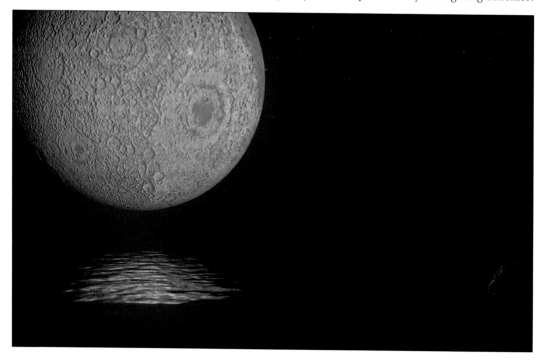

Street lighting

Streetlights are not all that difficult to produce following the tutorials you've done so far. Most streetlights use sodium, which appears to have a yellow-orange tint to it to the naked eye, as driving down the freeway at night will confirm. Streetlights are illuminating a larger space remember, so their falloff will often be pretty visible. Their cones of light can also be quite visible, especially on foggy or misty nights, so if this is the look you're after, introducing some volume lights and even some fog to bring out these hazy cones of illumination. The bonus chapter on the DVD looks at creating natural elements such as fog.

Just as with faking global illumination indoors, streetlights that cast light onto brightly colored objects should be dealt with in the same way, by placing a second light acting as the bounced light, with the color of the light matched to the object, and the shadows and specular illumination component turned off within the new light's controls.

The bright sources that outdoor lighting features can make for a rendering that has way too much contrast. The Exposure Control can be be very useful in addressing this problem. Without modifications, a scene lit by streetlights will have very dark areas

Figure 9.15
Streetlighting can be very visible

and extremely light areas, which won't look very realistic. Blue fill lights employed to counter this problem complement the way that our eyes work in low light situations, which is why this method looks so convincing. Indeed, there are few situations that allow for such atmospheric results as those set at night, as the artist has both extremes of darkness and light to work between. For this reason, night shots can be brooding and atmospheric, as in the film noir look of the 1940s, which often employed low-key lighting to emphasize the contrast between light and dark.

Tutorial - outdoor lighting fixtures

In this tutorial you will learn how to set up a scene involving a small outdoor lighting fixture of the type used at floor level, typically to illuminate paths in outdoor spaces. This unit has its light behind opaque frosted glass, which we'll use to demonstrate translucency, a technique that's applicable to many situations. This will involve setting up the fixture's lights and exploring the raytrace material's options to get the right effect.

Open the C09-03.max file from the tutorials folder of the DVD. You will see a cylindrical lighting fixture with glass panels. Your first job is to place the lights that will represent the actual bulb within this fixture. Place an omni light in the center of the fixture and give it a color of R:255, G:255, B:220. Set its Multiplier to 50.0, turn on shadow casting and change the shadow type to Raytraced. Turn on Inverse Square Decay and set the Start value to 0.15m. Now turn on the light's Far Attenuation and set the Start and End values to 0.1m and 0.5m.

If you were to render now, you wouldn't see anything, because the glass material for the lamp has not been set up yet. To do this, in the slot named *glass* in the Material Editor, hit the Standard material type swatch and select a Raytrace material. Change the Shading to Blinn, check the 2-Sided box and give the Diffuse color value a slight tint of yellow, say R:255, G:255, B:240. Give the Transparency color a light gray tone, around R:200, G:200, B:200 (it is this value that gives the glass its opacity, so experiment with this value if you desire) and change the IOR (Index of Refraction) value to 1.5 to represent glass. Finally, alter the Specular Level to 20 and the Glossiness to 0.

If you render now, you will see that your light is really blown out, but this light is designed to work on an HDR background that is set to a very low level. To load this, open the Material Editor and within the *foreground* material add a Bitmap to the Diffuse slot and browse to the materials folder, selecting hdri-03_color.hdr file. Set your White and Black Point as you have done previously and you'll find that your White Point should be at about 4.0. When you've okayed these settings, go to the

The HDR files used in this tutorial were kindly provided courtesy of Sachform.

These images are part of the company's URBANbase collection, which features 40 fully spherical HDR maps at a resolution of 4,000 x 2,000.

www.sachform.com

Output rollout of this bitmap and set the RGB Level to 4.0 to match your White Point value, like we have done previously. Finally, in the Coordinates rollout, set the U Offset to -0.8. Render again and you will see that your lighting is still blown out. However, alter your RGB Level value to 0.5 and render again and you will see that this type of map can be lit in this way.

Now change the shadow type of our light to Advanced Ray Traced and change the Density to 0.8 within the Shadow Parameters. Within the Advanced Ray Tracing Parameters rollout, increase the Shadow Spread to 3.0 and, finally, within the Optimizations rollout, check the Transparent Shadows box. Rename this light *omniShadow01*. With the light selected, use the Align tool to align this light to the foreground object, choosing to match the z orientation. To cheat a bit of light into our shadows, we'll add another light by cloning our existing light and renaming it *omniNoShadow01*. Turn off shadow casting and reduce its Multiplier to 10. Now alter the Far Attenuation Start and End values to 0.25m and 0.75m.

Open the Environment dialog and click the None button to browse for a new bitmap. Choose Scene as your Browse From option and select the topmost entry, the HDR map we used before. Select Instance and render and you'll see that you can clearly see the edges of your foreground object against the background. To correct this we'll add a general fill, for which you should use a Target Direct light, positioned at the opposite end of the foreground from the camera, with the hotspot set big enough to cover the whole foreground. Now turn off the Specular component and give it a pure white color, with a Multiplier value of 2.0.

Figure 9.16
Your two lights will together give the light fixture's illumination

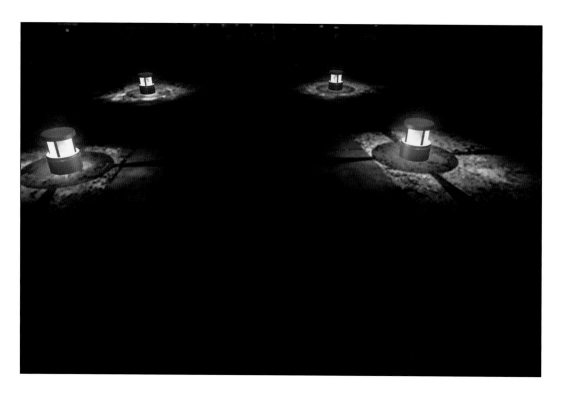

Figure 9.17
Your reflections should be weaker on the surfaces facing the camera

Now with your two omni lights selected, use the Select and Link button from the main toolbar to parent these lights to the point object. Don't forget to select another tool after you have completed this operation so that you don't continue linking objects. In the Front viewport, drag over your whole light fitting, including the point helper and lights, and select the Move tool.

Now in the Top viewport, hold down Shift and move your selection over to the left and down, following the lines of the foreground object. When you release the mouse, choose Instance. Within the Material Editor increase the RGB Level of your HDR map to 4.0 temporarily so that you can see what's going on in your viewport. Now move your new light fixture to the opposite corner of the pathway. If you want to create more copies of these lights along the pathway, you'll need to extend the foreground object and also cheat the perspective by scaling the lights down as they recede further back into the scene. You'll also need to scale the lights' illumination down this axis too, which was the reason we aligned their z-axes earlier.

A couple of finishing touches remain: firstly, you should add some frosting to the glass of the light fixtures, by adding a Noise map in the Bump channel of the *glass* material. Change its type to Fractal and its Size to 0.2. You would normally now need to turn on Supersampling if you were getting close to this type of material, but as we're not, there's no need.

Finally, you should add a lens effect to the lights to give them a bit of glow. Open the Rendering > Effects menu and add a Lens Effect. Now specify a Glow, using the > button to add this to the right-hand list. With this entry selected, change the Size to 1.0, the Intensity to 60 and the Radial Colors to the same color as your omni lights on the left and pure blue on the right.

Tutorial - neon lighting

In this tutorial you will look at the process of producing realistic looking neon lighting. You'll start by designing neon materials in the Material Editor, where you'll also apply Material Effects IDs that will link these materials to 3ds Max's Rendering Effects, where you'll apply glow, before animating the material to flicker on and off like a real neon sign.

Open the C09-04.max file from the tutorials folder of the DVD. You will see the basic geometry for a sign with several different neon elements. The first thing that we'll do is set up the materials that will represent the neon in its various states. First, select the illuminated neon tube, from which we will make an unlit version. In the top-left slot named *neonBlue,* set the Diffuse swatch a pure cyan color: R:0. G:255, B:255. Set the Self-Illumination to 100% and render.

Not bad you might think, and this might do from a distance, but neon is much more subtle than this. Neon's illumination falls off towards the edges of the tube and the glow is concentrated in the middle. In order to simply produce this, you should go to your Maps rollout and in the Diffuse slot choose a Falloff map. Choose

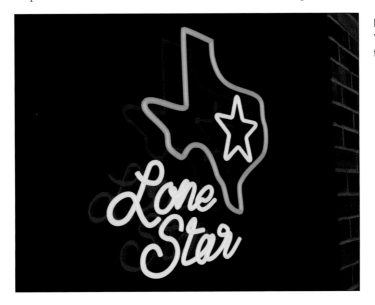

Figure 9.18
Your standard materials might work for a distant element of a shot

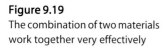

Figure 9.19
The combination of two materials
work together very effectively

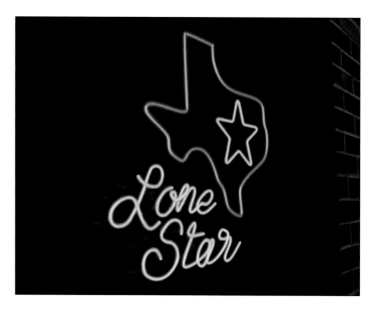

Towards/Away as your Falloff type and color the topmost swatch
a white tinted with a small amount of cyan and the bottom
swatch a light cyan (R:200, G:255, B:255). Edit your Mix curve to
curve up and to the left and render now. What you have looks
that little bit more believable and this is a definite improvement.

However, for close-up neon we can do better still. In another
blank slot, change the material type from Standard to Raytrace.
Make the material 2-Sided, give the Diffuse Color swatch a value
of R:200, G:255, B:255 and reduce the Specular Level and
Glossiness both to 0. In the Extended Parameters rollout, apply
this same color to the Fluorescence value, setting the
Fluorescence Bias to 1.0. Rename this material *raytraceBlue*.

Within the Maps rollout, add a Falloff to the Transparency slot
and add a point to the Mix Curve to bring it up and to the left,
but leave the point set as corner. Leaving the Falloff Type as
Parallel/Perpendicular, choose the *neon* selection set from the
drop-down in the main toolbar and apply this new material to
these selected objects. Back in the Extended Parameters rollout,
turn on Fog, setting the End to 100 and the Amount to 10. Finally,
set the Fog color swatch to R:69, G:255, B:255. Render now and
you'll see that this material almost looks right, it's just that the
bright core of the material is now somewhat lacking and doesn't
look quite realistic enough. Select the *neonInner* selection set and
apply the *neonBlue* material from the top-left slot of the Material
Editor to these objects. This materaial now needs a bit of a
tweak. Change the two color swatches in the Diffuse color's
Falloff map to make them R:233, G:255, B:255 and R:200, G:255,
B:255 respectively. You now have one material applied to your
inner line objects and another applied to your outer loft objects.

With these two sets of objects featuring your two different materials, the look of your lit neon is complete. In order to give us a complementary color to your cyan, let's duplicate these two materials and give them a red/orange look. Drag your standard blue neon material to another sample slot and rename it *neonRed*. Change your two falloff colors to R:255, G:220, G:144 and R:255, G:156, G:0. This will give you an orange look for the core of the light. Drag your raytrace blue neon material to another slot and rename it *raytraceRed*.

Change the Diffuse color to R:255, G:200, B:200 and give this same color to the Fluorescence. Give the Fog color a pure red and you're done. Now apply these two materials to the two objects that make up the map neon object: the standard material to the line object and the raytrace material to the loft object. Render again and you will see that the lit neon is looking very realistic and almost finished. What is needed to give this that little extra something is some simple glows. For this we'll need to change the Material Effects IDs of the two standard materials, giving the blue material to 1 and the red material to 2.

The glows are applied in Rendering > Effects. From this dialog, add a Lens Effect. From the Lens Effects Parameters list, specify a Glow, click the arrow poining to the right and check the Interactive checkbox. (At this point 3ds Max will render out a frame, but once this has been done, the effect will be displayed so that it can be altered interactively.) Now, down in the Glow Element rollout, within the Options tab, check the Material ID box and in the Image Filters section, deselect All and check only Edge. Back in the Parameters tab, set the size to 0.1 and the Intensity to 80. Finally, alter the Radial Color swatches so that

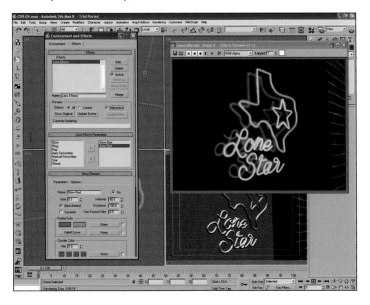

Figure 9.20
Your glow setup can be done interactively until it's right

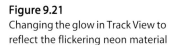

Figure 9.21

Changing the glow in Track View to reflect the flickering neon material

the center color (the one on the left) is R:0, G:69, B:255 and the rightmost edge color R:91, G:253, B:255. You should repeat these last set of operatoins to add another Glow, this time with Effects ID set to 2 and the radial colors set to orange and red for the left-hand and right-hand swatches respectively.

We're not finished yet, however, as we still need to set up an unlit version of these neon materials for when the neon light flickers off. Starting with the *neonBlue* material, hit the Standard button and select a Blend, opting to keep the old material as a sub-material, which will allow us to swap between the two materials in a very simple fashion. Drag a Copy of Material 1 to the Material 2 slot and change the Mix Amount to 100 before clicking the Material 2 button to enter this material.

First of all, rename this *unlitBlue* and change its Self-Illumination to 75 and Opacity to 25. If you now go back up a level (and change the name of this material to *neonBlueInner*) you can now change the value of the Mix Amount Spinner to mix between these two sub-materials. You'll need to repeat this for your red standard material and then your two raytrace materials. For these final two materials, you should change your Fluorescence bias to 0.5 and your Fog Amount to 5.0.

Finally, we still need to animate the flicker of the material. Open up the Track View Curve Editor from the Graph Editors menu and expand the branches down from Scene Materials to the MixAmount track for any one of the materials you have applied to the neon lettering. Display the track as a curve by clicking on the Function Curves button and using the Add Keys button found in the editor's top toolbar; add ten keys randomly along the dotted line that runs straight through 0%.

Right-click the first one and change this to Time 0, Value 0 and alter the In and Out Tangent Types to step. Cycle forward to the next key and change this to Time 4, Value 100, then the next one to Time 5, Value 0; then Time 8, Value 100; Time 9, Value 0; Time 14, Value 100 and finally Time 15, Value 0. For each of these keys you should also set the In and Out Tangent Types to Step. You should now go to the Controllers menu and select the Out-of-Range Types command and select Loop to continue this flickering across the full 100 frames of the animation. You'll need to repeat this for your blue raytrace material. You can copy and paste into the MixAmount channel, choosing Instance so that your keys will be linked. Again, paste a Copy of these keys into the red standard material, shuffling the keys around a little to give the red a different timing for its flicker. Copy these and Paste and Instance into your red raytrace material.

The glows also need to be changed in Track View to reflect this flickering. You should change the Intensity values of the two Glow Lens Effects to match these keys that you've just entered. Use the same time values, lowering the Glow's intensity to 40 rather than 0, with the same Stepped In and Out Tangent Types. Be sure to set the Parameter Curves Out-of-Range Types to Loop once more. Render now and you should have a fairly convincing result. There's a version on the DVD if you don't want to wait.

Figure 9.22
Your final materials with glows looks very convincing and realistic

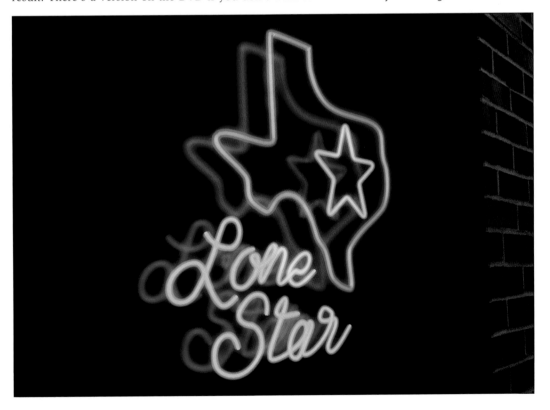

'To them, I said, the truth would be literally nothing but the shadows of the images.'

Plato's *Republic*

The tutorials in this chapter are with thanks and acknowledgement to Pete Draper and his superb book 'Deconstructing the Elements with 3ds Max' also published by Focal Press.

Specific lighting problems

From time to time you will come across a lighting task that requires you to take a slightly different tack. Such tasks might require slightly different techniques to those covered so far, although they might only require that their application be extended somewhat beyond the usual. This chapter tackles two such procedures that fall outside regular categories and which should help you to approach such unusual problems.

This chapter does not aim to cover exhaustively every special case that you might encounter. Instead, it takes two specific examples - broadly speaking one indoor and one outdoor - and examines each one in close detail, so that you can learn from these lessons how specific tasks are approached, and hopefully then have a better idea of how to take on similar problems. For starters, the lighting of an underwater scene is covered, which could also easily be applied to the task of setting up the lighting for an extremely foggy scene.

Image courtesy of:
Pascal Blanche
lobo971@yahoo.com

Whether you are tackling an alien landscape, a heavily fogged scene or an underwater environment, hopefully these two examples will illustrate how to approach similar related problems within your own particular production environment.

Tutorial - underwater lighting

In this tutorial you will look at the unique lighting challenge thrown up by the illumination of an underwater scene. Though most lighting tasks can be approached in several ways, this is particulaly true of underwater scenes. We'll use volume lighting, depth-of-field and projector maps to create an underwater environment that's both realistic and atmospheric.

Open the C10-01.max file from the tutorials folder of the DVD. You will see the surface of the water above the camera and below it the seabed, both of which are represented by two planes. As you can see, our seabed has a Noise modifier applied to it; using the same technique we'll first give the water's surface some movement. Select the *waterSurface* object and add a Noise modifier, setting its Scale to 100 and the Z Strength to 0.5m. Check the Animate Noise checkbox and set the Frequency to 0.2. Go into Gizmo sub-object mode and in the Left viewport, rotate the gizmo 60 degrees clockwise. Now rotate this gizmo 45 degrees clockwise in the Top viewport.

Right-click this modifier, Copy it and Paste a new version above it in the stack. Set its Scale to 1,000 and its Z Strength to 4m, reducing its Frequency to 0.1. Now in the Top viewport, rotate this modifier's gizmo 90 degrees anti-clockwise. Rename these

Figure 10.01
Setting your Out-of-Range Types allows you to repeat animation

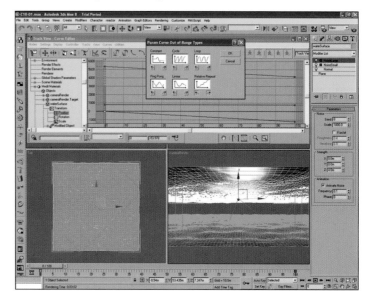

modifiers *noiseSmall* and *noiseLarge*. Turn on Auto Key, go to
frame 100 and select the NoiseSmall modifier's gizmo, moving it
down and to the left by about 10 units in X and Y. Turn off
AutoKey and right-click the object in any viewport, choosing
Curve Editor from the bottom-right quadrant. Expand the
Modified Object branch and choose the noiseSmall X, Y and Z
Position channels. Now set the Tangent Types to Linear and
change the Out of Range Types to Relative Repeat. Your wave
motion will now continue beyond the current 100 frame range.
Similarly, you'll also need to change the tangents on the
keyframes for the Phase track to Linear for both of these Noise
modifers and set the Out of Range Types to Relative Repeat.

For the water's material, find the *water* material slot and set the
Ambient, Diffuse and Specular colors to be R:7, G:16, B:27; R:0,
G:70, B:110; and R:255, G:255, B:255. Set the IOR of this material
to 1.33 within the Extended Parameters rollout. Give this a
Specular Level of 150 and a Glossiness of 30 before allocating a
Falloff map to the Self-Illumination, setting the Falloff Type to
Fresnel. In the Bump channel, choose a Noise map, which
should be Fractal, with a Size of 75. Go to frame 100, hit Animate
and change the Phase to 100. Turn off Animate and in Track
View, expand Scene Materials > *water* > Maps > Bump (Noise)
> Phase and select this track, setting the Tangents for these
keys to be Linear and the Out-of-Range Type to Relative Repeat.

Back in the Material Editor, you should click the Noise button and
change this to a Mask, keeping the old map as a sub-map.
Allocate a Falloff map to the Mask slot and set the topmost color to
R:100, G:100, B:100. Now add a Falloff map to the Refraction slot
and swap the two colors around, setting the Mix curve to match
that of figure 10.02. You should then add a Raytrace map to the
topmost slot in the Falloff parameters. Add another Falloff map to
the Reflection slot, changing the bottom color swatch to R:75,
G:100, B:110 and editing the Mix Curve so that it curves up and to
the left. Up a level in the Maps rollout, reduce Reflection to 25.

To illuminate the seabed, we'll use a pure white omni light
positioned at X:0, Y:0, Z:15. Give this a Multiplier value of 1.0,
leave shadows turned off and turn the Far Attenuation on using
45 and 90 as the Start and End values. Rename this *omniSeaBed*.
If you render now, you should have a nice gentle falloff of light
for the seabed, but no illumination of the water. To fix this,
create another omni light renamed *omniWater*. This should also
be a pure white color and should not cast shadows. A Multiplier
value of 1.0 should look about right. The positioning of this light
is very important to achieve the right highlights on the water's
surface as what we're doing is placing the light below the water
so that it will cast specular hightlights on its underside rather
than placing it above the water. Somewhere around X:0, Y:180,
Z:–120 should do the trick.

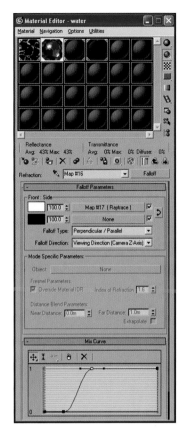

Figure 10.02
Your mix curve will cause a sudden
cut off in the Bump map

Sky materials

The sky image for this tutorial was provided courtesy of Marlin Studios. This forms part of its Panoramica product, which is a high-res (up to 10,000 x 2,000) collection of 180/240/360 degree and hemispherical land and sky panoramic textures.

www.marlinstudios.com

In Rendering > Environment, add a Fog effect. Set the color to R:65, G:85, B:110 and check the Fog Background and set the Fog Type to Layered. Now set the Top to 25m, the Bottom to -10m and the Density to 100. Rendering now you will see the depth that this adds. Create one further omni light, acting as a local fill. This should be placed at the same position as the camera, as if your camera had a local light, and given a color of R:150, G:180, B:200. Give it a Multiplier value of 1.0 and turn off its Specular component by clearing the Specular checkbox. Finally, turn its Far Attenuation on, setting 30 and 60 as the Near and Far values.

Next we'll create some caustic effects to simulate the patterns of light that you would see on the seabed. Create a Free Direct light pointing straight down in the Top viewport, centered on the *water* object. Now make this a rectangular light, whose Hotspot and Falloff fits just within these objects - 85 and 95 should do it. Give it a pure white color, a Multiplier of 1.0 and turn off shadow casting. Click the light's Projector Map button and pick Cellular. Now drag this swatch onto a blank slot of the Material Editor, choosing Instance and renaming it *waterCaustic*. Click the Cell Color and set it to a pure black. Rename this light *directCaustics*.

In the Cell Characteristics section, select Chips and Fractal. Set the Size to 300, the Spread to 0.3, and the Iterations to 5.0. In the Division Colors section, set the topmost swatch to a less saturated version of the *waterSurface* material's Diffuse swatch and set the bottom to match the Specular swatch - R:195, G:205, B:220 and R:235, G:245, B:255 respectively. Finally, within the light itself, Exclude the *waterSurface* object from the light's illumination and shadow casting. At frame 100, hit Animate and change the material's Z Coordinate value to 250.

Figure 10.03
Setting up your caustic material

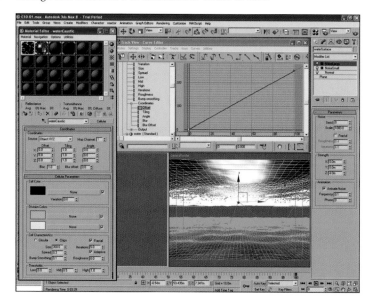

Turn off Animate and in Track View, expand this track - Objects > *directCaustics* > Object > Projection Map > Coordinates > Offset - and change the In and Out Tangent Types to Linear and set the Parameter Curve Out-of-Range Type to Relative Repeat.

To create some shafts of light coming through the water towards the camera, create a Target Spot light, with a pure white color value and a Multiplier value of 1.0. This light should be set to circular rather than rectangluar. Its Hotspot and Falloff should be set to 0.5 and 2.5, its shadows should be turned off and its Far Attenuation should be turned on and set to 205 and 245. The positioning of this light is important - it should be pointing directly into the camera from the sky map's light source. If the light is placed at X:0, Y:140, Z:105 and its target object at X:0, Y:-50, Z:-5, the effect should be about right.

Back in Rendering > Environment, add a Volume Light and pick the direct light you've just created, which you should rename *directVolume*. Set the Density to 1.0, with Maximum and Minimum Light values of 90% and 0% respectively. Turn on Exponential, set the Fog Color to pure white and the Attenuation Color to R:0, G:0, B:160. Set the Attenuation Start and End values to 100% and 85%. Finally, turn on Noise, setting the Amount to 1.0, the Uniformity to 0.3 and the Type to Fractal. With the Levels set to 2.0 and the Size set to 4.0, you're all ready to render again. The time to render a frame will now have leapt up quite considerably, but the effect is worth the effort.

To give our camera some movement, select it and go to the Motion tab. Within the Assign Controller rollout, click to highlight the Rotation track and press the buttton above to assign a

Animated materials

When designing complex animated materials like this caustic effect, it's often a good idea to use the Material Editor to render a preview of the material before committing to a full render. In 3ds Max, to the right of the sample slots, the Make Preview button lets you preview the effect of an animated map on the object in a sample slot.

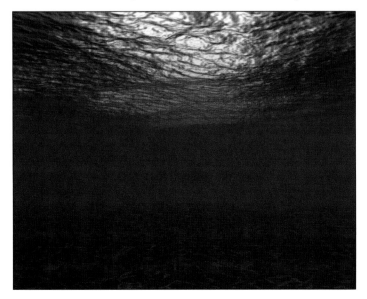

Figure 10.04
The caustic light will project moving patterns across the sea bed

Rotation List controller. Now select the next rotation controller slot marked Available and use the Assign Controller button again, this time to choose a Noise Rotation controller. Set the X, Y and Z Strength to 10, 5 and 15 respectively and change the Frequency to 0.01, unchecking the Fractal box. If you hit Play now, this should get some rolling movement that looks like our camera is being buffeted around by the movement of the water.

One last thing that you might want to consider using is a softer antialiasing filter than the one 3ds Max defaults to. The Soften filter applies a Gaussian blur to the finished frame, which can suit misty or hazy effects, such as in this case. A filter that simply blurs the image might not sound all that desirable at first, and though it might not look it upon examining a single still image, when applied to an animation can create a subtle softness that helps remove just a little bit more of the CG edge. For a further discussion of 3ds Max's different antialiasing filters and their application, refer to chapter 18.

Figure 10.05
Your finished image should have a soft and hazy underwater feel

However, a better technique would be to take this sequence into Combustion and apply this blur there - that way you wouldn't need to rerender the sequence again if you needed a different level of blurriness. We'll take a look at what's possible with compositing applications in chapter 15.

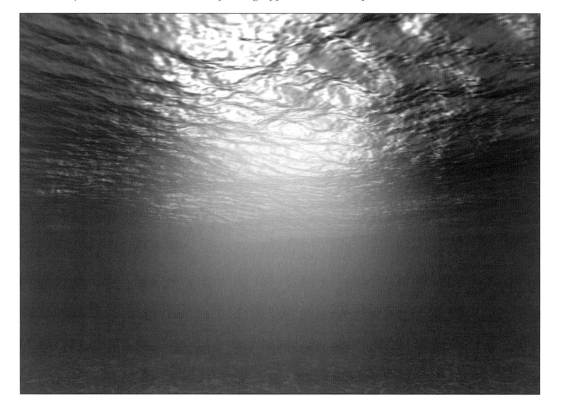

Tutorial - candlelight

Though the first bonus chapter on the DVD covers natural effects like fire in more detail, we'll take candlelight as a special case and consider it here. This can be thought of as a gentle intro-duction to fire, with more details within this bonus section of the DVD. We have an extremely primal attraction to fire and to be able to depict it accurately along with its warm and sensual feelings can make a CG scene very alluring, unlike a lot of the cold, plastic-looking animation that we see so much of.

If you look back at table 2.02, (see p.19) you'll see that candlelight has one of the lowest color temperatures around - approximately 1,900°K - which means that when we see it represented on either daylight-balanced or tungsten-balanced film, it is always going to appear somewhere between yellow and red.

However, the emotional associations that we have with fire and candlelight in particular mean that many cinematographers will play around with the way that candlelight appears in their films, and you may well see candles appearing to be yellow, but you may also see them looking distinctly white. We too as CG artists can do just the same.

Many people fall into the trap of simply making their CG candlelight some variation of yellow or orange and leaving it there. If you examine a candle closely, however, even though the source is very small, its light appears to slightly surround the objects it illuminates and its mid-tones appear quite desaturated. Convincing CG candlelight needs far more than just the correct color - the mid-tones must be made to appear quite colorless.

In this tutorial you will look at simulating the candlelight of a single candle. This will involve setting up several lights to represent the different tones emitted by the flame, paying close attention to the decay and attenuation of these sources, whilst making sure that the shadows are as realistically dark. You'll then finish the whole thing off with the actual candle flame.

Open the C10-02.max file from the tutorials folder of the DVD. You will see a candlestick and a bust side-by-side on a table. We'll first of all create three lights that represent the inner, middle and outer parts of the candle's illumination. Start with an Omni light and center it on the *flameR* object, naming it *omniMiddleNear*. Give it a Multiplier of 1.5 and a warm orange color of R:255, G:180, B:0. The Decay should be set to Inverse Square with a Start value of 1.5. The Far Attenuation should be set to Start and End at 0 and 50. Clone a Copy of this omni and rename it *omniInnerNear*. Change the color to R:255, G:250, B:175 and the Decay Start value to 1.0. Finally, clone this light one last time and rename it *omniOuterNear*. Give this a color of

R:250, G:225, B:150. Change the Start value of the Inverse Square Decay to start at 2.0. If you render now, you'll see that the illumination local to the top of the candle looks great, but the illumination really is just that, local.

What we need to do is clone copies of these three lights and extend their reach so that they illuminate the adjacent bust, giving us some more far-reaching light in the scene. Create a Copy of each, making the Start value for the Decay on each start at ten times the original distance: so 10, 15 and 20 for the inner, middle and outer lights. Rename these, replacing the Near in the name to Far. These lights should not illuminate the *candleR* object, so hit the Exclude button within the light's General Parameters and select this object and move it to the right-hand list, making sure the radio buttons above are set to Exclude and Both. A render now will demonstrate the light reaching the bust and providing some subtle illumination.

We're not done yet though - we need to add some more lights to complete the flame's illumination. Create another omni and give it a Multiplier of 0.8 and a color of R:255, G:210, B:155 to represent the orange light at the base of the flame. Set the Decay to Inverse Square again and alter the Start value to be 1.0. Turn on Far Attenuation and set the Start and End values to 0 and 30.

Rename this light *omniLow01*, go to the Motion panel and within the Assign Controller rollout, click the Position channel label to select it. Now hit the Assign Controller button above and to the left, within this rollout, and select an Attachment controller. Down in the Attachment Parameters rollout click the Pick Object button for the Attach To option and select the *flameR* object.

Figure 10.06

Use the Exclude function to stop the candle object being illuminated

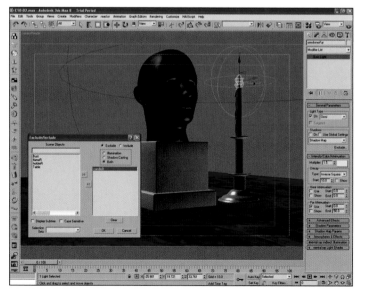

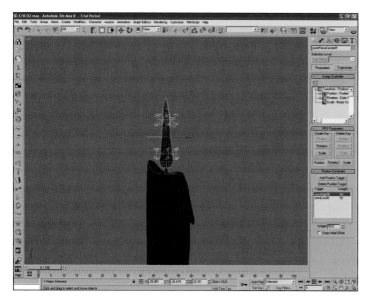

Figure 10.07
The Position Constraint controller
will control your lights' position

Now click the Set Position button and Move the light to just
above the curved base of the flame, almost a quarter of the way
up the flame object. We want to have these lights arranged
around the outside of the flame object at this level, so Clone an
Instance of this light. Returning to the Motion panel, click the
Set Position button once more and move this light around the
flame, adjusting its position to keep it level vertically. What you
are aiming for is four lights arranged equally around the flame
object but at roughly the same height.

You now want to do the same thing but up towards the top of
the flame, about three-quarters of the way up. This light should
be renamed *omniHigh01* and given a light yellow color of R:255,
G:245. B:175. Set the Decay to Inverse Square, setting the Start
value to 0.8 and turn on Far Attenuation, setting the Start and
End values to 0 and 30 again. You should now Clone Instances of
this light and place them around the flame object, like you did
with the row of lights near the base of the flame.

If you hit the Play button now, you will see that the lights that
are attached to the flame mesh will move with its Noise mod-
ifiers. What we want is for the lights that are placed at the
center of the flame to move in a similar way, but we don't want
them to be constrained to the outside of the mesh, so we'll have
to take a different approach. Create a Point helper object and
using the Align tool, align this object to the same X, Y and Z
position as any of the six lights central to the flame object.

For this object, instead of an Attachment controller, add a Position
Constraint. Click the Add Position Target button and select one of
the lights from the top row of lights on the outside of the flame

mesh. Your helper will jump up to the level of this row, so select another light from the bottom row, but make sure that the light you select now is on the opposite side of the flame from the first light you selected. This will bring the helper back down to the midway point between these two rows of omnis, where its position will be constrained to the average of these two lights' positions. Now you should select all of the six lights and use the Select and Link button to parent your lights to the point helper. If you play the animation now, you can see that these lights move with the flame whilst staying central to the two rows of lights.

Rendering now will reveal a result that is quite dark, as you might expect, but we can use some blue fill lights to cheat some illumination into the scene. Create a Target Direct light somewhere around X:50, Y:45, Z:75, with the target centred on the bust. Give it a color of R:120, G:120, B:255 and a Multiplier of 0.2. Turn off Specular in the Advanced Effects rollout.

Create another Target Direct light, this time placed on the opposite side of the table - at around X:50, Y:-60, Z:75 - again targeted on the bust. Give this a pure blue color and a Multiplier of 0.05, again clearing the Specular component. Render now and you should see that the blue fills make a very subtle difference just adding some fill without breaking the illusion of darkness.

Figure 10.08
Your blue fills and glows should have finished things off nicely

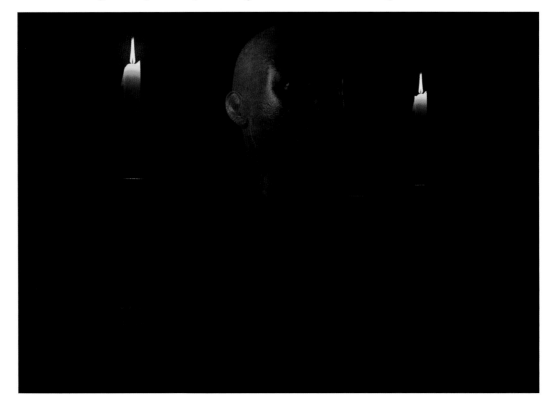

Finally, we'll add a glow to the flame that will finish things off nicely. Within the Material Editor, change the Material ID Channel of the *flame* material from 0 to 1. Open up the Rendering > Effects menu and choose a Lens Effect. Add a Glow and within the Glow Element rollout, change its name to *glowSmall*. This needs a Size of 1.0, an Intensity of 80 and should have its Use Source Color field set to 100, which makes the glow inherit its color from the light or, in this case, material it's assigned to. Within the Options tab of this rollout, you should check the Material ID box.

Repeat this operation to add another Glow, called *glowLarge*, which should be set to have a blue color of about R:50. G:40, B:255, It should also have a Size of 10 and Intensity of 125. Set this glow to work with the same Material ID of 1. Render now and you'll see the effect of these two glows on your output.

Finally, drag and select the candle holder, candle, flame and all the lights you've created and, in the Left viewport, hold down Shift and Move this to the other side of the bust, choosing Instance when prompted. If you render again, you'll find that your new candle seems far more illuminated than the other. This is because the three lights that cast the illumination that reaches the bust had the *candleR* object within their Exclude lists. However, these new copies need to have this new candle object within their Exclude lists. Select *omInnerFar01* and add the *candleR01* object to the Exclude list. Repeat this for *omniMiddleFar01* and *omniOuterFar01* and you're done.

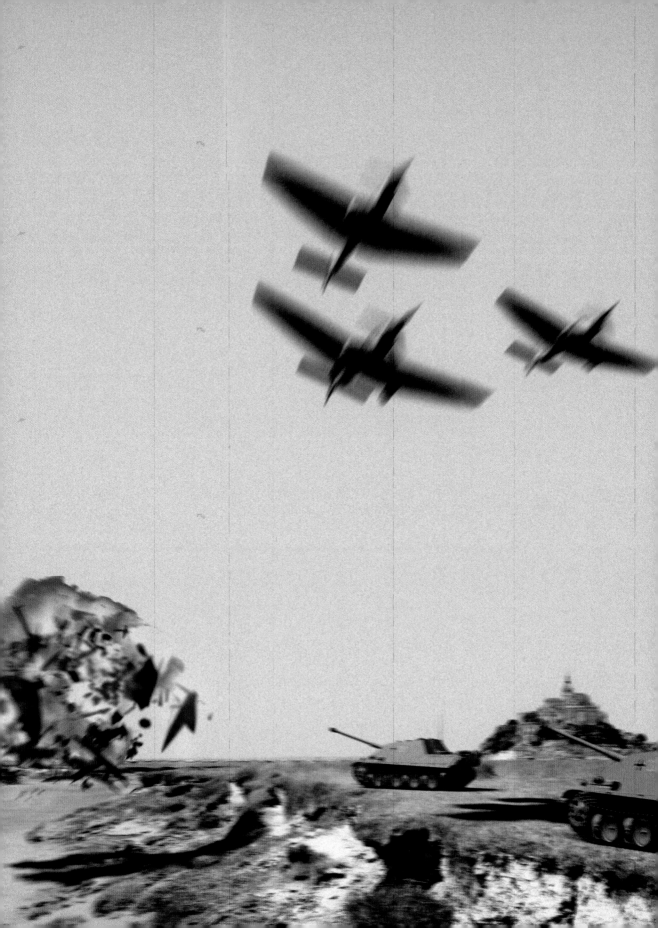

11

'My name is Raquel Welch. I am here for visual effects and I have two of them.'

Raquel Welch *(presenting the Academy Award for Best Visual Effects)*

Background plates

Working within visual effects and post production frequently involves integration of computer-generated elements with live-action sequences, as well as still photographs and matte paintings. Working with background plates like these presents a sizable challenge in terms of integrating the CG elements, and lighting of course plays a key role in this process.

Backplates like these can originate on film, in which case they would have had to be digitized, which involves a scanning process called telecine, before they are available as a digitial sequence. Similarly, live-action that started life on DV may need to be deinterlaced before it can be used as a backplate. This process involves converting the two interlaced fields that make up each frame into full frames and is detailed further in chapter 16. The first stage of matching up backplates with CG content involves camera matching, which can be an easy or a difficult process, depending on the individual sequence.

Image courtesy of:
Big Face Productions
www.big-face.com

If the camera within the live action is static, then matching your CG camera can involve a simple matter of trial and error with positions and lens types. A process called camera tracking, which is also known as matchmoving, can also be employed to match cameras. This process is used widely where a match for moving cameras is required and is discussed further in chapter 19. With the footage in a digital form and a matched camera, it's possible to start constructing a shot that will blend CG elements together with the live-action backplate.

Furthermore, background plates can also be mapped to geometry within your 3D scene using mapping coordinates based on the matched camera. This process, known as camera mapping, produces a 2.5D environment which a camera can move through, though this movement is restricted due to the way this scene is constructed with textures projected using planar coordinates.

The major part of working with backplates from a lighting artist's point of view is matching the CG lights with those in the plate and this we will cover in detail. If these lights are to cast shadows and interact with the footage, then matte objects need to be placed that also match the scene's geometry. With the vast majority of CG work involving backplates, compositing software is employed to tweak the final output and ensure that it blends into the footage in as seamless a manner as possible.

If you are working with live-action footage, then the best time to start thinking about match lighting is not when it first appears in digital form, but before the shoot itself begins. Most CG artists are not fortunate enough to be involved directly with the shoot and (certainly in my experience) consider themselves lucky if

Figure 11.01

Balls used to record lighting data as demonstrated by Framestore CFC

they get handed any notes or reference photographs. However, if you are working for a smaller outfit and are lucky enough to be involved in this stage of the process, there are many things that you can do to ensure that the shot goes as smoothly as possible. Detailed notes and measurements of the set's dimensions and light locations can help tremendously, as can reference photography, particularly if texturing work has to be carried out to match this environment. Data on the camera's lens type is very helpful, as is making sure that a reference grid is recorded by the camera in order to calculate lens distortion. The final thing that can be of use is photographic reference of the lighting using reference balls.

Lighting reference data

The balls generally used to record lighting data as a reference come in two types: a matte light gray color ball and a highly reflective ball. Though professional versions of these are of course available to purchase, you can in fact make your own matte version using a polystyrene ball (available from certain art and craft stores) painted a 20% shade of gray with a matte finish.

This can then be placed on set and recorded using the same camera, preferably just before or after the filming of the shot so the light has not altered greatly. If working with film, this should be scanned at the same time as the rest of the shot on the same telecine, and if color correction is being applied, then it should receive the identical treatment. Following this, the image should be brought into a paint package like Photoshop or 3ds Max, where its RGB values can be interrogated. These values can then be assigned to the lights in the 3D scene. Indeed, if the reference image is brought into your 3D application, then an equivalent sphere can be built and placed alongside the reference image. Given the same 20% gray matte finish, the task of lighting the scene then becomes much more straightforward, as once the 3D ball's lighting has been matched to the one in the background plate, the lighting setup should already be shaping up.

In order to further refine this solution, a reflective sphere is also helpful in gauging where any light sources are coming from. Cheap versions of these can be bought from some gardening stores and should be filmed in just the same way, using the same camera from the same position as the shot was taken from. Again, setting up a ball with a raytraced chrome material in 3ds Max will enable you to match CG lights with the ones in your plate. This helps particularly in terms of their direction and how highlights should be falling from the key light and any other bright sources. Using these methods you should at least be able to place your lights so that the highlights of at least the dominant light source fall correctly and are of the correct appearance.

More often than not, of course, you won't have access to any of this kind of data. You won't have even been on the shoot or have access to anyone who was on the shoot, and all you have to go on is the footage itself. In these instances, the shadows within the plate are the best guide to the direction of the dominant light source and objects that are on the lighter side of gray within this image can be interrogated for RGB values.

However, if you can ensure that these two types of balls are filmed as part of the shoot, then the job is going to be a lot easier, and there's a second very useful way that the reflective ball image can be used. This image can subsequently be used as a spherically mapped reflection map for the scene's objects.

HDR

There's a second approach to using reflective balls as a way of gaining lighting data from a scene that is a relatively old technology that's now a firmly established method of lighting in CG. As we discussed in chapter 6, High Dynamic Range (HDR) images are stored in a non-clamped color format, which gives a far larger range of luminance. Rather than being restricted to 8-bits, which represent each channel value with a single integer from 0 to 255, non-clamped color contains the value of each color as the renderer sees it, which provides far more accuracy.

Figure 11.02

HDR rendering (as produced in cebas' finalRender)

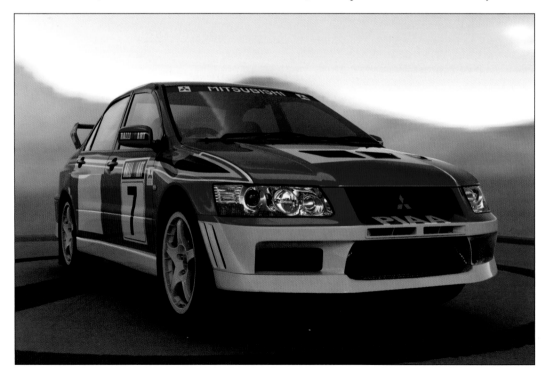

Figure 11.03
With pixels viewed as floating-point numbers, an HDR image can be darkened, lightened and even motion blurred more effectively than conventional 24-bit images. (HDR version right, 24-bit left)

Image courtesy of:
Paul Debevec
www.debevec.org

Whereas a white pixel in an RGB image could represent many things from a white wall to the sun itself, these two items have very different energies. By looking at each of the images from the different exposure levels, an energy value can be built up which allows the renderer to know the difference between the different whites. A white pixel with a value of 300, for instance, would be a little beyond the range of the regular 0-255 RGB system, but if the software encountered a pixel with a value of 10,000, for example, it would assume that this did not belong to a surface in the scene, but to a sky or light source.

HDR images are put together using a process that is a little involved, but one that is not actually too complex. First, the reflective ball must be photographed at different shutter speeds, without moving the camera. The range of exposure settings should ensure that the darkest parts of the scene are clearly visible in the longest exposure and that the brightest parts of the image are not blown-out to white in the shortest exposure. The interval at which you take the intermediate images between these two extremes of exposure depends on how well your camera's response curve is calibrated. If the response curve isn't known, then the safest bet is to take the images one stop apart. Once the camera's curve has been properly calibrated, you can take the sequence at three stops apart, but you can never take the images too close together.

These can be assembled together as a single HDR file in the excellent HDR Shop, an application designed to view and manipulate HDR images, which can be found at www.hdrshop.com. In theory, the view that the camera has of the mirrored ball contains all the information needed to capture the full 360° environment. However, the areas of the image that

Light probe images

www.debevec.org is the best place to visit for information about HDR imaging. As well as the invaluable HDR Shop software (pictured below), there are also HDR images to download and Paul Debevec's excellent Fiat Lux animation.

lie around the periphery of the ball are extremely distorted and will result in a poor image when unwarped. In addition to this, the reflection of the camera will be in the center of the sphere.

To get round this problem, the sphere needs to be photographed again, this time with the camera located 90° round from the last position, giving you two images that are perpendicular views of the sphere. With the two images cropped to the very edges of the sphere, the next stage in the process is to identify two corresponding points on the images. This gives HDR Shop the information it needs to perform a 3D transformation on the images, which will give you two images with the sphere captured at the same orientation. One of these images will still have the camera at the center and the other image will have distored edges. Putting these two images together with a mask so that your final HDR image contains neither the camera nor the distortions is the final stage of this process.

With these areas removed, you have a finished HDR image that can be used to illuminate your scene (as well as providing matching reflections). Because this image does not store the pixel color values as seen on-screen, but as floating-point numbers, this gives a far wider gamut of luminance information to the renderer. It is this energy information that is used in the rendering. Another term you might hear for HDR lighting is image-based lighting, which refers to the use of images as a replacement for light sources.

Figure 11.04
A HDR image viewed in toxik, which supports 32-bit float processing, allowing work with HDR images

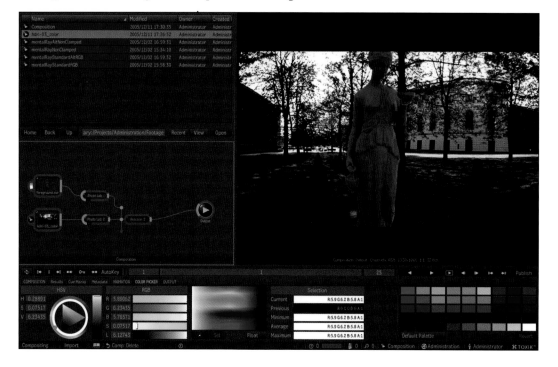

Whilst this all sounds great, the large variations in pixel values that give the renderer the information it needs can also cause sampling problems. Given the fact that adjacent pixels can have such extreme energy values of 10 and 10,000, using a low-resolution blurred version of the HDR image that you have created can work wonders, as these pixel-to-pixel variations are smoothed out and so too are sampling issues.

You may think that there would be a massive difference in quality between a heavily blurred 512 x 256 version of an HDR map that was produced from a 4,096 x 2,048 original, but often the smaller version will look better, render faster and produce less sampling issues. The high-res original can still be used as a reflection map.

However, there's a wealth of information out there on the web - www.debevec.org is a particularly good starting point - and this is a technology that can produce some stunning results. Though its use a few years ago in big Hollywood productions was fairly limited (*X-Men the Movie* was the only big use of the technology in 2001) it has well and truly caught on and was more recently used in *Spiderman 2* and *Batman Begins*, as well as *X-Men 2*.

Match lighting in practice

When working on a production with a mixture of live-action footage and CG elements, match lighting goes through many stages of development. The first time that the CG content is pulled together with the background plate little attention is generally paid to the lighting setup. This first stage generally involves getting an exact camera match, which can involve specialist camera tracking software, or can simply be matched by eye, especially if the camera is locked off for the shot.

With a matched camera in place, the next stage would involve putting together a rough lighting setup. If you have the lighting references of the matte and reflective ball that we mentioned earlier, this stage is not too involved. By recreating these objects, by placing two spheres in your scene, and assigning them the same matte gray and reflective chrome materials, your job positioning these lights and gauging their colors and intensities will be made a lot more straightforward. At this stage you might want to test out the shadows of your dominant light source, using matte objects within the scene to recieve shadows from these balls in order to establish that they sit fairly well with the plate, but at this stage you are not looking for an exact solution.

If you are fortunate enough to have HDR images generated of the location, then your lighting test at this stage would be easier still and would involve a similar process of placing 3D spheres and making sure that the HDR lighting setup produces a good match.

With this basic lighting in place, the scene is ready for content from the modeling and animation teams whose work may be in an early stage too. It may be that you receive untextured models, or they may be textured but not to a final standard. Likewise any animation work may not be locked down and the whole shot may still have to go through one or more approval processes with internal senior creative staff, or with external clients.

Changes by these other teams, particularly to texture maps and materials, can change the way that a lighting setup interacts with a scene and the way it looks at render time. It's important to not go too far down the path of sorting out the finer details of a lighting setup too soon, as things can change that will throw this whole setup quite drastically. Conversely, it is also not useful to start refining this lighting setup too late in the day, as the other teams' work will be too far down the line by this point should changes in their work be needed.

Once you get into this process of receiving work from these other teams, the process of finalizing the lighting setup becomes rather iterative, with your setup getting more and more finalized as the work handed over from these teams becomes likewise increasingly locked down and closer to the final version.

Figure 11.05
Building up a composite from an early stage is always a good idea

What is useful at this point is to start building up a composite within Combustion, or whatever other compositing software you are using. Alternatively, at this stage, you might already be

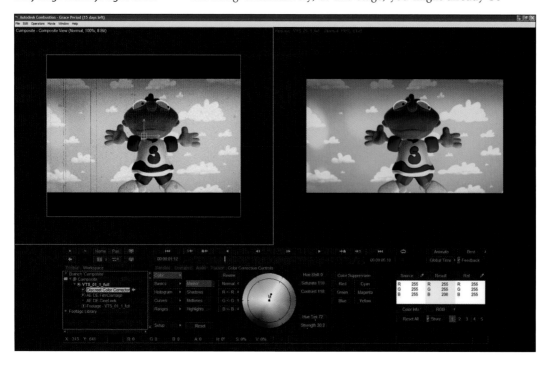

rendering content and passing this to your compositing team to start refining the final solution. The closer this process gets to being finalized, the more concerned you will become with the smaller details of a shot. What is useful about getting a working version of a shot into a compositing environment at an early stage is that you can begin to color correct and tweak any rendered content to ensure that it will match perfectly, rather than trying to adjust parameters like light colors that are easily changed within the compositing workflow.

Overall then, that's how the process works, or at least that's how it should work. You may be the one doing the modeling and animation too if you work in a smaller company. However, we can presume that you are doing the lighting work whatever sized company you are working for, so let's step back to the start of this process for a moment. If you are attempting to build up your lighting setup manually, using individual lights, you should work in the same way as you do when building up any three-point lighting setup. Your lights should be placed one by one in order of dominance, starting with the key light. The position of this should be determined by looking at the background plate, any notes and detailed measurements that were taken on the shoot, as well as any reference photography that also exists.

These scraps of information from the shoot can be invaluable at this stage, so whoever compiles these should ensure that they are always clear and consistent. For instance, the dominant light's position should always be referred to from the point of view of the camera in terms of its position from left to right, but relative to the subject in terms of its position from front to back.

For example, 'upper right, slightly forward' would be to the right and up from the camera, and slightly towards the camera from its subject. What is much more useful though is a quick set of measurements, which can provide much more accurate and usable information than descriptions of relative positions. Whilst reference photography and clear production notes can help to position a key light in 3D, there exists a fair margin of error to work within where the human eye will still perceive the results as being correct, so don't worry too much about position-ing the key light or any that follow with exact precision.

It can be useful to reduce the shadow color from a pure black to a dark gray or reduce its density value in order to get results that immediately begin to look more like global illumination, but care should be taken that the fill lights don't subsequently wash the contrast out from the shadows; so don't go too far down this route initially before at least your primary fills are placed. The next task would be to place any other logical lights, the number of which will depend largely on if your shoot was indoors or outdoors. After this, you should carefully place the fill lights,

starting with the most obvious bounced lighting, often referred to as the primary fill, which often will be the light reflected up off the floor, or from any walls or large elements within the environment. This will depend largely upon the angle of the key light and how it hits the various surfaces on set. The secondary fill lights can be as few as you want to get away with or as many as you want, so long as the final rendering looks convincing. However many fill lights you decide to include, the only shadow casting light should really be the key light.

Whilst bounced light might produce subtle secondary shadows, the chances are that these shadows will be so extremely subtle as to be unnoticeable. Anything less than very subtle will look plainly wrong, and adding secondary shadows that have the right level of subtlety will in the vast majority of cases just add to render times unnecessarily. Often just a few extra fill lights will be enough to create a convincing match. There is no need, certainly at the early stage of this setup to overly complicate things.

Lighting arrays can be considered, with the colors of the individual lights tailored to match the colors from within the plate. The use of lighting arrays avoids a common pitfall of setting up fill lighting in a less organized manner: the gap in a lighting setup that is often caused by the artist missing out the backlighting. To see whether a match lit rendering is evenly matched in terms of the contrast levels within the 3D elements and the plate, it's a good idea to look at the levels for the plate and the CG elements alone. You should see an equivalent match at both the black and white ends of the distribution, plus a fairly even spread between these two points.

It is worth stressing again that if you can get to the set, do so, and arm yourself with camera, tripod, tape measure, and blueprints of the set if they exist. Even if they do, take out your tape measure and jot down your own dimensions, making sure that you take diagonal measurements along the way to check your other measurements against.

Make notes as to where the lighting on set is located. An hour spent here can save many when it comes to building a 3D version. Take as many snaps as you think are necessary, then take some more: don't forget to take every surface flat-on if you plan on using its surface as a texture map; take a panoramic using a tripod from the middle of the set to record the environment, which can always be stitched together and used as a reflection map.

Of course, you'll probably need to hang around on set for the whole of the day, because the minute you're done taking your measurements and photographs and decide to leave, the production crew will no doubt decide to change the lighting set-up, or even move the set around.

Match lighting without reference

All this information on balls and probes is of no use whatsoever if the production you're working on does not include these kind of references as part of the shoot. So what do you do if this does not happen? There's always going to be times though where you can't even get near the set and all you have to work with is the background plate itself. When this is the case, the shadows will be your best clue as to where the dominant light is coming from.

Use any elements that are as near to white or a shade of gray as you can find in the plate to interrogate for RGB values and use these values to help with your lighting setup. If there's something that's easy to pick out and model within the plate, duplicate this element in 3D, using this as an aid not only in matching the illumination, but the highlights too. Match lighting is quite possible without any reference data, it's just that the process is a bit more time-consuming and laborious as it is more based on experimentation and making educated guesses.

Tutorial - match lighting without reference

In this tutorial you will learn how to match light a scene with no reference data. This will involve placing the plate onto an element that will act as the background and matching its mapping to the camera. Then the foreground needs to be modeled in 3D and given a shadow receiving material so that any objects placed in the scene will cast shadows. The task of lighting the scene can then begin.

Open the C11-01.max file from the tutorials folder of the DVD. You will see a plane and a camera, nothing more. Open the Material Editor, and in a new material slot, choose C11Plate.jpg as your Diffuse Color map and make this material 100% self-illuminated. Rename this material *backgroundPlate*. Change the Specular Level and Glossiness to 0 and apply this material to the box object, the one named *backgroundPlate*. With this object selected, add a Camera Map World Space modifier and in its controls, pick the scene's camera. If you render the camera view now, you should get the background image filling the frame.

To enable the objects that we're going to create in this environment to cast shadows on this background, we need to create some foreground geometry. Create a plane in the Top viewport that is roughly the same width as the *backgroundPlate* object and stretches from its front edge all the way to the camera. Next, move it vertically until its far edge is roughly in line with the horizon. To give us some detail, which we'll need to deform it to match the riverbank, increase its Length and Width segments to 50 in each direction. Now add an Edit Mesh modifier, followed by another Camera Map Binding WSM modifier, again picking the

camera. Rename this object *foreground*. Copy the *backgroundPlate*
material by dragging it to another slot, and rename this new copy
foreground. Apply this new material to your *foreground* plane. At
this object's vertex sub-object level, move groups of vertices
around to roughly match the foreground terrain, using Soft
Selection to make this task a lot more organic. Don't fret about
matching this too exactly, as the shadows will be moving fairly
fast over its surface. If you'd rather skip this step, open C10-
01a.max where this modeling is complete.

To aid us in placing a light representing the sun, create a sphere
floating somewhere over the grassy patch to the right. Now look
at which way the shadows on the plate are falling and create a
Target Direct light representing the sun that reflects this
direction, which is from almost overhead, slightly to the left and
away from the camera. As this is an outdoor scene, you'd be
using daylight-balanced film. The sun, as we've already discov-
ered, is almost overhead, so its color temperature, according to
table 2.01 (see p.13), is 5,000°K. Daylight-balanced film, you
should remember, has a color temperature of 5,600°K, so the light
has an ever so slightly smaller value. Using figure 2.05 (see p.14)
as a reference, this would mean that the light should be given
the very slightest hint of yellow. Set its Multiplier value to 1.0
and turn on shadows, setting the shadow density to 0.6 within
the Shadow Parameters rollout. You should increase the shadow
map size to 1,024 within the Shadow Map Parameters rollout.
Finally, turn on Overshoot and rename this light *directKey*.

Change a viewport to the direct light's view and adjust the
Hotspot cone until it is large enough to just cover the entire
plane. Now bring the *foreground* material's Self-Illumination

Figure 11.06
With your sphere placed, you can
begin to try to match the key light

down to 0 and render the scene, adjusting the light's position until the shadow orientation appears to match that of the scene. In order to give us water that will move and give our scene some life, we need to create this as a separate element. Clone a Copy of the foreground plane, delete the Edit Mesh modifier, leaving the Camera Map modifier, and move it into place just above the foreground plane, reducing its size and segments appropriately so it just fits the water. Rename this object as *water*.

For the water's texture, in a blank Material Editor slot, change the Ambient and Diffuse color swatches to black and up the Specular Level and Glossiness to 125 and 40 respectively. In the Diffuse Color slot, select the C11Plate.jpg image, setting its Amount to 40, and in the Reflection slot choose a Mask map. Place the C11Plate.jpg image in its Map slot, and in the Mask slot specify a Raytrace map. Back at the top level, in the Bump slot, select a Noise map, changing its Noise Type to Fractal and its size to 40. Turn Auto Key on and enter –1.5 for the Phase value at frame 0 and 2.8 at frame 300.

Open up the Curve Editor and set the tangent types for these keys to Linear and set the Out-of-Range Types to Relative Repeat, so that your water's bump movement will continue no matter what the frame range you decide to work with. Now turn AutoKey off and apply this material to the *water* object. Finally, rename this material *waterRaytrace*. If you move the sphere over the water and render again, you'll see that though we're getting reflections, the water is also receiving shadows which does not look right, so select and right-click the *water* object, and turn off Cast Shadows and Receive Shadows. Your last render also showed that we need some fill lighting.

Figure 11.07
Adjust the direct light's cone to just fit over the foreground plane

For this, merge in the light array from the C11-01array.max file. If you render with this array now in the scene you'll see that your sphere's lighting looks good, but the foreground of the scene is blown out. You will need to open up the *arrayDomeLights* group and for each individual light, exclude the *foreground* and *water* objects from each light's Illumination and Shadow Casting. This is a somewhat laborious process, however, when you're done, you have the basic scene set up.

Next we'll bring in some extra elements. Go to File > Merge and select the C11-01-merge.max file. Select all the objects and OK this. If you scrub through the timeline you should now see that this consists of four Spitfires flying towards the camera. Select the scene's camera and Clone a Copy, renaming this *cameraFree*. Set the bottom-left viewport as this new camera so that you have the two Camera viewports next to each other. Change its FOV to 40 degrees and go to frame 40 before hitting Auto Key. Move the target in the Camera viewport left towards the first Spitfire, as far to the left as is possible without the Camera Map becoming apparent, then move it up until it's level with the Spitfire (don't worry about reaching the end of the Camera Map beyond the top of the backdrop). At frame 100 move the target right and down to follow the Spitfire, again within the horizontal bounds of the Camera Map.

First move the key in the timeline from frame 0 to frame 20 and then shift-drag the key at frame 100 to make a copy of it at frame 150. At frame 100, change the camera's FOV to 30 degrees and then at frame 140 change it to 40. Move the key from frame 0 to 80. Select the camera's target object once again, right-click and choose Curve Editor.

Figure 11.08
Water needs to be created to give this area some movement

Expand the Transform > Position track if it's not already visisble
and select all the keys, then change the tangents to Linear.
Repeat this process for the *cameraFree* object's FOV. At frame
240, move the camera target to the left as far as it will go and
down slightly until it's level with the rightmost Spitfire, then at
frame 260 as far right as it will go and up until the horizon
disappears out of the bottom of the camera view. At frame 270,
move the target to the right until just half a Spitfire is left
visible, and move the target up level with it. Drag this key to
frame 280, adjust the In and Out interpolations in Track View to
Linear and turn off Animate.

Figure 11.09
Move the target towards the first
Spitfire without making the
Camera Map apparent

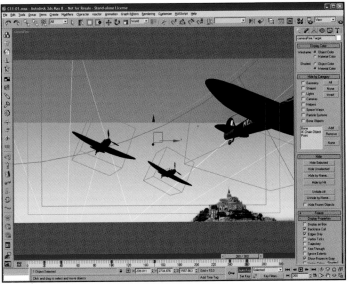

Figure 11.10
At frame 260 move the camera
target up and to the right

To mask off the sky, put C11PlateMatte.jpg into the *backgroundPlate* material's Opacity slot and uncheck the Tile boxes in the Coordinates rollout of both this and the Diffuse map. In the Utilities panel, pick Color Clipboard. Choose File > View Image File and select C10Plate.jpg. Right-click a colour at the very top of the sky and drag this from the swatch in the top menu bar to one of the Clipboard slots. Now grab a mid sky colour and one from just above the horizon.

In Rendering > Environment, choose a Gradient Ramp for the Environment Map. Drag this to an empty slot in the Material Editor, and in the Gradient Ramp Parameters rollout right-click the first flag to edit its properties. Now drag the colours from the clipboard to assign them to the ramp. You want to assign the darkest blue to Flag#1, the lightest to Flag#2 and the mid-blue to Flag#3. In the Coordinates rollout, enter –90 in the W Angle field and change the Mapping to Spherical Environment.

Select the *cameraFree* target object and right-click in a viewport, choosing Curve Editor. Now expand the Transform branch and highlight the Position label. Click the Assign Controller button above this area and choose Position List controller. Now select the slot marked Available and assign this a Noise Position controller, changing the X, Y and Z Strength values to 10 and the Frequency to 0.5 in the dialog that appears. If you scrub through your timeline you should see that your camera now has some shake.

Select the *backgroundPlate*, *water* and *foreground* objects, and by right-clicking, and choosing Properties, enable Object motion blur. Now add some Film Grain in the Rendering > Effects dialog, choosing a grain of 0.1 and leaving Ignore Background

Figure 11.11
Your camera target's animation should look like this in Track View

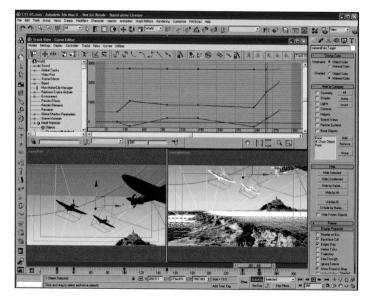

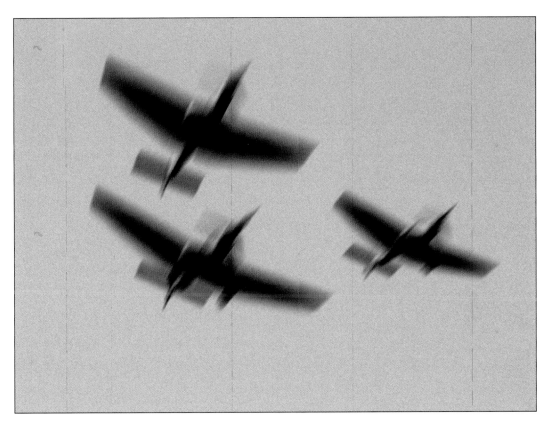

unchecked. Finally, before rendering, make sure the Object Motion Blur is turned on, with Duration of 0.5 and 10 Samples and Duration Sub-divisions. This will take a while to render, but of course a rendered version of the final sequence can be found within the images folder of the tutorial on the DVD.

Figure 11.12
With your matte placed, the camera can happily look up beyond the Camera Map

12

'From within or from behind, a light shines through us upon things, and makes us aware that we are nothing, but the light is all.'

Ralph Waldo Emerson, *The Over-Soul*

Physically-based lighting

When it comes to complex lighting effects, the scanline renderer can become a little restrictive. Global illumination requires the separate calculation of a radiosity solution, which takes time, but is at least possible. If caustic effects are required, the scanline has nothing to offer and a creative fake must be found. However, mental ray, which is included with 3ds Max as a second renderer, provides a solution for generating not just caustics, but other physically-based lighting effects like GI, as well as area lights and useful methods like ambient occlusion.

Whilst there is a time and a place for employing creative workarounds, as you've hopefully discovered by now, there is also a time and a place for employing a specific renderer for a specific task. 3ds Max's support for caustics makes it a first choice when it comes to these kind of tasks, but beyond this it has a great deal to offer a lighting artist, which is primarily why a chapter is being devoted to a renderer in a lighting book.

Image courtesy of:
David McKie
www.dmmultimedia.com

As powerful as mental ray is, it is fair to say that prior to 3ds Max 8, rendering with mental ray could be a little offputting. Even getting up and running with the renderer could be daunting as the documentation was somewhat sparse. Furthermore, the way in which mental ray was licensed was also a little restrictive, as its use was limited to one node per 3ds Max license. However, with 3ds Max 8, mental ray's licensing was opened up and its use is now possible across unlimited render nodes, meaning that it can be employed across whole render farms with backburner at no extra cost. Thankfully its documentation is also vastly improved.

The renderer offers so many lighting related features and is so powerful that as a 3ds Max lighting artist, you simply cannot afford to overlook it. However, as this is a lighting book, rather than a rendering book, this chapter won't go into an overly detailed breakdown of the individual controls within the renderer. Instead, it will go through the fundamental of its settings as we examine several lighting scenarios where the use of mental ray can offer something over the scanline renderer.

First of all we'll look at the application of mental ray for an indoor scene, then we'll look at using the renderer for an outdoor scene. Finally, we'll take a specific look at generating caustics. Along the way, we'll take a look at rendering ambient occlusion and using mental ray's area lights. This should give you a good overview of the renderer in these various situations, from which you should be able to explore further.

Before we jump into the first of these tutorials though, there's a couple of further points that are worth mentioning about the way that working with mental ray actually differs from the scanline.

Figure 12.01
mental ray offers so many features that you cannot afford to overlook it

Image courtesy of:
David McKie
www.dmmultimedia.com

Firstly, there is the way that mental ray deals with 3ds Max materials. For the most part, it treats 3ds Max maps and materials the same way the scanline does, though there are some exceptions. For example, maps used to create reflections and refractions - notably raytrace and flat mirror - are supported, but mental ray uses these as indications to use its own raytracing method, leading to some restrictions on which parameters are supported. Within the flat mirror map, for example, the blur feature is not available. Notably, the antialiasing settings within the Raytrace map are not used, because mental ray uses a different system of antialiasing, which we'll get to in a moment.

There are other quirks, like Overshoot or Include/Exclude not working with shadow mapped lights, only with raytraced shadows. Also, directional lights are assumed to come from infinity, so objects behind the lights are calculated. For a full explanation of these issues, you should refer to 3ds Max's online Help, but you should not be too put off by these issues, which might catch you out initially. However, mental ray really does have such a tremendous amount of good features that these few quirks are a price worth paying.

Finally, for those used to the top-down manner in which the scanline renders an image, the way that mental ray renders its output in rectangular blocks might seem a little peculiar. These blocks are called buckets and this method is used primarily to conserve memory. Though the order in which they render can be altered, the Hilbert method is the default when mental ray is assigned as a renderer. This is generally an option that won't need to be changed, as the order is decided by which is the least expensive bucket to render next and therefore it's generally the most efficient algorithm for bucket rendering.

Figure 12.02
The way that mental ray deals with raytracing differs from 3ds Max

Image courtesy of:
David McKie
www.dmmultimedia.com

Tutorial - global illumination

If you open C12-01.max, you will see the familiar indoor scene from chapter 8. You will no doubt remember the way we lit this scene first with radiosity, then with a selection of standard lights in order to build up a faked solution with the look of global illumination. Well, you can probably guess what we're going to do next: we're going to use mental ray's lights to show how simple these are, then we're going to render, again with mental ray. This should demonstrate how simple it is to take any scene, even one that's been set up for the scanline, into mental ray.

As you should remember from chapter 8, mental ray uses photon mapping to calculate global illumination, which is a fairly time-consuming process. However, in working out the GI, mental ray does not calculate a radiosity solution. A photon map is a model of global illumination in its own right. This map can be saved and reused in a similar way to working with a radiosity solution. Using a Photon map for GI in the way that mental ray does can cause rendering artifacts such as dark corners and low-frequency variations in the lighting. Whilst this is less of an issue when working with single images, when working with animated sequences, this can become more of a problem. These artifacts can be reduced or eliminated by turning on final gathering, which is an additional step that increases the number of rays used to calculate global illumination

In order to demonstrate the global illumination without making any particular changes to the scene we'll start by working with just a single light. Unhide the *mrAreaOmniWindow* light and turn this on. Render now, and you'll see that you'll get a rendered image which has some brightly lit pools of light and some very dark unlit areas. This is because the image that you are looking at contains the direct lighting only. In order to use mental ray the first thing that you need to do is to enable it as the renderer.

Open up the Render Scene dialog and within the Common panel, go to the Assign Renderer rollout and assign mental ray as the Production Renderer. The first thing you'll notice is that the tabs within this dialog change and it's here that you'll find all of the mental ray renderer's controls.

The first of these is the Renderer tab. This area contains the core renderer controls which start in the first section with the Sampling options, which is to all intents and purposes mental ray's equivalent of antialiasing. For preview purposes the Minimum and Maximum of 1/4 and 4 Samples per Pixel is suitable, so this can be left as it is, but for final renders this should be increased to 4 and 16, or to higher values still. These values are used to take samples at locations around and on the edges of the pixel and uses the Filter setting to combine these

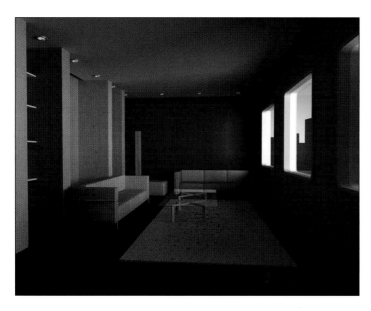

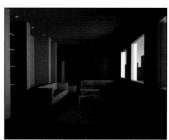

Figure 12.03
Turning on Final Gather (left) will
improve the GI solution

samples into a single pixel color. We'll change our Filter type to Mitchell, which is often the most accurate filter and is best suited to our renders. We can leave the rest of this panel as it is and move onto the Indirect Illumination panel.

Within this panel, enable Global Illumination within the first rollout and leave the settings as the defaults. Render now and you should see that the indirect illumination is being calculated, though the final result is a little rough and ready. The noise within the image can be improved by increasing the Samples per Pixel to 4 and 16, so do this and render again.

To improve our global illumination solution, we'll need to turn on Final Gather, which will open up our dark corners. However, this is where we will start to see a fairly hefty increase in our render times. Initially, leave the number of Final Gather samples at 100 and render again. You should see a marked improvement in your rendered image, as you can see from figure 12.03, but also a big jump in your render time. Finally, you should increase the number of samples to 500 and the Samples per Pixel to 16 and 64 and render again, this time making a cup of tea whilst you calculate your final quality image.

When this is done, you should hopefully agree that mental ray is simple to set up and work with, even though its render options can appear a little overwhelming. There are relatively few of these controls that you need to alter in order to start rendering with mental ray. You will also probably agree that it is rather render intensive when you are looking to generate a final quality image. However, there are a couple of functions that can help speed things up. If you sat with your cup of tea and watched

Figure 12.04
The indoor lighting turned on

the renderer's progress bar tick along, you would have seen that a large part of the render was spent calculating the Final Gather map. If you were rendering a sequence, for example if you had a camera that was moving through this scene, you could save out the Final Gather map for subsequent reuse across this sequence. If you have both of these boxes checked, the next time you render with these maps pre-saved, your render time should be roughly halved at this quality level for this scene.

In order to continue with this scene at a reasonable pace, you should reduce your Final Gather samples to 100 and bring the Samples per Pixel down to 1/4 and 4. Select the *mrAreaOmni-Window* light. If you look in the light's parameters you will see that this light is actually a spherical area light, so you've just had an introduction to working with mental ray's area lights too! We'll come back to these specifically later in this chapter.

Now unhide the *mrAreaSpot* lights and turn one of the ceiling spotlights on, which will turn them all on. As you can see from the names of these lights, they are also area lights, but these spots have this option turned off. By having this option available to turn on and off on a per-light basis, the mental ray lights have an extra element of versatility to them that the rest of the standard lights lack. This is another reason why mental ray is an invaluable option for lighting artists. In order to rerender with these new lights mental ray will have to calculate the scene from scratch. This will involve, of course, recalculating the Photon map and Final Gather maps, so if you had these maps set to be saved out for reuse, you should use the option to rebuild this map, or else your old maps will be reused. Your render should look something like figure 12.04

When this is complete, you should try creating one of these lights for yourself in order to create the sunlight that we created with a direct light back in chapter 8. Within the Create > Lights panel you will see that there are only two types of lights that are specifically prefixed with mr. Create an *mrAreaSpot* and place it at X:1,000, Y:-1,200, Z:800, targeted in the middle of the windows. Give it a Mutliplier value of 5.0 and a slightly yellow tint of around R:255, G:255, B:225. Finally, turn on Ray Traced shadows. Within the next rollout, change the Hotspot and Falloff values to 10 and 12 respectively, and you will find that the cone fits just over the windows. Change one of the viewport's views to this light and move its target object until the cone falls centrally over the four windows.

Turn the Area light option off in the Area Light Parameters rollout. Now change the Exposure Control from Linear to Logarithmic, turning its Brightness and Contrast to 70 and 50. You should now be used to the render settings, so try this light, which should look something like figure 12.05. There's also a cylindrical light within this scene, so you should take some time to experiment, adding your own lights and using 3ds Max's own lights as well as the mental ray lights. You should find that there is nothing particularly different or daunting about working with mental ray. Hopefully, you'll feel quite confident taking some of your own work from the scanline to mental ray, or building something specifically to test and explore the various features that mental ray has to offer over the scanline.

Figure 12.05
After placing a spot for the sunlight

Floating-point images

Back in chapter 8 we looked at generating spherical environment maps using the scanline renderer. As we discovered, these maps can be used to generate realistic reflections and when assigned to Skylights, they can be used to light a scene. Whilst lighting a scene using standard 8-bit (i.e. 8-bits or 256 colors for each of the Red, Green and Blue channels) image formats saved out of the scanline renderer will work to a certain extent; the best formats for saving out images for this use are the HDR and OpenEXR formats. This gives us the increased latitude of a 32-bit floating-point format, which enables us to store a far wider range of luminance. This increased latitude is useful when it comes to image-based lighting, but is also useful in compositing where this latitude equips a compositing artist with the flexibilty to change the levels of an image without clipping this information.

Having this degree of flexibility when compositing has caught on with the big effects houses, particularly Industrial Light & Magic, which has driven the development and establishment of the OpenEXR format. This format, like HDR, also supports full 32-bit floating-point. However, the key to its success lies in the fact that it also supports 16-bit half-float images. This still provides a representable dynamic range that is higher than most capture devices without the storage and memory implications of working with full 32-bit images. It is fast becoming adopted as a format of choice within the visual effects community, as 32-bit floating-point is percieved by a lot of visual effects houses as being too inefficient and pushing file sizes beyond a comfortable level. Consequently, the 16-bit half-float format is seen as a good balance between quality and file size.

Most effects work is done with 2K (2,048 x 1,556 pixel) images. As these are generally 10-bit (i.e. 10-bits or 1,024 colors per channel) images, these files are generally over 12Mb in size. A 2K half-float uncompressed 16-bit OpenEXR file will be about 18Mb, though this can be compressed to a quarter of this size, whilst a 2K 32-bit full-float image will weigh in at a hefty 36Mb when uncompressed. We'll take a look at compositing with floating-point images in a couple of chapter's time, but for the purposes of this chapter we'll take the use of floating-point images with spherical images for use with the Skylight.

Tutorial - floating-point images

In order to demonstrate what needs to be done to generate output of this type, you should open C12-02.max from the tutorials folder of the DVD. This contains our familiar indoor scene, set up to render with mental ray. In order to generate 32-bit floating-point output when rendering spherical maps, we just need to specify

the right options for the HDR output. Go to the Utilities panel and find the Panorama Exporter utility. Hit the Render button, which will bring up a dialog that has all of the options from the Render Scene dialog squeezed into a different format.

Though lighting scenes with images only requires small sized images - 512 x 256 would suffice - using these same images as reflection maps requires far larger output. Therefore, set the Output Size to 1,024 x 512, though you really should be rendering at least 2,048 x 1,024 for reflection maps. The next thing that needs setting is the Aperture Width, which should be set to match your camera: 21.779mm. The next rollout covers the Sampling Quality, which should already be set for you. One thing that is worth looking at in this rollout though is the drop-down for Frame Buffer Type. With this set at its default of Integer (16-bits per channel), your rendered image that appears in the frame buffer will not be a 32-bit floating-point image. Consequently, it will not be possible to save the image within this buffer anything above 16-bits per channel. However, if you have the render output set to 32-bit, then you will have saved 32-bit floating-point output, it's just the frame buffer that will be 16-bit integer. The safest bet here is to change this option to its other setting of Floating-Point (32-bits per channel).

Your other settings should already be defined for you - the Global Illumination and Final Gather settings are set to 500 photons per sample. Back in the topmost rollout, set the output to save out an HDR map. When you hit Save, the Setup dialog should appear, which will give you two options, the first of which saves the image by means of the unclamped color channel. The second option saves the standard RGB channel, which is good for HDR

Figure 12.06
The Panorama Exporter rollout contains the renderer's controls

images only if the renderer supports 32-bit floating-point output, which as we know mental ray does and the scanline doesn't. If you render with this option, you will get true 32-bit floating-point output, which is exactly what you want with HDR.

However, set your output instead to OpenEXR and hit Save again. This time, the OpenEXR configuration dialog will appear. You can see immediately that there are far more options with this file format and lots of compression options, all of which are lossless. Of these algorithms, the PIZ compression type will often surpass the other alternatives, especially when working with grainy images, which makes it perfect for rendering with indirect illumination. As well as the options to set the output to Float and Half-float as we've discussed, there is support for an Alpha channel as well as extra channels and attributes. Allowing extra attributes to be saved with a file is often invaluable in a complex production pipeline, where systems can be dependent on the ability to read in and out metadata such as this. The extra channels option allows for Z-Buffer, Object ID, Material ID, Node Render ID, UV Coordinates, Velocity, Normal and Coverage information to be saved within the file.

To use these additional channels within a compositing environment, however, your compositing application must be able to read them in, but most applications, at least at the start of 2006, still needed to have their OpenEXR import modules rewritten to implement this.

You don't need to render out this image, there is a high-resolution version of this - C12-02.exr - in the tutorials\materials folder of the DVD, which you can apply as your Environment

Figure 12.07

Your spherical map assigned to the environment will match perfectly

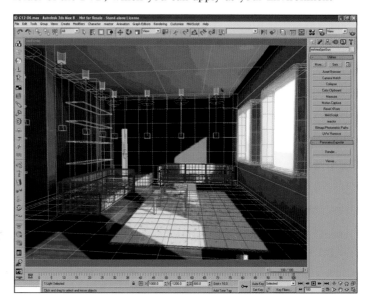

map. With the map's coordinates set to Spherical of course, you'll find that your image will match your scene once the U and V offsets have been set to 0.264 and -0.005 and the U tiling has been set to -1.0. This is to correct the fact that the Panorama Exporter outputs spherical images that are flipped horizontally, as we discovered in chapter 8. If you set the camera viewport to wireframe and turn on Show Safe Frames, you should find that this spherical image matches the geometry exactly.

Now select all your geometry, making it all non-renderable by choosing Edit > Object Properties and clearing the Renderable checkbox. Unhide the *venus* object. Turn off the *mrAreaSpotSun* light and select the skylight. Assign an instance of the Environment map to it, so that you have the same map assigned to the Environment as the Skylight. Change the RGB Level of this version of the map to 0.995. Finally, change your Exposure Control settings to Linear and alter the Brightness setting to 58 before rendering.

As you can see this is a pretty good match, and with the background and foreground sharing the same .exr image, changes can be made to the scene's exposure that will effectively relight this scene. Our look at compositing in two chapter's time will expand on these methods further still.

One thing that is worth mentioning here, however, is that the majority of 3ds Max's Render Effects, notably Hair & Fur, but also Lens Effects, Blur, Brightness and Contrast, Depth of Field,

Figure 12.08
Image-based lighting has invaluable flexibility in a floating point compositing application like toxik

Film Grain and Motion blur are not supported when rendering 32-bit floating-point output. Indeed, of 3ds Max's Render Effects, only File Output and Color Balance are actually supported, so this is certainly another thing to bear in mind when planning a project. Most of these effects are better carried out in a compositing application anyway, so this is not too much of a stumbling block, unless you desperately need hair or fur.

Ambient occlusion

Technical Directors from Industrial Light & Magic first presented a technique that they had developed at SIGGRAPH back in 2002. They called this technique ambient occlusion, which is a technology that the likes of ILM and Blue Sky have been using for years to give a level of realism to their output without the full cost of rendering a global illumination solution.

It's a sign of how fast these kinds of technologies move in CG that since 2002 this technology has trickled down from those major studios that have R&D departments into mainstream 3D applications like 3ds Max. It is worth emphasizing that the technology is actually part of mental ray and not part of core 3ds Max, so is obviously not available as a technique in the scanline.

The term ambient occlusion might initially sound quite confusing, especially to those who have not come across it before. However, in reality, this is an accurate definition of what it describes: how much ambient light the various surfaces of a scene would be likely to receive due to occlusion by their own forms. If a surface point is under a table for instance, it won't receive as much ambient light as a point on the tabletop itself. Ambient occlusion effectively describes how ambient light is distributed around objects which occlude each other and themselves.

This is a subtle, but very powerful, lighting effect that is independent of any light sources used to illuminate a scene. While this could be used as part of an object's overall material within a scene's final render, it is still relatively expensive in terms of computation time. Because of this it is either rendered out as a separate ambient occlusion pass or baked into a texture.

In the first instance, the rendered pass is composited using a multiply operator. In the second instance, the ambient occlusion pass can be added via the Render to Texture feature, which is something that can then be baked into the object via mapping. This technology is most widely used in games development, and Direct3D devices like the graphics engines within games consoles can display these baked textures quickly. The next two chapters cover compositing and lighting in games, so we'll move on to both of these techniques very soon.

Tutorial - ambient occlusion

In examining ambient occlusion we'll build on the outdoor techniques that we've just looked at. First of all open the C12-03.max file from the tutorial folder of the DVD. As you can see, this scene has no lights whatsoever. First of all create a Skylight, which, if you remember, can be placed anywhere. First of all we'll take a look at getting this light working with an HDR map. Drag the *environmentBlur* map from the Material Editor onto the Map slot of the light's controls. This has its coordinates set to match the Environment map and the Black and White Points of the HDR map set, along with the RGB Level of its output.

The next thing that you need to do is assign mental ray as a renderer. You don't need to change anything within the renderer's settings before you hit Render. The results won't look like they've been lit with an HDR image at all and that's because they haven't. In order to render with a Skylight in mental ray, you need to turn on Final Gather, so place a tick in this checkbox on the Indirect Illumination panel.

Render again with this feature turned on and you should see that your results are now properly illuminated using the HDR map. If you were to turn on the Global Illumination option at this point and render again, you would find that the render would look exactly the same.

In order to create a key light casting subtle shadows, create an mr Area Spot light at X:-5,000, Y:-10,000, Z:13,000, targeted in the middle of the statue. Set the Hotspot and Falloff to 8 and 10 and change the cone to Rectangle, with the Aspect to 0.5. If you

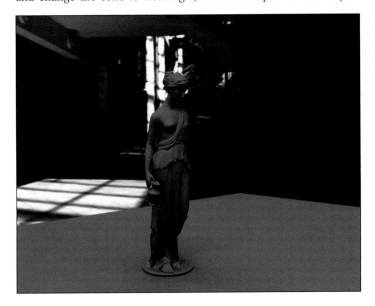

Figure 12.09
Using the Material Override feature is perhaps the simplest way to produce ambient occlusion

set one of the viewports to represent the light's view, you should find that the cone fits the statue quite snugly. If it does not, adjust it until it does. Now change the light's Multiplier to 0.5 and turn on Overshoot. Finally, choose a mental ray Shadow Map as the shadow type. Within the Shadow Parameters rollout, allocate the color swatch a gray of R:80, G:80, B:80 and change the Density to 0.75. The default settings for the mental ray Shadow Map should suffice, so render again.

You will see that you have subtle shadows that help tie the statue into its surroundings. What we have now built up is a simple HDR lighting solution. What's more, this renders very quickly. Now for the ambient occlusion. The simplest way to set this up to work is to use the Material Override feature within the Render Scene dialog's Processing panel. If you go to this panel and click the Enable button, you'll see the slot marked None become enabled. Now, within the Material Editor, within a blank sample window, click the Diffuse Color slot and pick the Ambient/Reflective Occlusion (base) map type. Now drag the entire material from the Material Editor onto the Material Override slot within the Processing panel of the Render Scene dialog.

Render now and what you've got is a basic ambient occlusion pass which could be composited on top of your main render using a Multiply operator to add this shading to your output. This pass is of pretty low quality and in order to get smoother and less noisy results, you would need to increase the samples. 64 would be a minimum number of samples for a still image, and if ambient occlusion were being used on a sequence, then a higher sample value would be needed, as this noise would be more easily noticed in a sequence as it would likely buzz.

Figure 12.10
HDR maps affect ambient occlusion

Your HDR map affects the ambient occlusion pass; if you turn it off and render again you will see that the results are different. This is not a big deal and you should use whichever one looks better when composited together. Furthermore, it was stated previously that ambient occlusion operated independently of the lighting in your scene. Render with the shadow casting key light turned off and load this image in one channel of the RAM Player. Now render again, this time with this light turned off and load this image into the other RAM Player channel.

You will see that the renders look different. Look closely though, and you will see that all that is different is that the levels of the image are increased uniformly. What this means is that to produce the same results when used within a composited image, the amount that this pass multiplies the image will need to be varied.

We'll take a look at compositing ambient occlusion in the next chapter, but for the moment we'll look at a nifty trick for putting your ambient occlusion pass straight into your rendered output without texture baking. Load the CH12-04.max file from the tutorial folder of the DVD.

This scene is already set up to render out an ambient occlusion pass without you having to adjust the scene in any way, so first of all hit Render and load the rendered image into one of the RAM Player's two channels. Now, within the Processing panel of the Render Scene dialog, turn off the Material Override feature so that the scene's original materials will now render.

Figure 12.11
Your ambient occlusion can be integrated into your render using an ambient only omni light

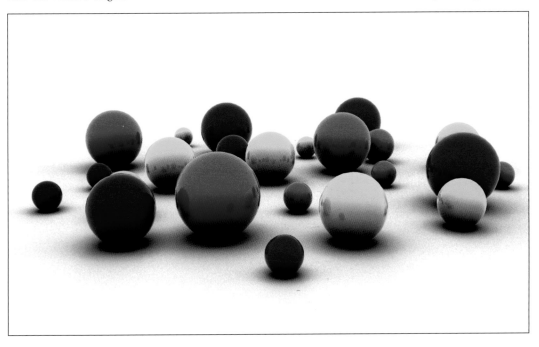

Next create an omni light and place it at X:0, Y:0, Z:0. Within the Advanced Effects rollout, check the Ambient Only box, which will disable the Diffuse and Specular options. Now, enable the Projector Map option and drag the Ambient/Reflective Occlusion (base) map from the *ambientOcclusion* material within the Material Editor. If you are finding that this does not work, you are probably dragging the entire material, so make sure that you just drag the map.

When this has rendered, load this into the other channel of the RAM Player and you'll see the difference in the two results. This method of using an ambient-only Omni light renders the ambient occlusion pass directly into the scene. Hopefully you will agree that this certainly adds something to the quality and realism of the final render and will be something that you will want to come back to. It's just another reason why sometimes only mental ray will do!

Tutorial - caustics with mental ray

We touched on caustics back in chapter 8, when we looked at different global illumination algorithms. If you remember, caustics are patterns of light that are caused by light being reflected or refracted by an object. If you place a drinking glass on a tabletop in direct sunlight, you will see these patterns on the table. Similarly, if you are in an indoor swimming pool, the interior lights will cause patterns to be generated off the water's surface. These dancing patterns will be generated by refraction onto the walls and floor of the swimming pool itself and reflected up onto the walls and ceiling of the room.

Figure 12.12
Your light will take advantage of mental ray's area light capabilities

During the discussion of global illumination algorithms, we looked at photon mapping, which is the algorithm that mental ray uses to calculate indirect illumination. Caustics are part of this calculation process, so there is nothing particularly unique about their generation, they merely need to be enabled. To enable caustics, you must have three simple things in place.

Firstly, you need to have lights in your scene that generate photons, which they all do by default. (It's when you begin to optimize your scene that you may find yourself wanting to turn off photon emission for certain lights). Secondly, you need to have at least one object that is set to generate caustics. By default all objects are set to receive caustics, but the option to generate caustics needs to be turned on within the Object Properties dialog, under the mental ray Panel. Finally, you must enable caustics in the renderer's settings, where they are found in the Indirect Illumination panel. They are turned on with a simple checkbox, like other mental ray indirect illumination options.

This, like most things in mental ray, is a pretty straightforward process once you know how. To demonstrate this, first of all open the C12-05.max from the tutorials folder of the DVD. You will see a simple lathed object on a flat surface. We'll start with our lights, for which we'll use an Area spot and a Skylight. Create an mr Area Spot light and position it at X:-250, Y:350, Z:60. Place its target somewhere central to the *dish* object. You should next enable Far Attenuation and set its Start and End values to 400 and 800. Set the Hotspot and Falloff values to 15 and 65. Now reduce the Shadow Density to 0.85 and within the Area Light Parameters, change the Type drop-down to Disc with a Radius of 60. Give the light 15 samples along U and V. Finally,

Figure 12.13
With your objects set to generate caustics, your render settings must also have this feature enabled

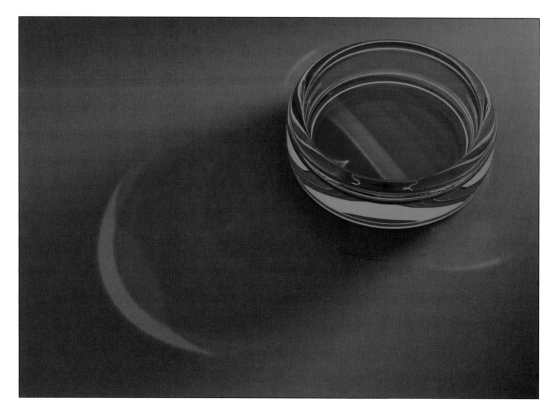

Figure 12.14
Glass objects produce caustics

within the mental ray Indirect Illumination rollout, uncheck the Automatically Calculate Energy and Photons option and turn on the Manual Settings. Set the Energy to 50,000, the Decay to 2.0, the Caustic Photon to 10,000 and the GI Photon to 10,000.

Now create a Skylight positioned anywhere in your scene and set its Multiplier to 0.2. With your lights complete, select the *dish* object and right-click it, choosing Properties from the lower-right quad menu that appears. Within the mental ray panel, enable the Generate Caustics option. Finally, you should assign mental ray as the renderer from the Common panel of the Render Scene dialog. Within the Renderer panel, set the Samples per Pixel to 4 and 64 and change the Filter to Mitchell. Within the Camera Effects dialog, choose Enable for the Depth of Field controls and set the drop-down to In Focus Limits, setting the Focus Plane to 315, the Far value to 360 and the Near value to 280.

Within the Indirect Illumination panel, you should enable Caustics by checking this option. Change the Maximum Number Photons per Sample setting to 500, enabling the Maximum Sampling Radius to 3.0 and changing the Filter to Cone. Within the Photon Map section, choose a path to store a temporary Photon map and make sure both the Use File and Rebuild boxes are checked. Similarly, in the Final Gather rollout, turn on the

Enable option and set the Samples to 100, setting the Filter to 3. Again, specify a temporary Final Gather map, checking the Use File and Rebuild boxes.

Your scene should render with relatively nice caustics that demonstrate how straightforward this type of effect is to generate. Like everything else with mental ray, it is just a matter of knowing which materials to use, along with the number of samples and different filters. Like everything else in CG, this all comes with experience and practice.

Rendering options

This chapter should have given you a small taster of what is possible using mental ray. In the ever-changing world of CG, the lighting artist has to be knowledgeable about the different rendering options available and the strengths of each solution. This also applies to third-party renderers, of which there are many that are used in production today: Brazil, finalRender and V-Ray are all used widely, and Maxwell looks set to join them. These renderers are all given a short introduction in chapter 19.

Though using lots of different renderers might seem a little daunting, there are lots of similarities between these products and the chances are that if you are working in a team there will be someone available with previous production experience on each of these renders. The nature of the project that you are working on will often dictate the renderer used: if you are working on something that requires intricate rock faces, like a Jason and the Argonauts remake, you will likely require high-quality displacement mapping, which is another of mental ray's strong points. The choice of which renderer to use for which which job will usually be a task for the Technical Director involved in early developmental work on a project.

All of these third-party renderers have their strengths and weaknesses, just like the scanline and mental ray. What you should have discovered in this chapter is that mental ray is a very powerful renderer, whose strengths lie in its ability to generate complex physical lighting. Displacement is also a particular strong point, and its ability to output 32-bit floating-point images for HDR output is also invaluable, as we'll demonstrate in a couple of chapter's time. Area lights are also available in mental ray, the renderer's materials are very powerful and now that it can be installed on unlimited render servers, it is a particularly appealing solution. However, on the negative side, its support for certain 3ds Max materials, filters and maps is not always great, it is comparatively slow to render and its documentation is still below par. However, as you will hopefully now agree, its many positives far outweigh any negatives.

13

'What I give form to in daylight is only one per cent of what I have seen in darkness.'

M C Escher

Games environments

The studios that house games development teams can be very technically testing environments. Games artists more than anyone working in a complementary discipline continually push the envelope of what's possible using hardware that continually changes and gets ever more powerful. The programming and R&D teams that work alongside the artists also ensure that within the games community 3ds Max is pushed to an extent that just would not be possible in other industries.

It is because of this cutting-edge application of tools and technologies that the demands on an artist can be more involved. Though working in a games company might still involve working in positions like modeler, animator and texture artist - roles that will be familiar to anyone working in visual effects or broadcast production - the industry-specific tools, techniques and technologies can mean that those moving from film or TV to a games studio can find this a challenging step.

Image courtesy of:
Xavier Marquis
www.xavier-marquis.com

During the course of this chapter we shall be looking at the subset of these techniques that are relevant to a lighting artist. Though positions advertised in this industry will occasionally call for lighting artists, you will see this job title more infrequently than you would in other industries. More often you will see lighting form part of the job descriptions ranging from Junior Artist to Lead Artist, and notably within the roles of Environment Artist and Level Designer. Perhaps more so than in other industries, you will be asked to demonstrate skills with modeling and texturing, as well as lighting.

Part of the reason for this is that games developers have to learn how to squeeze every little bit of performance out of the hardware that they have available to them, whilst keeping gameplay fluid. Because of this, lighting, which we all know can be an incredibly computationally intensive business, is often closely integrated with texturing tasks. To save on the computational demands of lighting games environments, often the lighting is painted into the textures that are applied to the scene's geometry. This does not however mean that the skills of a lighting artist are redundant within this industry, far from it.

When we talk about lighting that is painted into a texture map, a better description of this method, what we really mean is that the light is 'baked' into the texture map, not hand painted. This process of baking involves taking a scene's lighting and rendering the lighting and shadow information into the textures of the scene. These textures, which before this process were the unlit textures that we are all familiar with, are lit and instead of generating a rendered image, the output of the renderer is instead a new set of lit textures. These new textures are based

Figure 13.01
Lighting information is often baked into texture maps in games
www.blizzard.com

on the object's appearance within the rendered scene, rather than the unrendered scene. These newly generated textures are then baked into the object: that is, they become part of the object via mapping. These new baked textures can subsequently be used to display the lit object rapidly on Direct3D devices such as graphics display cards and game engines.

DirectX

This brings us neatly on to DirectX, which is an important technology central to games development. Developed by Microsoft, DirectX is a suite of multimedia application programming interfaces (APIs) built into Windows operating systems. Of this suite of APIs, Direct3D forms a major component of the graphics subsystem.

This technology provides a standard development platform, which allows developers to access specialized hardware features without having to write hardware-specific code. DirectX is a foundation on which many games are run and its use is also brought into 3ds Max via the Direct3D display driver. The same graphics acceleration chips that today's gamers rely on for interactive gameplay are used by artists wanting interactive 3ds Max performance so using the same display driver technology makes perfect sense, particularly if you work in a games studio.

With 3ds Max running using this display driver, the software will offer several different maps and materials, all of which are related to and used in games development, so it's important that we first of all start 3ds Max in this mode. If you don't have the

Figure 13.02
Microsoft's website is where DirectX can be downloaded from

software running at the moment, you should select Start > Programs > Autodesk > Autodesk 3ds Max 8 > Change Graphics Mode. This will bring up a dialog allowing you to choose the display mode that 3ds Max will run in. Choose Direct3D. If you already have 3ds Max running, this same dialog can be reached via the Customize > Preferences menu, where it is activated via the Choose Driver button on the Viewports tab. You will need to restart 3ds Max to change display driver though.

With this change made, start up 3ds Max and open up the Material Editor. Within a blank slot, click the Standard tab above and to the right of the material's rollouts. You will now see that a new option has appeared for DirectX 9 Shader. Double-click this entry to select it and choose DiscardOld Material when prompted. This material allows you to shade objects in viewports using DirectX 9 (DX9) shaders, which more accurately represent how the material would appear within a games engine.

Furthermore, if you now select another blank material slot, you will see that this material has a rollout which was not present before the change of display driver. The DirectX Manager rollout lets you display a material as a DirectX viewport shader. Not all standard 3ds Max features can be represented by DX9 shaders and it is possible to create a standard material that is more complex than a DX video card can display, in which case this option can be simply turned off.

DirectX viewport shaders are, however, especially useful for previewing texture baked materials. The next option within this rollout, which allows us to use two DirectX shaders: LightMap and MetalBump, is designed to work with two different types of

Figure 13.03
Your change in graphics mode will introduce the DirectX shader

Figure 13.04
The MetalBump shader is designed for displaying normal maps

texture baked maps. If you select the MetalBump shader from this drop-down, you will see that a further rollout appears above the DirectX Manager rollout, which is specific to this shader.

The Metal Bump shader is designed for displaying shiny surfaces, but also for displaying normal maps. We won't go into normal mapping in this chapter, as it is not really relevant to lighting, but it's worth mentioning that it is a method of adding high-resolution detail to low-polygon objects. A normals map, unlike the grayscale maps used for regular bump mapping, is a three-color map. The red channel contains the left-right axis of normal orientation, the green channel contains the up-down axis, whilst the blue channel contains the vertical depth. The 3ds Max tutorial on normal mapping is worth completing if you are looking to learn more about this technique.

Back in the DirectX Manager rollout, choose the LightMap option from the drop-down and take a look at the new rollout that appears above the one you're currently in. The LightMap shader can display both a base texture and a lighting map. As we've already touched on, the first of these two maps would be your completed map, textured as an unlit object. The second swatch contains the bitmap which contains the lighting intensity and color values of the object when lit within the scene.

Before we move on to texture baking, it's worth mentioning that whilst running in this display mode you will also find that there is a new file type in the filetype drop-down when you're rendering. The DDS file is the DirectDraw Surface format and can be used to store textures and cubic environment maps. This is a Microsoft-developed format that features compressed and

uncompressed pixel formats, along with mipmapping. Mipmaps are a set of lower-detail bitmaps. The first is half the size of the original image, the next is half the size of that, and so on down to a single pixel. These are used to optimize display time and reduce aliasing when a texture is displayed at less than full size. For example, if your original DDS image is 512 x 512 pixels, but the area in which it would be displayed is only 100 pixels square, the display device would interpolate between the 128 x 128 mipmap and the 64 x 64 mipmap.

Texture baking

Within 3ds Max, texture baking is carried out using the Render to Texture feature. This tool lets you render various scene elements into your textures, including lighting and shadows. You can use these baked textures in real-time 3D applications such as games to reduce the burden on the games engine, thus improving the frame rate and the fluidity of the gameplay.

As the feature is reliant on mapping coordinates, it won't work out of the box on any scene file. Geometry with repeated UVW mapping is not as well suited to this technique as geometry that has its UVW coordinates unwrapped flat. This way of working is not as commonplace in other industries as it is in games, where it is used to flatten the UVW coordinates of complex objects, allowing them to be textured using a single texture map.

Figure 13.05
The Unwrap UVW modifier allows complex objects to be textured

When you bake a texture using the Render to Texture feature, you choose one or more elements to render. These elements save aspects of the rendered scene: its geometry, lighting, shadows, and so on. Some texture elements can display in shaded viewports; others, require a DirectX viewport shader to view in 3ds Max, as we have just touched upon. The process of creating these elements is similar to the Render Elements feature that we'll come across when we get to compositing in a couple of chapter's time. However, whilst the Render Elements feature generates elements such as lighting, shadows, diffuse, specular and so on on the basis of the final rendered image, Render to Texture renders into the texture space of individual objects.

Tutorial - texture baking

The easiest way to explain how this feature works is to demonstrate it. Open C13-01.max from the tutorial folder of the DVD. You will see an environment that's representative of something that you would see in a computer game. The scene's geometry has a low poly count and the interior consists of a single obejct rather than being made up of separate walls, floor and so on. Whilst artists from other industries might model these as separate objects with different materials, the practice in games is quite different. If you select this object, you can see that at the top of its modifier stack is a UVW Unwrap modifier.

Select this modifier and hit the Edit button from the Parameters rollout. This will open up the Edit UVWs dialog that displays a lattice made up of UVW faces and vertices. You can see how the texture space is divided into various sections, with different face clusters overlaid on each. Choose Pick Texture from the drop-down in the dialog's main toolbar and choose the scene's only map. These face clusters are UVW mapping coordinates that correspond to different parts of the *interior* object's mesh. The view window displays the UVWs in the 2D space of the map, superimposed over a grid. Thicker grid lines show the boundaries of a texture map as it would appear in image space; the lower-left corner of the rectangle has the coordinates (0,0) and the upper-right has the coordinates (1,1). Within this window, you manipulate the UVW coordinates relative to the map by transforming the lattice vertices, edges, or faces.

This is how games models are generally textured, and this is the UVW space into which our textures will be baked. The texture displayed in the background of this dialog, as you can see, contains no lighting information: there's no direct illumination or shadows, just a flat evenly lit texture map. Close this window and open up the Render Scene dialog. As you can see from the tabs at the top of this dialog, mental ray is assigned as the renderer. This is purely for the purpose of this exercise, not

Figure 13.06

The Unwrap UVW modifier displays the UVW space of the interior

because this is widely used within the games industry, but becase it is a good idea to carry on with mental ray as the renderer, to help build on the concepts introduced in the last chapter. However, this could equally be the scanline, which could be using either of the Advanced Lighting plug-ins, it doesn't really matter. You could even be working with a third-party renderer. All of these different renderers work alongsde Render to Texture. However, mental ray will enable us to render using global illumination, which we'll then bake into the texture.

Hitting Render will reveal that Global Illumination and Final Gather are turned on, which gives us a nice indirect lighting effect. The sampling settings haven't been set very high, so the render might not look of the best quality, but it is reasonably quick to render. If you were actually rendering out textures for use in production, it would be important that the sampling settings were turned up to a suitably high quality.

Your render will reveal patches of direct light on the left-hand walls and floor, as well as shadows and bounced light, which are all generated at render time. Notably, this information is not displayed in the viewport. In order to bake this information into the textures, so that this doesn't have to be calculated at render time, first of all, with the *interior* object selected, choose Render to Texture, from the Rendering menu.

Within the Objects to Bake rollout, note that the *interior* object is the only one listed. Also note that the Selected Object Settings group > Enabled checkbox is on, and All Selected is chosen. This means that Render To Texture will use any selected objects. In the Mapping Coordinates section of this rollout you could

change the mappping channel to the existing channel, as you'd
likely want to use the unwrapped texture that you already have
set up. However, for the purpose of this exercise you should
leave it set to Use Automatic Unwrap. On the Output rollout,
click the Add button. This opens the Add Texture Elements
dialog, with a list of different types of texture elements you can
render. You should choose LightingMap and hit the Add
Elements button. You'll need to change the resolution of the
output to a reasonable size: 1,024 is the same size as our texture
map, so choose this option. You might also note that the path to
the file automatically defaults to the image folder within the 3ds
Max folder structure, so you might want to change this.

Though the drop-down for the Target Map Slot defaults to
Ambient Color, which is not where we want this map to
ultimately end up, you can leave this as the destination. This is
because, if you look at the options within this drop-down, the
LightMap slot is not available, as it is a DX9-specific slot. We'll
need to simply drag and move this from the Ambient Color slot
when it's rendered. At the bottom of the Render To Textures
dialog, click the Render button. You'll see that a further modifier
is added to the object's modifier stack before the render kicks
off. This second Unwrap UVW modifier was applied automatic-
ally by the Render To Texture function. This may take some
time, because you're rendering at a relatively high resolution.

When this rendering process has finished, open the Material
Editor. Click the first material, which was previously named
interior and you'll see that the Render to Texture process has
automatically renamed this material *orig_interior*. Now click on
an unused sample sphere and then hit the Get Material button.

Figure 13.07
The pools of light appear in the
viewport after rendering to texture

From the Material/Map Browser dialog > Browse From group, choose Selected. A single material now appears in the list. Its name is *interior [interior]*, and the type, Shell Material, appears next to the name. This material was generated automatically by Render To Texture, and then applied to the *interior* object.

Double-click the texture in the list to bring it into the Material Editor. This type of material is something that we've not covered thus far. Basically, the Shell material lets you combine two materials into one; you can see one material in the viewports while rendering with the other. When Render To Texture generates a Shell material, it uses the original material for rendering, and the baked material for displaying in the viewports. Though your viewports will look not different at the moment, go into the Ambient Light map of the *baked_interior* material and turn on the Show Map In Viewport button

You'll see that the *interior* object is still mapped accurately, but the cast shadows now appear in the viewport. For example, if you move the light source, you can see that the pools of light cast from the openings in the ceiling don't move as the light source moves, because they're now baked into the texture. You can also see that the texture map as applied to the *interior* object in the viewport appears to be of lower quality, but if you render the image, the texture is of its original high quality.

Figure 13.08
Your rendered texture will contain the lighting information

Staying within the Material Editor for one moment, you'll notice that the Shell material has only one rollout: Shell Material Parameters. It shows that the original material (*orig_interior*) is to be rendered with, while the baked material (*baked_interior*, generated by the Render To Texture process) is to be visible in the viewports. Click the Original Material button, and then, on the Material Editor toolbar, click the Show Map In Viewport button. Return to the top level of the material, and on the Shell Material Parameters rollout, under Viewport, click the top radio button (next to Original Material). In the Camera viewport, the *interior* object returns to its previous appearance, and the pools of light disappear.

However, this map is still assigned to the wrong slot and we need to move it to the LightMap DirectX shader. Within the DirectX Manager rollout of the *baked_interior* material, change the drop-down to LightMap. Now you need to drag the new map from its current location within the Ambient Color slot onto the Light Map slot of the DirectX Shader - LightMap rollout. Depending on your screen resolution, you might be able to drag this straight from the Maps rollout. Alternatively, you should drag an Instance of this map to a blank slot from where you should drag it onto the Light Map slot.

Now you just need to drag an Instance of your original texture map from this material's Diffuse Color slot to the Base Texture slot of the DirectX Shader - LightMap rollout. With both of these maps in place - the Base Texture map operating via Mapping Channel 1 and the LightMap operating via Mapping Channel 3 you just need to check the Enable Plug-in material checkbox within the DirectX Manager rollout.

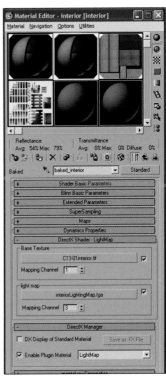

Figure 13.09
The DirectX plug-in material will display the LightMap

Figure 13.10
If your image looks incorrect, the mapping channel is set wrong

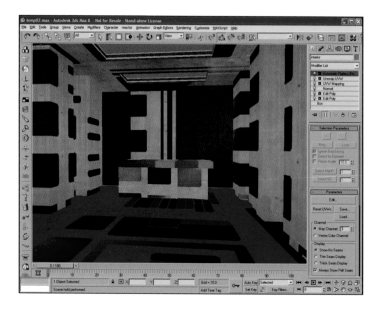

You might experience some problems with the display of this new Light Map, where it appears to be displayed incorrectly, as figure 13.10 demonstrates. However, this is just 3ds Max needing a nudge in the right direction. Within the DirectX Shader - LightMap rollout, move your Mapping channel for the Light Map off 3 and back to 3 again. This will force 3ds Max into updating the display correctly. This would not have been a problem had we rendered our LightMap into the existing map channel, which has been manually set up within the Unwrap UVW modifer.

The reason we didn't do this is that we had overlapping UVWs. If you open the Edit UVWs dialog for the Unwrap UVW modifier, you will see that in the bottom right, we have two walls that are laid over each other. The elements around the Skylights also share common UVW space. In order for the Render to Texture feature to work properly, each cluster must have its own space and not share this with other areas of the mesh. To sort this out, it would be a case of shuffling elements around within this Edit UVWs dialog, moving and scaling these elements down so that there was sufficient space to separate them out.

Besides the LightingMap, you can render individual elements one or more at a time. Notably, the sharp-eyed amongst you will have noticed a Texture Element entitled Ambient Occlusion (MR) map. This is related to the ambient occlusion technology that we covered in the last chapter, when we looked specifically at using this technique when working with mental ray. As you will hopefully remember, the ambient occlusion map type is only available when working with this renderer. As this is currently the case, it's worth mentioning that this is also available as a Texture Element within Render to Texture.

Ambient occlusion describes how much ambient light a surface can receive. The ambient occlusion map considers the obstruction - occlusion - of ambient light by an object's own surfaces as well as its surrounding objects. When calculating the ambient occlusion map in this way when rendering, you do not need to set up special lighting, replace materials on the objects, or use global material overrides, because the ambient occlusion map already accounts for these settings. Ambient occlusion maps can be rendered out and taken into Photoshop, where their use as the basis for dirt maps, or even as masks for reflections or specular light can be very effective.

In order to render out this element without generating a whole new Shell material, you should use the Add button to append this to your Output list. Turn off the Enable for your Lighting map and change the resolution for your ambient occlusion element to 1,024. Choose a different Target Map slot, for instance the Specular Color. Within the Baked Material rollout, turn on the Output Into Source option, which will replace any Target Map slot in the object's existing material. Care should be used with this option as it allows us to render over the content of existing map slots. Make sure that you are now rendering into the existing map channel of 3, as you don't want to be adding Automatic Flatten UVs every time you render out an element. Leave the settings for this element as they are and hit Render.

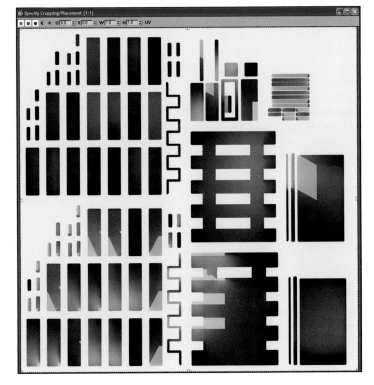

Figure 13.11
Your ambient occlusion texture element works with mental ray

Figure 13.12
Your viewport preview should compare with your render

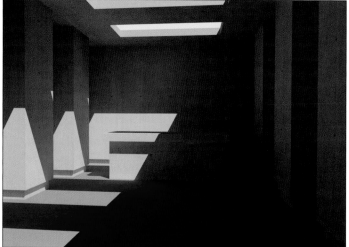

When this has rendered, you should see that your result looks like figure 13.11, which should look familiar following your work with this map type in the last chapter. We'll encounter this map type again in two chapter's time when we get to the chapter on compositing and render out an ambient occlusion pass to add an extra layer of realism to a composited image.

Indeed, what we are doing here is akin to compositing, but on a per-object basis, rather than on a series of rendered images. This makes sense because your renders for a games project, in the context of this tutorial at least, can go right back onto the scene's objects, as it is these that will end up in the game. Once your render has finished, you should open the two textures, the

Light map and the ambient occlusion map, within Photoshop.
Select the whole of your Ambient Occlusion image and Copy it to
the clipboard, before Pasting it onto the Light Map. Set its
transfer mode to Multiply and reduce its Opacity to around 25%.
This should add a little detail and dirt to your Light map.
Alternatively, you could use this map as a mask to a dirt map
that you have painted using another set of images.

Save a copy of this out as *interiorLightMapComp.tga* and back in
the baked_interior material, load this map into the LightMap slot
of the DirectX shader. You should now see the viewport map
update. Compare what you see in the viewport with what you
see in the rendered image in figure 13.13 and you should see
that, despite the fact the render is obviously of better quality,
that the global illumination has introduced some nice subtle
bounced light effects into this scene, which is not something
that you could hope to have a game engine calculate and render.

14

'The secret to creativity is knowing how to hide your sources.'

Albert Einstein

Visual hooks

In terms of shaping the atmosphere of a production, the lighting artist wields far more influence than the majority of his co-workers. His decisions set the mood of the story and can directly affect our perception of script, characters ... everything. However, often the creative vision of a script goes somewhere beyond our everyday reality. This is arguably more often the case than not when it comes to CG. As a result, to convince us that what we're seeing is as real as possible, it's often also the lighting artist's job to employ visual devices to reinforce the illusions created in CG.

The lighting artist has a big role to play in providing the visual hooks that make the visual effects look so believable. This can be quite a tall order when the effects so often take the audience way beyond the boundaries of credible science. Perhaps the most simple and commonplace technique is to add film grain to a rendering in order to make the audience believe that a CG shot was actually shot on film by a camera. This trick, which is very

Image courtesy of:
Darren Brooker

Character model:
Daniel Martinez Lara
www.pepeland.com

effective at a subliminal level, relies on replication of the artifacts of a physical medium that is known to us all. It's ironic that now we have the potential to get rid of the scratches, lines and bits of debris that find their way onto film, we choose to put more back in there digitally in order to recall film's familiar aesthetic.

Similarly, just as lens manufacturers have worked hard over the years developing special coatings to eliminate the artifacts that appear in their lenses, CG movies often can't seem to get enough of these lens effects. Though considered undesirable in traditional photography and cinematography, their popularity in CG lies in the fact that they are visual hooks that we associate with reality, or at least a photographic version of reality. These kind of effects are also fairly useful when it comes to hiding something that's not looking quite right too, but that's another story.

Inside the lens

To understand what causes the glows, streaks and flares that CG puts in and the manufacturers take out, you simply have to look at things through a camera lens. It does not even take an expensive one to demonstrate that the sun looks quite different when viewed in this way, rather than seen with the naked eye. It appears sharper, and you can see that lens flares are actually made up of several parts.

The artifacts that we see depend very much on the construction of the camera lens itself. The circular artifacts that can be seen are called lens reflections and the number of these that appear can vary depending on how many components the lens is made up of.

Figure 14.01
Real-life lens flares are generally more subtle than CG portrays

These are caused, as their name suggests, by light reflecting somewhere within the camera lens, which also produces other artifacts: the stars, streaks, rings, rays, glows, and so on.

Considering the amount of these effects that we see in CG, you'd think that the production of these kinds of artifacts was easy and you'd be not far wrong. Recognizing what kind of lens you're trying to simulate and knowing what kind of artifacts this lens is likely to produce is the most difficult part.

Glows

Glows, unlike the various other components of lens flares that we'll come to soon, have further production applications. For example, we often perceive glows around bright light sources such as the sun, or surrounding specular highlights on shiny metal objects. Though these glows themselves appear to be the same, they are in fact subtly different. A glow used as part of a larger lens flare effect would be designed to appear as if it were happening in the lens itself. Alternatively, a glow representing the glow surrounding a bright light source is generally perceived as happening at the source.

In this latter case, the appearance of the glow would depend largely on the source's intensity and the type of surface creating the reflection. Glows that appear around the sun also depend upon the weather conditions: on a misty or hazy day the sun will have a larger glow of a lesser brightness than the much smaller and much more well-defined glow that would appear on a fine and cloudless sunny day.

Figure 14.02
We perceive glows around lights to be happening at the source

Figure 14.03
Glows applied to unclamped colors
reinforce the highlights

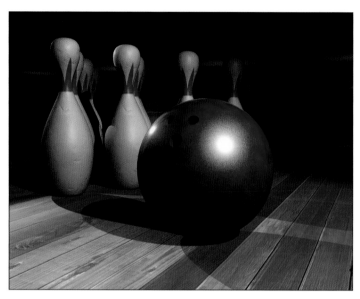

Glows on a scene's objects can be accomplished using several
methods. You've already encountered glows in context of a neon
sign back in chapter 10 and will recall that creating the actual
glow was not that difficult. The crucial part of setting up a glow to
look accurate is to set up the source for the glow using the right
element. As well as applying glow effects to lights themselves,
you can apply the glow to the whole object, generally using an
individual ID number applied to the geometry. This ID is then
also allocated to the effect, which glows the correspondingly
tagged geometry. This method works well and in a very simple
manner for applications like fluorescent light bulbs, neon signs
and so on, where it's the entire geometry that you want to glow.

You can also apply glows to specific materials, again usually
using an ID that is allocated to the individual material as well as
the effect. In this way, if an object uses several materials, you can
choose to apply a glow specifically to one or more of these
materials, which then glows a selected part of an object. This has
obvious advantages in that you can control very closely just
where the glow appears on your object using multiple materials
on one object. In some 3D applications, there are further advan-
tages to this method that aren't so apparent. For instance, in 3ds
Max, glows applied to whole objects won't appear in raytraced
reflections, but glows allocated to materials will. This is why, in
the neon tutorial, we set up the neon sign glow by material.

Glows can also be allocated to the areas of your image that are
brighter than pure white, which are sometimes called
unclamped colors and are generally found around bright metallic
highlights. Your final rendered frame might only emerge from the
renderer in 24-bit color, but it does actually render them at a

higher color depth. These extra bits can be used for storing information such as z-depth and alpha values, as well as details of the unclamped colors. This data can then be used as the basis for an effect, which is useful for adding a glow around only the brightest highlights in a scene, subtly reinforcing the intensity of these areas, as seen in figure 14.03. These are only some of the more commonly used options available for adding glows and there are many more: glows can also be allocated by alpha value, z-depth and so on. These methods of applying effects are not as widely used, but knowing how to apply glows by object, material and unclamped colors will make these less common options more easily understood.

With an understanding of how best to use the different methods for applying the glow effect, all that remains for you to master is how to control the amount of glow applied to your object or material and how this is applied. There are several different methods of controlling this, and these range from applying the glow to the entire source to just its perimeter. Glowing the entire source generally applies the glow outwards from the source's center. Because of this, the glow's size is dependent upon the object's size. Using the option for applying the glow to the perimeter of an object does not glow the object itself - it just glows around its edges, making it appear to be lit from behind: perfect for backlit signs.

One word of warning at this point: lens effects are often measured in pixel sizes, so a change of rendering resolution can change the relative size of these glows. Before changing the output size and simply rendering, it's best to check on how the glows have been affected by this change. Additionally, maps can be used to control

Figure 14.04
Glows can be as intricate and psychedelic as you want them to be

glows, and this is where we encounter the most powerful and most tricky area of working with glows. By using gradient ramps, noise and so on, you can begin to set up some extremely intricate glows, with varying colors and falloffs as shown in figure 14.04.

Designing complex glows can be a painstaking process, as their generation is often fairly experimental, and the different elements of a lens effect can sometimes seem to work against each other. Start by considering the source of the glow and how this would behave, taking into account the atmospheric conditions and how this would affect the result. If it's possible to compare the effect you're looking for with a photograph, then do so, and if you can observe the glow in the outside world, go and do it. By giving yourself a reference in this way, you'll save yourself a lot of time in getting the glow looking roughly right. From here, getting the effect to look perfect can take a little experimentation and practice, like most things in 3D.

Tutorial - glows

In this tutorial you will look at glows, using a scene based around the same neon sign that you encountered a few chapters ago, to experiment with the different settings. First you'll look at glowing unclamped colors using an additional sign within the scene, then you'll take a look at applying glows to entire objects, followed by glows applied by material.

The textures in this tutorial were kindly provided courtesy of 3DTotal.com.

The Textures are part of the 'Total Textures' Range, 15 complete and flexible texture collections for all 3D and 2D applications. The collections are high-res, fully tileable and include all bump maps and most specular maps.

www.3DTotal.com

Open the C14-01.max file from the tutorials folder of the DVD. You will see the same neon sign that you used in chapter 9, viewed from a different angle and with an extra sign in the foreground. First we'll give the bright highlights on the chrome lettering a subtle glow, by assigning a glow to the scene's unclamped colors. Before we begin, in the Render Scene dialog, turn off the scene's antialiasing, as we're going to be doing quite a few renders and this will speed up the whole design process.

Next choose Rendering > Effects and click the Add button, specifying a Lens Effect. Now with this effect highlighted, change its name to *Lens Effect - Chrome Unclamped*. Down in the next rollout, select Glow and click the topmost arrow to add a Glow effect to the window on the right. Close the Lens Effects Globals rollout so that you don't alter anything here accidentally and in the Options tab of the next rollout, check the box labeled Unclamp. Leave everything else as it is and select the Parameters tab to bring this to the top.

Check the Interactive box under the topmost list of effects if it's not already checked and when the preview appears, change the Size to 0.1. You should see the effect immediately update, giving you a glow that appears to be of the right size. However, its color

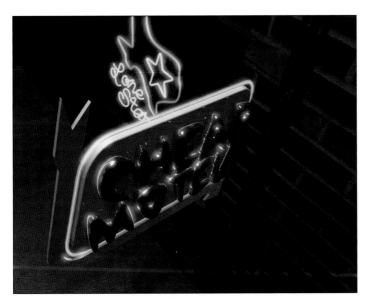

Figure 14.05
Glowing unclamped colors is an
effective way of subtly reinforcing
bright highlights

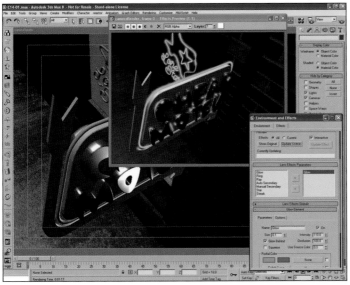

Figure 14.06
Using constrasting colors can help
when designing subtle glows

is not quite right, so change the Use Source Color field to 100%.
Adjust the Intensity until it looks about right, somewhere around
100 should look right. Rename this *Glow - Chrome Unclamped* and
turn the effect on and off to see the effect of this glow.

Whilst you're doing this you should see that this unclamped
glow is not constrained to any one material however, and the
neon tubes are also picking up this glow. Glowing unclamped
colors in this way is not possible on a per-object basis, so you
would need to think about compositing this shot, which we'll
come to in chapter 15.

Figure 14.07
Object-based glows do not appear
in raytraced reflections in 3ds Max

Figure 14.07
Object-based glows do not appear
in raytraced reflections in 3ds Max

Turn this effect off for the moment by clearing the checkbox
marked Active. Add another Lens Effect, renaming it *Lens Effect
- Neon Arrows*, then select another Glow, hit the arrow button
pointing to the right and in the Glow Element rollout rename this
Glow - Neon Arrows. Unhide the *signNeonArrows* object and
with the object selected, right-click in any viewport, choose
Properties, and change the G-Buffer Object channel value to 2.

OK this and in the Options tab of the Glow Element rollout,
check the Object ID box, changing its value to 2 to match that of
the neon arrows. Hit the Update Scene button back in the
Effects dialog to render again with this object included. Now, in
the Parameters tab, swap the two colored swatches around and
change the red one to give it a slight orange tint. Alter the Size
and Intensity settings until you arrive at a value that looks both
realistic and subtle. You should find that values of around 0.75
and 80 do the trick. If you look at the effect of turning the Use
Source Color to 100, you can see that this is not always the best
solution, and in this case it's better to specify a color.

With this value at 0, turn off this effect and Unhide the
signNeonLettering object. Right-click with this object selected
and again alter the G-Buffer Object Channel value, this time to 4.
Set up another Lens Effect as a Glow and in the Options tab of
the Glow Element rollout check the Object ID box, setting the
value to 4. With Interactive turned on, change the settings of
this glow to make a similar glow to the previous one, but green.

This might look just fine at first glance, but you should see that
this effect is not being rendered in its raytraced reflection. This is
because glows assigned by Object ID are not supported in

raytraced reflections. When this effect needs to be seen within reflections you need to apply glows by Material ID, so in the Options tab of the Glow Elements rollout clear the Object ID box and check the Material ID box instead. When the scene renders again, you'll see that the glow has disappeared. This is because the Material ID needs to be altered for this material too. So, in the Material Editor, at the top level of the *neonGreenStandard* material, change the Material ID Channel value to 2.

If you hit the Update Scene button back in the Effects dialog, this glow should now render happily on the geometry as well as its reflection in the chrome sign. To change the glow back to the correct color, set the leftmost Radial color to green. When this has updated, turn this effect off. Now Hide everything in your scene and Unhide just the *signLettersPlastic* object. Turn antialiasing back on in the main Render dialog. This object's material already has an Effects ID of 3, so set up another glow, using similar settings to the two glows already allocated to the neon objects, checking the Material ID box and changing its value to 3 also. Give this glow a bright red color and turn it on, making it Interactive. You should know what to expect of your results by now.

In the Options tab of the Glow Element rollout, clear the All box in the Image Filters section and instead check the Perimeter box. This produces a glow around the perimeter of the object, it is true, but with terrible aliasing. Now switch instead to Perimeter Alpha and you should see that the results are vastly improved. However, this method is far from perfect and will often also result in strange aliasing. To see this for yourself, Unhide the *signBack* object and hit the Update Scene button. You should see a rather obvious problem: the glow is now horribly aliased.

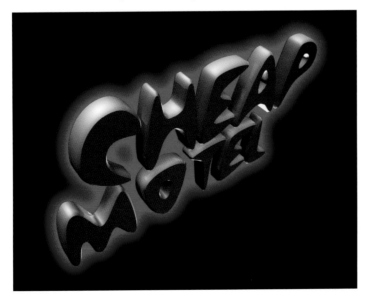

Figure 14.08
Glowing by alpha channel only works when there's nothing behind the object being glowed

The reason for this is that the Perimeter Alpha uses the alpha channel in generating the glow. If there is an object behind the one glowing, then this also forms part of the alpha information, so the glow does not know how to position itself correctly. You should be able to see that the right-hand and bottom edges of the sign is still antialiased perfectly.

If you hit the Display Alpha Channel button in the menu bar above the Effects Preview, you will see why: the alpha channel still forms the edges of the leftmost letters where there's nothing behind. This has obvious implications. The second problem is that the glow does not work well with raytraced reflections: you'd expect the glow to go over the top of the raytraced reflections of the letters, but as you can see it does not. Switch from Perimeter Alpha to Perimeter and max works out where the perimeter is a little better, but not accurately, and the glow is still not raytraced properly.

The only real answer to these kinds of issues comes with compositing. In chapter 15 we will explore the possibilities of taking your renders into combustion and build up a composition that allows all kinds of further possibilities.

Lens flares

Perhaps the most overused visual device in CG, the lens flare is used to bolster the impression of reality. As a visual hook, it instructs the audience that what they are seeing has been captured through a lens, when in fact it has been nowhere near one. If it had, the chances are that the artifacts one would see on the film would be much less pronounced than their faked CG equivalents. The manufacturers of such lenses strive to ensure that their components produce as few of these visual artifacts as possible, as those working in movie making and photography see them largely as unappealing.

Love them or loathe them though, the lens flare certainly does work as a visual device in CG and, like everything else, when used subtly and sparingly, they can certainly add another layer of reality to the overall illusion. However, when used abundantly and freely there's nothing that quite gives a piece of work away so unmistakably as being computer generated.

Building lens flares can seem a little intimidating at first, but this is only because a lens flare can consist of many different parts - stars, streaks, rings, rays, etc - but these individual components are certainly no more complicated than the glows that you just looked at. The key to building successful lens flares is to approach them as a layered composition and tackle each component individually. Like everything else, practice makes perfect, and you should maybe start by dissecting the examples that come

with your software. Trying to replicate these examples from scratch could perhaps then be the next step, or if you've got a copy of a recent sci-fi movie kicking around, take a good look at the many lens flares and how they appear.

Tutorial - lens flares

In this tutorial you will look at how to create a lens flare from the sun, shining directly into the camera over a body of water. You'll build up the various different components that make up a lens flare into a realistic looking flare and add some fog to make the scene more hazy and likely to produce lens flares.

Open the C14-02.max file from the tutorials folder of the DVD. You will see a scene that looks out over a body of water towards some pyramids during sunset. If you take a look at the scene, you'll see that the geometry is very simple and the lighting comes from a dome array and the lights representing the sun.

The first thing we need to do then is set up a glow for the sunlight. Add a Lens Effects and specify a Glow, renaming this *Glow - Sun Outer*. Within the Lens Effects Global rollout, use the Pick Light button to select the *omniSun* light and turn on the Interactive checkbox. Now close this rollout and move on to the Glow Element rollout. You are looking to replicate the sun's glow in the sunset image pictured in figure 14.09. For this, you should choose a size of 100 and an Intensity of 200, with orange and red colors for the left and right Radial Color swatches. Add a Gradient Ramp map to the topmost Circular Color slot and drag an Instance of this into the Material Editor. Change the black

Figure 14.09 (above)
Using reference material will invariably lead to better results

Figure 14.10 (left)
Adding a Gradient Ramp to the Circular Color slot

Figure 14.11

Adjusting your curves gives the secondaries a gentle falloff

flag to orange and the white flag to yellow, deleting the middle flag. Change the Gradient type to Radial and you should see the effect we're looking for. Within the Gradient Ramp Parameters rollout, set the Noise Amount to 0.5 and the Size to 6. If you experiment with these two settings you should see the variety that is possible. One important thing remains, and that's to clear the Glow Behind checkbox, which will make the effect look like it's happening in the lens, rather than at the source. Now add another Glow, renaming this *Glow - Sun Inner* and give this a Size of 20 and an Intensity of 200. This should give you a white Hotspot that's similar to our reference image. Clear the Glow Behind option for this glow too.

Add a Ring entry to the list of Lens Effects and watch the preview update. The ring as it appears with its default setting is much too big, so change the Size value to about 10 and reduce the Thickness to about 1. It is also way too bright, so bring down the Intensity to somewhere around the 30 mark. Again, clear the Glow Behind checkbox if it's checked and set the Use Source Color value to 0. Give the Radial Color swatches orange and yellow colors for the left and right respectively, which should give us a nice subtle effect. Next, add a Ray entry. This component just needs to have its Size value set to 200, the Number value brought down to about 20 and the Intensity to 25.

Add an Auto Secondary entry and first of all set the Minimum and Maximum values to 0.5 and 12 respectively. Vary the Intensity until these artifacts look right, which you should find happens around the 150 mark, where things still look reasonably subtle. To make these secondary flares appear more realistic, open up the Circular Color Falloff Curve and adjust the points so that

the effect of the secondary flares falls off from one side to the other. You should find that the values shown in figure 14.11 give a nice gentle falloff from the left to the right. Finally, add a Star entry to the list of Lens Effects and watch the preview update.

The result is rather large and unrealistic, so alter the Size and Width values until you're happy with the result; you should find that around 100 and 2 respectively look good. Now set the Quantity to 4, the Angle to 30 and with the Intensity set to around 20 you should have a pretty decent result. Don't forget to clear the Glow Behind checkbox if it is checked. Now turn off the Interactive option and turn all of the components of your lens flare on before hitting the Update Effect button. With all of the flare's parts displayed together, you can finally judge what your effect looks like as a whole and begin to make any little tweaks that you might think need making.

The flare looks pretty good, but the whole scene looks just a little bit too clear, and it's unlikely that this type of a sunset would appear in such clear conditions, as you can see from our original sunset reference image in figure 14.09. First, change the antialiasing setting in the main Render dialog to Soften, altering the Filter Size to 4.0. (A more sensible technique would be to render this normally and blur this in combustion later.) This will soften our rendered output slightly, but the scene needs something by way of an atmospheric effect. Open up the Environment dialog and add a Fog effect. Give the Fog a color of around R:255, G:230, B:210, check the Fog Background box and set the Far value to 30%. If you render now, you should have lens flare that reinforces the bright sunlight without appearing too computer generated.

Figure 14.12
Lens flares are best kept subtle

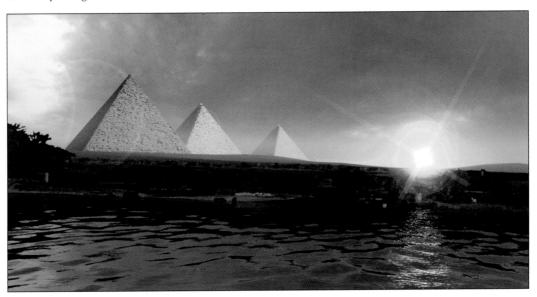

Highlights

The kind of highlights that you might see when looking across a body of water on a sunny morning can also be a very effective visual device, but only when used sparingly. Like all lens effects they too can also have quite the opposite effect if they are used too heavy-handedly, and your final render will end up looking computer generated. These kinds of sparkling star-like streaks radiate from light sources of high intensity, as well as reflections of these sources off shiny surfaces such as water, chrome and glass.

Highlights might seem similar to some of the elements that make up a lens flare, but they differ in how they are generated. Whilst lens flares actually appear within the camera lens and glows are generated at the source, highlights actually occur within the human eye itself. Whilst the source does not produce the highlight itself, the eye perceives the highlight as being positioned over the source, which should be kept in mind when designing these kinds of effects. Highlights appear for various different reasons, which can be as simple as moisture on the eyeball refracting the light.

However, as these effects are also dependent on the shininess of the materials in the scene, it's a good idea to bear in mind their inclusion from the moment that the design of materials and shaders begins. As well as using shiny surfaces, the lighting set-up can also affect the appearance of highlights, and it's the intensity of lights that is the primary factor in how highlights will appear. As such, highlights often look good when combined with a subtle glow, applied to the unclamped colors where the highlights will also appear.

Figure 14.13
Lens filters can be used to exaggerate highlights

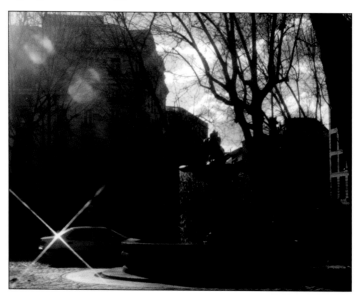

Tutorial - highlights

In this tutorial you will take the pyramid scene that you just used when creating a lens flare and you'll look at how to create highlights sparkling on the surface of the water. Open the C14-03.max file from the tutorials folder of the DVD. You will see the same scene that you've just been working on. The first thing to do is turn off the effects in the Rendering > Environment dialog. Also turn off the current Lens Effect, before adding another, specifying just a Glow from the list below. Rename these *Lens Effects - Highlights* and *Glow - Highlights*.

In the Options tab of the Glow Element rollout, check the Unclamp box and check the Interactive box. After the preview has generated, you'll see that the specular highlights on the water don't really receive the glow. Instead there's just a large glow that is centered on the sky's brightest area. This is OK; we just need to make some alterations in the Parameters tab. First of all, change the Size value to 2.0. This shows you that the water's specular highlights are not really glowing enough, just the sky in the background plate.

The problem is that the Specular Level of the *water* material is not high enough to produce the unclamped colors that the glow is applied to. If you change this setting in the Material Editor to 500, then hit the Update Scene button back in the Rendering Effects dialog, you should see that your water now generates the glow too. However, it is still less than perfect. If you change the Use Source Color value to around 70, this makes a sizable difference, as now the glow looks to be the right color at least. Back in the Options tab, change the Image Filters from All to Edge, which will

Figure 14.14
The water's Specular Level is too low to produce the right glow

lessen this effect further. In the Parameters tab, reduce the Intensity value slightly, to around 90, making sure that the Glow Behind box is checked.

Now turn on your existing Lens Effect, turning off Interactive for this entry if it's turned on. The sunset is now glowing a little too strongly, so in this first Lens Effect entry, change the *Glow - Sun Outer*'s Size to 50 and the *Glow - Sun Inner*'s Intensity to 10. click the Update Effect button. Finally, increase the Intensity of your Auto Secondary to 150 to make this effect look a little stronger. This now looks much better, and the water's highlights are

Figure 14.15
Setting up your highlights using the Video Post preview dialog

Figure 14.16
Your finished highlights should be subtle and not overwhelm

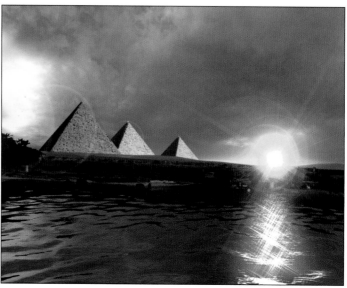

Figure 14.17
Your two Video Post events should appear underneath each other

glowing nicely. Now that you have these two effects working together harmoniously, turn off the first one, leaving just the water glow turned on.

Close the Rendering Effects dialog and open up the Rendering > Video Post dialog. Click the Add Scene Event button in the top menu bar and OK the dialog that appears, checking to make sure that *cameraRender* is displayed from the drop-down list. Next, click the Add Image Filter Event button, choosing Lens Effect Highlight from the drop-down. Your two entries should appear on the left-hand side of this dialog directly underneath each other. If they appear offset slightly from each other from the left to the right, you should delete the Image Filter Event and add it again, making sure that the Camera Event is not selected when you do this, or else this sequence will not function.

Now double-click the Image Filter Event icon and click the Setup button. Press the Preview button, then the VP Queue button to bring the scene into the preview window. In the Properties tab, set the Source to Unclamped and click the Up spinner button next to this value to increase it to 5. You should now have your highlights appearing only on the water's surface. In the Geometry tab, set the Angle value to 30 to match the value of the Star component of your existing lens flare. In the Preferences tab, set the Size to 10 and reduce the Intensity to around the 25 mark, which should give you a nice subtle effect.

Turn on the Lens Effect that you turned off earlier and click the grayed-out Queue entry in the left-hand side of the Video Post dialog to select both of the events you created. Finally, hit the Execute Sequence button in the top menu bar, typing in the same resolution settings as appear in the main Render dialog (720 x 405). Specify a Single image and hit Render. You should now see your scene with all the atmospheric effects, the Lens Effects and the Video Post highlights that you've just created.

15

'My friend James Cameron and I made three films together - True Lies, The Terminator and Terminator 2. Of course, that was during his early, low-budget, art-house period.'

Arnold Schwarzenegger *(presenting at the 1998 Oscars)*

Post production

As the name suggests, post production is the final stage of the production process and involves further work on the various elements of a shot: live-action footage, CG content, audio and so on. During this phase, there may be further color correction, blurring or sharpening of the CG elements in order to make them better match the backplate. Similarly, grain may be added to these elements in order to bed them into the shot. The addition of effects like lens flares and particle systems can also happen in post. Though final audio work and editing fall under the umbrella of post production, the main component of this process that concerns us is compositing.

The techniques a compositor employs on a project may range from the simple, like wire removal or stabilizing a backplate, to the complex, like the assembly of hundreds of elements into an intricate visual effects shot. These elements may need tracking so their movement matches that of the plate, or they may need

Image courtesy of:
Luciano Neves
www.infinitecg.com

keying if they have been shot in front of a greenscreen. The compositor may need to add new shadows and reflections as part of integrating these new elements; he may even need to relight the scene to a certain extent. This is why compositing is so important to a lighting artist or TD - its tasks overlap those of the lighting artist and there is a whole range of techniques that can be used in post that can save hours spent in a 3D environment.

Compositing

In order to complete extremely complex shots, particularly visual effects shots, to the necessary quality in the necessary time, the compositor's role is vital. The vast majority of work completed for broadcast television work does not come straight out of a 3D application ready to be put to tape. Instead, almost every professional production will be output in several parts ready for compositing. These constituent parts can be the different elements that go together to make up an effects shot, or they can be different passes of the same render. The production of multiple passes involves the output of separate layers for the different components of a rendered image: diffuse, highlights, depth, shadows, lighting and so on.

Figure 15.01
Compositing allows for much more complex effects to be constructed

The most straightforward example of a composited shot would involve some computer-generated content composited on top of a live-action plate, as in figure 15.02. In its simplest form there

would be just two basic elements that make up this shot within the compositing environment: the background environment and the foreground building. A compositor's job here typically might involve a number of things: adding some film grain to the foreground element, blurring or sharpening it or color correcting it. These tasks are aimed at doing one thing: making the CG foreground content match the background and integrating the render to the backplate to make as believable and photorealistic a composite image as possible.

The compositor's job is usually much more involved than this, however, and generally CG elements are rendered out into many different layers to enable as large a degree of flexibility as possible to be retained. As such, the compositor's job is an extremely artistic and skilful one. Rendering out the different CG elements in a form all set for compositing is not a difficult task. Starting with everything together in a single scene ensures that no obvious problems like changes in camera movements will develop. This scene then needs to be structured into layers or selection sets, with only those required visible at render time.

This can be done in different ways: either the objects that aren't to be rendered can be hidden, or the various layers can be saved out into individual files all XREFed into one central master scene file, with the XREFs turned off for layers that aren't required at render time. The advantage of this system is that it can use fewer system resources as you're loading less into your 3D application.

Figure 15.02
Compositing makes generating photoreal images much easier

Image courtesy of:
Andras Onodi
www.zoa.chu

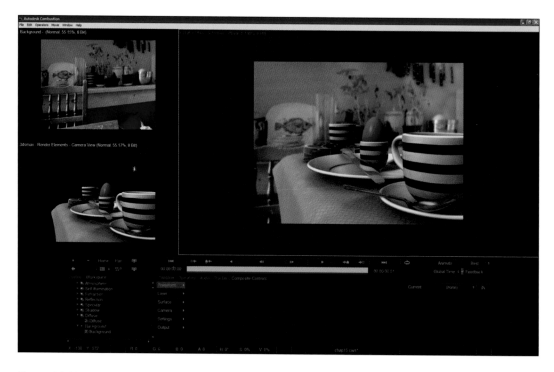

Figure 15.03

Rendering out different elements allows for greater flexibility

Beyond the control and flexibility that compositing offers, one other advantage of rendering out your production into separate elements is that it can actually save you render time. For instance, if your background consists of a static photographic or painted background image, you will only need to render out one frame, rather than the whole sequence, provided the camera is not moving of course. The remaining layers that make up your rendered elements can then be rendered out with alpha channels in order to enable them to be composited over the background image.

The complexity of your scene will dictate how many layers will need to be generated and rendered. For instance, if you were compositing a shot that featured two armies charging across a displaced plane that was textured to appear like a battlefield towards each other, providing your background was a still image and not an image sequence, you could take several approaches. You could manually render out the background battlefield element, which would only require one frame rendering. You could then apply a shadow/matte material to the battlefield element and the two armies and render out a shadow pass. With the battlefield object hidden and the two armies visible, you could turn off shadows and render the armies alone.

This would allow you to color correct the background separately to the armies. Likewise you could reduce the saturation of the shadows. This demonstrates the flexibility of this approach, as

once you're happy that your battlefield element looks reasonable, you don't need to render this again. If you were rendering all of these elements together in one scene, if you decide that the background does not look right, then you need to render everything again: the battlefield, the armies and, more importantly, the shadows. This might initially seem like a lot of effort, but working in this way can save time, duplication of effort and can enable more complex results than would be possible from a single render.

Arguably the primary reason involves saving on render times: if you output the whole scene every time you had to rerender because a revision had been requested, you would be forever rendering. If the revision involved changing the background battlefield element's texture slightly, then only one frame would have to be output to make this revision (provided the camera is locked off) compared with the full sequence if you were not working towards a compositing tool.

Indeed, rendering everything together in a complex scene is often simply out of the question in terms of the amount of memory it would require to do this. Splitting a scene into separate layers enables much more complex output. Going back to our example of the two armies on the battlefield, what if you want to color correct one army's uniform, but not the other. It might be difficult to render out the two armies separately, because as they meet in the middle of the battlefield, for instance, they would overlap. In this case, you could render one army with its uniform textures enabled and the other with a matte/shadow material applied to it, and vice versa. These two elements could then be brought into the compositor and color corrected separately, but there is a more sensible solution in the use of Render Elements.

Render Elements

Though we've been through most aspects of the Render Scene dialog, one area we haven't touched on is the Render Elements tab. This tab contains the controls for rendering various image information into individual image files. These are useful for the same reason that rendering images in different passes is, the added flexibility that having this information gives can save a lot of time and rendering. There are lots of elements that you can choose to render separately.

These range from the obvious: Alpha, Reflection, Refraction and so on, to the not so obvious: Velocity, Hair & Fur, and Material ID. This last type, for instance could have helped us out in our battlefield example. In order to color correct one set of troops, you would simply assign different Material IDs to these two materials. Now, with the Material ID element set to render alongside the

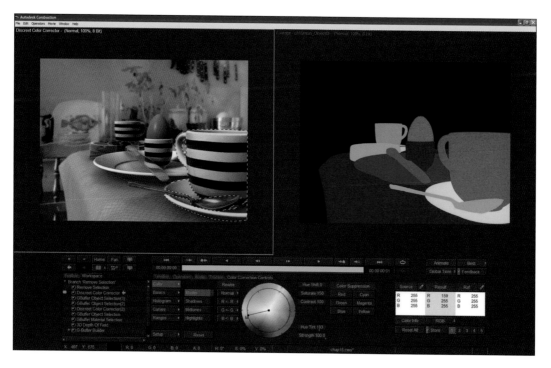

Figure 15.04

Rendering the Material ID element allows different elements of an image to be treated individually

troops pass, this additional image can be used to isolate the areas of the image that have different Material IDs allocated to them. This is shown in figure 15.04, above, where one cup and saucer have been color corrected based on their Material ID.

This is a simple example of what's possible with Render Elements and the full list of the available elements in table 15.01 demonstrates just how many different forms of extra information you can output using Render Elements. Taking a look over this list, you will see that some elements are more self-explanatory than others. What you might not notice are that some form part of what you would see in the full render and some do not. Those that do are perhaps the most easily explained. The Atmosphere, Diffuse, Reflection, Refraction, Self-Illumination, Shadow and Specular elements all return what you might expect of them when rendered and are aspects of a render that you should be thoroughly familiar with by now.

Related to these elements is the Blend element, which contains checkboxes for these aforementioned elements, as well as Ambient, Ink and Paint. By default, all elements are turned on in this rollout, and the Blend rendering is identical to the full, normal rendering, minus the background. This can be a useful element to combine the elements that you know don't need to be saved out individually into one file. The Ink and Paint elements that have just been mentioned return these components of any Ink and Paint materials used in the scene.

One similar element to these already mentioned is the Lighting element, which contains the effects of lighting within the scene, including color, shadows, direct and indirect light. This element's options allow you to specify which parts of the lighting - direct, indirect and shadows - are included in the rendering.

There is one further element that can make up part of a rendered scene, but, is actually a post effect, so is not included in the Blend options. The Hair and Fur element returns the component of the rendering created by the Hair and Fur modifier, but only supports one of the Hair and Fur modifier's rendering methods. The Buffer option must be specified within the modifier itself in order for the Hair and Fur to be rendered as as separate element.

The Background element returns the background, if you have an environment map assigned. This forms the base layer within your compositing software upon which other rendered elements are layered. As for the remaining elements, these all return views of the image that don't directly form part of the rendered image, yet they are all used in its generation and they are all useful in isolation. Of these elements, the first - Alpha - will be familiar to those people who have ever rendered out TIFs and TGAs. This returns a grayscale image where white represents complete opacity and black complete transparency. The darker the pixel, the more transparent it is.

Table 15.01
3ds Max's Render Elements

Alpha
Atmosphere
Background
Blend
Diffuse
Hair and Fur
Illuminance HDR Data
Ink
Luminance HDR Data
Material ID
Matte
Object ID
Paint
Reflection
Refraction
Self-Illumination
Shadow
Specular
Velocity
Z-Depth

The Material ID, which we mentioned before in our previous example, retains the material ID information assigned to an object and renders each ID as a different color. As discussed, this information is useful when you are making selections and can provide invaluable flexibility during the compositing process. The Object ID element works in a similar way and this pass displays the colors that each Object ID has been allocated. Whilst this may sound fairly redundant alongside the Material ID channel, having the combination of these two elements can be quite powerful. You can color correct sub-groups of one Material ID based on individual group IDs, or vice versa. With proper pre-planning you can use these two ID channels to organize the way that your different rendered objects can be color corrected.

The first of the final two elements is Velocity, which returns motion information which can be used in certain compositing applications, like Combustion, for things such as creating motion blur or retiming an animation. Finally, the Z Depth element returns a grayscale representation of the depth within the view, of objects within the scene. The nearest objects appear in white, and the depth of the scene in black. Intermediate objects are in gray, the darker the deeper the object is, within the view. This information can be used to add depth-of-field in post.

You might be forgiven for thinking that adding all these extra sequences to your render would add a lot of time to process this additional information. In fact you'd be both right and wrong: when you render one or more elements with the scanline, a normal complete rendering is also generated. The element renderings are generated during the same rendering pass, so rendering elements costs little extra render time, but it's a different story however when using mental ray.

When using this renderer, each Render Element is processed separately, so the rendering time will increase proportionally to how many elements you are rendering. Six Render Elements equals seven times the render time (one render each for the individual elements and one for the full frame).

This brings us on to two further elements that we purposefully skipped until now, because they are both related to mental ray. These are the only two passes that are specific to this renderer. The Illuminance HDR Data element generates an image that can be used for analyzing the amount of light that falls on a surface perpendicular to its normal. The Luminance HDR Data element meanwhile generates an image containing data that can be used for analyzing the perceived brightness of a surface after light has been 'absorbed' by the material of the surface. Both passes return 32–bit floating-point data, but whilst the luminance data considers material characteristics such as reflectance and transmittance, the illuminance data ignores these material characteristics.

Though, for best results, these elements should be rendered with mental ray because of the way that it can produce 32–bit floating-point output when writing to PIC, HDR, or EXR formats, these elements can actually be used with the scanline. If this is the case and you are using the scanline renderer, you should set the Scale Factor parameter, which acts as a multiplier, to adjust the range of values for the output data.

Another thing that is worth bearing in mind is that generating all these passes and elements can require large amounts of disk space. If you are rendering half a dozen Render Elements for half a dozen passes, that's 36 image sequences. If you are working with a lossless format, like TGA, or even with a 32-bit floating-point format, like EXR, then it's easy to see how the disk space on your project server is going to get eaten up. When you are dealing with this amound of data and this amount of passes, it is important that your projects are organized sensibly and individual frames and sequences are given an equally sensible naming convention so that different sequences can be easily identified. This naming convention might also have to include detail on revisions, ownership and so on, so it's well worth spending the time ahead of a project to get this right.

Time spent organizing an in-house working project structure is certainly time well spent. Having a documented file and naming structure that everyone adheres to is invaluable when you consider how complex some composited shots can become. When compositing a shot that consists of a dozen or more rendered passes, each of which contains rendered elements, keeping track of filenames can become a bit of a logistical nightmare. It's good then that the naming conventions that 3ds Max defaults to are both sensible and usable.

For instance, if you have assigned a file name and path for the complete rendering within the Render Scene dialog's Common tab, the Render Elements feature uses this name and path as the basis for names of the various elements. It appends an underscore and then the name of the element to the basic file name. For example, if the render file name is 'Z:\project\scene\shot\render\shot01.0000.tga', when you add a Specular Render Element, the default path and file name for the rendered Specular element will default to 'Z:\project\scene\shot\render\shot01_specular.0000.tga'.

Additionally, when you output Render Elements, you also have the option to output to a Combustion workspace file. One thing to note is that if you are rendering elements to composite over a background, the Diffuse, Shadows, and Alpha elements require an alpha channel, so you must remember to specify a format that supports this, like a TGA, EXR or RPF file. Similarly, 3ds Max supports some file types that Combustion does not, notably HDR

files, but also EPS, FLC, FLI, and CEL files. If you render to one of these formats, the Combustion workspace file is not saved. If your render file name was as above, when you enable Combustion output, the default path and file name will default to 'Z:\project\scene\shot\render\shot01.cws', though obviously this can be changed, as can all of the output options.

Tutorial - Render Elements

In order to see how this process can be implemented and how much control can be gained by using this workflow, we'll take a look at rendering a scene using Render Elements. We'll also generate a Combustion workspace, so that all of these elements are automatically brought into our compositing environment. We'll then move to Combustion, where we'll open this workspace and see just how flexible it is to work in this way by using the information from our various elements to change the appearance of the final composited image.

First of all, open the C15-01.max file from the tutorials folder on the DVD. You will see a kitchen tabletop that is similar to our first tutorial back in chapter 5. This scene has been set up to demonstrate most of the Render Elements and first we'll go through the process of setting these up. With the scene open, go to the Render Scene dialog and click on the Common tab. Set your output to somewhere convenient and specify a .tga file, as this is an uncompressed format.

Now go to the Render Elements tab. If you select the Add button, the list of elements should appear. Choose the first entry in the list, Alpha, and click OK to add this. You will now see that this has been added to the list within the Render Scene dialog. You should see that below this list, these elements have individual filtering controls, which by default are turned on. Some of the individual elements have additional parameters, which appear below this list, but our first selection does not. Also, below the list is the path to the file that the element will save out. This can be left as it is for this tutorial apart from one thing. You should check that your .tga output specifies a 32-bit file, as you will need the Alpha channel for several of the elements. Once you have specified this format for one of the elements, 3ds Max will take this as the default for all the others, so you only need to specify this once.

Now add an Atmosphere element, which adds another entry to the list. This will render out the steam from our mug, which is a volume light atmospheric effect in the scene. Next add a Background element, which will render out our background Environment map separately, which we'll use as the base layer for our compositing. Add a Diffuse element, as well as one for

Material ID, Matte, Object ID, Reflection, Refraction, Self-Illumination, Shadow, Specular and Z Depth. Our work is not finished yet, because some of these elements have additional parameters that need to be set up.

The Atmosphere element, like the Alpha element, requires no extra setup. The Diffuse element does have an extra parameter, which allows us to calculate the Diffuse element with or without the lighting. Without the lighting this pass would look totally flat lit with no variation in shading, so we want to leave this parameter in its default state, with lighting turned on.

The Material ID element requires no extra parameters within the Render Elements tab, but does require some effort within the Material Editor. This element renders out a different color for each individual Material ID channel that has been set. To do this, for each of the materials in the top two rows of the Material Editor, you should change the Material ID, starting at the top left and working across the top row, then left to right again on the row below. Give the first material - cup - an ID of 1, the second and ID of 2 and so on. You should make sure that any of these that contain Multi/Sub-Object materials have the ID set at all levels of the material. You should end on 8 for the tablecloth material. Your Material ID element will now return a different color for each of these IDs.

The Object ID works similarly, but instead this generates its colors based on the Object ID in the Object Properties dialog. As you have two saucers sharing the *saucer* material and two mugs and two spoons also with a common material, these objects will also share the same color in the Material ID element, as they

Figure 15.05
You need to set up your Material ID within the Material Editor

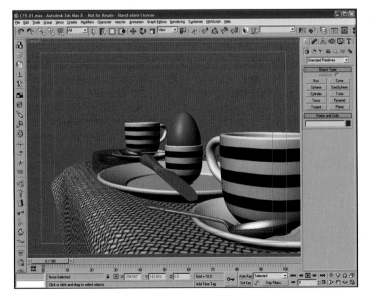

Figure 15.06
Some Render Elements make up the final rendered image

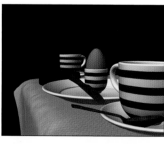

share the same Material ID. Giving these cups, saucers and spoons different Object IDs will enable these to be color corrected and adjusted individually. Give each of the ten objects in the scene different Object IDs, by changing this value in the Object Properties dialog.

The Matte element, as you can see, generates a matte based on either the Effect ID, which is the same as the Material ID, G-Buffer ID, which is the same as Object ID, or by the use of a simple Include/Exclude selection. You should set this option to Include all of your objects bar the tablecloth. The Reflection, Refraction and Self-Illumination elements have no extra parameters, so require no further attention. This is also true for the Shadows element.

The Z-Buffer element has within its extra parameters minimum and maximum values that define the near and far range of the Z Depth element. This defaults to 0 and 100, where 0 represents the camera and 100 represents 100 units into the scene. If you select the camera in the scene and look at its environment ranges, you can see that it actually goes from 0 to 100, so these values will do for the X Depth element. If your scene extended further back beyond the table though, these values would have to be altered correspondingly so that the white to gray was evenly distributed between the objects nearest to your camera in your scene and those at the far end that are the furthest distance away from the camera.

Now use the Add button and add a Lighting element to the list. The Lighting element, as you can see, has parameters for including the Direct and Indirect lighting, as well as the

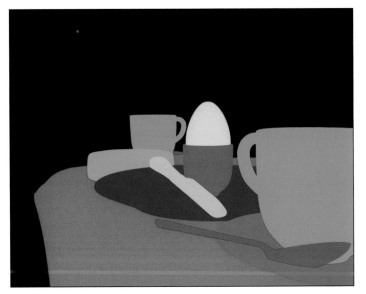

shadows. As we are going to render the shadows in the separate Shadow element, you can turn this option off. As there won't be any indirect light in this render, because the scene is setup using standard lights and the scanline renderer without any Advanced Lighting plug-in, you can also turn off the Indirect option. If you were using Radiosity or a third-party renderer that was set to calculate Global Illumination, you could add two of these Lighting elements, with one set to store the Direct Light information and another set to store the Indirect Light. This would then allow you to control these lighting components separately, within your compositing application, giving you extra flexibility in adjusting the look of your final composited image.

Finally, in the Output to Combustion group, which is found below the list of Render Elements, you should turn on Enable. This will automatically generate a Combustion workspace file, which by default is saved in the same location as all of your renders. If you are not happy with this location, you should specify another one at this point. Now you are ready to render, so make sure Elements Active, which can be found at the very top of the Render Elements rollout, is turned on, and then click Render to start rendering the scene.

When the main render has finished, all the elements that you have specified will pop up in separate frame buffers, one for each rendered element. If you watch the end of the render closely you will see that the extra time it takes for the elements to appear after the main render is completed is the only additional render time that generating elements costs. If you want to disable some of these for future renders, you can use the Enable checkbox that is available for each individual element.

Figure 15.07
Some render elements contain additional channel information

Tutorial - Combustion

Now that we have all of the Render Elements generated and the Combustion workspace saved out, it's time to move on to the actual compositing. You'll need to install the Combustion trial version from the DVD if you don't have it already. Once you've done this, start up the software and open up the Combustion workspace that 3ds Max just saved.

What you'll see looks like your final render, which is good, but this image is actually made up of all the Render Elements that 3ds Max just generated. Take a look at the Workspace tab in the bottom-left portion of the screen and you will see the elements that make up the composited version. The icons to the left of these elements' name tags indicate whether a layer is turned on or off. Yellow indicates that the layer is turned on, whilst a grayed-out icon is a layer that is not enabled. As you can see, the composite image in your viewport is made up of the Atmosphere, Self Illumination, Refraction, Reflection, Specular, Shadow and Diffuse layers, which are all composited on top of the Background image. Above the Workspace are eight buttons. The middle button of the bottom row changes the viewport layout. Use this to change the viewports to two, side by side.

If you click in either of these viewports you will see a label appear in the top-left corner which indicates which level of the composition you are looking at. At the moment both of these viewports show the camera view, which is the top level of the composition. Click in the left viewport to activate it and then double-click the Atmosphere label in the Workspace tab. This brings this layer into the selected viewport and makes it the active layer, which is signified by the yellow highlight that appears in the Workspace tab. If you click the triangle to the left of the name tag and the icon, you will see that underneath this level is another name tag, also labeled Atmosphere. This level contains the footage options, things like frame rate, field separation, channels and so on. At the level above this are the compositing options. Click the Atmosphere tab at the upper level and to the right of the Workspace tab you should see half a dozen menus appear, starting with Transform.

This menu allows you to perform transformation tasks on the layer, allowing you to Move, Rotate, Scale it and so on. With the Animate button enabled (above and to the right of the Transform options) any changes will be animated. This is how you would complete a pan across a larger image, which would be like a rostrum camera move. The second menu down is where you can create and alter relationships between the individual layers using parenting operations, hinges and so on. This can be very useful in defining how layers interact with each other when you are animating the motion of layered elements.

The next menu down contains the Camera controls, which allow you to alter the parameter of the camera that Combustion uses for the composition. Below this is the Settings menu, which contains options such as anti-aliasing. Finally, the Output menu is where the options for the final output are located.

Our image looks pretty good, but let's explore the possibilites of using the individual elements within Combustion to change our render. We'll start by adjusting one layer using a Discreet Color Corrector operator. Select your Self Illumination layer in the Workspace tab and by right-clicking, choose Add Operators > Color Correction > Discreet Color Corrector. You will see this operator appear in your Workspace tab and its options appear in the main tools area to the right. Click the Basics menu button. If you now experiment with your Gain value for the topmost field, which changes the R, G and B channels, you will see that you can alter how strong this layer's influence is. Change this to 125 and press the Color button to bring up the Color controls. Drag the small black square in the middle of this wheel up and to the right, into the orange area of the color wheel. You should see the image change color to reflect this. Position this dot somewhere near where it is in figure 15.08, to the right. Using this same technique, you should increase the gain of your reflection layer.

Now select the Atmosphere layer and click the button labeled Surface to bring up these options. Directly to the right of this button, you should see the Transfer Mode of this layer set to

Figure 15.08
Color correction is something that combustion is invaluable for

Figure 15.09
Different levels of your composition can be viewed in each viewport

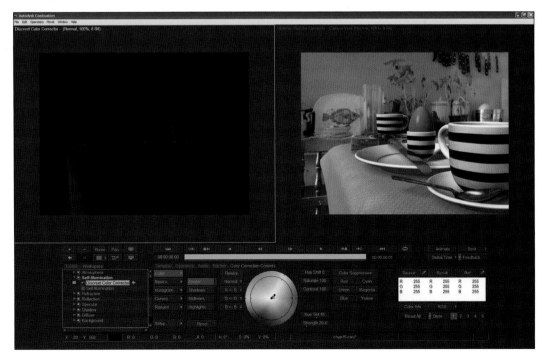

Normal. Change this to Add and you will see a visual change in how this element appears in your composition's camera view. These Transfer modes dictate how a layer interacts with the ones below it, and this will be a familiar concept to those used to working in Photoshop. The effects of these modes can be best observed by experimenting with them in Combustion.

With the Atmosphere layer still selected, you should choose Duplicate from the Edit menu. This will give you a duplicate layer, which will increase its effect in the composition. We have not created this extra layer to increase its visibility - we could have done that with a color correct operator. Instead, we'll use this duplicate to add some steam to the other cup. Within this layer's Transform menu, change the X and Y values to -330 and 10 respectively. This will position the layer over the cup at the rear of our scene. Right-click the Atmosphere(2) layer in your Workspace tab and choose Add Operators > Masks > Rectangular Mask.

You should now see the layer appear within your active viewport, over which you need to drag the rectangle's control points in order to shape this layer into a cone of steam. To soften the hard edges of this cone, choose In/Out from the Edge Gradient drop-down and change the In value until the edge looks suitably soft; about 35 should do the trick. This cone now looks about right, but looking at your camera view, it could benefit from being a little less visible than the one in the foreground. At the Atmosphere(2) level, within the Surface menu, alter the

Figure 15.10

Masks can be added to layers to dictate which areas are affected

Opacity of this layer, bringing it down to about 50% to make this new layer much more subtle. Next we'll add some depth-of-field using the Z Depth layer. To do this, select the topmost layer, labeled 3dsmax - Render elements within your Workspace tab. Right-click this and choose Add Operators > 3D Post > G-Buffer Builder. Had we rendered our images out in RLA or RPF format, this step would not be necessary, but as we rendered out using TGA files, we can use this operator to build the graphics buffer information from these individual files.

Once you've added this operator, you will see that there is a whole host of Operator Input options, the labels of which should look familiar. Click the button marked Z Buffer and from the resultant dialog, select the Z Depth footage. Repeat this process for the Material ID and Object ID options. Now right-click the new operator in the Workspace tab and choose Add Operator > 3D Post > 3D Depth of Field. Click the button with a + symbol to the right of the Near Focused Plane field and click in the camera viewport on the cup in the foreground. This should add a value to the Near Focused Plane field. If instead you get an error message, double-click the 3D Depth of Field label in the Workspace tab to bring this into the viewport.

Repeat this operation for the far focus, selecting the far edge of the plate. Though the Far Focused Plane field will update to about -560, nothing will change visually at this point because your blur size is set to 0. Change this value to 2 and alter the

Figure 15.11
The GBuffer Builder interprets your Render Elements intelligently

Blur type to Gaussian and you should see that your image is now nice and crisp in the foreground, yet subtly blurred toward the rear of the image. To color correct individual elements you can use the Material and Object IDs that you fed into the G Buffer Builder. In order to do this, you should right-click the 3D Depth of Field operator and choose Add Operator > Selections > GBuffer Material Selection. You can now use the + button to select portions of the image by their Material ID. Select either of the cups and you will see a selection appear that surrounds both cups. This is because these two elements have the same materials applied to them.

In order to select just the far mug, add a GBuffer Object Selection operator above the last operator and click to select the far mug. By changing the Selection drop-down to Subtract you can select the near mug, and by changing the drop-down to Intersect you can select the far mug. You should hopefully appreciate that by layering these selection operators and changing their selection methods, you can begin to build up complex selections. Now you should add a Discreet Color Corrector operator and reduce the saturation of this far mug to 75% to reflect the fact that it's further back in the scene.

To add some extra realism to this scene, we'll go back to 3ds Max and render out an ambient occlusion pass with mental ray, as we touched on in chapter 12. Within the Render Scene dialog, assign mental ray as the renderer from the Common tab. Open up the Material Editor and click the Diffuse swatch of a blank swatch, choosing Ambient/Reflective Occlusion (base). Change the Samples within this map to 256.

Now within the Processing tab of the Render Scene dialog, enable the Material Override checkbox and drag the material you just edited to the material swatch. You should turn off all of your lights and create an Omni light, moving it to X:0, Y:0, Z:0. Within its Advanced Effects rollout, turn on the Ambient Only option and drag the Ambient/Reflective Occlusion (base) map (the map, not the material) to the Projector map swatch. Hit F9 and once rendered, save this image from the frame buffer out into the same directory as the Render Element images. Save this as ch15_AmbOcc.tga, specifying a 32-bit TGA when prompted.

Back in Combustion, right-click the layer labeled 3dsmax - Render elements and choose Import Footage. Navigate to the ambient occlusion pass that you just rendered and OK this. Combustion will now bring this layer in above your duplicate Atmosphere layer, which is where we want it. Once imported, you should go to the layer's Surface menu and change the Transfer mode to Multiply, reducing the Opacity to 30%. This will darken the image somewhat, so to finish off we'll add a final operator to correct this.

At this top level add a Discreet Color Corrector operator. Within the Histogram menu, slide the left-hand triangular flag to the right to where the histogram starts, to indicate the distribution of the dark colors, which should give you a value of around 12. Similarly, move the middle flag until your image starts to lighten slightly, which should happen at around 1.03. What you want to achieve aesthetically at this final level of color correction is up to you and you should take some time to experiment.

By now you should have a good idea of what Combustion is capable of, and you should appreciate the extra flexibility that rendering out elements in this way adds to the artistic process.

Figure 15.12
Your final color correction will lighten your image somewhat

Taking compositing further

The great thing about using a compositing system within your 3D pipeline is the flexibility that it lends to your workflow. Once you have seen the benefits that a compositing system can bring to your workflow in terms of control, flexibility and render times, it will become one of the key components of your pipeline. It is fair to say that for those not used to working in this way, adapting your 3D working methods to compositing can take a little time.

However, once you begin to get up and running, the benefits of working in this way will soon begin to outweigh any drawbacks that might initially impact on your 3D workflow.

Though the ability to color correct, blur and add grain to individual elements is of great importance, with an increased understanding of the compositing process you will begin to understand that there is so much more to this process than simply color correcting and finishing a completed shot.

The range of techniques possible within a compositing application is so vast that a team of artists can happily work on a composited shot for weeks, or even months. However, getting to a decent level of compositing knowledge requires a thorough understanding of the many different image file formats and their compression algorithms and support for additional channels. Issues such as clipping and the intricacies of working at different bit-depths need to be understood, so that artifacts or banding do not get introduced during this stage.

This is especially true if you are working in a film compositing environment, because film has a wider latitude than our everyday formats such as TIF and TGA, which have 8-bits per channel. Even those who have worked in a 3D environment for many years may never have come across such file formats as CIN or DPX. These two formats are used for storing 10-bit film images. Working with these types of images, which work in logarithmic color space, involves the use of look-up tables (LUTs), which specify the mapping of input pixel values to output pixel values. This can describe how a linear device should interpret logarithmic footage with respect to a particular film stock that the composition is eventually to be output to, or can be used to give footage a film look if it is eventually to be delivered in a linear format, for television or DVD, for example.

Furthermore, these two file formats allow for further information to be stored in their headers, and ensuring that information like timecodes get dealt with correctly and generated alongside any composited output is critical to any further workflow that involves editing. Beyond this, keying techniques can take a little bit of experience before their use is fully understood, because although keying is a fairly straightforward process in isolation, complementary techniques like spill suppression and garbage mattes can make this a more complex area to master. Indeed, the subject of mattes and their manipulation, combination and treatment is something that can take someone new to compositing a little while to become familiar with.

The techniques and concepts discussed thus far have all been related to working within three-dimensions, and there has not really been much that has been discussed that wouldn't have been possible within a paint package like Photoshop. However, there are, or course, operations within compositing applications like Combustion that involve time as part of their controls, introducing the fourth dimension.

The timing or length of a sequence can easily be changed within a compositing application and a sequence's associated frame rate can be varied to slow it down or speed it up. Furthermore, this speed can be varied so that the shot's timing is essentially changed. This can be done for editorial purposes to better tie in to a narrative, or for visual effect where a director might think a camera move would work better if it were faster in places or slowed down towards the end, for example.

The system for animating these types of timewarps and motion retiming operations is, like in the world of 3D, keyframe-based and this area of compositing is not generally one that those used to working in 3D struggle with. An area that involves time-based operations and can cause some confusion for those new to compositing is tracking and stabilizing images. This is the process of determining the movement over time of a region of an image. For instance, if an object was moving in your backplate, for instance a bar of soap afloat in a tub of water, and you wanted to emboss a logo into the soap, you would be able to use tracking techniques to calculate the movement of the soap bar within the image sequence and assign this movement to the logo that you had generated so that their movement matched. Similarly these techniqes can be used in order to calculate and cancel out the movement of a backplate when a camera wobbled during filming or the film was not stable when moving through the camera's gate.

Just as we covered in the match lighting section, in an ideal world all of our background plates and elements would be shot in similar conditions and would all have been lit to match each other, at least fairly closely. However, in real life these elements are often far from being well matched. A lot of the skill of a compositor's job is involved in being adept in integrating these mis-matched elements. Just like working in 3D, each shot will have its own problems, but the answers to these issues will come with time and experience.

Just as a good lighting artist will be able to come up with solutions that are both creative and efficient, the same can be said for a good compositor. Being able to come up with these kind of solutions is also what makes a good compositing artist. If you don't want to be a compositor, the more that you understand of the compositing workflow the better, especially if you work or want to work in a visual effects environment.

part 3: tips and tricks

Image courtesy of:
Weiye Yin
http://franccg.51.net/

16

'The difference between pornography and erotica is lighting.'

Gloria Leonard, US Publisher

Working efficiently

Now that we've completed the main techniques section, it's time to turn our attention to how all these procedures can be made to work together most efficiently in a production environment. The last section of the book should hopefully have provided a thorough grounding in the various methods used to approach the many different tasks that a lighting artist can face. Now we'll attempt to tie everything you've learnt together into some kind of cohesive whole, looking back over the general principles involved and attempting to impose some order on how you should organize your working methods.

It is very difficult to actually teach somebody how to be a good lighting artist, because there aren't really any hard and fast rules, just a set of guiding principles and a whole heap of different techniques, many of which achieve the same thing in different ways. Nevertheless, one of the main points you should thoroughly understand by now is that lighting should be

Image courtesy of:
Juan Siquier
www.juansiquier.com

motivational, its purpose being to set the desired mood and atmosphere, thus establishing the all-important emotional connection between the audience and the production.

When setting up the lighting for a scene, there are thus many things that an artist needs to bear in mind and balance together: as well as creating the atmosphere and tone that the script dictates, the lighting artist must unify the scene into a cohesive whole whilst gently highlighting its focal points, as well as emphasizing the three-dimensional nature of the production. All of these motivational aspects must be kept in mind whilst ensuring that the many technicalities are also considered. The demand to keep render times as slim as possible is generally paramount, and knowing the many different methods of lighting can make for significant time savings.

It's no surprise then that you are more likely to deliver results that consistently fulfill these many different demands with an organized and efficient pipeline. Different studios might do things as efficiently as each other by different means, but what they all have in common is established methods for setting out their initial lighting, putting this to the test, examining how this could be improved and revising their setups until reaching a solution. While there's no one right method for everyone, what follows is a suggestion upon which your working processes should be based.

The first step

When first looking at a potential lighting task, your initial thoughts should be of understanding. Before you rush into creating any kind of light, think of the inherent purpose of the lighting, the requirements of the scene and the potential methods at your disposal for completing this task. By taking the time to consider your options, you will hopefully identify several possible approaches, from which the most suitable route can be selected. With alternative approaches already determined, the responsibility will not rest so heavily with the single solution. If you have the time, these different schemes can even be taken forward together in parallel, at least until you arrive at a critical juncture which forces you to go forward with only one. At the very least, this time spent attempting to appreciate the demands and requirements of the lighting should rule out which approaches would be inappropriate.

By examining the requirements of a scene in detail before you even set about creating your first light, you're ensuring that you don't get pulled down one particular route too quickly without considering your options. It's always difficult to abandon one particular solution and start working on another, especially if this alternative approach has not until this point been given adequate

thought. By giving the task at hand a small amount of thought before deciding on the best approach, you're less likely to have to do this, and you'll be better equipped should you have to. This might sound a little tiresome, but you should ensure that whatever machine you are about to work on has had its monitor properly calibrated, so that the output that you are seeing on screen is actually representative of your final output. Make sure that the program that you use to display an image for monitor calibration has any automatic color correction features turned off. A basic routine for monitor calibration is included on the accompanying DVD, and details of how to use it can be found in appendix A.

The key

Once you are sat in front of your calibrated monitor, ready to begin what you have decided is the most appropriate approach, ensure that there are no existing light sources in the scene as you first find it. You should also ensure that there's no ambient light in the scene by checking that this function is turned off. If you were to render now, you should get a black image, which is what you're looking for - a blank canvas from which to begin.

The dominant light source in your scene will determine where your key light is placed, which is where most artists would choose to start. This will generally be the main shadow casting light in the scene, so take care with this first light to make sure that you give any shadow maps the resolution they need. Use the light's sampling controls to blur the edges of the shadows appropriately - remember, the closer the light to the objects it is illuminating, the sharper the shadow will be.

Figure 16.01
Before you add a single light, stop to consider your potential options

You will probably start with a single spot or directional light functioning as the key light, but consider the source that this light is representing. Does an area light better represent this? Or a group of lights acting together as an array? You might not choose to replace the light that's acting as your key at the moment, particularly when you consider that the use of area lights can have a really costly impact on render times. Nevertheless, identifying issues like this as you create each light can save a lot of time when you're trying to rectify a problem with a setup consisting of dozens of lights. Take notes of potential issues and ideas like these as they present themselves; don't rely on remembering every aspect of every one of your lights. Place your lights steadily and purposefully, because even though you'll sometimes hit upon something that looks just right through pure serendipity, you're more likely to achieve the results you were after by being organized and methodical.

Fills and backlights

It's best to keep things relatively straightforward to begin with, so just as you'd be well advised to avoid area lights and arrays for your key, don't jump in and create fills representing every single instance of bounced lighting in your scene. Instead, think of the position of your camera and how the light from your key light would react in the scene and create only the ones with the most obvious contribution to your final output. Create these just as purposefully as you did with the key, making sure that nothing is obviously awry at this early stage. The chances are that all the lights you are creating at this point will change. Some might only be altered slightly; some will even get deleted should you decide to introduce arrays or area lights at a later time. Don't use this as an excuse for rushing things.

The same principles apply when it comes to placing your backlights. You don't need to go overboard initially, creating large amounts of lights in order to create the subtle halos of light that you might want to appear in your final output. This will just overcomplicate things very quickly. Instead work by the same straightforward principles you used to create your key light by complementing this with only a minimal amount of fills and some very simple backlighting.

As you create all of these lights, be very attentive to simple things like remembering to turn off the specular component of fills and backlights. Furthermore, get into the habit of performing a run-through of all of a light's options when you think you've finished creating it. This way, you'll more likely remember things like limiting the Far Attenuation of a light and so on. A little effort paying attention to basic detail at this point can save a lot of time and effort further down the line.

Figure 16.02
Use flipbooks or RAM players to
compare your rendered output

Rendering

It's never too early to start rendering. Start your first rendering as
soon as you've created your first light and continue to render tests
as often as you need them. If your scene is already too demanding
in terms of render times, there are many things you can do to
speed up your renderings at this stage. Disable all supersampling,
and motion blur, turn off antialiasing and even substitute
materials for those that are render-intensive. You need to be able
to see the effect of your lighting, and you can't do this without
rendering, so make sure that you can actually render in a
reasonable time to begin with.

Now, because you gave the scene a respectable amount of
forethought and placed your initial lights steadily and
purposefully, you will have a very clear idea of the role of each
individual light and what each is supposed to be doing for the
scene. As well as rendering the scene with all the lights on, to
check that you are getting the desired effect as a whole, you
should also get into the habit of rendering with individual light
sources isolated to test their individual contributions.

To judge the contribution of a single light source to an overall
lighting setup, it's useful first to render with this light turned off
entirely, then render again with the light on and take a look at
the results side by side. If your 3D application has a method of
displaying two or more images at once, like 3ds Max's RAM
Player, which allows images to be placed in different channels,
effectively on top of each other with a divider splitting the image
between the two channels - then use it. It's also a good idea to
give the light source that you are examining a bright color that

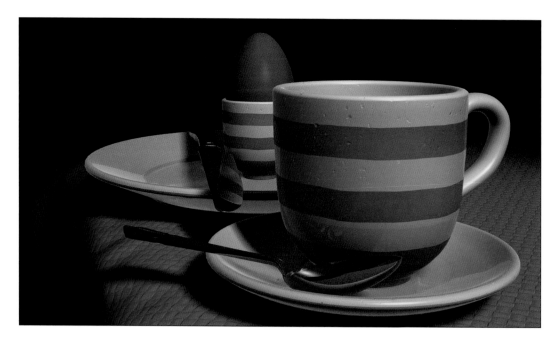

Figure 16.03
Giving lights contrasting colors can
help you judge their contribution

makes its contribution stand out from the scene. A color that contrasts with the rendered image will show up its contribution to the scene's illumination most effectively. Be careful when you allocate colors to these lights, however, that you don't increase or decrease the light's intensity by choosing a color with a different value. By giving lights different colors in this way, you can examine how the contributions of different lights blend together, without confusing their overlapping illumination.

You will always need to keep an eye on what the effect of changing individual lights is having on the scene as a whole, but by looking at lights in isolation you are reducing the chances of unpredictable results. Most people like to build up a lighting set-up starting with the light with the most influence, finishing with the one with the most sublte influence. There is nothing wrong with either method, but you can also learn a lot by going back over your setup the opposite way round, starting with the most subtle and analyzing how the lights build up together.

Revision

You'll spend the majority of your time making revisions to your setups, so it's important that you manage this part of the process as efficiently as possible. From the moment you have a basic setup in place that you are happy with, you will begin a gradual process of refinement that might see these initial half dozen or so lights multiply into many times this amount, with the contributions of each light becoming more and more subtle.

The same rules that have been outlined so far still apply, but with the amount of lights increasing it's all the more important to stick to them. As you are replacing the lights that were initially created or adding new lights to complement your originals, it's vital that you understand the role of each light and how they are working together. Use all the tools that your 3D application has to offer on this front. 3ds Max's Light Lister can be very useful for quickly turning on and off numerous lights to render the contribution of different lighting elements. This kind of feature is also invaluable for looking over a scene's lighting as a whole, checking that all the relevant lights have their relevant features turned on.

These next few points might sound like obvious advice, but it's amazing how many people don't consider the straightforward aspects of production. Set your applications to increment the files you are working on, so that you can always return to an earlier version to compare your results. This only works if you save your work at regular intervals too! Perhaps the most obvious advice is always to use a detailed and easily understandable naming convention, in order to keep track of your many lights and their purpose. This will be plainly apparent to most people, but is of paramount importance, especially if your work gets passed from person to person in a studio. Similarly, keep any production notes updated, so that the next person to come across your setup won't be cursing you as they struggle to get to grips with it. Hang onto any notes that you make as you work through the revision process towards a finished product, you never know when you are going to be asked to perform another revision.

Production pipelines

How your own working methodologies develop will depend largely on the pipeline that's in place at your studio. This will vary between different production houses and will depend on many factors: what business sectors the company works in; how many artists there are; how they are organized into teams, and so on. The job of a lighting artist often involves far more than just lighting. Indeed, more often than not a lighting artist's job will involve rendering, sometimes even modeling and animation.

If you work in a small company with few artists, the chances are that the work is organized less by discipline. In this case, you could well be doing the whole gamut of jobs, from modeling to rendering via texturing and animation. This does have its plus points in that it's easier to track down individuals responsible for previous work and talk to them about the scene, the work done so far and so on. This can also have its obvious disadvantages where you have people working in areas that are not their strong point. If you work at the opposite end of the spectrum, in a big production house, where a production gets passed through many

stages from its initial developmental phase right through to compositing, the higher the chances are that you will be doing nothing other than lighting work, or at least lighting with a little rendering. Large production houses often employ technical directors (TDs) whose job involves looking after the teams of lighting and texture artists, as well as writing shaders and other custom software with the studio's research and development staff. The advantages of working in a structured setup such as this is that people work only in their areas of expertise and so the quality of work is likely to be higher. However, this type of system, with work passed from team to team, can feel a little too much like a production line in a factory. Outside of the smaller companies, you'll sometimes find a role defined around the rendering pipeline. This role is built around the rendering pipeline and can take in additional areas from material design and texturing. However setting up the render parameters and producing the final render is generally central to this kind of role, which can often frequently move into aspects of lighting.

Whatever size the studio, generally the lighting staff are involved with the texturing work, as these two tasks are very closely tied together. Revisions to materials and textures form an integral part of the lighting design process, which is why these two areas often overlap in terms of workload. However, it's not just ineffective texturing that needs to be altered when it comes to lighting - often a model's geometry prohibits it from responding well to a lighting scheme.

Modeling issues

You'll occasionally come across a model that just simply does not react well to lighting, no matter how much effort and how many lights you throw at it. The model is not necessarily badly constructed; it's just that it hasn't really been built with lighting in mind, which can make the job of lighting nigh on impossible. The problem lies mainly with models that are angular, which will not catch the light as well as more organic shapes, as you can clearly see in figure 16.04. The sharp edge of the box on the left does not create a specular highlight, whereas the small bevel applied to the box on the right gives us a subtle highlight that looks much more convincing. The only difference between these two models is the bevel, which is simply applied and makes a world of difference to the end result. Objects in real life that might well appear to have right-angled edges rarely do, and everything from cardboard boxes through to household furniture has a curve to its edges, no matter how slight.

It's important the modeling team bears this in mind and puts to use the more organic modeling tools, such as mesh smoothing, which make it much easier to create flowing organic curves that

Figure 16.04
Modeling staff need to understand
the needs of the lighting team

respond well to a scene's lighting. Modelers generally understand
the needs of the animation team and build into their creations
sufficient geometry where it's needed, around the joints of
characters for instance. However, it's also important from the
lighting team's point of view that sharp angles be rounded
slightly wherever possible to give them a more realistic
appearance that can be lit well. With communication between
the different teams in a studio, issues like this can be avoided
and the lighting team's job made easier, which also benefits the
modeling team, who will see far less modeling revisions.

Texturing issues

Though you will sometimes be tasked with lighting an early
version of a scene that's untextured, more often than not you'll
be lighting a fully or at least partially textured environment. It's
beneficial to be involved in lighting a scene as early as possible,
and if you are presented with an early untextured version of a
scene, the lack of textures can be helpful in judging the influ-
ence of your lights; a decent lighting scheme at this stage can
benefit subsequent texture design. The more likely scenario,
however, is that you'll be handed a textured scene that needs to
be lit as quickly as possible in order to get the scene rendered.
Lighting is something that seems to be regularly left until late in
the day and needs doing quickly. The regrettable truth about

lighting in most studios is that it is not really considered important enough to warrant the effort it actually deserves. Even when lighting is considered worthy of some time in the schedule, you'll often find that vital aspects of the scene are missing: perhaps the animation has not been locked down and approved or the background plate is not the full resolution version.

Though it is undoubtedly a welcome change when the lighting design does begin at such an early stage that the textures have still not been produced, it's only when these are applied that you'll be able to really judge how your lighting scheme is taking shape. Textures make the world of difference to a lighting scheme and the purpose of setting up a fairly basic first lighting scheme is to see how these textures bear up. Another reason why your first attempt at lighting the scene should not become too complex is that often a test render at this stage will reveal that the materials need revision and once this is complete, you don't want to have to readjust a complex lighting scheme again. Before altering a material based on the test renders at this stage, you should be sure that the lights themselves are not at fault - specular highlights in particular depend upon the lights around them.

Depending on the nature of the production in question, the problems that you will generally encounter at this stage will be with materials that look too perfect. It's easy to produce materials that are shiny and plastic-like; however, realistic materials are much less reflective than your raytraced material would have you believe, with much more by way of dirt, scratching and general wear and tear. If you generate details like scratches, water stains and so on, keeping them in a library for future use is a very good idea, as you will always need this kind of detail.

Figure 16.05
Lighting of early untextured versions of scenes is not common

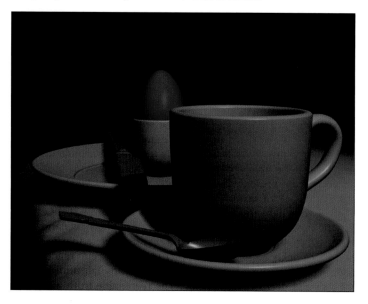

Keeping the saturation of colors down for natural materials can help make textures look more realistic, as can being subtle and cautious when using raytrace maps. These are just a couple of things that will help your textures look as good as possible and whilst texturing is not really the subject of this book, within the second bonus chapter on the DVD there are many lighting tips and tricks, a good deal of which concern materials.

Lighting your scene to the best possible degree is only possible when the textures have been designed to an equivalent standard, and modeling too, though arguably to a lesser degree. No matter how big or small your studio, the different teams need to understand the needs of the others and there also needs to be a clearly defined approvals and revisions process for making changes when these are required.

More revision

There will always be more revisions, whether these are caused by new versions of materials, the arrival of a plate which was delayed at the telecine stage, or a straightforward request to change something from your client or a senior creative figure. As such, you should never delete the old versions of the scenes

Figure 16.06
Only when textures are applied will you be able to really judge how your lighting scheme is shaping up

you've been working on or the notes that you've been frantically scribbling since you started working on the scene. However, to avoid too many unnecessary changes being made, the approval and revision process should be organized in a simple manner.

The client has every right to question the decisions taken on his behalf, as it's his money that's paying for the work, but he or she needs to understand the scope and potential of the medium to prevent requests for the impossible happening. Furthermore, from the earliest meetings with a client, there should be put in place a structured schedule with clear definitions of what they can expect in terms of deliverables on which specific dates. This not only identifies what they can expect, it also sets down from the outset the demands that will be placed on your studio and enables you to schedule this work alongside any other projects that your staff might be working on.

Once the demands and goals of a project have been identified, it's important to establish good lines of communication within the teams that will be assigned to it. Depending on how big the project is, there could be any number of people and teams working on it. What is critical to establish early on is the approvals process and in particular who answers to who. The client will meet generally with key creative staff, who will be headed by one figure - generally the Creative Director or Art Director - though this will depend on your company and the project. The feedback from these meetings will be channeled through this one individual down through the leaders of each team working on the different elements of the production.

Similarly, the relationships between the individual artists at the end of the chain should be organized so that the hierarchical structure of approvals and revisions is kept as simple as possible. This should ideally include the team of artists at the bottom level of the chain - we'll assume we're talking about the lighting team - who answer to their Technical Director, or whoever is in charge of their group. Ideally, this person should be the only figure who can authorize and request an artist from this lighting team to revise a scene; otherwise you can start to get conflicting opinions. Similarly, this person should ultimately only receive requests for revisions through one person, and so on.

The client meetings should be organized so that they happen at key points in the schedule, based around the work, not the calendar. You want the client to approve things as they have just been completed, so that the project can move to the next stage of production to minimize the risk of rework at a later date. For example, you don't want to have to wait until your main characters are modeled, boned for IK and textured before your client tells you that he wants the modeling work changing. The meetings, workload and approvals all need to be efficiently

managed in the schedule to keep rework to a minimum and efficiency to a maximum. Of course, this schedule needs to be flexible enough to be able to incorporate any changes that might be requested, as there will inevitably be some unforseen changes.

The client should be kept informed of the project at all times, and in the build-up to a meeting where work is to be presented, the client should be informed of what to expect. For instance, if it's modeling work that is being presented, then they should know that the work will be untextured, that what they will see is a rendered figure rotating through 360 degrees under basic lighting so that they can see all angles of the work. The client should know that they are not going to be able to see the figure walking or in different poses, unless this has been specifically agreed beforehand. The expectations of clients have to be managed in this way, so that they understand what to expect at each stage. It's also vital that clients understand technical differences of delivery mediums and does not go away from one of these meetings feeling that the studio is not close enough to their ideas.

Similarly, it needs to be made plain what can and can't be changed after each level of approval. Don't expect the client to know the technical aspects that you and the teams around you take for granted. If the output is not to be rendered into separate elements and composited together, perhaps because of a budgetary constraint, then explain the impact of this. It's always best to talk to your client in straightforward terms rather than overwhelm them with technical jargon.

Preparation

Just as it's important to prepare your client for such a meeting, it's also vital that you are organized and so are your staff. There's nothing like a high-powered laptop for these kind of meetings, but if you are using one, make sure that all the relevant files are on it and that you know exactly where they are. Using a laptop can be useful in that it can be used in isolation from the rest of the studio, but don't expect its hard drive's contents to look exactly like your own. Remember which 3D files generated which renderings and have everything stored in a logical system that preferably mirrors how the production files are organized.

If you choose to hold the meeting in the production studio amongst the artists, you are more likely to know exactly where everything is stored, but you run the risk of the client seeing artists working on his project, which can be dangerous when your client suddenly wants to see the effect of a suggested alteration. The best bet is to have a comfortable area that's separate from the production studio, so that the client feels at ease and so do the artists. However, sometimes a client will want

to see exactly what he's paying for and in these instances a tour of the studio floor will be required, with all hands conscientiously on deck, of course!

Knowing where your files reside is only the start though; you also need to know about the work that these files contain and how this has altered from previous meetings. The client might well have forgotten how something looked during your last session and it's useful if you are able to quickly pinpoint any previous versions for side-by-side comparison. Take any notes that you have prepared about the work you are showing into the meeting with you, as well as any notes that you took during the last meetings - don't rely on your memory alone.

Finally, though you might have been working with a variety of styles as part of your own experimentations, it's not generally wise to offer the client choices between too many different images as to how something would look. The purpose of these meetings is to get things signed off and approved as efficiently as possible, not to create extra work. In order to prevent this happening, you should also take extensive notes of what occurs in these meetings, and of what the client expects by way of revisions for the subsequent meeting. Often the comments made by clients can be imprecise compared with the technicalities of the language of CG. If your client wants something changed, make sure you both understand exactly what they want changing. If an image is criticized as being too harsh, then is this a lighting issue or a rendering one? This may be something that involves a little work in post production, but it might also require a revision to both the textures and the lighting.

Furthermore, the client might be the one paying the money, but you should not be afraid of voicing your disagreement. However, don't take any criticisms too personally and be prepared to fight your corner and explain your decisions. If nobody mentions your contribution, then it means that it hasn't caught the eye and this is generally a good thing when it comes to CG, especially in these kind of critical environments. There will be times, however, when it would be politically correct to draw attention to your work to avoid the criticism getting bogged down in some detail that might lead to a trouble-some revision, even if this work would fall on another team. If you're some way down the schedule, it's better to concern yourself and the client with tasks that fit in with this stage of the production's development than it is to have the client start up another discussion about the character modeling, for instance.

Guiding your client in this way through the production can be troublesome, but clear communication and a structured schedule, with approval points agreed with the client and based around the project rather than the calendar, can make all the difference.

Pitching for business

If you're working in one of the smaller or newer companies involved in CG, the chances are that a lot of the company's time will be spent attempting to attract new clients and drum up new business. This can be a wearisome process at the best of times, especially considering the tight budgets that most companies at this competitive level are operating on. Nevertheless, a convincing pitch that's professionally put together can make a whole world of difference to whether a job comes to your studio, and it can also make a difference in discussions about budgets.

The average pitch is a two-stage process, which can be thought of as similar to making a job application. The first stage involves the initial approach, which is like sending out the resume that you've been working so hard on. This initial approach, like your resume, will hopefully get you through the door and will enable you to sell yourself face to face. This second phase is like the job interview, where you get to sit with the client and present your ideas. Both stages take effort, but once you have the basics of a polished pitch in place, you'll find the process much less frustrating.

The first step, after you've identified the companies that you want to approach, is to identify the correct individual to contact. Getting through to the relevant person straight away not only saves effort, but given a little effort to research some basics about both the company and the individual also makes you look much more professional. This initial approach can be a tricky one, but by researching and understanding a few basics about the company you're approaching this won't be so much of a cold call. Generally, your first contact will be made by telephone, in which your goal is to inform them that you wish to send them some basic information by way of an introduction, to which you'll hopefully get a reply that promises to take at least a cursory glance at this correspondence.

The information that you send should then arrive promptly, as promised, to the person you talked to, so make sure that you've got the correct email or postal address and that your contact's name is spelled correctly. Any communication, whether email or letter, should be short, snappy and to the point. If you want to expand on any of the information, use a link from the email to the relevant part of your company website, which of course should always be simple enough to load in decent time, though it goes without saying that this should be visually appealing too; you are a creative company after all.

The follow-up call should certainly be made within the next week, too soon and you risk hassling the person before they feel they've had a chance to look at your document, too late and they might well have forgotten about the whole thing. It helps to

keep some kind of log of calls with your clients, so you can remember who you've spoken to, and at what point and where you left things. The names of all the other people you've dealt with along the way, every assistant and secretary, should also be recorded, so you can identify everyone you've spoken to by name if asked, which just makes you look so much more professional. Certainly don't hound people at this stage if (as will invariably happen) messages don't get returned, and if someone says that they are not interested, then say a polite farewell.

If, however, you get invited along to visit the company and make a presentation, then prepare yourself. This is where the stylish laptop comes in handy again. Make sure you have the relevant files to hand that you might need, but with your main sales pitch packaged together smartly inside something like Flash or Powerpoint. Never rely on the right codec being installed on someone else's machine; use your own and remember your power leads, passwords and so on.

It's important to appear professional, but also approachable, and how you are perceived as a person will generally be established immediately, so be polite and reasonably informal at first. First impressions count, so always arrive on time. You should then briefly map out for them what the next fifteen minutes or so will involve, before leading them through your presentation. Allow them the opportunity to question you at any point, but try to keep the presentation flowing.

When you're done, leave them some information. Printed matter is always good at this point, because it does not rely again on codecs and software applications. This should sum up exactly what was covered in the pitch, so your prospective clients are not relying on their memory. If you are leaving a DVD of your work, make sure it's simple to use and that any movies use a simple codec that is likely to be on most machines. Pop the codec install on the DVD too, with a note in a readme.txt file to explain how to set this up. This is the reason why VHS tapes are still a good idea - they are a foolproof delivery medium.

If this meeting went smoothly, all you have to do now is sit tight and wait for a response. The same rule applies about not leaving things more than a week, but again don't hound people, the last thing you want to do is to ruin all your good work by appearing aggressive or over-eager at this stage. There are no guarantees that even the most polished pitch will work every time, so don't be disheartened to hear that your efforts were in vain; if you gave it your best shot just move on to the next name on your list of potential clients. Hopefully your politeness and professionalism will have got you remembered for next time. It's never worth burning bridges in what is essentially a very tight-knit industry where your attitudes and approach will be remembered.

Experimentation

In-between all of the regular work that's scheduled into your week - the meetings with your superiors and clients and any other involvements you might have - you'll also need to find time for experimentation, both with your existing software and anything new that might be out there. Software in this industry changes at an alarming rate; your core 3D solution gets a major upgrade every year and a half, and the stream of new plug-ins and complementary products is constant. Whereas radiosity and global illumination for animation was unthinkable for the average studio to consider a few years ago, the increase in the power of our hardware gives the software developers the elbow room to be able to introduce such functionality.

The fact that hardware has increased as Moore's law predicted so far means that the applications we artists rely on get more powerful and as a result, more complex. Keeping up with just one major 3D solution can seem like a battle in itself, but for those involved with several systems plus plug-ins in a production environment, this can seem like a constant struggle.

Upgrading for the sake of upgrading is never a good idea, but this is rarely the case in animation, and there's always some new functionality that will justify the move to the new release. It's important then that any new features and abilities of a new version are examined thoroughly and the existing techniques and processes in place tested against possible better new methods.

Many 3D artists find the time to work on personal projects in their spare time, which is always a good idea for keeping your skills sharp, especially if you work in a large production environment and your job description is comparatively narrow.

Those in charge of the course at the college where I studied animation encouraged the students to do as many different short films as possible, with the onus on trying different things, rather than attempting just one marathon production. This was definitely a good piece of advice, and if you don't have the inclination to be working on a hefty side project during your leisure time, it's instead a good idea to stick to very short animations during any downtime that you might have at work.

Staying late at the office to work on something personal is understandably not everyone's idea of fun, but there will always be time to take a scene that's been produced for a client and rework it in a different direction than they requested, perhaps for the sake of experimentation. It seems that everyone in the business of computer graphics is incredibly busy, but nobody should be too busy to find some time to experiment and play a little with these great applications we all have at our disposal.

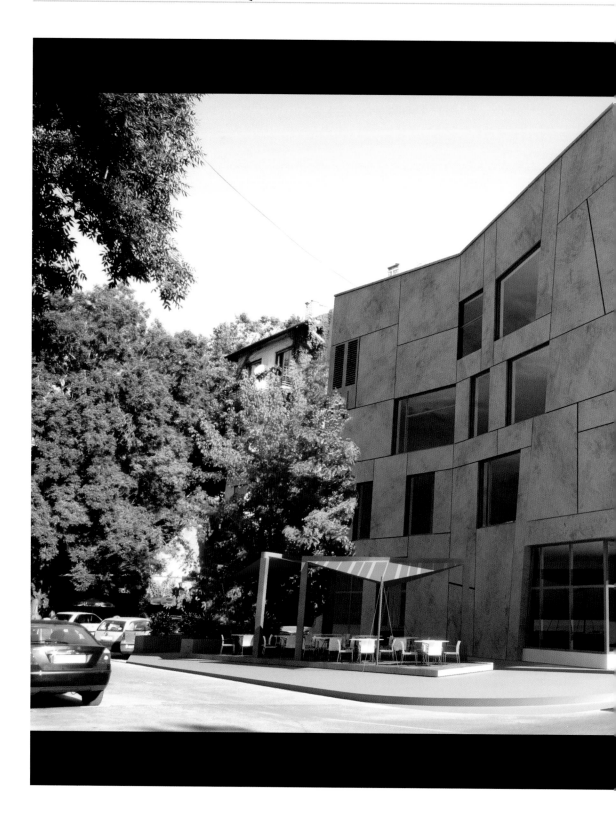

part 4: taking it further

Image courtesy of:
Andras Onodi
www.zoa.chu

17

'Harmony of form consists in the proper balancing, and contrast of, the straight, the inclined, and the curved.'

Owen Jones: *Grammar of Ornament*

Visual storytelling

The considerable role that lighting plays in terms of visual storytelling is undeniable. However, the production of imagery in any medium, from film to photography, fine art to illustration, requires an understanding of such concepts as composition, staging, mood and depth. This chapter will take the form of a discussion of these concepts, with the lighting artist's role always kept central to the discussion.

This area more than any other covered so far draws on principles from complementary disciplines, as well as from the psychology of visual perception, and because of this it is perhaps the area that those without a formal design or art background might want to research further for themselves.

What lies at the heart of good lighting, both in terms of the digital and real world, is the ability to put into visual form the ideas, or your director's ideas, about how a particular shot

Image courtesy of:
Marek Denko
http://denko.maxarea.com/

should look. Discussions of such concepts as composition and staging deal with the ability to visualize each shot in context of its scene and consider the aesthetic possibilities afforded by the many different juxtapositions and arrangements of cameras, characters and, of course, lights.

Within any given shot the lighting should be focusing the audience's attention on the areas pertinent to the action, whilst reinforcing the depth and 3D nature of the production. It also has a vital role in conveying a sense of place in terms of the clues it can give with regard to time, both time of day and time of year. A good lighting artist also bears in mind the characters they are working with, and their personalities within each scene, thinking about how this can best be communicated, along with the overall mood and sense of drama that the script conveys.

With these fundamentals always kept in mind, let's move on and discuss the further concepts that can help to reinforce the visual structure of a production.

Composition

Figure 17.01
Accepted shot types in cinematography can be applied to CG

Image courtesy of:
Platige Image - 'Fallen Art'
www.fallen-art.com
www.platige.com

The concept of composition is perhaps best discussed starting with the context of cinematography and the different types of shots that are used by film makers. To ensure that your production sits comfortably within the established boundaries of recognizable cinematic conventions it's useful to know the different shots, and even if you're not going to stick strictly to these principles, it's always best to know how to work by the rules before you start to break them.

You'll often hear terms such as 'extreme close-up' and 'wide shot' in the context of film making; there are five commonly accepted shot types with the two just mentioned at both extremes. From the largest down, here's how they work in terms of a character:

Table 17.01 Common shot types

Wide shot
Often used to show a location alone, or one with one or more characters, this is the widest shot, which is also often used during action sequences and establishing shots.

Medium shot
Generally this type of shot shows a character from the waist up.

Medium close-up
Generally accepted as a head and shoulders shot.

Close-up
Focusing on one particular area, in this case the character's face.

Extreme close-up
Frames a specific detail of a character's face, such as a character's eyes reacting to the action of a previous shot.

These types of shots can vary in context of the scale of the production that they feature in: in *Gladiator*, for example, some wide shots actually take in the whole arena environment. By contrast, in *A Bug's Life* this type of shot often takes in just the inside of the bugs' underground nest.

There also exist conventions that dictate how these types of shots are best used in relation to one another. For example, the first scene within a film will often start with a wide shot that establishes at once the environment in which the tale is set. This is invariably followed by a closer shot that gives more detail, with the audience fully aware of the context within which the story is unfolding. When there are specific details or reactions that help to tell a tale, set a mood or reveal an aspect of a character's personality, the close-up and extreme close-up are useful tools, especially in communicating the emotional side of a story.

Bear in mind that it's all well and good going for the dramatic sweeping wide shots to create atmosphere that we've all seen in films from *Lawrence of Arabia* to *Apocalypse Now*, but without the tighter shots, the tale will lack a personal touch and the nuances of the characters will be lost. Similarly, if your production is made up largely of tight shots, then the whole context of the tale might well be unclear.

There are also specific types of shots that work together well when working with a particular type of scene. The most relevant of these to animation are the combinations that are relevant to character-based productions. When you have two characters engaged with each other, the most basic of the possible shots is called the two-shot and is shown in figure 17.02. This is a very simple way of framing the action, but can be a little short of dynamic in some cases.

However, just as wide shots are often used early on in a film to establish a context for a tale, a straightforward two-shot is similarly often used to initiate a scene involving the interaction of two characters, before switching to different shots.

One such shot is the over-the-shoulder shot (OSS), which appears just as you'd think, with the character whom the focus is on facing the camera, and the secondary character in the foreground, with the camera using their back to frame the action and place it in context. This is often accompanied by a depth-of-field effect to ensure that the audience knows immediately where the focus of the shot is.

This type of shot is extremely familiar from many, many films, and next time you sit down in a film theater look to see how this shot is used in combination with others. You'll often find that the OSS is used in combination with the equivalent shot, but from the other character's point of view. This convention, called the shot/counter-shot, is also often punctuated with close-ups to concentrate on a character's reaction, and works well in animation, not least because there's only one lot of lipsync or facial animation to be carried out at once.

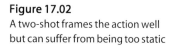

Figure 17.02
A two-shot frames the action well but can suffer from being too static

Figure 17.03
Over-the-shoulder shots can cut
down on animation work

A lot can be learned from these cinematic conventions, not just
in terms of composition using the physical objects and elements
within a shot: they can also teach us about using light with
composition in mind. Lighting's primary purpose is to illuminate,
but illuminate everything evenly in a scene and it's often
difficult for an audience to know where they are supposed to be
looking, which can lead to confusion and a loss of interest.
Lighting also has a purpose in terms of composition: to tell us
exactly where the focal point of a shot is - to enhance this whilst
not drawing attention to anything that's of lesser importance.
When a shot is only on screen for a matter of seconds, it's
important the audience is led as quickly as possible to the key
elements of the narrative.

This is essentially what composition in any visual form is all
about - directing the audience towards what is meant to be the
focal point of the image. As anyone with a formal art or design
background will tell you, there are many principles that relate to
visual composition. These principles are useful in that they can
be related to the planning of the layout of shots, but they can
also provide a valuable framework within which to analyze
existing imagery. Even early pre-visualization work can be
relatively complex in visual terms, and knowledge of the various
principles of composition makes for easier examination of the
visual merits and shortcomings of a particular shot.

As a lighting artist, you should always keep in mind that it's your
work that has the biggest effect on a shot's composition,
especially where relatively static shots are concerned. These
principles of composition are something that should be referred
to mentally when setting up the lighting of any shot.

Unity

When an artist steps back from a painting to look at the canvas from a distance, they are looking at the composition in terms of its unity. Though this is largely an instinctive process, there is a theory first developed in 1910 by three German psychologists that breaks down our intuitive tendencies into a framework of separate elements. Gestalt theory is actually a collection of principles that determines how we make sense of visual environments.

Though the word does not have a direct translation into English, it can be thought of as the manner in which a form has been put together. Its essence is that a composition as a whole cannot be surmised from analysis of its individual parts. The theory, which has been applied to painting, architecture, photography and design over the years, is concerned with how we use patterns to view a complex composition holistically.

The lighting artist should bear in mind these principles in attempting to provide their compositions with unity, as they can be applied to the use of light, color and shadow. Applying Gestalt theory in this way can help in establishing a unified composition: if an image does not follow these principles it can appear too visually unappealing, because the brain can't make much sense of it as a whole. On the other hand, if these principles are adhered to too strongly, the brain can read it too easily and will again lose concentration. Gestalt theory presents a framework of principles for analyzing composition, which can be broken down into several separate categories.

Figure 17.04
The principle of grouping deals with shape recognition

Grouping

Elements that are seen as being in close proximity to each other will be seen as belonging together, as can be seen clearly from figure 17.04, which we recognize as a number 2, rather than as a series of different colored dots. We are constantly comparing what we see with the many forms that we have already encountered in our lives in an attempt to make sense of the environment around us. Once familiar with a form or object, our brain records its various attributes for future comparison.

Taking the example in figure 17.04 a step further, we can clearly see within figure 17.05 the same number, despite the other dots surrounding it. The brain sees the elements that are in close proximity to each other and perceives these as a single entity. However, it is not just when using proximity that our brains tend to assemble individual elements as a whole.

The way in which our brains group separate elements together is most clearly evident when these objects share the same attributes of form. This can be seen in figure 17.06, where the separate elements are grouped together by color, which is the attribute that is used in testing for color blindness.

One tendency that we have which falls into the category of grouping is that of closure, or continuity, which is also demonstrated by figures 17.04 and 17.05. Despite the gaps in the shape of the number 2, the brain recognizes the underlying shape and perceives this as being whole, choosing to mentally fill in

Figure 17.05 (above)
Grouping is used within tests
for color blindness

Figure 17.06 (left)
Grouping explains how we see
shapes in random arrangements

those broken segments in order to form an unbroken contiguous form. In figure 17.04, the lack of figure 17.05's additional dots reinforces this recognition, and if all the dots making up the number were of the same color this would be clearer still.

Emphasis

Try staring at a blank wall for more than a couple of minutes. Compare this with the ease with which you can stare at a wall with a painting, photograph or any other focal point (especially a television). A CG image can be thought of in a similar way: if the eye has nothing to focus on, then it will appear empty and listless. This is perhaps where the lighting artist can have the biggest effect: the careful and considered placement of lights can help to reinforce the location of the focal point of an image.

An image can have more than one focal point, but of these one should stand out, and it is part of a lighting artist's job to keep the audience's attention on the main focal point, whilst also emphasizing the secondary focal points to a lesser extent. Whilst this is being carried out, obviously the whole image has to remain harmonious. By looking at the script and the personalities of the characters involved, you can begin to identify what are the primary and secondary focal points of an image. From here a lighting artist can begin to formulate a scheme that highlights the desired areas and plays down any distracting elements. There are several means by which an element can be emphasized, which follow on from the aforementioned Gestalt grouping principles.

Figure 17.07
Emphasis through contrast is
perhaps most relevant to lighting

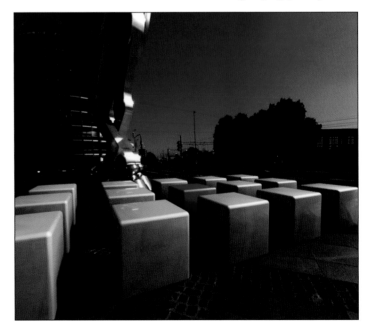

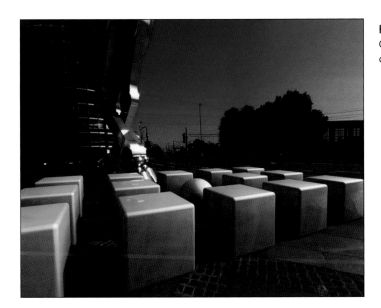

Figure 17.08
Our brain tends to sort objects into curvilinear and rectilinear

Using contrast to emphasize an area of an image is arguably the most effective and the most relevant to lighting design. There are several ways of making an element contrast with its surroundings: in painting and photography color, size, shape, texture and so on can be used to provide the contrast, but in animation you also have the added possibility of using motion. Whatever the difference, the brain automatically registers that something is breaking the overall pattern. The greater the contrast, the more obvious the focal point of the image. For example, in figure 17.07, the red cubes obviously have a great similarity to each other, but the blue cube stands out quite clearly because it is of a different color.

This method of using contrast relates strongly to the grouping principle that we've already discussed. In deliberately choosing to allocate a contrasting color to the cube in figure 17.07, the element becomes clear because it is resisting the grouping of its surrounding objects. The fact that this element is not displaying the same behavior as the other cubes makes it a clear focal point. Isolating an element in this way can be a strong visual technique for drawing an audience into the desired part of a composition.

When our brain is evaluating the forms that we constantly encounter, there are many attributes that it is recording and comparing. Though there are many differing shapes of objects, our brains tend to group them into two categories: one consisting of curved forms and another made up of angular forms. We are instinctively more attracted to angular lines and this is something that we can take advantage of when setting up a shot. An extreme example of this tendency would be the placement of a curvy character within a very stylized and angular environment.

Figure 17.09
Shadows cast from objects can
emphasize a scene's different planes

The audience will not only quickly focus on the subject, but will also feel drawn towards it. However, taking advantage of this categorization would usually require more subtle means: the simple staging of a character within or beside a largely angular form like a doorway or window would bring attention to the curved form, making it more of a focal point.

One particular characteristic that we are very sensitive to is the shape formed by the outline of a single form or several intersecting forms. We will construct edges as part of the shape recognition process as our eye scans along outlines of objects. Just as our brain attempts to mentally construct small gaps, it will also follow existing edges and construct new edges to elements that almost touch, leading the eye along the new outline. This can be used as a potent device to lead your audience into an image towards the desired focal point.

Furthermore, a shadow cast from a vertical object that falls along the floor and up a wall behind the object emphasizes the fact that the floor and far wall are planes of different orientations and depths in the image. The visual power of vanishing points has long been recognized and used as a visual device in painting.

This can be a potent device to lead a viewer's eye into a desired area, especially when the composition's objects are also purposefully oriented to point toward this region. However, in 3D the fact that our vanishing points are set up for us can result in us not giving them as much thought as we sometimes need to, as our compositions can pull attention away from the desired focal point of an image if they draw us into the image too strongly.

Conversely though, lines can be constructed that lead the audience's eye towards a desired focal point. There are several ways in which this can be achieved. The use of a series of physical objects, like a queue of people all facing in the same direction, can lead the viewer's eye into a specific portion of an image. However, these lines do not have to be constructed using physical elements, and the axes of objects, particularly those that are long and thin, will give a sense of linearity that can lead the eye, as will, of course, the sightlines of your characters.

If the line of people were shuffling along, then the emphasis that this device would create would be further strengthened by its movement, especially if it were the only dynamic element of a scene. The use of motion in this way is something that we as animators can apply in many different ways.

Furthermore, just as motion can be used to provide emphasis in this way and direct your audience's eye through a shot, it should also be considered in the context of the different shots that make up a scene. How your elements are juxtaposed from shot to shot has a great effect on how your audience's attention will be guided across the screen.

One of the primary reasons why we can cut between different locations, characters and even times in the edit and not lose our audience is because of the way our brains remember and compare forms. This process of recognition is what binds together a series of complex cuts between shots.

One of the things that we are particularly good at recognizing is the human form, in particular the face. In our dealings with other people, we absorb a lot of visual detail from people's faces in order to remember them and are immediately drawn to this region of the human form. This is something that can be demonstrated quite clearly in cinematography's over-the-shoulder shot. Given the back of a head and a face to choose between,

Figure 17.10
Larger objects attract us more, but if only the smaller object is fully within the frame, this is reversed

Figure 17.11
Emphasis through tangency
provides an uneasy tension

we unsurprisingly choose to immediately focus on the face. Furthermore, if the back of the foreground character breaks the frame of the image, then we are even more drawn to the character facing the camera.

This fact relates to using size as a device for emphasis, which is one of the more straightforward methods of calling attention to something, as our brains are automatically drawn towards larger elements. An overly large character interacting with an exaggeratedly small one can be compelling. The contrast in size will draw us to the larger character, but if the camera moves and only the smaller character is left fully contained within the frame, then the emphasis shifts to the other, smaller character.

The methods of creating emphasis mentioned so far are usually employed purposefully to stress the desired focal points of an image. However, tangency is a little bit different, in that it generally provides a negative emphasis, which is usually off-putting, creating something that the eye is not fully at ease with. Moving objects around to avoid such undesirable tangencies is not always the job of the lighting artist, but his or her work is also likely to result in similar uncomfortable tangencies. For example, if shadows form tangencies with other shadows or objects, these in turn can become distracting.

Nevertheless, though tangencies will more often than not create an undesirable distraction, this visual tension can also be used constructively. By juxtaposing two elements that almost touch, our desire to see them connect attracts our attention.

Depth

Though we are lucky in many ways that our hardware and software automatically calculate depth into our rendered images, of course the sequence of images that are output is still flat and two dimensional and this depth is really an illusion. Though you might never guess, *South Park* is actually put together using Maya, and purposefully staged to look flat and 2D, primarily by having all the surfaces flat on to the camera. If the primary surfaces within a shot are facing the camera in this way, then a scene will not display the depth that it could. Similarly, bad lighting can rob a scene of its depth and the way that lighting is used to emphasize the orientation and juxtaposition of a scene's surfaces imparts a great deal of depth to a scene.

In determining the relationships of objects and their comparative depth in a moving image, we use many methods. We look at the comparative size of objects as a clue to which are nearer the camera. Similarly we look at which elements are overlapping others to judge which ones are in front of others. These are simple examples; just because an object is small, it does not necessarily mean it is in the distance, so our brain employs more complicated procedures to help identify comparative depth and size.

We must be careful not to do things to confuse these processes, like using narrow-angle lenses too thoughtlessly, as these reduce the sense of size and depth in a shot. Conversely, there are devices that we can use that provide vital clues, such as depth-of-field and focus. The way in which light casts shadows across a scene can be of great benefit in establishing the size and relative position of its objects, as can use of several other techniques.

Figure 17.12
Using narrow lenses can make a shot look flatter than you want

One of the primary devices for adding depth to a scene in CG is the use of atmospheric effects such as fog and mist or dust and pollen. Furthermore, these techniques also go a long way in enhancing a scene's mood. Just as smoke and fog machines are commonly found on live-action shoots, atmospheric effects should be understood by the CG artist as being part of their everyday toolkit for enhancing the depth and mood of a shot.

Equally, atmospheric effects can impart a sense of depth to indoor scenes, like in figure 17.13, where a row of windows runs down one side of the camera and shafts of light are penetrating across the view of the camera.

The biggest clues we use in judging depth are size and overlap. These factors are the most plainly understandable ways of stressing the depths of objects in a scene. When looking at the comparative depths of several forms, we naturally expect the larger elements to be nearer than the small ones. However, without a context to place these images in, it can be impossible to make comparisons and judge which object sits at what depth. In these kinds of situation, making sure that these objects overlap can be a simple method of making this clearly apparent.

If we are familiar with the visible forms, then we will begin to make these judgments and for this reason we must be careful and thoughtful in our compositions, as figure 17.14 demonstrates. Though both pictures show a large and a small circle, in the lower of the two images, the smaller circle looks as if it is located further into the image, whilst the topmost image looks more as if

Figure 17.13

Atmospheric effects can impart depth to indoor shots too

Figure 17.14
The smaller circle looks as if it is located further into the image in the lower image

it is a large and a small object. This is because, on the left, the two circles sit at the same position vertically, which is something that we should look out for when something does not look quite right in terms of its depth.

One thing that often betrays the depth of a CG production is scale, something that can also give away a miniature as being just that. If the scale of an object's textures looks wrong, whether this object is a physical one or a computer-generated one, it will stand out. Furthermore, it's these surface details that give us a great deal of information as to how close an object is. Though not strictly a lighting task, often a TD's responsibility will involve both texturing and lighting, and this is something that should be looked out for when something appears wrong with a shot. Generally, it's the fact that a surface texture is of too large a scale for something that makes a scene look not quite right and this should be examined closely.

At the other end of the scale from these potentially problematic small objects, lie the forms of considerable volume, like a scene's buildings and the ground plane, which certainly have a large role to play in emphasizing depth in an image. An object whose volume recedes into the scene should be lit to underline this

depth. A building receding from the camera is a perfect example of something that can be lit to show off the depth of the scene, but lighting in this way is something that should really be employed at all times, no matter what the subject matter. Without lighting from different angles, any object will appear flat and uninteresting and large objects are a particular challenge.

A very useful and powerful tool that can be used both to emphasize depth and stress focal points is color. Indeed, the value and saturation of these colors are also important factors in reinforcing depth. Lighter values often seem to be closer to the camera than darker ones, which fade into the background; this is reinforced further in a shadowy theater environment. With bold colors in the foreground over more neutral tones, the viewer is left in no doubt as to what is the focus of the image.

Using more saturated colors in the foreground of an image can add to the perception of depth. This can be used, for example, to lengthen the appearance of a space, which will appear more elongated if the lighting is brightest in front of the camera, with a marked falloff towards its far end. Conversely, if this is reversed, as in figure 17.15, and the end of the room has a window with bright light emanating from it but falling off towards the camera, this can produce a very powerful image that draws us into this area.

Similarly, if the background is out of focus because of a depth-of-field effect as is the case in figure 17.16, or if there's some fog in the environment, the more saturated colors of the background become diluted. This example also works because contrast helps

Figure 17.15

Lighter values at the end of a long room can draw the audience in

Image courtesy of:

Johannes Schlorb (right)
www.schloerb.com

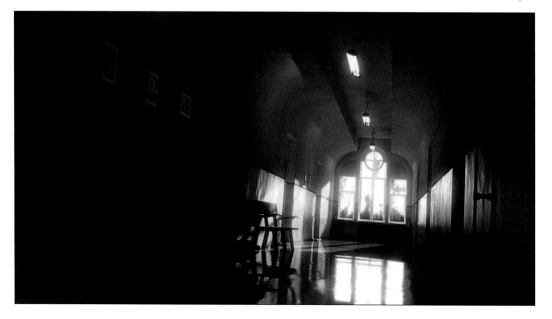

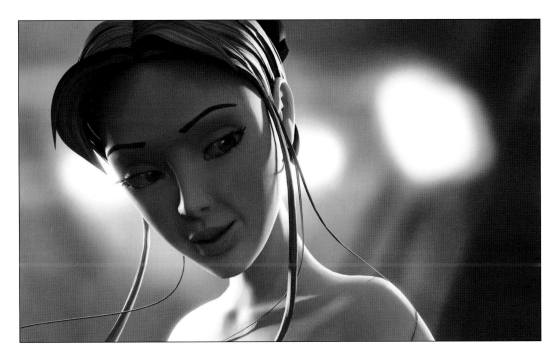

us to judge depth and relative position. Areas of greater contrast we associate with the foreground and those of lesser contrast we perceive as being part of the background. A rather strange phenomenon is the fact that warmer colors appear to be closer than colder colors, which is another property that figure 17.16 also demonstrates. This most likely occurs because the human eye needs to focus slightly further away to see a blue element than it would to see a red element in exactly the same location - this behavior is known as chromatic aberration and occurs in all lenses. As you can see, this can be used effectively to give a scene a tangible sense of depth, but as you can imagine, is not applicable to all situations. However, with the common practice of using blue light subtly as a night time fill to bring out the details in overly dark shadows, there's no reason why a practical light in the foreground should not be of a warm color to take advantage of this.

Mood and drama

Virtually everything that appears in a scene can affect the atmosphere of a production, from the set and the score to the characters and the camerawork. Getting the mood of a script over to your audience is something that can be achieved not only with lighting, but with most other components of a scene too. When considering the dramatic qualities of a scene it's worth bearing in mind the less obvious factors that will contribute to the mood of a shot, and how they can combine with your lighting scheme.

Figure 17.16
Saturated colors in the foreground and a muted, blurred background establish a very clear focal point

Image courtesy of:
Arild Wiro
www.secondreality.ch

It's always worth remembering that as a lighting artist working in a 3D environment, the end result of what you and your fellow artists have labored over is invariably a series of flat two-dimensional images. Keeping a camera view open in your 3D application should be something that is ingrained by now, but sometimes not even this is enough.

Though this view might demonstrate quite clearly how something is moving, the wireframe or flat shaded preview is a far cry from the final rendered image. The whole of your world might have been laboriously constructed in three dimensions, but at render time all this depth is flattened to a bunch of pixels. When this occurs, every element becomes a flat form within this image and in these forms there lies a lot of emotive power. Within this context, our brain organizes things between shapes and spaces, both positive and negative, between planes, lines, edges and axes.

Figure 17.17
The use of contrasting areas of tone is a great stylistic device

Image courtesy of:
Plaksin Valery
plaksin@ktk.ru

Figure 17.18
Simply rolling the camera slightly injects a sense of tension

Vertical lines speak of movement and the built environment, whereas horizontal lines reflect the stable lines of the landscape and the horizon. These lines of course also lie comfortably parallel to the periphery of the theater or TV screen and therefore look at ease in this position. A common technique to inject tension and volatility into a shot is to roll the camera slightly; so all the horizontal and vertical lines are set at a slightly more dynamic angle, as is demonstrated in figure 17.18.

Just as using a slight camera roll in live-action and CG work moves the stable horizontal and vertical lines to a more dynamic angle, giving the shot an uneasy look, placing objects to look somewhat unbalanced can have a similar effect. Our feelings towards something that looks unbalanced are primarily feelings of unease but also of fascination. This is demonstrated by the eternal appeal of the Leaning Tower of Pisa. Looking at the instability of the structure, your mind wants to stabilize it, but of course it can't, which is why this is such a visually powerful building.

As we touched on in the previous section on emphasis, the eye will search for and follow paths within an image based on repeated elements, sightlines and edges, amongst other things. Two repeated elements make for a linear path that the eye will follow, with the eye drawn to objects placed along its length.

Repeating elements in an image is a very powerful way of channeling your audience's focus through an image. Our eyes will be drawn between these similar elements as the brain makes comparative judgments between them. In this way, repetition of

shape and color can not only bring about a sense of harmony to an image, but can also set up routes through the image, which the eye will naturally follow. If only two repeated elements are used, then the path is a linear one, with our attention drawn to objects located along it.

As the number of repetitions grows, our brain begins to group these similar objects together as the grouping principle of the Gestalt theory describes. Taken further, we begin to separate the objects into different groups. Repeating elements in this manner over time can begin to introduce a sense of rhythm into a sequence, especially if the editing of these shots is done with this in mind, and whilst this is not often the role of a lighting artist, even when working as a TD, this should be taken into account if the production requires a sense of rhythm.

This concept of paths also applies to the overall balance of an image, where imaginary vertical and horizontal axes act as the pivots to the elements on either side of them. If the objects on either side of the vertical axis are perfectly mirrored, then this symmetry can impart a very stable and secure feel to a shot. This device is frequently used in architecture, where this kind of formality is often desirable. Indeed, in attempting to portray formal settings, symmetry is a powerful tool. One of the architectural lecturers under whom I was studying once used a phrase that sticks in my mind to this day: 'Symmetry equals the box equals the coffin equals death.' The extreme nature of this statement is no doubt why it stays with me, but there is a valid point about the formality of symmetry not always being desirable.

In CG, however, the use of balance about an axis can help to organize a busy scene into two halves, which gives an immediate central focal point. Balancing an image about an axis can at times create a more aesthetically pleasing image, as you can see in figure 17.21, but it can also have an effect on our interpretation of the script and the characters, especially where vertical balance about the horizontal axis is concerned.

Figure 17.19
Symmetry imparts a stable feel that is used heavily in architecture

As we'll cover in detail in the following section on camerawork, the vertical positioning of characters relative to the camera can carry a clear message about their personalities. This is because

we see height as one of the most noticeable characteristics of a person. Having a character visibly low in the shot can make him or her appear submissive, whereas placed towards the top of the shot, the same character can look much more dominant. We'll go into this in more depth in the following chapter.

We take cues as to our own position from the vertical position of objects, as well as obviously the location of the horizon, which we are used to seeing divide our vision just below the halfway mark. The vertical position of the camera gives us visual clues as to where you, as the viewer, are located, which is why for most regular work the camera is located at eye level. Even slight deviations above regular eye level can lend a feeling of power to the viewer, and this also works in reverse. If the camera is looking at a scene from the point of view of a character, targeting the camera slightly up or down can be very effective to help convey the personality of the character.

In addition to these two symmetrical forms of balance, there also exists an asymmetrical balance that is a much more subtle and powerful device. Although it is also something that is far more difficult to accomplish, when carried out successfully it gives more understated results. The subtlety of this kind of balance takes out the staged aspect that can be all too evident with

Figure 17.20
The vertical position of the camera and horizon gives a visual clue as to where the viewer is located

symmetrical arrangements, but achieving this subtlety of balance can take a fair effort, especially when you are dealing with moving images. This is attained more by intuition than anything else, with the different shapes that make up the final image positioned within the frame to balance around its central point, given a distance from this imaginary point according to their visual impact due to size, color and so on.

There's a simple equation in math that states that Force = Mass x Distance from the Pivot, which forms the basis of the calculation of the loads on beams in structural engineering and applied mathematics. This can be applied similarly to balancing a composition, with mass representing the visual impact, which as we've already mentioned is principally determined by an object's size, but also by its color and shape.

If a large form is located a certain distance from the central point of the image, which can be thought of as the pivot, then a balance can be achieved by positioning an equivalent force in the opposite half of the image. If you are not balancing the composition using a similar object, then the distance needs to be altered proportionally with the relative visual impact of the two elements in order to result in the same force.

With a smaller shape, for instance, the distance from the pivot would need to be increased to result in the same force, so the smaller form would have to be located further away from the center of the image, towards the image's periphery. Balancing a composition in this way can make the shot appear stable and secure, as we are visually comfortable with it. Setting up this kind of harmony to break it down suddenly can be a powerful tool.

Figure 17.21
Asymmetrical balance is subtler
but more difficult to achieve

Image courtesy of:
© Blizzard Entertainment
www.blizzard.com

Figure 17.22
The balance of positive and negative space should be considered

Positive and negative space

Our brains organize these 2D shapes that our final rendered images are made up of in several different ways. We obviously categorize things as being part of either the foreground or the background, but we also group things into positive or negative space. The positive space is formed from the main elements that are acting as foreground focal points, whilst the negative space consists of the adjacent background area.

Negative spaces aren't necessarily areas devoid of detail, as in figure 17.22, which demonstrates positive and negative space quite clearly, but they are the areas that don't catch the audience's attention. Despite this, care should be taken over how the negative spaces in an image are shaped and positioned around the positive spaces, and the balance between these should be kept in mind.

There is a balancing act that a lighting artist must constantly be aware of: the need to incorporate the separate elements of a scene into an integrated whole, whilst drawing out certain elements in order for the image to be immediately identifiable. Too much emphasis on one extreme can lead to too clearly defined an image, which is imminently understandable but dull. At the other extreme, there's the danger that the image will be too intricate, which can be beautiful, but also too much for an audience to take in quickly. Of course, this depends on the length of the shot and the action that's taking place: if it's a long establishing shot, the level of intricacy can of course go up a whole level of magnitude.

The rule of thirds

When putting together a shot, the rule of thirds can help in terms of arranging these shapes. By thinking of your image as divided into three sections vertically and horizontally, you can use these guides to help position your main elements. Positioning objects in the dead center of a frame can work in certain circumstances, perhaps when a deliberate symmetry is desired, but most of the time this looks too unexciting. By placing your elements along these imaginary lines, or on any of the four intersections, you'll straight away have a far more appealing arrangement. In landscape painting, you'll hardly ever see a horizon line placed exactly halfway up the canvas, as this can appear to divide the painting up too evenly, and this applies to CG shots as well.

Within any given shot the lighting should be focusing the audience's attention whilst reinforcing the depth and 3D nature of the production. It also has a vital role in conveying a sense of place in terms of the clues it can give with regard to both time and day and time of year. A good lighting artist also bears in

Figure 17.23

The rule of thirds can help you to set up well-composed shots

Lemony Snickets 'Littlest Elf'
by Smith & Foulkes
at Nexus Productions
www.nexusproductions.com

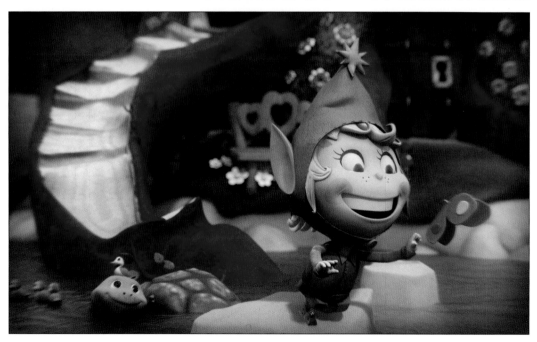

mind the characters they are working with, and their personalities within each scene, thinking about how this can best be communicated, along with the overall mood and sense of drama that the script conveys.

Whilst the principles and theories discussed in this section should certainly be kept in mind when setting up individual shots in a production, sometimes there is simply not the time or budget to set each shot up perfectly so that each one holds up individually. Indeed, often this is not even desirable. If a shot is only going to be on screen for a second or so, its composition will have to be fairly straightforward and plainly understandable, as this kind of shot needs to be comprehended almost immediately. The desire to change lighting from shot to shot in order to give each one individual treatment needs to be balanced with the need for continuity, though it's surprising how much you can actually do in terms of varying your lighting without drawing attention to this fact. Conversely though, being too afraid to change the lighting of a particular scene from one shot to the next can restrict the visual opportunities available.

With these fundamentals always kept in mind, let's move on and discuss the further concepts that can help to reinforce the visual structure of a production.

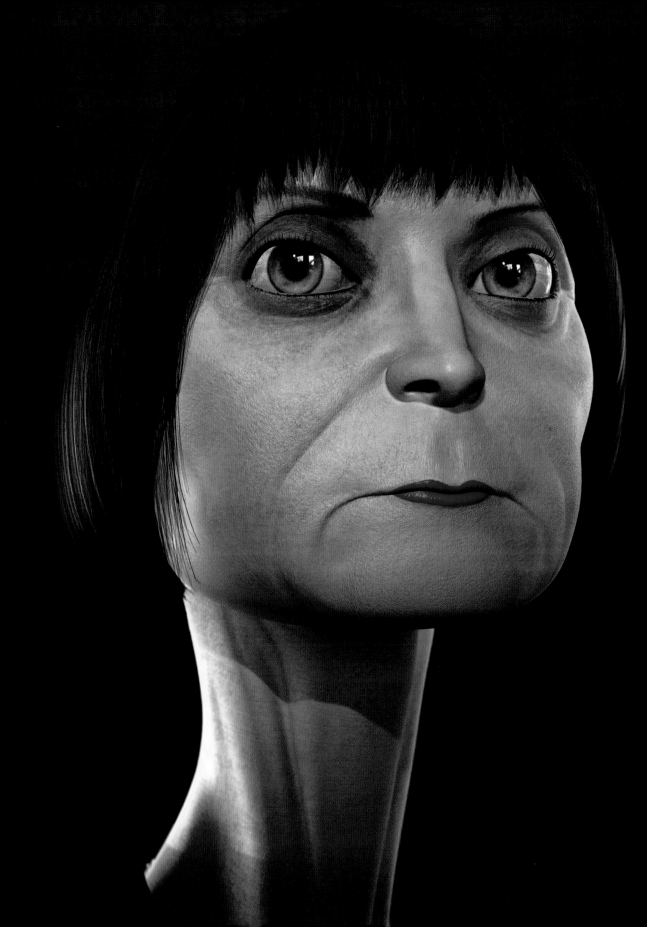

18

'Film cameras are generally bulky, heavy affairs. When they move it is generally with a plodding massiveness that belies their inertia. Video cameras on the other hand are light, flimsy affairs that we can fling around with mindless abandon.'

Scott Billups, *Digital Moviemaking*

The camera in 3D

Several books advise the new generation of moviemakers using lightweight, insubstantial digital camera equipment to strap several kilos worth of weights to their DV units in order to make their shots look more filmic. Similarly, in CG, our cameras can easily be moved around and though the agility of a camera in 3D has brought us some incredible camera moves, a little thought for the weight that a film camera's bulk brings to a shot can certainly furnish a CG shot with a more cinematic feel.

Though CG might seem laborious at the best of times, we do have it much easier than film makers in many ways. We can control our lights individually without having to resort to silks or bounce cards, and we can fling our cameras around 3D space with gay abandon. Camera movements that take us from the massive to the microscopic are easily possible with CG and many films and productions have benefitted from the ease with which 3D cameras can be manipulated. However, if you are looking to slot your

Image courtesy of:
Fred Bastide
www.texwelt.net

production between conventional cinematic reference points, you would be well advised to follow some rules to make your cameras and lights behave as they would if they were on set.

There's nothing that quite gives a 3D animation away as being CG than an overuse of camera movement, especially when the camera seems to move with a fluid ease that a real camera just simply cannot manage. The fact that you can move your camera around in this fashion has led to this technique being one of the most overused practices in 3D animation. If you want the audience to look at your production as a film in its own right it's best not to remind them that they're watching CG with all kinds of unrealistic camera moves.

The camera's controls

In any 3D application the camera's controls mimic the movements that real cameras make (and here we mean big bulky film cameras, not portable DV cameras). However, there are several key differences. For instance, the pan function generally moves the camera itself and careful consideration should be taken of this transformation - would rotating the camera as if it were on a tripod not work better? Furthermore, the inertia that the operator would be faced with when moving his camera should be mimicked using ease in and out curves to give the movement this weight. Similarly, a camera can be rotated to look up and down, but should generally not be rotated around its remaining axis to roll. A little roll to move your shot's lines slightly off the familiar horizontal and vertical can be very effective, but you should generally avoid animating this paramater during a shot.

One control that is provided in 3D that mimics its equivalent in the world of cinematography is depth-of-field, which provides the effect of focal distance in a real-world camera. Moving this focal distance gives what's known as a rack focus, and this can often be seen when action is changing from the foreground to further back in the shot, or vice versa. Animating your Depth-of-field controls can imitate this type of real-world shot, though Depth-of-field effects can be very expensive to render.

Zooms can be used, but if you watch most feature film work you would struggle to spot a single zoom: the camera is actually moving closer to the subject, which is called dollying. Zooms are pretty much restricted to camcorders. As such, unless you are trying to make your 3D produciton look as if it's been filmed using a hand-held camera, instead of animating the zoom feature, it's best to actually move your camera, but always try to give the move some weight. However, these are not rules, just guidelines that presume that you want your animated production to have the same look and high production values as a polished feature film. There will be times where this is not desirable, and there is one

Figure 18.01
Amateurish camerawork seals the
illusion in the stunning *Pepe*

Image courtesy of:
Daniel Martinez Lara
www.pepeland.com

particular animation that demonstrates beautifully how a well-crafted photorealistic environment can be made to look even more convincing by employing wobbly hand-held camera work.

Daniel Martinez Lara's website - www.pepeland.com - is the home of a stunning animation called *Pepe*, which you can see in figure 18.01. Do try and download it, it's well worth the effort. If you do, you can see when it begins that the illusoin of reality is reinforced because of the unedited look to the footage of an artist's studio. The camera moves, pans the studio and its focus wanes in and out, typical of most home movies. These camera moves are in fact so deliberately constructed that it is this that completely clinches the illusion. *Pepe* is also as expertly lit as it is textured and without these skills, the illusion would never have been possible in the first place.

Line of action

With cinematic conventions we have the concept of the line of action, which dictates how different shots can be set up so that they'll look cohesive when edited together. This imaginary line of action runs directly between two characters that are communicating, or in the case of a single character, runs in the direction that he/she is facing.

A moviemaker should try to avoid presenting a viewer with shots taken from both sides of this line, as it completely switches the direction of the action. This convention is quite useful in that it makes the task of the lighting artist easier, as the lighting setup will remain if not the same then similar, requiring little by way of adjustment for different shots within a scene, with key and primary fill lights located on the camera's side of the line of action

Figure 18.02
Your cameras should all be on the same side of the line of action

Scene courtesy of:
Jolyon Webb - Codemasters
www.codemasters.com

and backlights and possibly some secondary fill lights behind. For regular character-based work, most of these shots will be taken from around eye-level. However, if you start to move the camera and its target up and down in this circumstance you can begin to inject some drama into the shot, which suggests a surprising amount about the atmosphere and personality of the character. Low-angle shots make the character loom large over the audience, which has the effect of making him or her appear powerful and strong, which can be used well when trying to paint someone in a heroic light, or identify a character as being evil or powerful.

With high-angle shots the reverse applies, the character appears smaller, which can again be used to accentuate the fact that someone is small or childlike, but it can also emphasize that someone is vulnerable or pathetic. Furthermore, these kinds of angles have a similar effect on the actual environment within which the action takes place, making a character appear trapped in the corner of a room or having the space around someone look really open and expansive.

Perspective

This is just the beginning of the larger subject of perspective, which has a huge effect on how spaces are perceived. Take a simple scene and set up a camera. Now change the camera's field of view gradually from a very narrow 15 degrees up to a really wide angle of 85. See how the sense of space is drastically altered; not only do spaces look deeper, but also objects within them seem to be further apart the more the field of view is increased. And just as the distance between objects is exaggerated using wider angle lenses, so is movement towards and away from the camera.

Indeed, if your shot involves getting close to a character, and you want to keep more of a sense of the background in your render, you should opt for a wider angle lens. The fact that your camera is so close to a character also exagerrates their movement, which is useful for action shots. Likewise, if you are close up to a camera with a narrow lens, then the sense of depth can be lost, which might not sound awfully desirable, but can be quite useful for claustrophobic crowd scenes. However, get too close with a lens of too wide an angle and you start to get a fisheye effect, where the lens begins to distort the subject.

Narrow angle lenses distort things less, and this kind of lense positioned a distance away from the subject is the most becoming. For more natural looking shots, the best advice is to work using your common sense. Keep the camera within the boundaries of the set that you have constructed and think about how a cameraperson would actually position himself or herself to get the equivalent shot. One thing that you should not really be doing too much, however, is swapping and changing lenses from shot to shot, as this will just draw attention to itself and distract from the all-important storyline.

Figure 18.03
Clockwise from top left: 15, 28, 50 and 85mm lenses. The distortion is less the narrower angle the lens is, but the further away the camera needs to be to get the same shot

Scene courtesy of:
Jolyon Webb - Codemasters
www.codemasters.com

Point-of-view shots

Something that's considerably easier to set up in 3D than in real life and can be particularly effective is the point-of-view (POV) shot. This is where a shot is taken from the point-of-view of a character, so what the camera records is what the character would see. In cinematography, a cameraperson generally has to receive some basic direction in terms of movement. One great thing about 3D is that not only are our cameras eminently movable, they can also be constrained to anything, so if you want to you really can capture exactly what your character would see. The fact that our cameras also do not have a physical size means that this is applicable to any character, no matter how small.

The character from whose point-of-view the shot is taken might need to be hidden, it might not, depending on the scene. For instance, you might be happy with just the camera movement, but you might want to be looking from the point-of-view of your character sat at a typewriter, in which case you would want to see arms reaching out from under the camera with fingers tapping away. This all depends on what you are trying to achieve. Indeed, a lot can be achieved using this kind of shot, from humor to suspense. For instance, if your character was a small dog that was chasing somebody down the street snarling and attempting to bite their ankles, then this would provide an unusual and amusing angle, given even more comic effect with the addition of growling noises. Alternatively, if you had a character about to jump out at another from a dark corner, rather than film this actually happening with both characters in frame, filming it from the point-of-view of the character about to get the fright will scare the audience in the same way, giving the shot much more impact.

POV shots are also useful in terms of workload, as you are effectively removing a whole character from a shot, which can make a big difference in terms of animation and rendering. In spite of this, there are also words of warning about the POV shot: its overuse can be quite off-putting, and as with most things, it's best used subtly, for maximum effect. Sometimes though, it's difficult not to use the POV shot; for instance, as a shot involving one person following another would be difficult to film without giving away the identity of the stalker.

Technical aspects

In the last chapter we discussed the art of composition. Now it's time to look at the important technical aspects that must be kept in mind when outputting your work for the different media that you'll want to work with. Whilst the comparative ease and cost of burning a DVD makes this medium ideal for sending out showreels, and the web is by far the best place to showcase your

work to whoever wanders by, there's nothing to beat a full-res screening in a theater or on a big-screen television for leaving a good impression. However, rendering for film and video has a few hazards due to the many different formats that exist side by side.

PAL and NTSC

These two broadcast standards need to be understood if you ever have to deliver your work to a broadcast production company. PAL is the system used in most of the world and employed across most of Europe. (France has its own system, SECAM, which was also adopted in Eastern Bloc countries as a political move because of its incompatibilities with US transmissions.) NTSC is the system employed in the USA. PAL is generally considered technically superior to NTSC for several reasons: primarily its better resolution - 720 x 576 over 720 x 540 - and the fact that the US system is notoriously bad at color reproduction. (Hence the acronym that you will hear half-jokingly applied to NTSC: Never Twice the Same Color.) However, NTSC does suffer less flickering because it operates at around 30fps, whereas PAL works at 25fps.

This is because of the way these formats were developed around the frequencies of mains electricity, which ran at 50Hz and 60Hz. We say around 30fps because NTSC actually operates at 29.97fps, following an adjustment from the 60Hz starting poing by the format's developers, the National Television Standards Commitee. 3D applications generally work at 30fps and use a standard method of dropping 0.1% of the frames to be output correctly. This is something that must be remembered, but is not generally

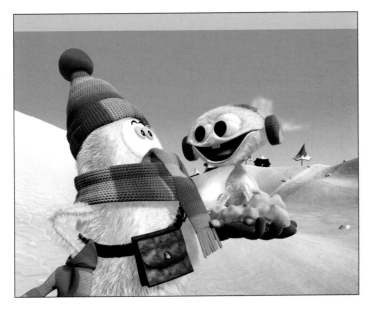

Figure 18.04
A 720 x 540 frame (inset) contains around 7% less vertical resolution

© 2002 Sesame Workshop/
Pepper's Ghost Productions

something that will case nearly as many problems as you might at first think. This is especially true when working with 3D software, as this is dealt with automatically. These applications split your work up much more finely than the timeline suggests. 3ds Max for example, splits a second up into 4,800 segments so that when you pick any frame rate the software just takes the appropriate number of samples from this total.

Aspect ratios

The next major difference in these formats is their aspect ratios. Aspect ratios can be described in two ways: frame aspect ratio and pixel aspect ratio. The first ratio is the proportion of the width to the height of the frame dimensions of an image. PAL and NTSC both have the same frame aspect ratio of 4:3, that is 4 width to 3 height. These ratios are both identical because this is the aspect ratio of a standard TV screen, and this is at the end of the day what both systems get broadcast onto. 4:3 can also be referred to as 1.33, which is the same ratio made decimal. Similarly HD is referred to as 16:9 because of its frame aspect ratio.

So far this is pretty straightforward, but it was mentioned before that PAL and NTSC had different resolutions: 720 x 576 and 720 x 540. The latter of these two resolutions fits this 4:3 ratio (i.e. 720:576 is the same ratio as 4:3) but the former does not. This is because there are different ways of filling the 4:3 space of your TV screen. NTSC broadcasts at 720 x 540, so if you've rendered a 720 x 540 image, this will be transmitted with each of your pixels mapped to one of the televisions and will appear square on both your computer monitor and when broadcast. This introduces the concept of pixel aspect ratio, which is the ratio of the width to the height of a pixel as it appears in the broadcast image. 720 x 540 has a pixel aspect ratio of 1:1, because its pixels are square.

Table 18.01 Broadcast formats and aspect ratios

Format	Resolution	Frame aspect ratio	Aspect ratio on PC monitor	Pixel aspect ratio
NTSC DV	720 x 480	4:3	3:2	8:9
NTSC D1	720 x 486	4:3	40:27	9:10
NTSC D (Square pixels)	720 x 540	4:3	4:3	1:1
PAL D1/DV	720 x 576	4:3	5:4	16:15
PAL D1/DV (Square pixels)	768 x 576	4:3	4:3	1:1
HDTV 720p	1,280 x 720	16:9	16:9	1:1
HDTV 1080i	1,920 x 1080	16:9	16:9	1:1
HD PAL	720 x 576	16:9	5:4	64:45
HD NTSC	720 x 540	16:9	4:3	4:3

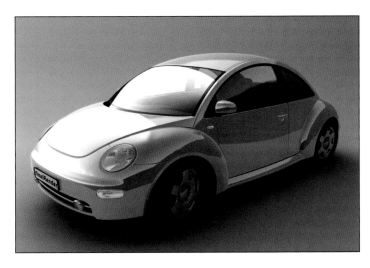

Figure 18.05
NTSC DV footage as it would
appear on your PC monitor (left)
and when broadcast (below)

Complications arise because there are more flavors of NTSC that
don't have this 1:1 ratio, and this is due to the fact that
historically, different disk recorders have used different horizontal
and vertical resolutions. D1 NTSC operates at 720 x 486 which
might not appear to be a 4:3 format, but is because its pixels do
not have a 1:1 aspect ratio, or put more simply, they are not
square. 720 x 486 uses a pixel aspect ratio of 0.9:1, which means
that the pixels are taller than they are wide, stretching them
upwards. Whilst this might seem odd, this is just a historical
legacy that has to be dealt with and is not as difficult to deal with
as you might first think.

If images that use non-square pixels are displayed on a computer
monitor without correction (you can display these images
correctly using combustion, which can correct for these ratios
visually) then images appear distorted. For example, circles
stretch horizontally into ovals when NTSC D1 footage is viewed
on a computer monitor. However, when displayed on a broadcast
monitor, the images will appear correct.

The various PAL and NTSC formats are listed in table 18.01
opposite, along with their frame aspect ratios, pixel aspect ratios
and the aspect ratio regarding how they would appear on a
computer monitor that can only display square pixels.

As you can see, this is a fairly confusing situation, and is less than
perfect. If setting up a production from scratch and you have the
choice, it's best to choose the NTSC D standard, which uses
square pixels. The advantage of this is that what you will see on
your computer monitor will not be distorted. Similarly, if you're
working with PAL, 768 x 576 is the best option for working with
square pixels, but as you'll have to downsize this to 720 x 576 for
broadcast, you will effectively be rendering more detail than can
be broadcast. For this reason, a more sensible option would be

perhaps to opt for 720 x 576 from the start, using a compositing application like Combustion to preview your output with its pixel aspect ratio corrected if you do not have access to a broadcast monitor that will display the correct image. Of course, if you are going to repurpose your output for streaming via the web or distribution via CD, then you will have to produce a corrrected square pixel version for these versions.

HD and film

There's not a huge amount of difference in working to any widescreen or film format over working to regular 4:3. The picture simply needs to be composed for the following common formats:

Table 18.02 Aspect ratios of widescreen, HD and film formats

4:3 (or 1.33)
Standard television screen, whether PAL or NTSC

16:9 (or 1.78)
HDTV/widescreen television

16:9 (or 1.78)
Anamorphic PAL/NTSC

5:3 (or 1.66)
A format popular in some parts of the world because it's closer in shape to a TV screen, so productions broadcast in the theater will be fairly consistent when aired on TV

1.85 (or Academy Aperture)
This feature film format has been standardized by the Academy of Motion Picture Arts and Sciences

2.35
Another feature film format, sometimes referred to as Cinemascope or Panavision, which are particular formats that use this aspect ratio

There are other formats that you may have to work with, but these are certainly the most common. Your shots should simply be composed to work when seen at these aspect ratios. 3ds Max has an option to turn on visible guides within the Camera viewport that show the view through the camera cropped to match the resolution specified in the Render Scene dialog. This feature, Show Safe Frames, also displays guides that show several zones. These zones demonstrate where the shot's action and titles should be located so that these elements do not get lost on the non-visible areas of your television screen behind the bevel.

What does need to be considered beyond the composition of your image within the widescreen frame is the fact that you may have to produce an additional 4:3 version for television broadcast. There are several options for taking a widescreen production and producing a 4:3 version, the most straightforward of which is perhaps letterboxing. This involves sizing the 16:9 image down proportionately to fit across a 4:3 screen and placing it on a black background. The 4:3 version will then be presented as a kind of widescreen; it's just that this version of widescreen should in fact be dubbed 'shortscreen' because of its reduced vertical resolution.

A second option involves simply cropping a portion of the 16:9 image from the left and right sides to fit the 4:3 screen. This is known as pan and scan, as the 4:3 portion that gets taken from the frame can be animated; this may be from the left of the 16:9 frame at the start of a shot, but by the end of the shot has panned to the right of the frame. This makes the process easier, but you still need to make sure that the action that takes place in your 16:9 version occurs in a central area, so important elements won't get cropped off when it comes to the 4:3 version. Even with this taken into account, this method is often less than perfect in that it changes a shot's composition and framing, which can alter the whole emphasis and balance unnecessarily. What was exposed on the negative does not always make it into the final image with film work. Some film formats expose a larger portion of the negative, which gets cropped down to fit the aspect ratio. However, for effects work, the full film frame is often digititzed using the previously mentoined process called telecine. Capturing the whole frame in this way is known as scanning it at

Figure 18.06
HD has an aspect ratio of 16:9

Image courtesy of:
Honda 'Grrr' by Smith & Foulkes at Nexus Productions

Figure 18.07
HDTV image letterboxed on a 4:3
screen (right) and (below) resized
using pan and scan

Images courtesy of:
Honda 'Grrr' by Smith & Foulkes at
Nexus Productions

full gate. This means that the studio working on the visual effects
might have to render at an even larger size. This is especially true
if the producers are thinking ahead to subsequent conversion to
4:3 and want the shot to be used with the full width of the frame
in view. When you consider that rendering a full frame for 35mm
1.85 aspect work can involve image sizes of 4,096 x 3,312, a few
simple calculations show that this is the same as rendering over
32 PAL frames. The upside of working like this though is the
added flexibility that it provides in enabling a shift of framing,
which can be incredibly useful in visual effects work.

Overscan

While we're on the subject of cropping, when broadcast on
television, your PAL or NTSC frame will have the edges chopped
off it slightly. Put your elements too close to the edge of the
picture and you risk them being cut off or cropped when
broadcast. This is because the cathode ray tube within a
television set actually projects a picture that is slightly larger than
its screen size, as the screen continues slightly beneath the bezel
of the TV. This process is known as overscanning and again is a
historical legacy from the days when variations in picture size
where caused by electrical current fluctuation. To cope with this
occurence, which varies from TV to TV, the animator must
ensure that a border known as a safe area is kept around the
action. There are several guidelines for safe areas. As previously
mentioned, 3ds Max has the ability to display these guides
within the camera viewport to show where these safe areas are
located. The closest to the centre of the image of these areas is
the title or caption safe area, which occupies the middle three-
quarters of a broadcast image. Outside of this zone lies the action
safe area, which takes up around 90% of the image.

Figure 18.08
Guides representing safe areas can and should be turned on

Anything lying outside this area should not be crucial to a shot, as there is the danger that this will be lost on certain television sets. Similarly, ouside this is the picture safe area, which will likely be cropped on any TV. Don't ever be tempted to reduce your PAL or NTSC frame by 90% to save on rendering time, as some systems do show the whole image, including the overscan, such as broadcast monitors, projector systems and LCD screens.

Fields and motion blur

It was stated in a previous section that PAL and NTSC were developed to operate at 25 and 30fps due to the mains frequency, which was 50 and 60Hz respectively. Further to this, these two systems actually split each frame up into two interlaced fields. Each of these two fields are displayed at 25 and 30fps, but are offset from each other, making the actual refresh rate 50 and 60Hz, which to the human eye does not flicker. This is something that you will need to be aware of, but is something that you'll not necessarily have to delve into, because 3ds Max, like most 3D applications, has a field rendering option should you need to work this way. The upside of field rendering is that it makes a shot appear smoother, but the downside is that it imparts a shot-on-video look, which is probably best avoided.

Indeed, the only time that you should really ever have to work with fields is if you are given some interlaced footage to work with. The best approach in this instance is to deinterlace the footage using combustion and render out your full frames with no interlacing from 3ds Max. A far better solution for providing smoothness to a shot is motion blur. This has a more filmic feel to it, as this simulates that way that a real camera works. A camera has a

Figure 18.09
Clockwise from top left: No motion blur or fields, motion blur, fields and motion blur, fields only

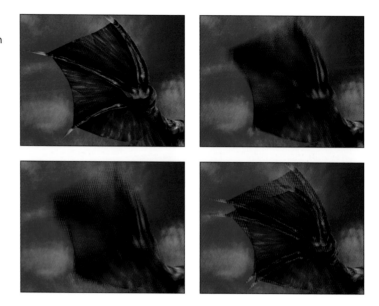

shutter speed, and if significant movement occurs during the time the shutter is open, the image on film is captured blurred. Motion blur is applied to fast moving objects in a scene to make them appear blurred based on their movement, which will have the effect of making their movement smoother in the finished animation.

If you are working with a live-action plate and need to match the amount of motion blur to your CG elements, there's a simple formula to calculate what you might at first think would be a fairly difficult problem. What you need to do is take your shutter angle and work this out as a ratio of this angle to the full 360 degrees. For example, if you had a shutter angle of 90 degrees, then this is 90:360, or 0.25. 3ds Max has motion blur settings from 0 to 1, so in this case you would apply 0.25 motion blur.

Antialiasing

One thing that television can be quite unforgiving with is aliasing, recognizable as 'jaggies' or staircasing, where a sharply defined line displays jagged edges, which can appear to crawl or at least flicker when displayed on screen. This is simply because a TV screen has a limited amount of pixels to display an image with, so objects that are very defined can appear jagged.

The answer to this problem is antialiasing, which applies a filter that smoothes and eliminates these artefacts. As antialiasing adds to render times, it is not uncommon to work with this feature off when rendering images that are at an early stage of development. Likewise, if you are rendering out different passes of a fininshed image for compositing, any that are subsequently going to be

blurred can often be left without antialiasing as blurring will take care of this. Indeed, if you find yourself with a sequence demonstrating the undesirable jagged effects and do not have time to rerender, your only real hope of eliminating these artefacts is through blurring. However, if a very small Gaussian blur of the order of 0.5 to 0.75 pixels does not sort this out, your only option is really going to be to rerender the shot. There are many types of antialiasing filters available within 3ds Max, plus other related techniques such as SuperSampling, which you should verse yourself in thoroughly. Taking some time just to experiment with what each filter does is a good idea if you don't already know. Controls for antialiasing can generally be found within individual material and map types, particularly raytraced materials, and within the renderer, where the final application of antialiasing across the entire image is carried out during the render.

Within 3ds Max there's a list of eleven different basic antialiasing filters that form the last step in antialiasing during the final render. They work at the sub-pixel level and allow you to sharpen or soften your final output, depending on which filter you select this, in turn will depend on the media of your final output.

Sharpening filters

For still high-resolution renders, especially for print output, the antialiasing filter should be one that sharpens the image, making it as detailed and clear as possible. Of 3ds Max's filters, there are several that should be considered in these circumstances:

Area:
The filter that 3ds Max defaults to, computes antialiasing using a variable-size area filter. The parameters for this filter can range between 1.0 and 20.0 pixels as the size, and the smaller the filter size, the sharper the effect.

Blackman:
This 25-pixel filter provides a sharpening effect, similar to the Sharpen filter found in Photoshop, but without the edge enhancement found in Catmull-Rom. There are no controllable parameters for this filter.

Catmull-Rom:
Named after Edward Catmull, one of the co-founders of Pixar, this 25-pixel reconstruction filter gives a sharpening effect like the Blackman filter, but it also has a slight edge-enhancement effect. There are no controllable parameters for this filter.

Sharp Quadratic:
This sharpening 9-pixel reconstruction filter from Nelson Max has no controllable parameters.

Experimentation with these filters is the best way of establishing which of these options is the best for a particular image, but for print resolution images Catmull-Rom is the best bet, as it sharpens the object textures themselves as well as the edges of the objects.

Softening filters

Whilst filters that provide sharpening effects might bring out the detail in individual images, these filters can cause problems when applied to an animated sequence. Filters that soften your results not only take the CG edge off a finished rendering, but also give a smoother look to animation output for television broadcast. Though the results might not look as good when you examine one image in isolation, when examining the animation as a whole, these filters can make a world of difference.

Figure 18.10
Softening filters (above) can give a more natural look to animation over sharpening filters (below) which are great for print output

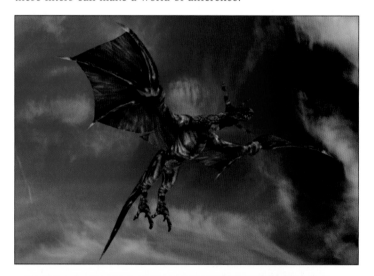

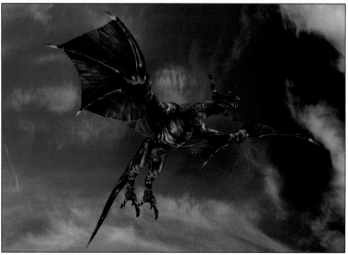

Cubic:
This 25-pixel filter is based on a cubic spline and provides blurring, with no user-controllable parameters.

Quadratic:
This 9-pixel blurring filter is based on a quadratic spline, with no user-controllable parameters.

Soften:
This filter provides an adjustable Gaussian filter, which gives a blur that's variable between 1.0 and 20.0 pixels.

Video:
The name of this filter suggests that this 25-pixel blurring filter is optimized for video, but in reality it is way too soft a filter for all NTSC and PAL applications. It has no user-controllable parameters.

Between the extremes of softening and sharpening lie several other filters, which have different uses:

Blend:
This blends between sharp area and Gaussian soften filters, with a 1.0 to 20.0 size filter and a blend value of between 0 and 1. This is particularly recommended for shots that use depth-of-field, where its use can reduce the visible effects of multiple camera passes.

Cook Variable:
This general-purpose filter either sharpens or softens the image depending on the value that is specified. Values of 1.0 to 2.5 are sharp, whilst higher values (up to 20.0) blur the image.

Mitchell-Netravali:
This two-parameter filter provides a trade-off between blurring, ringing and anisotropy. The user is given control of two values - Blur and Ringing - which can vary from 0.0 to 1.0 and which both default to 0.333. If the ringing value is set higher than 0.5 it can impact the alpha channel of the image, causing non-opaque ghosting effects.

Plate Match/MAX R2.5:
This uses a method that involves no map filtering which dates back to 3ds Max 2.5 and is used to match camera and screen maps or matte/shadow elements to an unfiltered background image. This method produces inconsistencies when rendering objects that are supposed to match the environment background, because the antialiasing filters do not affect the background. In order to correctly match an object's map to an unfiltered background image, you need to use the Plate Match/MAX R2.5 filter so that the texture is not affected by the antialiasing.

These cover 3ds Max's antialiasing options and provide an example of what's available for this particular solution. If you are not familiar with these options, you simply need to work through them one by one with a sample scene or two and familarize yourself with their strengths and weaknesses.

SuperSampling

Though this kind of technology might go by different names in different 3D solutions, there are additional features for ensuring perfect antialiasing within troublesome materials, generally ones that involve raytracing. Within 3ds Max the main extra tool that you have at your disposal is called SuperSampling, and is one of several antialiasing techniques that the software performs. Textures, shadows, highlights and raytraced reflections and refractions all have their own preliminary antialiasing strategies. SuperSampling is an additional step that provides a best guess color for each rendered pixel, performing an additional antialiasing pass on the material. The SuperSampler's output is then passed on to the renderer, which performs a final antialiasing pass.

SuperSampling should in theory only be turned on when you notice artifacts in your final renderings, though with experience you'll know where these are likely to occur before going near the Render button. SuperSampling is helpful when you need to render very smooth specular highlights, or subtle bump mapping is required. SuperSampling requires considerably more time to render, although it does not necessarily require any additional RAM. Though raytrace materials and raytrace maps both perform their own SuperSampling, they are often the areas that need this

Figure 18.11
Technologies like SuperSampling provide extra tools for antialiasing - invaluable when raytracing

feature turned on the most. However, if you use a raytrace map to create reflections or refractions, turning on this option significantly increases render time, because the material is SuperSampled twice. In general, the SuperSampler should be avoided with raytraced reflections or refractions until the final render, particularly if the output is to a high resolution.

Continuing with 3ds Max, there are four SuperSampling methods available when this option is turned on:

Adaptive Halton:
This filter spaces samples along X and Y axes according to a scattered, quasi random pattern. Depending on the user-controlled Quality setting, the number of samples can range from 4 to 40. The sample at the center of the pixel is averaged with four samples surrounding it, like the pattern of a five on a dice.

Adaptive Uniform:
The samples in this adaptive filter are spaced regularly, from a minimum quality of 4 samples, to a maximum of 36. The pattern is not square, but skewed slightly to improve accuracy along the vertical and horizontal axes.

Hammersley:
Whilst this filter samples regularly along the X axis, along the Y axis it spaces them according to a scattered, quasi random pattern that depends on the user-controlled Quality field, which allows the number of samples to vary from 4 to 40.

Max 2.5 Star:
As you might guess, this is the SuperSampling method that was available in 3ds Max 2.5, with five samples arranged in a star pattern.

Of these four filters, regular sampling, as performed by the first and last methods, is more prone to aliasing than the irregular patterns performed by the Adaptive Halton and Hammersley methods. These two methods, as well as the Adaptive Halton filter have a Quality value, which can be set from 0.0 to 1.0. A setting of 0.0 gives minimal SuperSampling, with about four samples per pixel, whilst 1.0 is the highest possible setting, with between 36 and 40 samples per pixel, that gives high-quality results, though can be very time-consuming.

Again, you should familiarize yourself with these options in the same way that you should teach yourself what each antialiasing filter has to offer. The names of filters will change from solution to solution, but this does not really matter as long as you know which is best for the different looks that you want to achieve in your finished output.

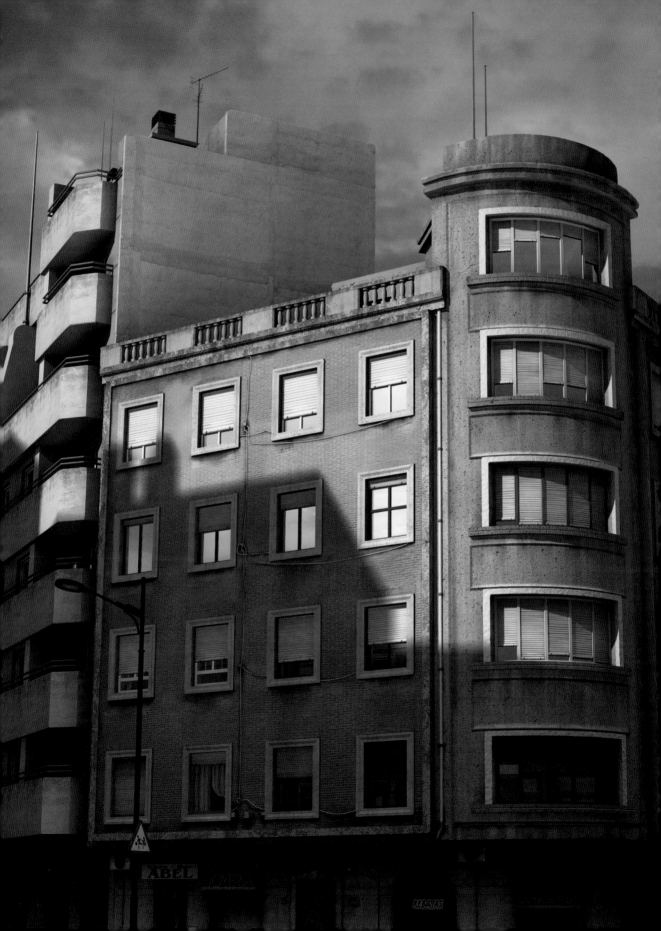

19

'How is education supposed to make me feel smarter? Besides, every time I learn something new, it pushes some old stuff out of my brain. Remember when I took that home winemaking course, and I forgot how to drive?'

Homer J. Simpson

Looking beyond lighting

Though this book deals primarily with lighting, this area cannot be comprehensively covered within one book without spilling over into several related areas, notably materials, rendering and compositing. We've looked at all of these areas in some depth in the previous chapters, but we have by no means looked at these exhaustively and there are many books available for those with a particular interest in any of these areas. Notably, there are additional third-party renderers, which we'll take a look at in this chapter, before going on to a discussion of MAXScript and looking at what third-party plug-ins and resources are also available to the 3ds Max user.

This chapter aims to round off everything covered so far, and we'll start with a look at the third-party renderers that are available for 3ds Max, which (as well as mental ray, obviously) you should be aware of, as each of these products has particular strengths and is more suitable to some projects than others.

Image courtesy of:
Juan Siquier
www.juansiquier.com

Brazil

As an established renderer that's been around since SIGGRAPH 2002, Brazil has built up perhaps the strongest following of all the available third-party renderers for 3ds Max. This is particulary true within the visual effects community, where Brazil has been used on *Sin City*, *Hellboy* and *Sky Captain and the World of Tomorrow* by The Orphanage, on *Cursed* by Frantic Films and *The Day After Tomorrow* by Dreamscape Imagery. Notably Brazil has also been integrated into the pipeline of the matte departments of both Pixar and Industrial Light & Magic. The renderer was used to generate mattes for *Star Wars: Episode 3 - Revenge of the Sith* and *The Incredibles*.

In addition to these film credits, Brazil is also used widely at Blur Studios, which is without a doubt one of the most advanced and demanding 3ds Max studios in the world. Blur has used the renderer on features like *Bulletproof Monk* and its Oscar-nominated short, *Gopher Broke*. Furthermore, the studio also completed the stereoscopic 3D ride film *SpongeBob Squarepants* using BrazilToon, the renderer's toon shading system.

The excellent *Honda Grrr!* commercial, which was created by the UK-based Nexus Productions, was rendered using Brazil and has won four BTAA awards including Best Commercial. This commercial can be found on the DVD and is well worth watching. With this high-profile level of users, Brazil has certainly proved that it can slot into the most demanding of

Figure 19.01
Nexus Productions used Brazil on the opening stop motion styled sequence to 'Lemony Snicket's A Series of Unfortunate Events'

Image courtesy of:
Lemony Snickets 'Littlest Elf' by Smith & Foulkes at Nexus Productions

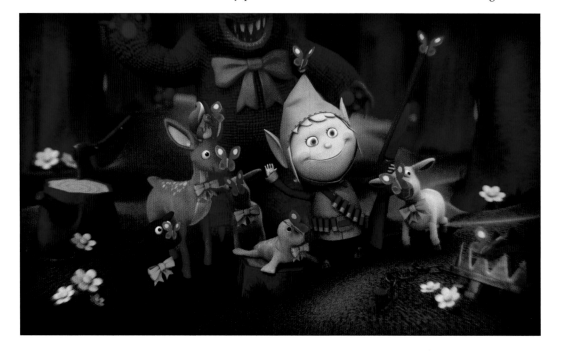

pipelines. Indeed, Splutterfish, Brazil's developers, wrote the HDR I/O and OpenEXR I/O plug-ins that are part of core 3ds Max. (These plug-ins are available for free download on the company's website for versions 3 to 8 of 3ds Max.)

The early support for OpenEXR goes some way to explaining the adoption of Brazil in the visual effects community. It's perhaps true that Brazil is not used as widely in the visualization community, but just because it is used at the high-end of visual effects, does not mean that it is aimed exclusively at this high-end of the market. Indeed, Brazil's workflow is very straightforward and is as reliable as it is usable.

Version 2.0 of the software introduced rendertime displacement, 3D motion blur, implicit surface rendering and increased performance. Some of these features had already existed in rival renderers and their arrival within Brazil might be seen by some as a little behind the pace of those developing rival renderers. However, Brazil is an established renderer and is a full floating-point, multi-threaded scalable system. It introduces its own light types, but offers full support for 3ds Max's and offers image-based lighting, caustics and more, all via bucket rendering.

Brazil is sold in two different configurations: the Artist Bundle and the Renderfarm Bundle. The first bundle offers one workstation license and two render-node licenses. The second bundle offers four non-GUI render-node licenses. These bundles are priced at $1,200 and $750 respectively. Additionally, student and school pricing is available, and there is also a freely-downloadable non-commercial learning edition of the software.

Figure 19.02
Platige Image used Brazil on its impressive short 'Fallen Art'

Image courtesy of:
Platige Image
www.fallenart.com

Brazil 2.0

Artist bundle - $1,200
1 workstation & 2 render nodes
Renderfarm bundle - $750
4 render nodes

Available for 3ds Max versions 3, 4, 5, 6, 7 & 8.

www.splutterfish.com

All in all, Brazil is a widely-used and widely-respected renderer whose workflow is straight-forward, is well integrated with 3ds Max and has a large and vibrant user community.

finalRender

As one of the first third-party renderers to reach the market, debuting in late 2001, finalRender Stage-0 was certainly perceived as the most advanced Global Illumination renderer for 3ds Max. Almost two years later, when Stage-1 was released, cebas had on its hands a clear technological lead on its rival developers. Indeed, as new releases of these rival products make it to the market today, a lot of the new features that they see introduced have been in finalRender for over two years.

A prime example of this is 3D motion blur, which finalRender has had in its arsenal since 2003. This feature however has just made it into Brazil with the release of 2.0. finalRender was seen then as a very powerful advanced renderer and it still is today. The problem is, the technological gap that cebas had over its rivals has been closed over time as other rivals have stolen a march on its feature set. Buoyed by the success of finalRender for 3ds Max users, cebas has for the last couple of years been concentrating a lot of its efforts on developing this renderer for Cinema 4D and Maya, a move that has seen it lose ground to its competitors.

Figure 19.03
GI, area shadows, depth of field...finalRender can do it all

Image courtesy of:
Arild Wiro
www.secondreality.ch

It's true that finalRender is the only third-party renderer to be Autodesk-certified, and that is probably because cebas got its product to market so far ahead of everyone else's. Stage-0 had built a reputation of being a very capable renderer, but it had also got an equal reputation for having an awkward workflow. By the time Stage-1 was released, it had ironed out many of the

quirks and limitations of the previous version. At this point it was
seen by many as simply the most capable renderer available for
3ds Max. However, with development efforts elsewhere and no
major new release coming from cebas in over two years, its rivals
have all but caught up in terms of technology. cebas has not
rested on its laurels though, and during the time since Stage-1
shipped, it has released three service packs that saw improve-
ments in memory usage, workflow, performance and introduced
invaluable core tools like Advanced Bitmap Pagers.

Perhaps it is the somewhat idiosyncratic versioning of the releases
of finalRender (Stage-1 Service Pack 2a doesn't exactly trip off
the tongue) that has led people to believe that its developers
have been standing more still than they actually have been.

finalRender ticks pretty much all the boxes that you could ask it
to: caustics, 3D motion blur, volumetric lights, fisheye and
panoramic cameras, micro-triangle displacement, area shadows,
sub-surface scattering and geometry-based lighting. All this with
not one, not two, but three Global Illumination engines that
provide the flexibility to use the method that works best for an
individual project. Futhermore, it offers one of the best toon
renderers on the market, which sells on its own for over half the
price of finalRender Stage-1.

Finally, ten-CPU distributed bucket rendering and free unlimited
network rendering make finalRender a hell of a lot of renderer
for not a huge amount of cash. If you can get to grips with
finalRender's controls, then it really does offer one hell of a
bang for your buck.

Figure 19.04
Sub-Surface Scattering has been in
finalRender since 2003

Image courtesy of:
Arild Wiro
www.secondreality.ch

finalRender

Stage-1 - Single license - $795
(unlimited render nodes)
Stage-0 - Single license - $95
(unlimited render nodes)

Available for 3ds Max versions 4,
5, 6, 7 & 8.

www.finalrender.com

Undoubtedly a very powerful
renderer, but one that can suffer
from its workflow. Feature-wise,
not a lot can touch it. At the
price, considering the free
network rendering, it's a bargain.

Maxwell Render

Of the third-party renderers discussed here, Maxwell stands out for several reasons. The first of these is that, at the time of writing, Maxwell had only just made it to market, whereas its rivals were all far more established. Like all version 1.0 products, it still has quirks and creases that need to be ironed out, but the gallery and the forums on the Next Limit site are testimony to how well received and widely used the renderer is already.

The second reason is that Maxwell is a standalone renderer, operating via plug-ins, to 3ds Max 6, 7 and 8, as well as Maya, XSi, LightWave, Cinema 4D and many other applications besides. Whilst this might put some people off, the purchase price includes a floating 4 CPU license, which means that the Windows, OSX and Linux versions of the software can be installed and these nodes used from pretty much any 3D application via the plug-ins. This is ideal from a pipeline perspective and will appeal to those outfits who work across a host of 3D applications.

Figure 19.05
Maxwell was well received during its pre-release phase

Image courtesy of:
Gianni Melis
gerets@tele2.it

The third reason why Maxwell stands out is that it is written entirely around the physics of light. Whilst other renderers may also be, this is only true to a certain extent. All of Maxwell's elements however, from light emitters to materials and cameras, are entirely based on physical models. Indeed, the renderer does not operate in the physically incorrect RGB color space, instead it considers light as an electromagnetic wave defined by a

spectrum that ranges from infrared to ultraviolet, which sandwiches the entire visible spectrum. Only when the calculated spectral energies arrive at the camera are they converted to any kind of color space.

There are very few parameters to control with Maxwell and the user can even dictate how long they want a render to take. Maxwell always converges on a correct solution, so given time it will theoretically produce an artifact-free result. In terms of technologies, Maxwell has pretty much got it all: 3D blur, caustics, object light emitters, sub-surface scattering and so on. The only thing it's really lacking is displacement mapping. However good this all sounds there is a catch. The rendering engine works beautifully, but the workflow between 3D application and renderer leaves a lot to be desired. This introduces a completely additonal step with a new interface, new rules, and a proprietary texture handling scheme. In this way, it is rather similar to the old Autodesk product LightScape, which took geometry from any environment and produced stunning results in a somewhat cumbersome environment.

Opinion is divided about this standalone application, with those using applications that don't have powerful texturing and lighting tools, like CAD applications for instance, very keen on this aspect of Maxwell. However, for many whose software already contains powerful tools for cameras, materials and lights, to take their scene into a third-party environment, is being seen as an awkward workflow. What you think of the software will depend on your standpoint. What is indisputable, though, is the quality of its output.

Figure 19.06
CAD users will be taken with Maxwell perhaps more than others

Image courtesy of:
Goat
www.goat.com

Maxwell Render

Version 1.0 - $995
(4 CPU license)

Standalone renderer, with plug-ins available for 3ds Max versions 6, 7 & 8.

www.maxwellrender.com

Maxwell's physically-based approach produces stunning results and its standalone nature will appeal to some. However, its workflow is the main problem and presents a considerable investment of time.

V-Ray

Within the architectural market, it is fair to say that V-Ray has pretty much become established as the renderer of choice. Take a look on the Chaos Group website and the gallery is largely composed of elegantly lit architectural imagery. This fairly reflects the renderer's installed base, but you'd perhaps be surprised to see that amongst the V-Ray testimonials, studios like *Animal Logic, Digital Dimension* and *Digital Domain* line up alongside the design visualization users in paying the renderer lip service.

Of these three big-name visual effects studios, Animal Logic has used the renderer on film projects, commercials, game FMVs and even a documentary. *Digital Dimension* employed the renderer on *Final Destination II*, completing over 80 visual effects shots, as well as for in excess of 50 shots on *The Last Samurai*. *Digital Domain* worked with none other than David Fincher for the making of the *Nine Inch Nails Only* video, which saw the studio introduce a new 3D application and renderer to its pipeline: 3ds Max and V-Ray. What's more, they did this on a typically tight schedule and followed this up with spots for Motorola and Lexus using the same renderer.

In the games industry, *Ubisoft's Myst* series is about as big as they come, and for *Myst IV Revelation*, V-Ray was used on every single game environment and cinematic, with scenes containing in excess of two million polygons (after optimization), referencing over 600 textures. This is particularly amazing when you consider

Figure 19.07
V-Ray's success grew out of the visualization community

Image courtesy of:
Richard Minh Le
www.richardminhle.id.au

that V-Ray's displacement was also implemented, and this was back in the summer of 2004, around two years after version 1.0 first shipped. Surely there is no more challenging environment for a global illumination renderer than a games project such as this?

Since that date a lot of high-end features have found their way into the software: caustics, 3D motion blur, blurry reflections, displacement, sub-surface scattering, area lights and camera effects, and all this with distributed bucket rendering to ten PCs (there is no limitation on the number of CPUs a machine can contain) and unlimited network rendering.

V-Ray seems to have become the choice of the design visualization community because of several factors. Primarily it is easy to use, which is a factor that is always welcome in any market. Add to this the fact that V-Ray has a very active community and in the Chaos Group a very supportive developer, and it's easy to see why it has attracted such a large number of users. What's more, the announcement of a beta program to bring V-Ray to Maya means that this user community will inevitably widen further still.

The company also has plans to release a standalone version of V-Ray for Windows and Linux, allowing users of 3ds Max and Maya (as well as XSi eventually) to render independently of their 3D applications. This marks a critical juncture for the developers and hopefully this widening of its development focus will not see efforts on the 3ds Max version diluted too much. That would be an awful shame, as V-Ray has seen its installed base widen and its reputation grow for very good reasons.

Figure 19.08
V-Ray's success has grown from the architectural visualization market

Image courtesy of:
Benjamin Leitjeb
www.selwy.com

V-Ray

V-Ray Advanced - $799
V-Ray Educational - $250

Standalone renderer, with plug-ins available for 3ds Max versions 3, 4, 5, 6, 7 & 8.

www.vrayrender.com

The choice of the design visualisation community, and for good reason. Ease-of-use is coupled with fast render times. The development of a stand-alone renderer will attract a lot more users.

MAXScript

Whilst 3ds Max has more than enough functionality for the majority of its users, those wanting to go beyond its out-of-the-box functionality should look no further than its scripting language: MAXScript. This built-in language allows for the user to script most areas of the software, from modeling to animation, materials to rendering.

Once written, scripts can be packaged into the user interface via custom utility panel rollouts; they can be assigned to toolbars, menus, or keyboard shortcuts. The MAXScript syntax includes minimal punctuation and formatting rules and so is relatively easy for non-programmers to pick up. Furthermore, the MAXScript Macro Recorder can be used to capture many of the actions performed within the software, and the MAXScript commands that it generates that correspond to those actions can then be used in constructing further scripts.

However, MAXScript is also rich enough to enable sophisticated programming tasks, with capabilities such as 3D vector, matrix, and quaternion algebra. MAXScript is well suited to working with large collections of objects; for example, making complex procedural selections, constructing random star fields, or placing objects in numerically precise patterns.

The language has many special features and constructs such as coordinate system contexts, object primitives and materials that mirror high-level concepts in 3ds Max itself. It has an animation mode with automatic keyframing and access to scene objects using hierarchical path names that match the 3ds Max object hierarchy. Anyone who is familiar enough with 3ds Max to be learning MAXScript will generally not have too much of a problem in this department.

There are also plenty of online resources out there - notably the long-established scriptspot.com - where tutorials and extensions, as well as scripts, are shared amongst the 3ds Max community. If

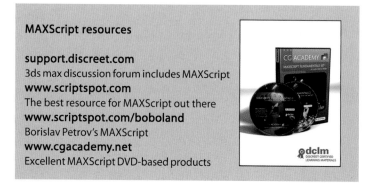

MAXScript resources

support.discreet.com
3ds max discussion forum includes MAXScript
www.scriptspot.com
The best resource for MAXScript out there
www.scriptspot.com/boboland
Borislav Petrov's MAXScript
www.cgacademy.net
Excellent MAXScript DVD-based products

you are looking for a tool to extend some area of your workflow, then the chances are that someone has written something for it, or for something that is at least similar that may provide ideas or a starting point. It is also a great resource for those learning MAXScript and by deconstructing an existing script, it is possible to learn a lot about the way that such scripts are put together.

Beyond MAXScript, the SDK, which uses C++, complements 3ds Max's native scripting language. Which language you choose depends partly on how you want to work, and partly on what you want your plug-in to accomplish. Both languages have their strengths and limitations, but it is possible to develop complex applications with either of them.

In general, MAXScript plug-ins run more slowly than comparable plug-ins written in C++, so if performance is an issue, using the SDK is probably preferable. On the other hand, MAXScript provides some methods that are higher level than those to be found in the C++ SDK, and supports a few 3ds Max features and capabilities that are not exposed to the SDK. If your feature needs functionality supported by MAXScript but not the SDK, then MAXScript is your only choice. In particular, exposing 3ds Max features via OLE/ActiveX controls is easier to code in MAXScript than it is with the SDK.

The SDK is preferable when performance is important; in general, this is when computation rather than interactivity is the main purpose of the plug-in. Performance is most often an issue when the plug-in handles large sets of entities such as objects, sub-objects, files, notification messages, and so on.

Even a quite basic level of MAXScript knowledge can go a long way and there aren't many visual effects Technical Directors around without at least a rudimentary working knowledge of a scripting language. If you see your own career progressing from the role of a lighting artist to that of a lighting TD, then not only is it vital that you have a thorough understanding of materials and rendering (with 3ds Max's own scanline renderer and mental ray, in addition to third-party renderers), it is also important that you understand the compositing process. On top of this, if you have some scripting knowledge, then your TD skillset is pretty much complete.

If you are motivated to learn MAXScript, then the best starting point is the 3ds Max Help files themselves. Beyond this, I would recommend the training DVDs produced by CG-Academy, which are excellent. The Autodesk online store also stocks several courseware products that cover MAXScript and there are also several books available. There's also the MAXScript community, which is always a great source of information and knowledge. Some suggested resources are listed on the opposite page.

Figure 19.09
Turbo Squid is the Autodesk
certified plug-in publisher

Plug-in away

Whether you work in visual effects, games development or
architectural visualization, CG production is a tremendously
competitive business and in order to stay ahead of the game,
large studios employ R&D staff to extend the creative possibilities
of their services on a technical front. This can involve, at the
simplest level, writing basic scripts, all the way up to the
development of in-house production tools like hair and cloth
simulators, fluids and dynamics engines or camera trackers that
work alongside commercial 3D applications.

At the end of the day, 3D applications cannot be all things to all
people, and there's always going to be things that a studio, no
matter how big or small, wants to produce that simply won't be
possible with the software as it ships. For those of us without
access to R&D teams, the answer lies in plug-ins, which bolt on
to commerical applications, providing extended functionality.

There are many plug-ins out there, provided by dedicated third-
party developers, that are available to purchase and that cover all
manner of subjects, from fire to lipsyncing and everything in-
between. There are also numerous free plug-ins available, but
generally these won't come with any form of technical support,
so not too much emphasis should be placed on them in a
professional production environment.

Sometimes nothing but a plug-in will do what you want to do, so
for the purpose of demonstrating what's available, both
commerically and freely, there follows a selection of the best that
apply to those working in and around lighting.

www.3daliens.com
Developers of the Glu3D particle-based fluid simulation solution
that is available for both 3ds Max and Maya.

www.archvision.com
The RPC (Rich Photorealistic Content) plug-in is popular within
the architectural visualization community.

www.artbeats.com
Great royalty-free stock footage that covers explosions, effect and
so on, delivered at different resolutions with alpha channels.

www.bionatics.com
Developer of 3D plant and tree system, for architects and game
developers using 3ds Max.

www.cebas.com
The developer of finalRender also makes several plug-ins for 3ds
Max, including GhostPainter, psd-manager and ScalpelMAX.

www.chaosgroup.com
The developer of V-Ray also makes the fluid dynamics engine
ChaosAura and fire simulator, Phoenix.

www.cubicspace.com
Real-time renderer brings interactive rendering to 3ds Max as
well as Autodesk VIZ.

www.cuneytozdas.com
Several incredibly useful plug-ins for 3ds Max users, including
the invaluable Texporter and Color Correct plug-ins.

www.darksim.com
Developer of the procedural texture application Simbiont, which
features plug-ins to 3D applications that include 3ds Max.

www.deeppaint3d.com
Deep Paint 3D provides an intuitive environment in which to
paint and texture 3ds Max models interactively in 3D.

www.digieffects.com
Digital film effects tools that include the excellent Cinelook, an
After Effects plug-in that simulates the look of many film stocks.

www.digimation.com
Publisher of several commercial 3ds Max plug-ins, including
V-Ray, HyperMatter 2 and SpeedTreeMAX.

www.doschdesign.com
Provides good quality 3D models and textures that are widely
used in the architectural visualization industry.

www.mankua.com
Texture Layers, Power Stamper and Kaldera provide tools for
texture artists working with 3ds Max.

www.nextlimit.com
As well as the Maxwell renderer, Next Limit also develops the
Real Flow fluid simulator, which can be used with 3ds Max.

www.okino.com
A translation solution that allows work to be taken from different
3D formats and transferred between 3ds Max, Maya, and so on.

www.reyes-infografica.net
The Reyes plug-ins were widely-regarded in the early days of 3ds
Max, but are a little long in the tooth nowadays.

www.turbosquid.com
The place to visit for a sizable catalog of Autodesk certified
animation plug-ins, from renderers to particle systems.

Figure 19.10
Three of the best 3D sites around:
(from the top) cgchannel.com,
highend3d.com and fxguide.com

Useful websites

There are many resources for 3D artists on the Internet, some more useful than others. This list is by no means exhaustive, but should give you a few places from which to explore further.

www.autodesk.com
The home of Autodesk, developers of 3ds Max and combustion.

www.cgarchitect.com
Perhaps the best resource for architectural visualization.

www.cgchannel.com
A great online resource for the CG community.

www.deathfall.com
Better than average resources for 3D artists.

www.fxguide.com
Great resource for high-end visual effects and compositing.

www.gamasutra.com
Great resource for those interested in the games industry.

www.highend3d.com
Excellent website for users of professional 3D solutions.

www.scriptspot.com
Valuable and established resource for all thing MAXScript.

www.vfxpro.com
Excellent established site for visual effects resources.

Studio websites

In order to stay up to date with those at the cutting edge of computer graphics, it's a good idea, as well as looking at the sites dedicated to general 3D and CG, to bookmark the websites of those studios employing interesting techniques. Among the bigger studios listed here are several of the more cutting-edge 3ds Max studios. Regular visits will help you keep up to date with who's doing what and with which tools.

Animal Logic - www.animallogic.com
The Australian vfx studio that boasts a highly skilled R&D team and whose credits include *Lord of the Rings* and *The Matrix*.

Blue Sky - www.blueskystudios.com
Best known for *Ice Age* and *Robots*, the studio is built around its own renderer, which produced first radiosity in a film, in 1998.

Blur - www.blur.com
Perhaps the best known 3ds Max house, Blur's work spans film effects, game cinematics, tv spots and, of course, shorts.

Digital Domain - www.digitaldomain.com
From *I Robot* to *Apollo 13*, this US giant has Academy Awards and BAFTAs that are testament to its standards of excellence.

Framestore CFC - www.framestore-cfc.com
The biggest vfx studio in Europe, with movie credits including Troy and Blade 2, has 11 Emmys, 2 BAFTAs and 2 Oscars.

Industrial Light & Magic - www.ilm.com
From *Star Wars* to *War of the Worlds*, ILM's vfx work is second to none and its commercial work is pretty incredible too.

The Mill - www.mill.com
Europe's only visual effects Oscar was won by The Mill for *Gladiator* depite being best known for its commerical work.

Moving Picture Company - www.moving-picture.com
Another leading European light, MPC's work is as strong in film as it is in music, television and advertising credits.

Nexus Productions - www.nexusproductions.com
One of London's most cutting-edge 3ds Max studios is best known for its award-winning advertising work.

The Orphanage - www.theorphanage.com
Another studio which has come to the fore over recent years with excellent work on *Sky Captain* and *The Day After Tomorrow*.

PDI/DreamWorks - www.pdi.com
The animation division of DreamWorks employs over 200 technologists and it shows in such films as *Madagascar* and *Shrek*.

Pixar - www.pixar.com
From *The Incredibles* to *Toy Story*, Pixar is the studio with the midas touch. And it also has its own renderer in RenderMan.

Rhythm & Hues - www.rhythm.com
Consistently good work across big features from *Daredevil* to *Cats & Dogs* make Rhythm & Hues a force to be reckoned with.

Sony Picture Imageworks - www.imageworks.com
State-of-the-art vfx company with Oscars for its work on *Spider-man 2* and its shorts, is a major force in the industry.

Weta Digital - www.wetadigital.com
Based in New Zealand, and best known for its work on the *Lord of the Rings* trilogy, is a powerhouse in the visual effects world.

Figure 19.11
Three of the giants of CG's websites

The companion DVD

This book's DVD contains all the files required for the tutorials that appear in the techniques section of the book. Also, there are demo versions of 3ds max 8 and Combustion 4 so that these tutorials can be completed by anyone, even those that do not already have the software. There are also links to the website of this book's publisher, Elsevier, the author's website, and a simple monitor calibration routine.

The DVD should run automatically, but if you have Autorun disabled on your computer, it will not begin automatically. If this is the case you can run the software by double-clicking the *startHere.exe* file located on the root of the DVD. The instructions for using the DVD are very self-explanatory and anyone who can find their way around a 3D package should find navigating the DVD no problem whatsoever. Once launched, the welcome screen explains that you should click to continue, then select one of the options from the left-hand side of the screen.

Figure A.01
The welcome screen should appear
when the DVD is placed in the drive

Software requirements

In order to use the tutorial files contained on the DVD, you will need to have 3ds Max 8 installed on your computer. The DVD contains a 30-day trial version, which is installed by following the software link from the DVD's first menu. In order to install 3ds Max, you should ensure that your machine meets the minimum specifications, which are outlined in the box below.

Minimum 3ds Max 8 system requirements

- Intel® Pentium® III or AMD® processor, 500 MHz
- 512Mb RAM
- 500Mb swap space
- Graphics card supporting 1,024 x 768 x 16-bit color with 64Mb RAM
- DVD-ROM drive
- Windows XP Home Edition SP2, or Windows 2000 SP4
- Microsoft Internet Explorer 6

Recommended 3ds Max 8 system requirements

- Dual Intel Xeon® or dual AMD Athlon®or Opteron® processors
- 1Gb RAM
- 2Gb swap space
- Graphics card supporting 1,280 x 1,024 x 32-bit color with 256Mb RAM
- DVD-ROM drive
- Microsoft Windows XP Professional SP2
- Microsoft Internet Explorer 6

For further information on any issues with installing the trial versions of 3ds Max and Combustion, you should refer to the Autodesk website: www.autodesk.com

Tutorials

It is worth mentioning a little about how the tutorials should be set up on your local PC. The tutorial files are stored in .max format and should be copied to the desired directory on the hard drive of the PC that you are going to be completing the tutorials on.

The *materials* directory should also be copied somewhere locally, preferably into 3ds Max's own maps directory. This should ensure that everything works correctly. However, should you get error messages when rendering that there are image files missing, you need to point 3ds Max to the location of this folder of materials that you copied to your machine. If you copied it into 3ds Max's existing maps directory, then there should be no problems. If you placed this folder elsewhere, then you should

select Customize > Configure Paths and in the Bitmaps tab, add the path to the folder that you copied. Once this has been done you should have no problems opening the tutorial files. As already mentioned, there is a 30-day trial version of 3ds Max 8 on the accompanying DVD, so everything that is required to get started as a lighting artist is included. It is worth noting that the tutorial files will not work with previous versions of 3ds Max. Additionally, chapter 15 requires the installation of Combustion 4, which is also provided on the DVD, again as a 30-day trial version, for those users who do not already own this product.

The tutorial files themselves are accessed via the *Tutorials* link from the main menu of the DVD, which when clicked will open the relevant directory in Windows Explorer. This folder contains all the necessary files to complete all of the tutorials contained in the techniques section of the book.

Its content is organized by chapter, so within the tutorials folder you should open the folder of the relevant chapter, where you will find the files in the .max format for 3ds Max 8. As already mentioned, to avoid problems these files should be copied to a convenient location on your local hard drive, perhaps into 3ds Max's own scenes directory.

Within the DVD's *tutorials* folder itself you will also find a folder called *materials* which contains all the textures required for every one of the book's tutorials. You could point your 3D application to this folder on the DVD, but you're better off copying it to your local machine. Within each of the individual chapter folders, you will also find a directory called *completedVersions*, which contains, as the name suggests, these same tutorial files as they should look once completed. If you're getting unexpected results from any of the tutorials, open up one of these files and compare your results with this version.

Figure A.02
From the next menu, you should choose an option from the left

focalpress.com

This link will take you to Focal Press's website, this book's publishers, where you can browse their catalog of titles, make purchases online and subscribe to their monthly e-newsletters to ensure you keep up to date.

stinkypops.co.uk

This link takes you to the author's own website, where you can take a further look at his past and present work and download additional content and tutorials as they become available. Also there's a whole bunch of lighting links. You can also get in contact about any aspect of the book and CG lighting in general.

Figure A.03
Clicking the Calibrate link displays
an image for basic monitor
calibration

Calibrate

Though by no means a professional monitor calibration routine,
the link marked *Calibrate* will display a simple grayscale image
for the purposes of calibrating your monitor to be able to display
the complete range of grays from white to black.

You should adjust your monitor's brightness and contrast controls
so that you can clearly see the full range of grays, from left to
right and vice versa. If you are able to read the phrase *calibrate!*
both at the top and at the bottom of the displayed image, then
your monitor is displaying the full range of tones, which means
that you should not be overlighting or underlighting a scene to
compensate for your monitor being set incorrectly.

One thing that is worth noting is that if you want to create and
display this kind of image within your 3D application or within
your image-editing application, make sure that any proprietary
color correction features that this software might have are turned
off. In Photoshop, for instance, this means enabling the Color
Management Off option, found under Edit > Color Settings,
within the Settings drop-down.

The image that makes up this particular menu - *calibrate.jpg* -
can be found in the monitorCalibration folder, which is located at
the root level of the DVD. This is certainly not a professional
calibration routine, it is a simple grayscale image that simply aims
to ensure that your renderings will display the full range of tonal
values possible. If you are working towards printed output, it is
certainly worth putting together or finding a suitable test image
that displays the full range of colors and tones that you are
aiming to eventually output.

You should have this printed on the device on which your work
will eventually be output and attempt to match your monitor to
this print by simply putting the print alongside your monitor and
adjusting its controls to get the closest match that you possibly
can. Furthermore, by looking at the distribution of an image's
colors using the Photoshop Image > Adjust > Levels feature,
you should be able to see whether the distribution roughly
matches what is being displayed on your monitor and alter your
final output to compensate for this.

Software

As previously mentioned within this section, the DVD contains 30-day trial versions of both 3ds Max 8 and Combustion 4, which are required to complete the tutorials contained within the Techniques section. The *software* link will take you to a menu where the installation of these trial versions can be instigated.

To install one of the demonstration versions included on the DVD, simply pick from the two options on the left-hand menu, and the installation routine should begin automatically. Alternatively, you can browse to the software folder of the DVD, where there are two further folders. Within the 3dsMax8 folder, the launch.exe file kicks off the installation and within the combustion4 folder the Combustion4TrialSetup.exe file should be used.

Figure A.04
From the software menu you can choose to install the two different solutions from the left-hand menu

3ds Max 8

30-day trial version of 3ds Max 8, the world's best-selling professional 3D platform. Developed as a total animation package with a feature set designed to accelerate workflow, 3ds Max is the leader in 3D animation for game development, design visualization, visual effects, and education.

Combustion 4

Combustion 4 is an all-in-one professional compositing application. Designed with an easy-to-use interface, extensive toolset, non-destructive workflow, for producing professional video motion graphics, repurposing video content for the web, or creating effects for films or TV.

Textures

This menu link takes you to a further menu that details the companies - Sachform, 3D Total and Marlin Studios - who were kind enough to supply textures which were used in several of the book's tutorials.

Figure A.05
Visualizing the XYZ Color Space provided courtesy of Sony Picture Imageworks. © 2005 Sony Picture Imageworks. All rights reserved

Clicking on each of their individual links from this menu will launch a further menu for each company. From here, you will find a link to the websites of these companies, as well as a link to open a folder containing additional resources that some of these companies have provided. Within these folders you will find additional textures and further product information about the collections where the individual texture files came from.

Movies

This menu link will take you to a further menu that lists the two movies mentioned in the book - the *Honda Grr!* commercial by Smith & Foulkes at Nexus Productions and *Visualizing the XYZ Color Space* provided courtesy of Sony Picture Imageworks.

Both Nexus Productions and the excellent *Honda Grr!* commercial are mentioned in several places in the book and the movie is well worth watching. Similarly, *Visualizing the XYZ Color Space*, kindly provided by Sony Picture Imageworks is an excellent and informative movie that is very helpful in terms of understanding the XYZ color space.

Figure A.06
Honda 'Grrr' by Smith & Foulkes at
Nexus Productions

Other menu items

As well as the tutorial content, the links to the website for the
book's publisher and the monitor calibration routine, there are
several other basic features of the DVD. These are outlined below.

Browse DVD

To jump straight to the DVD's contents, simply click the link
marked *Browse DVD* and the DVD application will exit, with
Windows Explorer appearing at the root level of the DVD.

Exit

To exit the DVD application, simply click the link marked *Exit*.

B

Glossary of CG, lighting and cinematography terms

Achromatic
White, black or gray colors that contain no hue.

Action safe area
An area that occupies the central 90% of a broadcast image, which all of a shot's action should be located within in order to avoid it being cropped when viewed on a television due to overscanning.

Additive color
The color mixing system that works by blending three primary colors.

Aliasing
Aliasing is the unwanted staircase effect at the edge of a line or area of color when it's displayed by an array of discrete pixels. This is cured using a process called antialiasing.

Alpha channel
An 8-bit channel in a 32-bit color image which stores transparency data.

Ambient light
Light that is present in the environment. It has no focus or direction.

Analogous colors
Neighboring colors on the color wheel.

Anisotropic
Material whose surface exhibits eliptical highlights like brushed metal.

Antialiasing
An algorithm to prevent the jagged appearance of edges in an image, which works during rendering by averaging adjacent pixels with sharp variations in color or brightness.

Aperture
The opening in a lens that controls the amount of light passing to the film.

Area lights
A type of light that lights a region of space with its soft and diffuse illumination. These are often really an array of point source lights arranged around the shape.

Array
A multiple instance of objects arranged in a pattern.

Artifact
An undesirable item in an image that is a side effect of the process used to create or modify that image.

Aspect ratio
The ratio of the width to height of the dimensions of an image.

Atmospheric effect
Components of a 3D software solution that produce effects like fog and fire.

Attenuation
Describes how a light's intensity falls off over distance.

Bit-depth
A way of specifying the color resolution of an image by measuring the number of bits devoted to each component of the pixels in the image.

Bitmap
Also known as a pixel or raster image. An image composed of pixels.

Black point
The numerical value that corresponds to the darkest area that will be represented when the image is viewed in its final form.

Blooming
The effect of glowing edges around bright highlights occurs because film enables light to leak through it..

Bluescreen/greenscreen
The process of photographing a subject in front of a bluescreen or greenscreen with the intention of extracting a matte using keying.

Brightness
An attribute of visual perception in which a source appears to emit a given amount of light.

CGI
Computer Generated Imaging, especially computer graphics imagery that is produced for use in motion pictures (such as for special effects).

CMYK
A color space that is often used in printing and which stands for Cyan, Magenta, Yellow and Black (Key).

Caption safe area
See *Title safe area.*

Caustics
A result of specular light transmission that causes bright light patterns like the shimmering patterns that can be seen in swimming pools.

Channel
A channel of data that makes up an image is typically composed of 8 bits, for instance a 32-bit image is generally made up of four channels: Red, Green, Blue and Alpha. Additional channels such as G-buffer, Z-depth can also feature in image data.

Clipping
The process whereby data above or below a certain threshold is removed or lost. This can be an intentional or unintentional process.

CODEC
Short for compressor/decompressor, a codec is an algorithm for compressing and decompressing digital video data and the software that implements that algorithm.

Color
Also called hue. It is the property of objects that is derived from wavelength reflection and absorption. It also denotes a substance or dye that has a particular shade or hue.

Color balance
Film stock has a particular color balance which determines which color of light appears as white light when photographed.

Color bleeding
Result of Global Illumination rendering, where adjacent colors bleed subtly into each other because of the bounced lighting.

Color cast
A perceptible dominance of one color in all the colors of a scene or photograph.

Color constancy
The ability to perceive and retain a particular object's color property under different lighting conditions.

Color correction
A process that alters the color balance of an image.

Color depth
The number of bits required to define the color of each pixel of an image. 1-bit images are just black and white: 8 bits provide 256 shades between black and white (grayscale); 24 bits provide millions of colors (eight each for red, green and blue); 32-bit color provides an additional 8 bits for an alpha channel.

Color space
A method for representing the color in an image. Typical color spaces are RGB, HSV and so on.

Color temperature
Measures in kelvins (°K) the perceived temperature of a light source compared to an ideal blackbody emitter.

Complementary colors
Colors located directly across from each other on the color wheel.

Component
One of the elements that is used to define the color of a pixel. In most digital images, the pixel color is specified in terms of its red, green and blue components.

Compositing
The manipulated combination of at least two source images to produce an integrated result.

Cone
Photoreceptor located in the retina responsible for color perception.

Contrast
Measures the difference between light and dark areas of an image.

Cookie
Also called a cucoloris, an irregularly patterned object placed in front of a light source to cast discernible shadows to break up uniformity.

Cucoloris
See *Cookie*.

Daylight-balanced film
Film stock that has been designed to be used in daylight conditions, where its 5,500 °K color balance makes daylight appear white.

Decay
Describes the way in which a light's illumination attenuates over distance.

Depth map
See *Shadow map*.

Depth-of-field
Defines an area between a near and far point from a camera within which an object will appear sharply rendered.

Desaturation

A process that removes color from an image.

Diffuse

In CG, the diffuse color is the color that the object reflects when illuminated by even omnidirectional lighting. Also refers to scattered non-directional light.

Diffuse reflection

The component of light reflecting from a surface caused by its dull or matte surface, which reflects the light at random angles giving the surface an equally bright appearance from many viewing positions.

Diffusion

The way in which light is scattered from a surface by reflection. Also refers to the way in which light is transmitted through a translucent material.

Direct illumination

Light that travels directly from a light source to a surface which it illuminates.

Directional lights

Directional lights cast parallel light rays in a single direction, as the sun does - for all practical purposes - at the surface of the earth.

Dispersion

The separation of light into different wavelengths due to passing through different media that have different refraction indices from each other.

Displacement mapping

A grayscale map that alters surfaces causing a 3D displacement.

Dolly

A wheeled platform used for mounting a camera.

Dynamic range

The range of brightness values in an image, from brightest to darkest, often expressed as a ratio.

Electromagnetic spectrum

With short wavelength gamma and x-rays at one end and long wave radio waves at its other, the electromagnetic spectrum also includes a narrow band that we perceive as light, the visible spectrum.

Exclude/Include

Useful feature which allows objects to be excluded or included in a selected light's illumination.

f-stop

The ratio of the focal length to the aperture of a lens.

Falloff

See *Hotspot/falloff.*

Field

An image composed of either the even or odd scan lines of a video image. Two fields played sequentially will make up a video frame.

Field dominance

The order in which the fields in an interlaced image are displayed. Essentially, whether the odd or even field is displayed first.

Field rendering

Involves the software rendering an extra sub-frame image between every two frames and compositing each frame and the following sub-frame into a single image with two fields. The result is 60 fields per second animation that appears smoother when viewed on a television monitor than standard 30 frames per second animation.

Fill light
A light source placed primarily to open up the dark shadow areas of a scene. Fills can also be placed to mimic bounced light.

Frame rate
The rate at which sequences of images are captured or displayed, generally measured in frames per second, or fps.

Full gate
The process of digitizing an entire film frame common in effects work.

Gamma correction
Gamma correction compensates for the differences in color display on different output devices so that images look the same when viewed on different monitors.

Gels
Heat resistant material placed in front of light sources, which is colored to tint the light and match colors of light.

Global ambience
In real life, the distributed indirect light from other objects in a scene. In CG, an unrealistic control that is supposed to mimic this light component.

Global illumination
Illumination that incorporates the light reflected from other objects.

Go-betweens (gobos)
Sheets of metal or wood placed in front of lights that shape their illumination into patterns or break up the illumination.

Grain
The particles of silver halide in a piece of film do not have uniform sensitivitiy and are not distributed uniformly. When projected, grain can be perceived, which varies between different film stocks.

Gray card
A card that has a gray and white side, with both sides reflecting a predictable amount of light, generally around 20%-90%.

HDR (High Dynamic Range images)
Images that can capture a higher than normal range of brightness due to the fact that they're made up of several images taken at different exposures.

HDTV
High-Definition Television. A new television standard with greater resolution than the existing NTSC, PAL and SECAM standards.

HLS
A color space that is represented by Hue, Lightness and Saturation.

HSV
A color space that is represented by Hue, Saturation and Value.

HVC
A color space that is represented by Hue, Value and Chroma.

Highlight
A bright focused reflection formed on an object in the scene.

Histogram
A graph of the distribution of a particular characteristic of an image's pixels.

Hotspot/falloff
The bright circle at the center of a pool of light is the hotspot, and is of even intensity. The outer extremity of the light, where it meets the darkness, is the falloff. The difference in circumference between the hotspot and the falloff determines the relative sharpness of the pool of light.

Hue
Hue is the color reflected from or transmitted through an object, measured as a location on the standard color wheel, expressed as a degree between 0 and 360. In common use, hue is identified by the name of the color.

IOR (Index of Refraction)
In the physical world, the IOR results from the relative speeds of light in a vacuum and the material medium.

Illuminance
The amount or strength of light falling on a given area of a surface.

Incident light
Direct light falling on a subject.

Indirect illumination
The illumination that results from light being transmitted between objects.

Intensity
A light's intensity is controlled by its Value field and its Multiplier field.

Interlacing
The technique used to produce video images whereby two alternating field images are displayed in rapid sequence so that they appear to produce a complete frame.

Inverse square law
The realistic falloff of light from a source as it covers more area.

Kelvin
The unit of measurement used in color temperature.

Key light
The main light source in a scene, the key light is defined by being the most dominant light in a given scene.

Key-to-fill ratio
The ratio of a key light's intensity to the fill light intensity, measured at the subject. Low values create open shadows and a happy atmosphere, whilst high values produce high contrast and moody results.

Letterboxing
The process of placing a widescreen image onto a regular 4:3 frame with black borders above and below the image filling the frame.

Light probe
Used to record lighting, a mirrored ball is shot at a range of exposures and these images are combined to create an HDR image used to light the scene.

Light Tracer
One of 3ds Max's Advanced Lighting Modes that provides soft-edged shadows and color bleeding, like radiosity. The Light Tracer does not attempt to create a physically accurate model and can be easier to set up.

Local illumination
Lighting using only the direct components of your light sources, where the transmission from other objects in the scene is not taken into account.

Log arithmic space
A nonlinear color space whose conversion function is similar to the curve produced by a logarithmic equation.

Low-key
A high key-to-fill ratio creates a high contrast scene.

Luminaire
A term used in the lighting world to describe light fittings of different designs, normally including the bulb, reflectors, housing, and so on.

Luminosity
The emission of light energy per second.

Map
The images assigned to materials as patterns are called maps and can include standard bitmap types such as .bmp, .jpg, and .tif, procedural maps and image processing systems such as compositors and masking systems.

Matte
An image used to define or control the transparency of another image.

Matte painting
Traditionally matte paintings started life as paintings of environments on glass that are combined with the filmed actors.

mental ray
The mental images renderer can generate physically correct lighting effects, including raytraced reflections/refractions, caustics, and global illumination.

Moore's law
The observation that computing power increases exponentially over time, and that historically it has doubled every 18 months over a long time span.

Motion blur
Motion blur is applied to fast moving objects in a scene to make them appear blurred in each frame, which will have the effect of making them appear to move smoothly in the finished animation.

Multiplier
The Multiplier value in every light in 3ds Max lets you increase the intensity or brightness of the light beyond its standard range.

NTSC
NTSC, or National Television Standards Committee, is the name of the video standard used in North America, most of Central and South America, and Japan. The frame rate is 30fps or 60 fields per second, with each field accounting for half the interleaved scan lines on a television screen.

Negative brightness
A light created with negative brightness will remove light from its area of illumination, creating a region of darkness that can be useful for selectively darkening areas or creating false shadows.

Noise
Used to create random patterns in materials, animation and geometry.

Non-square pixels
The result of rendering at a different pixel aspect ratio than 1:1, necessary because of the historical legacy of many digital disk recorders.

Normal
A vector that defines which way a face or vertex is pointing. The direction of the normal indicates the front, or outer surface of the face or vertex.

Omni lights
Omni lights provide a point source of illumination that shoots out in all directions. Easy to set up, but the focus of their beam can't be restricted.

Opacity
Defines how opaque a material is: from totally transparent at 0% to totally opaque at 100%.

Overscan
Broadcasters intentionally overscan the video image to ensure that no unintentional black areas are visible on a television screen. The result is that portions of an image around the edges are not visible on a typical set.

PAL

PAL, or Phase Alternate Line, is the video standard used in most European countries. The frame rate is 25fps or 50 fields per second, with each field accounting for half the interleaved scan lines on a television screen.

Pan and scan

The process of reframing a widescreen image to fit into a standard 4:3 screen involves cropping a portion of the original image, though the area visible can be animated to scan across the widescreen version.

Penumbra

A partial shadow between regions of total shadow and total illumination.

Photometric lights

Lights that use real-world photometric light energy values.

Photon

The single unit of light illumination.

Photon mapping

An approach to rendering global illumination creates a resolution independent Photon map that stores the lighting information.

Picture safe area

The central 90% or so of a broadcast frame that will be safe from cropping due to overscan.

Pixel

An acronym that stands for Picture Element, this is the smallest component that makes up the display on a computer monitor. Just as each dot on the screen is a pixel, images are likewise stored in a pixel form that is mapped to the screen pixels for viewing.

Plug-in

An additional product that is used within or alongside a software solution, plug-ins extend the functionality of an application in a specific way.

Point light

A local source of illumination that shines in all directions from a single infinitely small point.

Point-of-view shot

A shot taken with the camera representing the point-of-view of a character, for example the exaggerated gait of a drunken character.

Primary colors

Fundamental colors that when combined create a secondary color. Light's primaries are Red, Green and Blue.

Projector map

By adding a map to a light, you turn it into a projector. You can assign a single image, or you can assign an animation to simulate shadows seen through leaves or window frames, in the same way that gobos are used in theater lighting.

Quadtrees

A quadtree is a data structure used to calculate raytraced shadows. The quadtree represents the scene from the point-of-view of the light. The root node of the quadtree lists all objects that are visible in that view. If too many objects are visible, the node generates four other nodes, each representing a quarter of the view, each with a list of objects in that portion. This process continues adaptively, until each node has only a small number of objects, or the quadtree's depth limit (which can be set for each light) is reached.

RGB

A method of representing colors as the combination of Red, Green and Blue light, which works through additive mixing.

Radiation

The transfer or release of energy through particle emission, which all objects emit in some form.

Radiosity

The method of calculating global illumination that accounts for both the direct and indirect illumination in a scene.

Raytraced shadows

Shadows are generated by tracing the path of rays sampled from a light source. Raytraced shadows are more accurate than shadow-mapped shadows. They are more realistic for transparent and translucent objects.

Raytracing

A rendering algorithm that simulates the physical and optical properties of light rays as they reflect off and refract through objects in a 3D model. This method generally traces rays of light backward from the imaging plane to the light sources.

Reflection

The abrupt change in direction of a wave front at an interface between two dissimilar media so that the wave front returns into the medium from which it originated.

Refraction

The change in direction of light as it passes from one transparent material to another. This causes an apparent shift in the image showing through the transparent material.

Renderer

The software, often a component of a 3D software package, that calculates and displays the resultant image frames from a 3D scene.

Rendering

This is a process that combines a geometric model with descriptions of its surface properties, lighting and so on to create a visual image.

Resolution

The number of pixels per unit. The higher the number of pixels, the higher the resolution, and the greater the capacity to display detail.

Roll

To rotate a camera or light about the horizontal plane.

SMPTE

SMPTE (Society of Motion Picture and Television Engineers) is the standard time display format for most professional animation work. From left to right, the SMPTE format displays minutes, seconds, and frames, delineated by colons.

Safe area

Comprised of three separate regions, the safe area defines how close to the edge of a broadcast image various elements should go.

Sample range

Sample range affects the softness of the edge of shadow-mapped shadows, determining how much area within the shadow is averaged.

Saturation

The extent to which a color is made purely of a particular hue; the vividness of the hue.

Scanline rendering

As the name implies, this process renders the scene as a series of horizontal lines.

Self-illumination

Self-illumination creates the illusion of incandescence by replacing any shadows on the surface with the diffuse color.

Shade

The color resulting from the addition of black to a pure hue.

Shadow color

The color allocated to a light's shadows.

Shadow map

A shadow map is a bitmap that's projected from the direction of the spotlight. This method provides a softer edge and can require less calculation time than raytraced shadows, but it's less accurate.

Shadows-only lights

Lights whose sole purpose is to generate a shadow with no illumination. These are often faked using two lights of the same intensity, one with a negative value and one with a positive value so the illumination cancels itself out. The positive light is the only one set to cast shadows.

Skylight

A light type in 3ds Max that models daylight and works as a dome above the scene. The Skylight works best with the Light Tracer.

Snell's law

A law that defines how light refracts.

Soft light

Light which has been scattered in some way that casts shadows with soft edges. The larger and closer a light source, the softer it will be.

Specular reflection

The component of the light reflecting from a surface caused by its shiny or glossy nature. Shiny surfaces reflect light striking them in clearly defined angles of incidence, resulting in hotspots corresponding to the direction of the light sources providing the illumination.

Spotlight

A local source of illumination that shines in only one direction.

Subtractive color

The process of color mixing that exists in pigments where the primaries of red, yellow and blue combine together to make black.

SuperSampling

SuperSampling is one of several antialiasing techniques. Textures, shadows, highlights, and raytraced reflections and refractions all have their own preliminary antialiasing strategies. SuperSampling is an optional additional step before the renderer performs its final antialiasing pass.

Superwhite

See *Unclamped color.*

Technical Director

Commonly abbreviated to TD, the Technical Director's job is the one that commonly involves the task of lighting a production and can also include texturing, rendering and shader development.

Telecine

The process of digitizing film, where each frame is scanned and stored digitally. It is at this stage where color correction often takes place.

Texture mapping
The process of applying textures to a 3D model.

Three-point lighting
A convention, established in cinematography, that helps to emphasize three-dimensional forms with light.

Throw
How a light is broken up by objects around it into patterns and shapes.

Throw pattern
Used to mimic go-betweens in real lighting, a throw pattern when allocated to a light breaks the light up according to the map.

Tint
The color resulting from the addition of white to a pure hue.

Title safe area
The central 80% of a broadcast image, outside of which it is not recommended to place titles.

Tone
The addition of gray to a pure hue.

Translucency
A translucent material transmits light, but unlike a transparent material, it also scatters the light so objects behind the material cannot be seen clearly.

Transmission
The conduction of light through a media.

Transparency
The characteristic of an image that allows an underlying image to be visible.

True color
Describes hardware and software that can support up to 16M color values. Also known as 24-bit or (with alpha channel data) 32-bit color.

Tungsten-balanced film
Film stock that has been designed to be used in artificially lit conditions, where its 3,200 °K color balance makes tungsten lighting appear white.

Unclamped color
An unclamped color is brighter than pure white and is most likely to appear in highlights on shiny metallic objects. Used in HDR rendering.

Umbra
The totally occluded area of the shadow that has no illumination.

Value
The relative lightness or darkness of the color, usually measured as a percentage from 0% (black) to 100% (white).

View-independence/-dependence
A view-independent calculation is calculated for the environment and hence is not tied to any one particular view. This means that rendering from any point of view can be carried out using these initial calculations. View-dependent calculations must be calculated for each rendered frame.

Visible Spectrum
The narrow band of the electromagnetic spectrum that we can see.

Volumetric lighting
Provides light effects based on the interaction of lights with atmospheric matter such as fog, smoke, dust, and so on.

White point
The numerical value that corresponds to the brightest area that will be represented when the image is viewed in its final form.

Bibliography

Ablan, D. (2002). *Inside LightWave 7*, New Riders Publishing.

Ahearn, L. (2001). *3D Game Art: fx & Design*, Coriolis.

Alton, J. (1995). *Painting With Light*, University of California Press.

Anders, P. (1998). *Envisioning Cyberspace: Designing 3D Electronic Spaces*, McGraw-Hill Professional Publishing.

Apodaca, A. A. and Gritz, L. (2000). *Advanced RenderMan*, Morgan Kaufmann.

Ascher, S., Pincus, E., Keller, C., Brun, R. and Spagna, T. (1999). *The Filmmaker's Handbook: A Comprehensive Guide for the Digital Age*, Plume.

Barratt, K. (1980). *Logic & Design in Art, Science & Mathematics*, Design Books.

Beckman, J. (1998). *The Virtual Dimension: Architecture, Representation, and Crash Culture*, Princeton Architectural Press.

Bell, J. A. (1999). *3D Studio MAX R3: f/x & Design*, Coriolis.

Billups, S. (2000). *Digital Moviemaking: The Filmmaker's Guide to the 21st Century*, Focal Press.

Birn, J. (2000). *Digital Lighting & Rendering*, New Riders Publishing.

Birren, F. (1978). *Color & Human Response*, Van Nostrald Reinhold.

Bizony, P. (2002). *Digital Domain: The Leading Edge of Visual Effects*, Watson-Gupthill Publishers.

Boardman, T. (2004). *3ds Max Master Class Series, - DVD 5 - All Dressed Up*, discreet.

Boardman, T. (2005). *3ds max 7 Fundamentals*, New Riders Publishing.

Boardman, T. and Hubbell, J. (1999). *Inside 3D Studio MAX 3, Modeling, Materials and Rendering*, New Riders Publishing.

Bobker, L. R. (1979). *Elements of Film*, Harcourt Brace Jovanovich.

Boughen, N. (2003). *LightWave 3D 7.5 Lighting*, Worldware Publishing.

Brinkmann, R. (1999). *The Art and Science of Digital Compositing*, Morgan Kaufmann.

Child, J. and Galer, M. (2002). *Photographic Lighting Essential Skills*, 2nd edition, Focal Press.

Cohen, D. (1994). *Professional Photographic Illustration*, Silver Pixel Press.

Davies, A. and Fennessy, P. (2001). *Digital Imaging for Photographers*, 4th edition, Focal Press.

Davies, G. (2004). *Focal Easy Guide to Discreet Combustion 3*, Focal Press.

Davies, G. (2004). *3ds Max Master Class Series, - DVD 9 - 3D with the Compositing Process in Mind*, discreet.

Debevec, P., Pattanaik, S., Reinhard, E., Ward, G., (2005). *High Dynamic Range Imaging: Acquisition, Display, and Image-Based Lighting*, Morgan Kaufmann.

Demers, O. (2001). *Digital Texturing & Painting*, New Riders Publishing.

Dong, W. and Gibson, K. (1998). *Computer Visualization: An Integrated Approach for Interior Design and Architecture*, McGraw-Hill Professional Publishing.

Draper, P. (2004). *Deconstructing the Elements with 3ds max 6*, Focal Press.

Driemeyer, T. (2005). *Rendering with mental ray*, SpringerWienNewYork.

Ebert, D.S., Musgrave, F.K., Peachey, D., Perlin, K. and Worley, S. (1998). *Texturing and Modeling: A Procedural Approach*, Academic Press.

Ferguson, M. (2000). *Max Ferguson's Digital Darkroom Masterclass*, Focal Press.

Fleming, B. (1999). *3D Modeling & Surfacing*, Academic Press.

Foley, J.D., van Dam, A., Feiner, S. K. and Hughes, J.F. (1990). *Computer Graphics, Principles and Practice*, Addison-Wesley.

Friedmann, A. (2001). *Writing for Visual Media*, Focal Press.

Galer, M. and Horrat, L. (2002). *Digital Imaging Essential Skills*, 2nd edition, Focal Press.

Gallardo, A. (2001). *3D Lighting: History, Concepts & Techniques*, Charles River Media.

Glassner, A.S. (1989). *An Introduction to Ray Tracing*, Academic Press.

Glassner, A.S. (1995). *Principles of Digital Image Synthesis*, Morgan Kaufmann.

Goldstein, N. (1989). *Design and Composition*, Prentice Hall.

Goulekas, K. E. (2001). *Visual Effects in a Digital World: A Comprehensive Glossary of Over 7,000 Visual Effects Terms*, Morgan Kaufmann Publishers.

Graham, D.W. (1970). *Composing Pictures*, Van Nostrald Reinhold.

Hall, R. (1989). *Illumination and Color in Computer Generated Imagery*, Springer-Verlag.

Harris, M. (2001). *Professional Architectural Photography*, 3rd edition, Focal Press.

Heckbert, P. S. (1992). *Introduction to Global Illumination*, ACM SIGGRAPH.

Huffman, K. (2001). *Psychology in Action*, 6th edition, John Wiley & Sons.

Imperiale, A. (2000). *New Flatness: Surface Tension in Digital Architecture*, Birkhauser.

Jacobson, R.E., Attridge, G.G., Ray, S.F. and Axford, N.R. (2000). *The Manual of Photography, Photographic and Digital Imaging*, 9th edition, Focal Press.

James, J. (2005). *Digital Intermediates for Film and Video*, Focal Press.

Katz, S. D. (1991). *Film Directing Shot by Shot*, Michael Wiese Productions.

Katz, S. D. (1992). *Film Directing Cinematic Motion*, Michael Wiese Productions.

Kelly, D. (2000). *Digital Compositing In Depth*, Coriolis Group.

Kent, S. (2001). *The Making of Final Fantasy: The Spirits Within*, Brady Games.

Kerlow, I.V. (2000). *The Art of 3-D Computer Animation and Imaging*, Rockport Publishers.

Kerlowi. (1996). *Computer Graphics for Designers & Artists*, 2nd edition, John Wiley & Sons.

Kuperberg, M. (2002). *Guide to Computer Animation for TV, games, multimedia and web*, Focal Press.

Lammers, J., Gooding, L. (2002). *Maya 4 Fundamentals*, New Riders Publishing.

Landau, C. and White, T. (2000). *What They Don't Teach You at Film School: 161 Strategies to Making Your Own Movie No Matter What,* Hyperion.

Laytin, P. (2000). *Creative Camera Control,* 3rd edition, Focal Press.

Lewis, I. (2000). *How to Make Great Short Feature Films,* Focal Press.

Lowell, R. (1992). *Matters of Light and Depth,* Broad Street Books.

Lynch, D. K. and Livingston, W. (1995). *Color and Light in Nature,* Cambridge University Press.

Lyver, D. and Swainson, G. (1999). *Basics of Video Lighting,* Focal Press.

Maffei, T. P. (2004). *3ds Max Master Class Series, - DVD 6 - Texture Mapping within 3ds Max,* discreet.

Malkiewicz, K. (1986). *Film Lighting: Talks With Hollywood's Cinematographers and Gaffers,* Prentice-Hall Press.

Malkiewicz, K. (1989). *Cinematography: A Guide for Film Makers and Teachers,* Simon & Schuster Inc.

Mascelli, J. V. (1998). *The Five C's of Cinematography: Motion Picture Filming Techniques,* Silman-James Press.

Masson, T. (1999). *CG 101: A Computer Graphics Industry Reference,* New Riders Publishing.

Matossian, M. (2001). *3ds max for Windows,* Peachpit Press.

McCarthy, R. (1992). *Secrets of Hollywood Special Effects,* Focal Press.

McFarland, J. and Polevoi, R. (2001). *3ds Max In Depth,* Coriolis.

McGrath, D. (2001). *Editing & Post-Production,* Screencraft series, Focal Press

McKee, R. (1997). *Story,* ReganBooks.

Minnaert, M. G. J. (1993). *Light and Color in the Outdoors,* Springer-Verlag.

Mitchell, M. (2004). *Visual Effects for Film and Television,* Focal Press.

Novitski, B. J. and Mitchell, W. (1999). *Rendering Real & Imagined Buildings: The Art of Computer Modeling from the Palace of Kublai Khan to Le Corbusier's Villas,* Rockport Publishers.

Ojeda, O. R. and Guerra, L. H. (2000). *Hyper-Realistic: Computer Generated Architectural Renderings,* Rockport Publishers.

Osipa, J. (2002). *Stop Staring!,* Sybex Inc.

Parish, D. (2002). *Inspired 3D Lighting and Compositing,* Premier Press.

Perisic, Z. (2000). *Visual Effects Cinematography,* Focal Press.

Rabiger, M. (2000). *Developing Story Ideas,* Focal Press.

Ray, S. F. (2002). *Applied Photographic Optics,* 3rd edition, Focal Press.

Rickitt, R. (2000). *Special Effects: The History and Technique,* Watson-Guptill Publications.

Rogers, P. B. (1999). *The Art of Visual Effects: Interviews on the Tools of the Trade,* Focal Press.

Saleh Uddin, M. (1999). *Digital Architecture,* McGraw-Hill Professional Publishing.

Schaefer, D. and Salvato, L. (1986). *Masters of Light: Conversations With Contemporary Cinematographers,* University of California Press.

Schoenherr, M. (2001). *Exploring Maya 4, 30 Studies in 3D,* Peachpit Press.

Steffy, G. (2001). *Architectural Lighting Design,* John Wiley & Sons.

Tarrant, J. (2000). *Practical Guide to Photographic Lighting for Film and Digital Photography,* Focal Press.

Thomas, F. (1995). *The Illusion of Life: Disney Animation,* Hyperion.

Valentino, J. (2001). *Photographic Possibilities,* Focal Press.

Vineyard, J. and Cruz, J. (2000). *Setting up Your Shots: Great Camera Moves Every Filmmaker Should Know,* Michael Weise Productions.

Watkins, A. (2002). *The Maya 4 Handbook,* Charles River Media.

Watt, A., and Watt, M. (1992). *Advanced Animation and Rendering Techniques: Theory and Practice,* Addison-Wesley.

Weishar, P. (1998). *Digital Space: Designing Virtual Environments,* McGraw-Hill Professional Publishing.

Weishar, P. (2002). *Blue Sky: The Art of Computer Animation,* Harry N. Abrams.

Whitaker, H. (2002). *Timing for Animation,* Focal Press.

Wright, S. (2001). *Digital Compositing for Film and Video,* Focal Press.

Zakia, R. D. (2001). *Perception and Imaging,* Focal Press.

Zellner, P. (1999). *Hybrid Space: New Forms in Digital Architecture,* Rizzoli.

Recent photography and digital imaging titles available at
www.focalpress.com and all good bookstores